The Emergence of the
African-American Artist

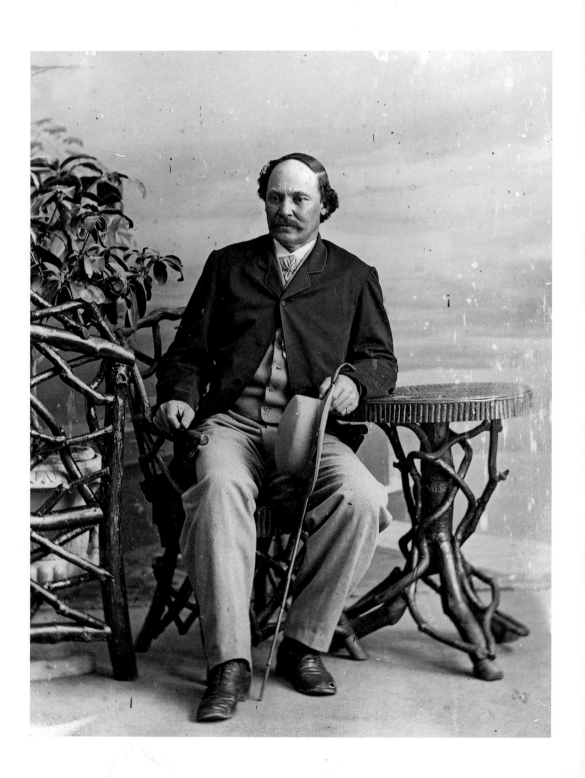

The Emergence of the African-American Artist

Robert S. Duncanson
1821–1872

Joseph D. Ketner

University of Missouri Press

Columbia and London

Copyright © 1993 by
The Curators of the University of Missouri
University of Missouri Press, Columbia, Missouri 65201
Printed and bound in Japan
All rights reserved
First paperback printing, 1994
5 4 3 2 1 98 97 96 95 94

Library of Congress Cataloging-in-Publication Data

Ketner, Joseph D.
 The emergence of the African-American artist: Robert S.
Duncanson, 1821–1872 / Joseph D. Ketner.
 p. cm.
 Includes bibliographical references and index.
 ISBN 0-8262-0974-2 (pbk.)
 I. Duncanson, Robert S., 1821–1872. 2. Afro-American painters—
Biography. 3. Landscape Painters—United States—Biography.
I. Duncanson, Robert S., 1821–1872. II. Title.
ND1839.D85K48 1993
759.13—dc20
[B] 92-21542
 CIP

♾™ This paper meets the requirements of the American National Standard
 for Permanence of Paper for Printed Library Materials, Z39.48, 1984.

Designer: Rhonda Miller
Typesetter: Reporter Typographics, Inc.
Printer and binder: Dai Nippon Printing Co.
Typefaces: Sabon and Tiffany Med. Italic

This book is brought to publication with the generous assistance
of Dr. and Mrs. Harmon W. Kelley and Walter O. Evans, M.D.

Frontispiece photograph of Robert Duncanson taken in 1864 by William Notman.
Courtesy the Notman Archives, McCord Museum, McGill University, Montreal, Canada.

To my parents and family

CONTENTS

ACKNOWLEDGMENTS

A decade of research on Robert S. Duncanson provided the foundation for this critical biography and led to the discovery of new information that stimulated a comprehensive reconsideration of his art as well as his life. After the artist's death, his life and work fell into obscurity. The scholars who rediscovered his work in the 1950s and 1960s perpetuated assumptions about his life based upon oral tradition. My principal aim in this study is to provide new and accurate information on Duncanson and to dispel the many myths generated by the uncritical repetition of undocumented opinions about the artist. In addition, I examine the ordeals faced by an African-American artist living in antebellum America and explore the distinctive perspective masked behind Duncanson's seemingly mainstream landscape painting.

Uncovering the scant documentation that survives on Duncanson required extensive research to reassemble the events of his life into a comprehensive narrative. Over the decade of my work on Duncanson a number of individuals, scholars, and institutions assisted in the realization of this book. It would not have been possible without the patience, encouragement, and support of my wife, Patricia, and sons, Joseph and Alexander.

Among scholars Dennis Au, Assistant Director of the Monroe County Historical Museum, Michigan, and Dennis Reid, Curator of the Art Gallery of Ontario, Toronto, contributed the most vital biographical research on the painter. Au uncovered a body of data on the Duncanson clan in Monroe that opened a new chapter on the artist's life. Reid, while researching the history of Canadian painting, discovered many details concerning Duncanson's life and importance to cultural developments in Canada during the 1860s.

A number of other individuals generously shared their knowledge of Duncanson's art and life. At an early stage of my research the late Romare Bearden related the circumstances surrounding the discovery of *Land of the Lotus Eaters* (1861) in the collection of the King of Sweden. David Driskell and Edward Shein's broad awareness of African-American arts helped in locating artworks in private collections. Also, many private collectors graciously permitted me to view their paintings and documents, including Judy Carter, Cincinnati; Rene de Chambrun, Paris; Mrs. Alan Van Duesen, Toledo; Warren and Charlyn Goings, New York; Richard Manoogian, Detroit; Richard Rust III, Cincinnati; William Rybolt, Cincinnati; and E. Thomas Williams, New York.

Over the past decade I have traveled to a number of institutions and libraries for my research. Several museums offered the opportunity to write essays on specific aspects of Duncanson's career that eventually contributed to the production of this work. Dr. Ruth Meyer, Director, David Johnson, Assistant Director, and Heather Hallenberg, former Curator of Education, of the Taft Museum, Cincinnati, have encouraged my research for many years and sponsored my work on the Belmont murals. In Montreal, Mr. Stanley Triggs and Nora Hague at the

Notman Archives of the McCord Museum, McGill University, and Mr. Yves Lacasse, Assistant Conservateur at the Montreal Museum of Fine Arts, guided me through the Canadian resources on Duncanson. At the Detroit Institute of Arts, Mrs. Nancy Rivard Shaw offered valuable assistance with the Institute's extensive holdings of the painter's work. Lynda Hartigan, Curator at the National Museum of American Art, permitted access to the National Museum's collection, the largest assembly of Duncanson's paintings, and provided vital documentation on these objects. John K. Howat, formerly Lawrence A. Fleischman Chairman of the Department of American Art, contributed important data on the Metropolitan Museum of Art's fine paintings by Duncanson. The Washington University Gallery of Art, St. Louis, and the Fort Wayne Museum of Art, Indiana, provided time for the research and travel essential to realizing this project.

The major research on Robert Duncanson centered in Cincinnati, the artist's primary residence. I spent several summers studying in the Cincinnati Historical Society and the Cincinnati Art Museum. The staffs of these two institutions were consistently amiable and helpful. I am especially grateful to the staff of the Cincinnati Historical Society, under the directorship of Gale Peterson. At the Cincinnati Art Museum, former curator Denny Carter Young and her assistant Francis Martindale made their files and holdings on Cincinnati art available to me. The librarian, Patricia P. Rutledge, readily provided resources that could not be located elsewhere.

Professors Louis Hawes, W. Eugene Kleinbauer, and Sarah Burns at Indiana University first suggested Duncanson as a subject and guided my graduate research on the artist, which initiated this project. In the early stages of preparing this manuscript Professor David Sokol, University of Illinois–Chicago Circle, provided me with valuable advice and guidance. In addition, my discussions with Professor David Lubin, Colby College, opened new avenues of interpreting Duncanson's art. I am especially grateful to my colleague J. Gray Sweeney, Professor of Art History, Arizona State University, for his long-standing encouragement of my work on Duncanson, beginning with his publication of my essay on the African-American artist's career in Michigan. I am indebted to Gray for his critical reading of this manuscript, which was instrumental in refining the text for publication.

I sincerely appreciate the advice, assistance, and support of all of the above people and institutions, and any that I may have inadvertently overlooked.

The Emergence of the
African-American Artist

The spiritual striving of the freedmen's sons is the travail of souls.

—*W. E. B. Du Bois*

INTRODUCTION

*R*obert S. Duncanson achieved unprecedented renown in the art world of antebellum America, despite the adversity he faced as a freeborn "person of color," earning national and international acclaim for his landscape paintings. Duncanson's progression from a humble housepainter to recognition in the arts signaled the emergence of the African-American artist from a people predominantly relegated to laborers and artisans. Although Duncanson is little known today, in the mid-nineteenth century critics, patrons, and the public acknowledged him as the "best landscape painter in the West."[1] He pursued his artistic career during a time of tremendous racial prejudice, yet his inner drive and considerable talent motivated him to break racial barriers and emerge as the first African-American to create artworks of enduring cultural value. Duncanson blazed a trail through social, economic, and political discrimination, opening the way for other African-Americans to pursue careers in art. In this regard, his career paralleled those of Phyllis Wheatley in literature and Frederick Douglass in politics in their astonishing ability to rise above racial oppression to create significant early expressions of African-American cultural identity.

Duncanson was the first African-American artist to appropriate the landscape as part of his cultural heritage and as an expression of his cultural identity. African-American arts initially developed from slave crafts into the works of skilled free tradesmen and portrait painters, such as Joshua Johnson in the early nineteenth century. Beginning with Duncanson's success as a landscape painter, African-American artists moved into the mainstream art world. This progression from portraiture to landscape painting paralleled the development of the arts in the United States from the colonial era into the early years of the republic. During this period white artists progressed from expressing American culture through likenesses of leading citizens to conceptualizing the national identity in the landscape. African-American visual culture experienced a similar development with a cultural lag forced by the restraints of slavery and legislated oppression of freemen in the antebellum United States. By painting the landscape, Duncanson metaphorically claimed the American land as a valid vehicle for expressing African-American culture as a part of the larger American cultural experience. He achieved this by investing the mainstream aesthetics of American landscape painting with a veiled significance that was understood by the African-American community.

Duncanson matured as an artist in Cincinnati, his primary residence from 1840 until his death. Because of its economic prosperity and rapidly growing population, Cincinnati became a major art center, boasting that it was the "Athens of the West."[2] After working as an itinerant artist throughout the 1840s and struggling to master the techniques of painting, Duncanson was influenced by a regional group of Cincinnati landscape painters, including T. Worthington Whittredge (1820–1910) and William Louis Sonntag (1822–1900). These artists and the fertile cultural environment of Cincinnati

inspired the young African-American
to pursue a career in art as a landscape
painter. In the 1850s and 1860s,
Duncanson emerged as the principal
landscape painter active in the Ohio River
valley, receiving impressive recognition
for his views of the American wilderness
and his pastoral landscapes, which
were often suggested by popular romantic
literature. At this time Duncanson and
James Pressley Ball (1825–1905?), a
daguerreotypist, formed the nucleus of a
group of African-American artists;
remarkably, the two were acclaimed as the
leading artists of Cincinnati during the
decade prior to the Civil War.

Duncanson exiled himself from the
United States in the early 1860s, deeply
troubled by the racial strife of the
Civil War. He traveled through Canada to
England to escape the physical restraints
and psychological trauma of the war
and to exhibit his "great picture," *Land of
the Lotus Eaters* (1861, Plate 11), to
an international audience. Canadians
warmly received the distinguished African-
American painter into their cultural
community without reservations about his
skin color. Duncanson remained in
Canada for several years and contributed
decisively to founding a national landscape
painting school. He then toured the
British Isles, where the aristocracy sought
his company and patronized him, and
English critics hailed his work as equal to
that of any modern landscapist. In his
final years the artist suffered a tragic
dementia, perhaps caused by lead poisoning
during his years as a housepainter, that
led him to believe that he was possessed by
the spirit of a master painter. His illness,
combined with the pressures of racial
oppression and his lofty ambitions, proved
too great for him to manage, and he
collapsed while hanging an exhibition in

Detroit, dying in a sanatorium shortly
thereafter.

After Duncanson's death, his achievement
lapsed into obscurity. Yet the quality of
his art and his remarkable feat of rising
from poverty and racial oppression
to international fame as an artist merit a
reconsideration of his art and life.
This account of his life based on rediscov-
ered archival documents vividly illuminates
the terrible adversity that an African-
American artist confronted in antebellum
America, and the critical evaluation
of his work reveals the importance of his
contribution to nineteenth-century
American art and African-American
cultural heritage.

Duncanson's racial heritage and the
social environment in mid-nineteenth-
century America had a direct impact on his
art and career. Born into a poor family
of free African-American tradesmen,
Duncanson received no formal art educa-
tion. After an apprenticeship in the
family trade of housepainting, he taught
himself the fine art of painting by diligently
copying prints and painting portraits
and sketching from nature. Driven by a
great ambition that he often expressed in
his letters, he progressed from practicing the
skilled trades to become a landscape
painter with a distinctive romantic vision
of nature. Although it is clear from
Duncanson's letters and paintings that he
was quite well read, no records exist
documenting any formal education as a
youth. Despite this handicap, he partici-
pated throughout his career in the
elite cultural circles of Cincinnati, Detroit,
Montreal, and London, exhibiting a
sensitive and often profound understanding
of romantic literature in his art.

As a "freeman of color" struggling to
establish a career in the strictly white art
world of antebellum America, Duncanson

faced many obstacles. He and his family continually confronted racial prejudice, usually living in districts segregated from the white residential areas. In the decades preceding emancipation, legislation increasingly restricted the activities, movements, and opportunities of "free colored persons." At this time Duncanson witnessed the white backlash to increasing abolitionist sentiments that led to several periods of racial riots and murders in Cincinnati's black district, "Bucktown." A major portion of Cincinnati's booming economy depended upon southern trade, forcing Duncanson to face the specter of slavery daily in the markets, at the docks, and across the river from his home.

However, in the midst of this pervasive racism, Duncanson experienced some advantages because of his mulatto complexion and the sustained patronage of abolitionist sympathizers. Contemporary documents constantly refer to Duncanson as a fair-skinned mulatto, a distinction that had important social consequences in this era. To some members of the white population Duncanson exemplified the favorable results of miscegenation between masters and their slaves. Many contemporary white Americans were convinced of their racial superiority and conversely of the biological inferiority of African-Americans as well as native Americans. At this time a number of pseudo-scientific theories concerning the origins of the human race proposed biological models for interpreting the perceived physiological inferiority of peoples of African descent. The misguided knowledge of the time asserted that these marginalized races were doomed to extinction unless they interbred with Caucasians.[3]

It was popularly believed in antebellum United States that, due to the mix of Caucasian and negro blood, mulattoes were superior to darker African-Americans. Therefore, in both the slaveholding South and the North, society permitted mulattoes and mixed-blood people certain minor privileges and opportunities that were not available to other nonwhites. Socially separated from the Anglo-European population, and completely disenfranchised politically and economically, mulattoes were denied ready access to American society; nonetheless, compared to darker African-Americans, they received more favored treatment.[4] Whether because of the paternal sentiments of slave masters toward their illegitimate offspring, or because of contemporary society's stratification of racial prejudice, American society permitted mulattoes greater access to an education and the skilled trades, thereby providing them the means to pursue higher social and economic status. Duncanson's limited opportunities to learn the painting trade and to aspire to be a fine artist were a legacy he inherited from his grandfather, a former slave from Virginia who was the offspring of a miscegenational relationship.

During the mid-nineteenth century Cincinnati served as a center for the free "colored" population and was a stronghold of abolitionism. Duncanson took advantage of this supportive environment, benefiting considerably from abolitionist patronage. He was closely associated with several well-known abolitionists during the 1850s and painted portraits of those patrons. He actively participated in antislavery events and, on several occasions, presented his paintings on behalf of the African-American population to noted abolitionists as gestures of appreciation for their work. The abolitionist journals were quick to recognize his artistic accomplishments and antislavery activities, promoting him as

mplar of the creative potential of
_an-Americans.

Paradoxically, Duncanson's art rarely
addressed the issues of racial oppression
and prejudice that a free black man
faced in antebellum America. His only
treatment of an explicitly African-American
subject is *Uncle Tom and Little Eva*
(1853, Plate 7), commissioned by a
prominent Detroit minister and newspaper
editor known for his abolitionist sentiments.
Duncanson's sensitive interpretation of
Harriet Beecher Stowe's novel makes a
powerful statement concerning his attitude
toward slavery. The artist and patron
did not choose a dramatic scene such as
Tom's death by flogging or the escape of
Eliza, but a contemplative moment at
the turning point in the novel that reflects
a central theme of the book, salvation
through spiritual love and sacrifice. *Uncle
Tom* illustrates Duncanson's personal
association with the plight of his enslaved
brethren and reveals his belief in salvation
from the evils of slavery.

Instead of creating explicit images
dealing with contemporary racial concerns,
Duncanson, like other nineteenth-century
African-American artists, worked primarily
within the broader American cultural
aesthetic. His ultimate contribution was his
romantic vision of landscape painting.
His paintings deal with the perceived
national cultural identity as it was manifest
in man's relationship with nature and
portrayed through the landscape. His use
of the mainstream landscape aesthetics
to interpret these themes was distinctive
among his contemporaries. Furthermore, a
critical examination of his landscapes
reveals a disguised content; to use W. E. B.
Du Bois's term, one must lift the veil
of the mainstream aesthetics in order
to read the artist's emotional reaction to
and beliefs concerning the struggle of

blacks in antebellum America. Thus, an
analysis of Duncanson's adaptation of the
complex landscape aesthetics and his
African-American perspective will provide
the key to understanding his art.

In the years following the War of 1812
the new nation sought to establish a
national identity. Due to the overwhelming
presence and unique character of the
"New World" wilderness, Americans linked
their cultural identity to the landscape.
The literary works of William Cullen
Bryant, Washington Irving, and James
Fenimore Cooper first manifested this
trend, which was further realized in the
paintings of Thomas Cole (1801–1848),
the "father of American landscape
painting," and his contemporaries Thomas
Doughty (1793–1856) and Asher Durand
(1796–1886), who established the so-
called Hudson River School style. In their
canvases these artists established the
first distinctively American vision of the
native landscape, not only portraying the
physical attributes of the land but also
expressing an American spiritual, political,
and social identity.

The American landscape painters found
the stylistic precedent for their works
in the English landscape painters and
aestheticians of the late eighteenth and
early nineteenth centuries who codified the
form and content of landscape painting.
Early English theoreticians interpreted the
landscape in terms of three aesthetic
modes: the beautiful, picturesque, and
sublime. The "beautiful" landscape
style was based on the seventeenth-century
classical landscape masters and conveyed an
image of a serene world that harks back
to an ideal arcadia bathed in a golden
sunlight emanating from the heavens.
Other English artists turned to the realistic
style of the seventeenth-century Dutch
landscape painters to create "picturesque"

scenes of the uncultivated, rural country-side. Later writers, particularly William Gilpin (1724–1804), codified the picturesque into a set of formal pictorial qualities that could be found in rough, craggy trees, sharp contrasts of light and shadow, and rustic anecdotes. The unique contribution of British landscape art and aesthetics was the "sublime" aesthetic mode, characterized by tremendous mountains, deep valleys, vast spaces, and cataclysmic storms that aroused in the spectator feelings of terror, awe, and wonder in the face of omnipotent nature.[5]

The stylistic models of the beautiful, sublime, and picturesque proved instrumental for early American landscape painters. Artists of the Hudson River School adapted the English landscape tradition to their native scenery and used those conventions to endow their pictures with didactic content that elevated landscape above the purely topographical record of a place and reflected their perception of a divine covenant with nature. To achieve such ambitions artists aspired to Sir Joshua Reynolds's academic aesthetics, elaborated in his *Discourses on Art,* which charged the artist to distill the ideal from nature and to depict noble subjects from history and literature. By the 1850s, however, American artists and critics were turning to the popular theories of John Ruskin as outlined in his series of books on *Modern Painters* (1843–1860), in which he declared a "truth to nature" aesthetic that revealed the moral soul and sentiment of nature. Ruskin's ideas linking art, God, and nature with man had a great appeal to Americans and dominated aesthetics in the United States until the Civil War.[6]

Without any language barrier, Americans had ready access to these printed volumes on aesthetics and to travel books with engravings after recognized British landscapists. In addition, American artists regularly traveled to England during this period, and many English artists emigrated to the United States, creating a channel of cultural exchange. American artists utilized the English prototypes as the foundation for envisioning their cultural identity through landscape. Acutely aware of the English aesthetics, American critics interpreted the content and judged the quality of landscape painting through these modes.

Duncanson first learned an appreciation for the conventions of landscape painting from his Ohio River valley contemporaries Whittredge and Sonntag, who exposed him to the style and aesthetics of the primary landscape painters of the era, Cole and Durand. Many Hudson River School artists exhibited at the local Western Art Union exhibits, and reproductions appeared in the leading periodicals of the day, including the *American Art Union Bulletin.* Duncanson certainly read the leading art publications such as *The Crayon, The Cosmopolitan,* and *Northern Light,* all of which were readily available in Cincinnati. Durand's series of "Letters on Landscape Painting" published in *The Crayon* (1855), which constitute an American artist's interpretation of Ruskin, particularly influenced Duncanson. In these essays Durand, then president of the National Academy of Design, outlined aesthetic ideals for American landscape painting. The metaphorical content of Duncanson's paintings reveals his awareness of these resources and his involvement with broader American aesthetic ideals.

A contemporary of Frederic E. Church (1826–1900), Albert Bierstadt (1830–1902), Martin Johnson Heade (1819–

1904), and John Kensett (1816–1872), Duncanson is often considered a second-generation Hudson River School artist. As opposed to the sublime landscapes of Church and Bierstadt, and the transcendental-luminist works of Heade and Kensett, Duncanson forged a distinctively picturesque-pastoral vision of landscape painting with allusions to popular romantic literature. At their best, the African-American artist's paintings rival those of his contemporaries. He was sensitive to contemporary cultural issues, and his artistic development closely paralleled that of his contemporaries. Although his vision of the landscape was firmly based in contemporary taste and aesthetics, it also reflected his social and personal concerns as an African-American.

Over the three decades of his active career Duncanson created landscape paintings that characterize his personal sentiments and aesthetic tastes. A commission in 1848 from Reverend Charles Avery, an abolitionist minister and businessman, to paint *Cliff Mine, Lake Superior, 1848* (Plate 2) marked his transition from an itinerant portrait and "fancy" painter to a painter of landscapes. From this auspicious beginning Duncanson progressed to the point of being considered "the best landscape painter in the West" for his native landscape views and historical subjects. His finest paintings, such as *Blue Hole, Flood Waters, Little Miami River* (1851, Plate 3), *Western Forest* (1857, Plate 9), *The Rainbow* (1859, Plate 10), *Land of the Lotus Eaters,* and *Ellen's Isle, Loch Katrine* (1871, Plate 20), demonstrate his mastery of contemporary conventions and his evolving synthesis of academic literary subjects and aspirations to the "truth to nature" espoused by Ruskin. The painter's vision of the landscape included such sublime images

as a *Western Forest* (1857) after a tornado and views of primeval forests, mountains, cataracts, and rivers similar to those found in works by Cole, Church, and Bierstadt. Unlike some of his New York contemporaries, Duncanson did not explore the vast new territories of the western frontier, South America, and the Arctic. He preferred to remain close to his familiar sketching grounds in the Ohio River valley, but he also painted scenes from his tours of England, Scotland, Italy, and Canada.

Duncanson's landscapes primarily express pastoral and picturesque sentiments, as can be seen in such paintings as *Blue Hole, The Rainbow,* and *Ellen's Isle.* In these works the landscape is not a menacing, sublime force, but a fertile field receptive to man's use for farming, fishing, and raising a family.[7] Duncanson's arcadian view of the American landscape is evident in his repetition of the traditional pastoral motif of a shepherd tending his flock in such works as *Valley Pasture* (1857, Plate 9), in which settlers appear to receive divine blessing in their benevolent relationship with nature. The providential association among man, God, and nature appears most clearly in *The Rainbow.* In this idyllic view of an American pasture, the artist crowned a settler's cabin, nestled in the woods, with a rainbow's arc, a symbol of God's promise of redemption.

Duncanson's view of a domesticated landscape reflects the increasing settlement of the Ohio River valley region during the 1850s. It also signifies an underlying content, perhaps subconsciously motivated, that expresses Duncanson's vision of an ideal world, devoid of the adversity that an African-American confronted in his daily life in antebellum America. Duncanson utilized the beautiful and picturesque

modes of British aesthetics to interpret the Ohio River valley landscape and portray an America free from racial oppression. David Lubin has speculated that the bodies of water Duncanson painted with figures or a boat crossing, such as in *Blue Hole* or *Ellen's Isle,* can also be read as representing the painter's quest to metaphorically cross the River Jordan of slave songs and make the passage to freedom.[8] These interpretations underscore the artist's conscious, but subtle, transformation of the conventions of landscape painting to convey his aspirations as an African-American for an ideal, arcadian world.

Several layers of meaning can also be read into the landscapes of ancient ruins that Duncanson created following a "grand tour" of Europe in 1853. The first African-American artist privileged to make the traditional "grand tour" of Europe, he produced a series of paintings of Italian ruins that were largely inspired by Cole, who established for Americans the style and iconography of Italianate landscapes. The Italian landscape possessed a host of historical associations that could not be found in the American wilderness and that American artists and critics considered "elevated" subjects appropriate to serious art. Duncanson's paintings of *Time's Temple* (1854, Fig. 50), the *Temple of the Sibyl* (1859, location unknown), and *Recollections of Italy* (1864, Plate 16) captured the traditional romantic attitude toward Italy, elevating the landscape to the academic status of history painting. The idyllic mood of the pastoral landscape, overcast by the ruins of ancient civilizations, provided a *memento mori,* a reminder of nature's eternity and man's temporality. For Americans who believed that they were establishing a new society founded on Protestant Christian principles, the ruins of

a pagan civilization offered a sobering view of the course of history. James Jackson Jarves wrote at the time of Duncanson's first tour of Europe that an artist was responsible for portraying this theme as a warning for a youthful nation: "I would press home to the heart of every American who goes abroad, the necessity, if he would do his duty to his own country of reading and interpreting to his countrymen, so far as in him lies, these sacred writings on the wall."[9]

In addition to conveying Jarves's message, Duncanson's Italian paintings reveal an underlying signification that would have been readily understood by an African-American. The fact that the Romans relied on slave labor to maintain their empire was not lost on Duncanson. His ancient Italian ruins paintings not only portrayed the demise of pagan civilizations but also alluded to the ultimate fate of slaveholding nations—a fate to which the new nation would succumb, if it did not heed the warning and read the "sacred writings on the wall."

The most impressive manifestation of the African-American artist's aspirations toward traditional academic landscapes appears in his grand historical views of paradise, which were inspired by literature and by Cole's allegorical series and Church's tropical scenes. Duncanson proclaimed that his ultimate ambition was to create a "great picture" to rival the European and American masters of painting.[10] Traditionally the "great picture" was an ambitious work depicting an elevating subject, often historical or literary, that was intended to tour to a mass audience. Duncanson typically conceived of his "great picture" as a grandiose vision of paradise inspired by romantic literature. His first experiments in this genre, *The Garden of Eden* (1852,

Plate 4) and *Dream of Arcadia* (c. 1852, Fig. 26), were direct copies after Cole demonstrating his enormous influence on the young African-American's developing conceptions of appropriate subjects. Following his "grand tour" of Europe in 1853, Duncanson returned to Cincinnati and began a series of landscapes derived from romantic literature that constituted a major statement of his artistic aspirations. *Land of Beulah* (1856, location unknown), *Land of the Lotus Eaters,* and the *Vale of Kashmir* series (1863; 1864, Plate 14; 1867, Plate 18; and 1870, Fig. 100) reveal the artist's ambitious search for spiritual content in nature, his vision of paradise, and his ideal of civilization.

In his literary paintings Duncanson created imaginary visions of paradise that succinctly convey his search for a ideal world and express his belief in the divinity of nature. Nature held a deeply religious connotation for many Americans, including Duncanson, and the vast wilderness of North America evoked associations with the biblical Eden. Numerous other artists of this period also painted paradisiacal landscapes, but few explored the subject as often and as thoroughly as Duncanson. Even more than the pastoral views of the American landscape, Duncanson's visions of an exotic paradise, far removed from the reality of his existence, express his subconscious desire to escape the oppression experienced by a "free colored person" in antebellum America.

The culmination of Duncanson's academic ambitions was *Land of the Lotus Eaters,* a historical landscape of enormous size and complex significance that he intended to be a rival to the work of Church and even of European academic artists. Perhaps more than any other painting in his career, this work reveals his

vision of paradise and reflects his view of contemporary racial and political issues. Selecting the epic poem *The Lotus Eaters* by Alfred, Lord Tennyson as his subject, and borrowing a composition from Church's *Heart of the Andes* (1859, Fig. 60), Duncanson created the largest and most ambitious painting of his career. In this painting he depicts Ulysses and his soldiers on their return from a decade of war with Troy encountering the Lotus eaters and receiving their narcotic blossoms. After seeing a photograph Tennyson praised the painting, but correctly observed that it was "not quite my lotos land."[11] Conceived when the Civil War was imminent, and completed after the start of hostilities, the painting not only portrays the artist's vision of paradise but can also be interpreted as a metaphor for Duncanson's view on the role of slavery in the Civil War. The representation of dark-skinned natives serving the Grecian warriors lotus blossoms closely parallels the master-slave relationship in the southern United States. The apathy of Ulysses's men resulting from the narcotics reflects a contemporary opinion that the embattled southerners had grown complacent and dependent upon the labor of enslaved natives for their luxurious standard of living. In his most ambitious painting, Duncanson offers his vision of an exotic tropical paradise, and a veiled metaphor warning the war-torn nation of the evils of slavery.

Duncanson intended to tour his masterpiece across Europe, but the Civil War interrupted his plans. On the border of the slaveholding south, racial tensions climaxed in Cincinnati at this time. To escape the war and to secure easier passage to England, Duncanson left for Canada in 1863. Upon his return from self-imposed exile in 1867, he commenced a

series of Scottish landscapes stimulated by his travels and the literature of Sir Walter Scott. The Scottish literary landscapes dominated his work until the final years of his life and marked a stylistic transition characterized by a subtle synthesis of literary subjects and landscape aesthetics that culminated in *Ellen's Isle, Loch Katrine,* a painting rich with meaning for both his white art patrons and the African-American cultural community. In his final paintings Duncanson achieved a resolution of the aesthetic and stylistic developments of his thirty-year career. The luminosity that fills such paintings as *Ellen's Isle* conveys a spiritual quality without indulging in literal narrative. In these works he sustained his pastoral and paradisiacal vision of nature as the fundamental vehicle for his aesthetic expression, and he sensitively integrated the elevated sentiments of grand literary and historical themes.

Duncanson's untimely demise in 1872 tragically ended his career at a climactic moment of artistic resolution and triumph. Following his death, his art fell into obscurity for nearly a century. Not until the 1950s during the revival of the Hudson River School did scholars begin to reevaluate his art. With the single exception of the restoration of the "Belmont" murals in the William Howard Taft Home in Cincinnati (now the Taft Museum), between 1930 and 1932, Duncanson's art remained unknown until James A. Porter resurrected him with his pioneering article "Robert S. Duncanson: Midwestern Romantic-Realist" in 1951. During the next several decades, Duncanson's work reappeared in a number of exhibitions and essays devoted to the rediscovery of Ohio River valley artists and the Hudson River School tradition. A landmark in the revival of scholarship on the artist was

the first retrospective exhibition of his paintings in 1972, the centennial of his death, which was curated by Guy McElroy for the Cincinnati Art Museum. During the succeeding decades a number of scholars, particularly Dennis Reid, S. Allen Pringle, and Dennis Au, researched Duncanson's art and uncovered significant new biographical information in relation to their studies on Canadian art and Michigan history. In 1980 James D. Parks published a modest book devoted to the artist. Limited in scope, Park's work lacked the archival research and scholarly perspective for a full assessment of Duncanson's art and his place in American culture of the era.[12]

This body of literature proved important to reviving Duncanson's career but provided only an incomplete picture of this important African-American artist. Despite the number of publications and exhibitions that have included Duncanson, no art historian has previously attempted a thorough scholarly assessment of his life and art. Furthermore, the earlier literature on the artist perpetuated a series of myths generated by the oral history that dated from around the turn of the twentieth century. Several scholars mistakenly recorded that Duncanson was the son of a Scottish-Canadian father and a black mother. Others purported that he received an education in Canada as a youth and that the Anti-Slavery League sponsored him to study art in Europe prior to 1840 and that he returned in 1870. In order to redress these misconceptions, the newly discovered sources that illuminate Duncanson's daily life are quoted extensively.

Duncanson's paintings are his legacy to American art and provide the principal resource for interpreting his cultural values and aesthetic ideas. An in-depth analysis of

the major paintings in relationship to other art of the era establishes the basis for appreciating and understanding his contributions to American culture. The Catalog of Artworks serves as a prolegomenon to a Catalogue Raisonné of Robert S. Duncanson, listing only 162 paintings and one drawing that have been confirmed as by Duncanson. Over his thirty-year career Duncanson, who was known as a prolific artist, produced many more works that have been lost. The list offers a point of departure for future authentication and identification of his work.

Duncanson's remarkable achievement as an African-American who rose from poverty to break the shackles of racial oppression in antebellum America, and earn international distinction in the arts, merits a comprehensive examination and reconsideration. He played a central role in the evolution of African-American arts, while working within the mainstream American culture of the era. His paintings not only convey contemporary aesthetics, but they also signify the complex and often veiled social and political concerns of an African-American artist. Thus, Duncanson's career presents a wealth of possibilities for examining comparative and interdisciplinary connections between his art and romantic literature, American culture studies, African-American studies, and psychological analysis. A consideration of his role as an African-American artist in American society, his fantastic vision of paradise, and his relationship to his New York contemporaries are central issues of this biography. In the matrix of Duncanson's life and art, the illumination of these issues provides the model and foundation for future critical interpretations of other nineteenth-century African-American artists and their unique role in American culture of the era.

1

"Portraits . . . historical and fancy pieces of great merit"
Apprenticeship and Itinerant Beginnings

*R*obert Duncanson's life reflects the travails of an African-American whose opportunities were dictated by the discriminatory social and political system of the antebellum United States and by the legacy of the slave system from which his family had been freed two generations earlier. In his youth Duncanson was apprenticed in the family trades of housepainting and carpentry passed down from his grandfather, a former Virginia slave who had been taught the skilled trades during bondage. After his apprenticeship, Duncanson practiced the housepainting and decorating trade for a few years before his artistic aspirations led him to Cincinnati to pursue the fine arts. It was a radical decision for a young African-American to attempt to break through the racial barrier of the art world and become one of the first of his race to participate in the mainstream American and European cultural circles. However, it is apparent from his letters and the comments of his colleagues that Duncanson possessed an energetic, ebullient personality and held lofty artistic goals. His ambitions did not permit him to be satisfied with simply plying a trade; rather, he sought artistic recognition.[1]

Driven by his insatiable determination and an innate talent, Duncanson progressed through a period of itinerancy, traveling during the decade of the 1840s to ply his trade as a painter of portraits and historical and fancy pictures. At this time

his technical skills improved dramatically through his self-taught apprenticeship in draftsmanship and painting. As an itinerant African-American artist he found it difficult to secure commissions and at times was nearly destitute, but the patronage of a few abolitionist sympathizers kept his hopes alive, and within a few years the regional press could proclaim that the young artist painted "portraits . . . historical and fancy pieces of great merit."[2] Near the end of the decade Duncanson received a commission that would change the course of his career. A noted abolitionist minister and the principal stockholder in the Pittsburgh and Boston Mining Company, the Reverend Charles Avery, commissioned him to paint a large landscape depicting his copper mine in the Upper Peninsula of Michigan in its first year of profitable production. *Cliff Mine, Lake Superior, 1848* (Plate 2), a haunting image of a ravaged landscape, launched Duncanson's artistic career and entrenched him in a network of abolitionist patronage that sustained him throughout his thirty years as an artist. Yet Duncanson's success was firmly rooted in his family heritage as an African-American tradesman.

The Duncanson family can be traced back to Charles Duncanson (c. 1745–1828), Robert's grandfather, a former slave from Virginia who was emancipated and moved north to New York State around 1790 with his son, John Dean (c.

1777–1851).[3] Perhaps because he was the illegitimate offspring of his master, Charles Duncanson had been permitted to learn a skilled trade and later to earn his release from bondage. In the states of the Upper South it was a common practice for masters to award their illegitimate offspring preferential positions, to provide them with an education, and to teach them skilled trades. Following the Revolutionary War a large number of slaves, especially mulattoes, were freed in Virginia due to the fervor of revolutionary ideology, changing economic factors in the Upper South, and the guilty conscience of some masters about their illegitimate children. However, in the last decade of the eighteenth century white attitudes to freedmen were increasingly hostile in the Upper South, and the benefits of freedom were legislated away from free African-Americans by Black Laws. At this time many freedmen fled north for the guarantee of freedom brought by emancipation laws in all northern states by 1804.[4] The Duncanson family followed this pattern and moved north to settle in Fayette, New York, to escape the social and economic restraints on "free colored persons" in the slaveholding south. There Charles's son, John Dean, and John's wife, Lucy (c. 1782–1854), whom he had brought up from slavery in Virginia, established an extended family that grew to include five boys and two girls.

Fayette was a small community in the picturesque Finger Lakes district, secluded from the mainstream of western expansion that followed the War of 1812. Apparently, Fayette was too small to adequately support the family's growing number of skilled tradesmen. After Charles Duncanson's death in 1828, John followed the current migration routes and moved his family west across the Great Lakes to settle in Monroe, a thriving commercial town at the western tip of Lake Erie in what a decade later became the state of Michigan. Within a few years of his arrival, John Duncanson was so successful as a housepainter and carpenter that he was able to buy several plots of property in Monroe to house his large family. The Duncansons settled permanently, establishing the first extended family of African-Americans in the Monroe area.[5]

Robert Duncanson, along with his brothers, was raised and apprenticed in the family trades of housepainting, decorating, and carpentry. In the early nineteenth century, painters and glaziers commonly worked at gilding, plastering, hanging' wallpaper, and painting interior decorations, in addition to exterior house, coach, and sign painting. Only a few of the more skilled painters would attempt "fancy pictures."[6] Certainly Robert was introduced to painting, glazing, carpentry, and other skills by his father and older brothers. As a youth of ten to fourteen years, he would have assisted on projects by carrying supplies and cleaning brushes. By the age of fourteen he would have been initiated into mixing colors, preparing surfaces, and painting as a formal apprentice. At the age of seventeen he was prepared to embark into business on his own.

In 1838 Duncanson and an associate, John Gamblin, formed a partnership in the business of painting and glazing. On April 17, 1838, the following advertisement appeared in the *Monroe Gazette* announcing Duncanson's first venture in the trade of housepainting: "A NEW FIRM, John Gamblin and R. Duncanson, Painters and Glaziers, beg leave to acquaint their friends and the citizens of Monroe and its vicinity, that they have established

themselves in the above business and respectfully solicit patronage" (Fig. 1).[7] When the advertisement first appeared, some of the local citizens may have recognized "R. Duncanson" as the son of John Dean Duncanson, the local African-American carpenter, housepainter, and handyman. Robert was following in the family tradition.

Of the five Duncanson brothers, Robert was the only one to rise above the level of an artisan and eventually develop into an accomplished artist, although three of his brothers also apprenticed in the painting trade: Nathan (1817–1891), John Dean (c. 1818–1871), and Simeon (c. 1823–1890). The census records that the fifth and oldest son, William (c. 1815–c. 1855), was mentally incompetent and incapable of practicing a trade.[8] Robert, the next-to-youngest brother, was the first of the sons to enter the painting trade, when he advertised his partnership with John Gamblin in 1838. Three years later, the city of Monroe hired Robert's brother John Dean to paint highway mileage signs. By 1850 the youngest, Simeon, had founded

his own practice in the painting trade. While economic considerations forced Nathan and Dean to turn to other trades later in life, Simeon established a solid reputation until his death in 1890 as a house, sign, and fancy painter. Lucius B. Duncanson, Simeon's son and Robert's nephew, was the third generation of the family to enter the painting trade in Monroe. Lucius, probably inspired by his famous uncle, left examples of his attempts at easel painting, but these are crude pictures fashioned by an amateur.[9] Although Simeon and Lucius painted easel pictures, they never created works of enduring artistic value. Except for Robert, the members of the Duncanson family were shackled by their slave legacy and unable to progress beyond the skilled trades of painting, decorating, and carpentry.

Gamblin and Duncanson advertised their painting firm actively until April 1839, when they apparently disbanded. It is not known what commissions resulted from their advertisements. Perhaps the competition from other housepainters was strong and there were not enough jobs

A NEW FIRM.

JOHN GAMBLIN & R. DUNCANSON, Painters and Glaziers, beg leave to acquaint their friends and the citizens of Monroe and its vicinity, that they have established themselves in the above business, and respectfully solicit patronage. They pledge themselves to do work in the most superir style, and to use the best and genuine materials for the same on the lowest possible terms,—lower than ever executed in this city.

Monroe, April 16, 1838. 32-4w

Fig. 1. "A New Firm," *Monroe Gazette,* April 17, 1838. Courtesy the Monroe County Historical Museum, Monroe, Michigan.

to sustain the partnership. Some may speculate that the Monroe community was unwilling to sufficiently support the business enterprise of an African-American housepainter, but that is untenable considering John Duncanson's success as a tradesman. It is more probable that Duncanson's ambition to become an artist, rather than an artisan, caused the firm to dissolve. In 1838, when he ventured into housepainting, the arts were not an active part of life in Michigan. Monroe, located on the tip of Lake Erie, was a boomtown in the 1830s, expanding rapidly due to the commerce along the Great Lakes waterways. Business was substantial enough to support a number of house and sign painters, decorators, or glaziers,[10] but the town could not sustain Duncanson's artistic aspirations.

At this time Cincinnati was the economic and cultural center of the United States west of the Appalachian Mountains. More important for Duncanson, Cincinnati was one of the major population centers for "free colored persons" in America and an important locus of abolitionist activity. Pursuing his artistic ambitions, Duncanson packed his bags and moved to Cincinnati, probably traveling down the Miami Canal from Toledo around 1840, to embark on his artistic career. The aspiring artist sought a receptive cultural climate with known sources of patronage, other artists, and exhibition venues, which, in the West, could be found only in Cincinnati.[11] Although he established his career in Cincinnati, he always maintained close family ties to Monroe. This bond of kinship placed the artist in a position to play an integral role in the cultural development of Detroit, as well as Cincinnati.

Duncanson settled in Mt. Healthy, a small village just north of Cincinnati,

where he stayed with the Reuben Graham family. An African-American descendant of Virginia slaves, Graham was an associate of John Dean Duncanson, and they may have been childhood friends in Virginia. While living with the Graham family, Robert apparently became attracted to the daughter, Rebecca, and married her around 1842. They had two children, Reuben P. (c. 1844–?) and Mary (c. 1846–?), who were named after Reuben and Mary Graham. Unfortunately, no records verify Duncanson's marriage due to the practice common in the antebellum era of not including "free colored persons," such as the Grahams and Duncansons, in municipal records. Often only oral family history preserves the family history and lineage.[12]

Mt. Healthy, known for its strong abolitionist sympathies, was home to a tightly knit African-American community. Within the next decade it was to become an important stop on the Underground Railroad. While living there Duncanson was patronized by one of the town's founders, Gilbert LaBoiteaux. Oral tradition claims that LaBoiteaux purchased paintings from the maturing artist to encourage his work during his difficult, early years.[13] The moral and financial encouragement that Robert received from his family and friends in Mt. Healthy provided an essential stimulus to his aspirations.

In addition, the proximity of Mt. Healthy to Cincinnati permitted Duncanson to participate in Cincinnati's cultural life. Although opportunities for formal training in art and for exhibition were severely limited for painters working in the Midwest, Cincinnati boasted the first art academy and the most lucrative cultural environment for artists. The Cincinnati Academy of Fine Arts was founded in 1838 and held classes in drawing from

casts. The academy hosted its only exhibitions in 1839 and 1841 before it folded, but it was succeeded by the Society for the Promotion of Useful Knowledge, which was formed in 1840. This society held only two exhibitions, in 1841 and 1842, before it also closed. The second exhibition marked Duncanson's debut, when he exhibited a "Fancy Portrait," "Infant Savior, a copy," and "Miser."[14] These titles indicate the direction taken by this young artist in his early years. It is doubtful that as an African-American he was permitted to attend the academy classes, most likely forcing him to teach himself art by painting portraits and copying prints.

Inscribed on the verso "R.S. Duncanson Pinxit 1841 Cincinnati," *Portrait of a Mother and Daughter* (Fig. 2) is Duncanson's earliest datable painting. It suggests the style of a "Fancy Portrait" such as

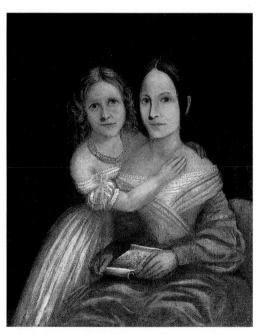

Fig. 2. Robert S. Duncanson, *Portrait of a Mother and Daughter,* 1841, oil on canvas, 30″ × 25″. Fulton County Arts Council, Hammonds House, Atlanta, Georgia.

he presented in his first exhibition. Granted, the double portrait is a mannered and labored work, but, as the artist's first known painting, it demonstrates great potential and is comparable to examples by numerous more experienced primitive limners in the early nineteenth century. The dark, muddled coloring and the stiff, flat figures indicate the artist's emerging understanding of painting, an understanding that progressed quickly and was more fully realized within the next few years.

Duncanson's most impressive portrait of this period is the *Portrait of William J. Baker* (1844, Plate 1), which is considerably more accomplished than the earlier portrait. William sits on a grassy knoll against a wooded backdrop staring at the viewer as he pets his dog. The landscape setting, the playful activity, and the barking dog give this painting a livelier mood than the double portrait. In addition, the depth of the landscape, the treatment of the shirt, and the sense of volume in the figure display a much greater technical accomplishment. Although the handling of William Baker is still very mannered, the artist has endowed the boy and his dog with an expressiveness that demonstrates his growing artistic sensitivity.

Duncanson probably painted this portrait on commission for William's father, a Kentucky gentleman. That a southern businessman would have commissioned a portrait from an African-American painter raises questions regarding their business relationship. It is noteworthy that the Baker family did not commission the young artist to paint portraits of the adults, but only the children, William and Margaretta. They were generous in awarding Duncanson the portrait commissions, but one is led to speculate whether

they wished to maintain the subordinate relationship of blacks to whites in the southern states. The situation appears to have been common in Duncanson's early commissions and is evident in his other portraits of the women and children in patrons' households, such as the *Portrait of a Mother and Daughter,* and in his subsequent portraits of the Berthelets in Detroit. Patrons did support the African-American artist in his early years, but he was usually only granted less significant commissions.

The 1842 Society for the Promotion of Useful Knowledge exhibition catalog listed two of the paintings by Duncanson, "Infant Savior" and "Miser," as copies after popular prints. These paintings are no longer extant but were probably comparable in handling and conception to *Trial of Shakespeare* (1843), which is the artist's earliest known historical painting. In this work Duncanson copied a painting by the Scottish academician Sir George Harvey, *Shakespeare before Sir Thomas Lucy,* which the young artist had probably seen in printed form.[15] For the first time in his young career, he grappled with the problems of academic figure group compositions. His understanding of anatomy, figural proportions, and volume in this work reveals his tentative draftsmanship at this early stage of his development. However, his copy of a famous historical composition also reveals his dedication to improving his drawing and painting techniques through the study of prints after recognized masters.

For a self-taught itinerant artist, Duncanson had already achieved an impressive measure of accomplishment by the mid-1840s. At the 1844 Mechanic's Institute Fair, he exhibited several copies after prints that the local critics favorably

noted in the newspapers. A reviewer for the *Daily Cincinnati Gazette* believed that "the copies from prints by him [Brannon] and Duncanson look like the works of very young artists—such as may be expected to produce better pictures hereafter, which we have no doubt they will do with suitable encouragement."[16] In just a few brief years Duncanson's art had markedly improved. He had received the endorsement of the local art critics and had begun to create his own genre compositions, or "fancy pictures," and estate views.

In Duncanson's earliest imaginary composition, *Vulture and Its Prey* (1844, Fig. 3), he ventured into a dramatic subject with a predatory bird, perched in a tree high above the ground, tearing at its catch. The dark and moody background

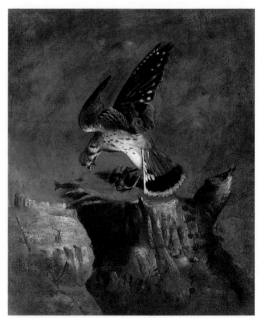

Fig. 3. Robert S. Duncanson, *Vulture and Its Prey,* 1844, oil on canvas, 27⅛″ × 22¼″. National Museum of American Art, Smithsonian Institution, Washington, D.C., gift of Harold Deal.

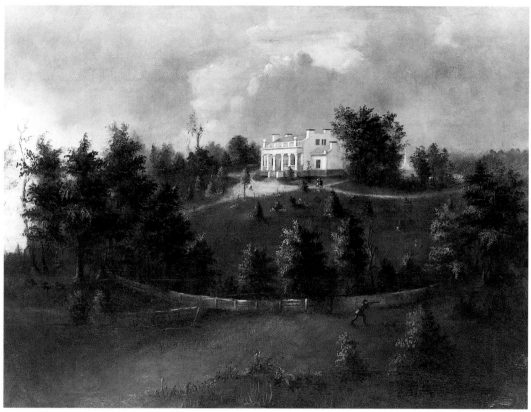

Fig. 4. Robert S. Duncanson, *Mt. Healthy, Ohio*, 1844, oil on canvas, 28″ × 36¼″. National Museum of American Art, Smithsonian Institution, Washington, D.C., gift of Leonard Granoff.

sky is handled in sweeping strokes of the brush that heighten the drama of the scene. Once again, the artist's youthful draftsmanship is revealed, but, more important, the picture breathes with an excited spirit and mood that mark an advancement over his previous works.

Around 1844, Duncanson received an important commission, for his first estate view and, more significantly, his first landscape painting that prefigures his mature work. *Mt. Healthy, Ohio* (Fig. 4) depicts, with topographical accuracy, a grand manor atop a hill overlooking a broad river. The title of *Mt. Healthy* for this painting is erroneous. It clearly depicts one of the many estates that lined the southern banks of the Ohio River

and were often the property of Kentucky merchants and landowners whose wealth was made in commercial trade at Cincinnati. The commanding view of the mansion on the hilltop looking across the river to a distant city presents an image of the estate owner's wealth and power, while the picnicking and hunting groups represent the leisurely social life associated with the landed aristocracy in the southern United States. For an African-American the image of a white house on a hill certainly signified the wealth and power of the dominant white society. In this painting only the figures of blacks serving the picnickers or collecting the game are missing to drive home the message.

With his background of working in the skilled trades, it is not surprising that Duncanson embarked on a unique photographic project with another artist in 1844, in what might have been one of the earliest collaborations between a painter and photographer in the United States. On March 19, 1844, Coates and Duncanson advertised a spectacle of "Chemical Paintings . . . comprising four splendid views after the singular style of Daguerre" to be on view for the entertainment of the Cincinnati public. For twenty-five cents, a person could see images of the "Hagia Sophia," the "Last Supper," the "Destruction of Nineveh," and "Belshazzar's Feast," all with musical accompaniment. The four pictures were shown to the public in sequence, each changing before the audience's eyes with increasingly exciting lighting effects. In the culminating image, "Belshazzar's Feast," there appeared "the miraculous writing on the wall" that "presents a climax of sublimity of which, unless witnessed, no adequate conception can be formed." With each of the images, the darkened auditorium was gradually illuminated, causing the lighting effects in the pictures that thrilled the crowds.[17]

The "Chemical Paintings" were certainly created on light-sensitive, chemically treated surfaces that were allowed to develop under the house lights before the crowd. Because of his artistic background, Duncanson probably composed the images, while Mr. Coates worked with the photographic techniques. The images themselves were derived from numerous popular prints of these subjects. In particular, they suggest the work of the English painter John Martin (1789–1854), whose biblical subjects included such scenes as Belshazzar's feast and were marked by their fantastic compositions and dramatic contrasts of light and dark. Duncanson's venture in "chemical paintings" provided experience that would prove important for his work in the daguerrean studios of Cincinnati in the 1850s.

Despite the artist's progress, evidently he was not encouraged by the meager patronage available in Cincinnati. Commissions were limited, especially for a young African-American artist just beginning in the arts, and he could not compete with the more established white painters such as James H. Beard (1811–1893), Miner K. Kellogg (1814–1889), Thomas Buchanon Read (1822–1872), and the brothers John (1817–1881) and Godfrey (1820–1873) Frankenstein, who dominated the major patronage in the region. Duncanson faced greater difficulty securing commissions and purchases from the white patrons, who were largely unwilling to support an African-American artist. Only late in the 1840s with the rise in antislavery sentiments did abolitionist sympathizers begin to actively patronize the young African-American.

With few commissions to sustain him, Duncanson was forced to pack his painting supplies in the fall of 1845 and take his business on the road. By December his itinerant tour had led him back to Detroit, near his hometown of Monroe, where he settled into a downtown studio. Confident in his abilities, he advertised himself as a "Portrait and Historical" painter and boldly offered his clients a guarantee: "Portraits warranted, and finely executed, or no pay."[18] The competition was less intense in Detroit than in Cincinnati, so he remained there until May 1846 keeping himself active with commissions. After being overlooked for several months, his paintings finally

caught the attention of the local press, which announced the presence of the artist to its readers:

> We have intended for some time to call the attention of our citizens to the paintings of Mr. Duncanson, a young artist who has been some weeks here. . . . Mr. Duncanson has already taken the portraits of a number of our citizens and has designed and finished several historical and fancy pieces of great merit. The portraits are very accurate likenesses and executed with great skill and lifelike coloring. . . . Mr. Duncanson deserves, and we trust will receive the patronage of all lovers of the fine arts.[19]

During this period Duncanson received his first significant portrait commission, to paint the likenesses of several members of the prosperous Berthelet family of Detroit. Five Berthelet portraits are extant: of Henri, his sons Louis and Joseph, Joseph's son, William, and a double portrait of Joseph's wife and second son.[20] Family tradition states that Duncanson painted all five; however, on stylistic grounds, only two appear to be from his hand. The only work in the group that is signed and dated is the portrait of William, inscribed "R. S. Duncanson 1846" on the verso (Fig. 5). William sits in a chair, rigidly posed in front of a drapery backdrop in a typical portrait composition. His facial expression and blank frontal stare recall the portrait of William Baker from two years earlier. Among the remaining four portraits only that of Henri Berthelet (Fig. 6) resembles Duncanson's portrait style. In addition, William's and Henri's portraits are the only ones in the group that measure thirty by twenty-five inches, a size Duncanson often used. The portrait of Henri portrays the dour old businessman in the last months of his life in a pose that

is the reverse of William's. The pale, chalky treatment of the faces and the tightly drawn hands and dress in these works mark them as by the same artist. The paintings of Louis, Joseph, and the double portrait are decidedly different from Duncanson's work and must have been painted by another artist.[21]

Drunkard's Plight (1845, Fig. 7) exemplifies Duncanson's attempts at fanciful genre subjects during this period in Detroit. The image of a pitiful drunk with his broken bottle being confronted by a distraught woman and child illustrates the painter's interest in genre subjects with didactic content. The decade of the 1840s saw the establishment of a genre painting tradition in America with the work of Francis William Edmonds (1806–1863), William Sidney Mount (1807–1868), George Caleb Bingham (1811–1879), and others.[22] Influenced by British popular prints, American genre painters depicted scenes of citizens engaged in everyday activities that echo contemporary social mores and political concerns. Many of the genre paintings from this period offered an egalitarian image of Americans, while others provided biting social commentary or humorous anecdotes.

Duncanson was initially exposed to the genre painting tradition through the work of Cincinnati artist James H. Beard, who in the 1840s was one of the most successful painters working in the area. Beard's reputation was built on humorous and moralizing paintings of contemporary life such as *The Long Bill* (1840, Fig. 8), which was featured at the Society for the Promotion of Useful Knowledge exhibitions in 1841 and 1842. Although generally inspired by the genre painting tradition and Beard, Duncanson's *Drunkard's Plight* is not a direct copy of a

Fig. 5. Robert S. Duncanson, *William Berthelet*, 1846, oil on canvas, 30″ × 25″. Detroit Institute of Arts, gift of William T. Berthelet.

Fig. 6. Robert S. Duncanson, *Henri Berthelet,* c. 1846, oil on canvas, 30″ × 25″. Detroit Institute of Arts, gift of Miss Mary Stratton.

Fig. 7. Robert S. Duncanson, *Drunkard's Plight,* 1845, oil on board, 15¼″ × 19¾″. Detroit Institute of Arts, gift of Miss Sarah Sheridan.

particular painting or print, but an imaginative adaptation of current stylistic directions. In addition, *Drunkard's Plight* indicates the artist's sensitivity to contemporary issues by responding to the vogue for temperance subjects in the 1840s.

With *Drunkard's Plight,* Duncanson may have influenced the development of another young Detroit artist, Frederick E. Cohen (c. 1818–1858). Within months after the black painter opened his studio, Cohen began actively pursuing his career. Although Cohen had been living in Detroit since 1837, no record of his work exists before he advertised his business of "Portrait, Miniature, Historical, and Scriptural Painting" in a studio just

down the street from Duncanson. Cohen's early *Near the Old Post Office, Detroit* (c. 1846, private collection) offers a humorous anecdote of an old fruit vender whose basket spills its contents that falls into the same stylistic tradition of American genre painting upon which Duncanson drew.[23] It is entirely possible that the two artists, living in the same neighborhood, became associates, and Duncanson may have guided Cohen's artistic development.

In the summer of 1846 Duncanson tired of Detroit and returned to Cincinnati, where he resumed painting portraits and began to expand his production of genre and historical subjects. At this time, his struggles and achievements as an

Fig. 8. James Henry Beard. *The Long Bill,* 1840, oil on canvas, 30⅜″ × 24⅞″. Cincinnati Art Museum, gift of Mrs. T. E. Houston.

African-American artist attracted the attention of a reviewer for William Lloyd Garrison's Boston-based abolitionist newspaper *The Liberator.* After a visit to the artist's studio the reviewer wrote, "I had a great treat last evening in the view of some portrait paintings and fancy pieces from the pencil of a Negro, who has had no instruction or knowledge of the art. He has been working as a common house painter, and employed his leisure time in these works of art, and they are really beautiful."[24] The reviewer continued to describe one of the artist's pictures, which depicted a bumbling person who spilled a basket of fruit on a rural path. The humorous anecdote implicit in this genre subject was typical for Duncanson's "fancy pieces" at this time and is similar to the scene depicted in Cohen's *Near the Old Post Office, Detroit,* possibly serving as a source for it.

In conclusion the author of *The Liberator* article related an emotional encounter between Duncanson's wife and the "lady from Nashville in whose family the wife of the artist was reared and brought up a slave." The recently freed slave wanted to give the woman two of her husband's paintings as an expression of her appreciation for being released from bondage. In return, the woman offered money for the pictures, deeply offending the artist's wife. "The Negro burst into tears and said, 'what do I care for $25? I would rather you should have the paintings than that I should receive $500,' and she added that if her mistress did not take them, she would be forced to believe that she placed no value upon them. I turned from the scene between the mistress and the slave and asked myself, wherein, do the kindly feelings of gratitude which flow from the heart and throb in the bosom of the Negro differ from

those of the white race."[25] This patronizing portrayal of the artist's wife in a demonstration of her gratitude to her benevolent former mistress was possibly a nineteenth-century journalist's exaggeration of an actual occurrence; certainly it demonstrates a stereotype of free negroes promulgated by the abolitionist journalists of the day.

The unidentified author of *The Liberator* article attempted to convey the compassion and cultural capabilities of African-Americans, attitudes rejected by proslavery elements in antebellum American society. In so doing he provided a moving account of Duncanson's family heritage. Although the artist is not mentioned by name in the article, the description could apply to no one other than Duncanson, who was the only African-American artist known to be painting in Cincinnati at this time. His wife, Rebecca Graham, a former slave born in Tennessee, was the black woman referred to in the article.[26] The article in *The Liberator* indicates that the artist's paintings had begun to elicit the interest and support of abolitionist journals and patrons even at this early stage of his career.

Intrigued by the popularity of travel prints, Duncanson painted two canvases after prints of exotic lands in the late 1840s. Travelogues of distant, little-known lands were a rage in this era, captivating the imaginations of the antebellum public. Typical of his contemporaries, Duncanson was lured by prints of exotic places such as the Middle East, Africa, the South Pacific, Central America, and the American West. Especially popular in the 1840s were the journals of the pioneering exploration of Central America by Englishmen John Stevens and Frederick Catherwood, which were published as *Incidents of Travel in the Yucatan* in 1843.[27] Their

discovery of forgotten ancient civilizations on the American continent caused great excitement. Stevens's exotic accounts stimulated Duncanson to create two imaginary views of Mayan ruins from Catherwood's engravings. *Mayan Ruins, Yucatan* (1848, Fig. 9) is an utterly fantastic composition that bears only superficial resemblance to actual Mayan ruins. The image was contrived from Catherwood's engravings of the primary structure at Kabah (Fig. 10) and the Casa del Gobernator at Uxmal. The general design elements, the tropical palm trees, and the figure groups appear to be drawn directly from Catherwood. However, Duncanson was not able to convincingly render the architectural details of the Mayan monuments and

the effect of the dense, craggy tropical forest of the Yucatan peninsula.

As an itinerant artist, Duncanson moved regularly among Cincinnati, Monroe, and Detroit between 1845 and 1849. He must have had a studio in Detroit in the summer of 1848 when, in August, the steamship *Goliath* was docked with the first profitable load of copper ever mined in America.[28] To commemorate this occasion the Reverend Charles Avery (1784–1858), the primary investor in the Pittsburgh and Boston Mining Company, commissioned Duncanson to paint *Cliff Mine, Lake Superior, 1848* (Plate 2). This was the artist's largest commission to date and his most ambitious landscape during the 1840s. Avery was a Methodist minister and staunch antislavery activist who

Fig. 9. Robert S. Duncanson, *Mayan Ruins, Yucatan,* 1848, oil on canvas, 14″ × 20″. Dayton Art Institute, purchase with funds provided by the Daniel Blau Endowment.

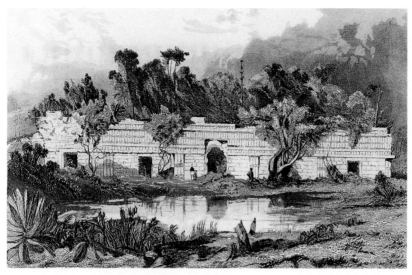

Fig. 10. Frederic Catherwood, *Kabah,* engraving from John L. Stevens's *Incidents of Travel in the Yucatan* (London, 1843), 1:pl. 15. Courtesy the Library of Congress.

led emancipation causes and established schools for African-Americans in Pennsylvania. His abolitionist sentiments certainly prompted him to support Duncanson with this commission and initiated a relationship between the mulatto and the minister that would last until Avery's death.

Duncanson's painting accurately depicts the first significant copper mine in the United States, located on the Upper Peninsula of Michigan. From the foreground platform the spectator can view the foreboding cliff looming over the cabins and outbuildings of the mining camp. The only relief from the rugged face of the cliff and the severe buildings are the incidental figure groups that provide an anecdotal element to the painting. The twisted trees and battered trunks of the foreground stand as metaphors for the power of nature and the cycle of life. The rugged cliff, gouged in the middle and littered at its base with buildings, suggests a wilderness ravaged by man and industry.[29]

Although Avery probably expected a simple topographical portrayal of the mine, the painter imbued the scene with a romantic sentiment for nature by utilizing stylistic and iconographical conventions that indicate his awareness of current intellectual concerns. Many early American artists, writers, and intellectuals shared a romantic belief that nature, found in her primitive state in America, was a pure manifestation of God's creation. Through an emulation of her beauties and a depiction of her wonders, man could come closer to the divine. To destroy her through pragmatic utilitarianism was to defile the works and will of God. Thomas Cole summarized this attitude in his "Lecture on American Scenery": "Poetry and Painting sublime and purify thought, and rural nature is full of the same quickening spirit: it is in fact the exhaustless mine from which the poet and the painter have brought such wondrous treasure. . . . I cannot but express my sorrow that the beauty of such landscapes are quickly passing away— the ravages of the axe daily increasing—the most noble scenes are made desolate, and oftentimes with a wantonness and barbarism scarcely creditable in a civilized society."[30] Duncanson's metaphors for the destruction of nature in *Cliff Mine* indicate his awareness of and empathy with

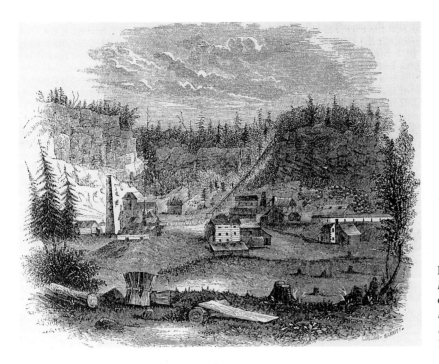

Fig. 11. *Cliff Mine Lake Superior,* engraving from *Harper's New Monthly,* March 1853.

Cole's sentiment as expressed in his writings and artworks.

A more strictly topographical view of the Cliff Mine was recorded by Robert E. Clarke in the summer of 1852. His accounts of the Cliff Mine published in the March 1853 issue of *Harper's* include an engraving of the mine taken from the shore below the mining operations (Fig. 11).[31] Clarke's view is much tamer than Duncanson's, with framing trees and foreground props. The dominance of the cliff is not accentuated, nor does the engraving include any figure groups to lend the mining camp a breath of life. The print does record the gaping wound in the side of the cliff, which had widened considerably under vigorous mining in the four years since Duncanson's painting. Duncanson's painting, on the other hand, presents a haunting impression of the ravages of commercial exploitation of the landscape that is totally lacking from Clarke's topographical print. The African-American's artistic sensibilities enabled

him to give the cliff a dominating presence and to cause the scene to resonate with allusions to the destruction of nature.

The commission for *Cliff Mine* changed the course of Duncanson's artistic development by redirecting his interests from portrait and genre painting to landscapes. Several other factors also influenced Duncanson's newfound interest in landscape painting, including the introduction of the Hudson River School style to Cincinnati by T. Worthington Whittredge and William Sonntag around 1845. The Western Art Union, established in 1847, furthered the cultural development in the city with its public exhibitions that included numerous paintings by artists in the Hudson River School.[32] Duncanson had attempted a landscape early in his career in the estate portrait *Mt. Healthy, Ohio* and had also exhibited a landscape at a local fair in 1845.[33] Yet landscape painting did not fully engage his imagination until Avery's commission for *Cliff Mine*.

The commission required the painter to take a special sketching trip to study the mine. This trip initiated a series of summer sketching excursions from 1848 to 1850 to study the rugged landscape and dense forests of the Upper Peninsula region, resulting in such paintings as *Man Fishing* (1848, Fig. 12) and *The Catch/ The Farmer's Apprentice* (1848, Fig. 13). The rich verdure and bright blue skies in these works differ markedly from the harsh depiction of nature in *Cliff Mine*. The rocky bank on the opposite shore in *The Catch* recalls the rendering of the cliff mine and suggests the locale of this painting. However, instead of the foreboding sublime presence of the cliff, *The Catch* features an old, worn rock topped with a scraggly growth of trees and grass on its scarp. The picturesque painting is further enlivened by the humorous predicament of the farmer's errant apprentice, who has been caught fishing, instead of working.

In the following summer of 1849, the artist toured the Lake Superior area again with his friend and apprentice, Junius R. Sloan. Sloan copied one

Fig. 12. Robert S. Duncanson, *Man Fishing*, 1848, oil on canvas, 25″ × 30″. Dr. Walter O. Evans, Detroit.

of Duncanson's drawings on this trip, *Residence of old South-Wind Chief outlet of Lake Superior* (1849, Fig. 14). The drawing focuses on the chief's cabins in the middle ground, with a view of the lake complete with a sailboat in the distance and a group of figures on the pier in the foreground. This trip to the Upper Peninsula also inspired a group of four paintings entitled *The Seasons,* two of

Fig. 13. Robert S. Duncanson, *The Catch/The Farmer's Apprentice*, 1848, oil on canvas, 18″ × 24″. Private collection, East Harwich, Massachusetts.

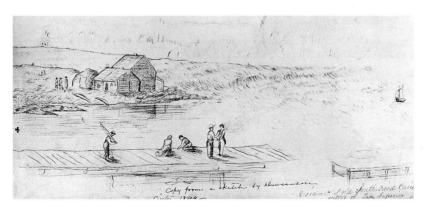

Fig. 14. Junius R. Sloan after Robert S. Duncanson, *Residence of old South-Wind Chief outlet of Lake Superior*, 1849, pencil on paper. Valparaiso University Art Gallery, Valparaiso, Indiana.

Fig. 15. Robert S. Duncanson, *Summer*, 1849, oil on canvas, 11½" × 16". Mr. and Mrs. Meyer P. Potamkin Collection.

which survive, *Summer* and *Winter* (1849, Figs. 15–16). The handling of the trees and cabin in these two canvases links them with the landscapes of 1848 and the *Chief South Wind* drawing of 1849. The academic subject of the seasons often served artists as a metaphor for the cycle of life and enabled them to endow a landscape with didactic content. In his series of *The Seasons,* Duncanson made his first attempt at creating a landscape painting with a conventional symbolic meaning.

The artist's final tour of the Lake Superior region in the summer of 1850 is evidenced in his oil sketch of *Carp River, Lake Superior* (1850, Fig. 17). The small format and broad execution of the painting suggest that he sketched it on the site. The battered and weathered trees indicate his interest in capturing the sublime forces of nature, as well as the picturesque qualities found in *The Seasons, The Catch,* and *Man Fishing.* The rugged wilderness of *Carp River* reflects the influence of Sonntag's Ohio River valley landscape paintings. Since the departure of Whittredge to Düsseldorf in 1849, Sonntag was considered to be the "most eminent" landscape painter in

Fig. 16. Robert S. Duncanson, *Winter*, 1849, oil on canvas, 11½″ × 16″. Mr. and Mrs. Meyer P. Potamkin Collection.

the west. During the late 1840s Duncanson and Sonntag had become colleagues, and by January 1850 the African-American artist had settled into a studio adjoining Sonntag's in Cincinnati.[34] In such close proximity, Sonntag's work had a demonstrable influence on the young painter's stylistic development, and over the next decade their careers would become closely intertwined.

Stimulated by Sonntag's example, Duncanson proudly exhibited his efforts in landscape paintings at the Western Art Union in 1850. He presented his series *The Seasons* and seven other landscapes, including two views of the "Dead River,"

one of which may have been *Carp River*.[35] This exhibition proclaimed the artist's entry into the field of landscape painting. The paintings attracted positive attention from the press: "Duncanson, favorably known as a fruit painter, has recently finished a very good strong lake view."[36] More than a decade after Duncanson and John Gamblin entered the painting trade as "A NEW FIRM" in 1838, Duncanson found his niche in art as a landscape painter. Over the next decade he would progress to become a major figure in the Ohio River valley group of mid-nineteenth-century landscape painters.

Fig. 17. Robert S. Duncanson, *Carp River, Lake Superior,* 1850, oil on board, 8″ × 10″. Courtesy of Sotheby's, New York.

2

"A Token of Gratitude"

The Ohio River Valley Landscape Tradition

*T*he commission from the Reverend Charles Avery to paint *Cliff Mine, Lake Superior, 1848* resulted in Duncanson's emergence as the most significant African-American artist of his generation and one of the primary Ohio River valley landscape painters. In addition, the commission from one of the leading antislavery activists of the day initiated Duncanson's lifelong relationship with the abolitionist community. The abolitionists patronized him, and their journals championed his artistic accomplishments as exemplifying the cultural contributions of African-Americans. As a token of his gratitude for Avery's patronage and encouragement Duncanson presented his first major historical landscape, *The Garden of Eden* (1852, Plate 4), to Avery in a ceremony that was trumpeted by antislavery journals across the United States.

When Duncanson chose Cincinnati for his home in 1850, he selected a city that had long been recognized as a center for the "free colored" population in the United States and a hotbed of abolitionist sentiment. Although Cincinnati lay on the border of slavery and its economy was based on river commerce with slave states, the city offered a receptive environment for the young African-American artist to pursue his artistic ambitions. Ohio laws provided mulattoes, and persons with a fair complexion, with the same legal protection accorded whites, while darker

"free colored persons" were not permitted the basic liberties of owning property, voting, and obtaining legal representation.[1] Furthermore, Cincinnati served as an early center for abolitionist political activity. After being evicted from Kentucky for publishing his abolitionist periodical *The Philanthropist,* James G. Birney moved across the river to Cincinnati, where his journal incited political activism for the antislavery cause. Motivated by Birney, the faculty and students of nearby Miami University took up the cause and publicly proclaimed their advocacy through their teaching and publications. In the 1850s John Mercer Langston, the noted African-American abolitionist, also worked in Cincinnati. Moreover, the region was recognized for the educational opportunities it provided with a free black school system and one of the first black schools of higher education in the United States, Wilberforce College, in nearby Xenia, Ohio. Duncanson was attracted to this center of abolitionist sentiment and African-American education, where he benefited from its programs and patronage and expressed his gratitude by participating in its activities.

At the time Duncanson moved into a studio adjoining William Sonntag, Cincinnati was also a flourishing cultural community. Since the 1830s the city was experiencing a tremendous boom in population and economy that resulted in its becoming the commercial center of

America west of the Appalachian mountains. The economic strength of Cincinnati fostered the development of a class of wealthy patrons essential to encouraging a thriving arts culture. In his accounts of *Cincinnati in 1841,* local chronicler Charles Cist prophesied, "Cincinnati must be regarded as one of the points where art in these latter times is one day to rear proud trophies and speak with a new power to the sense of the beautiful, the divine in man." By 1851, Cist could proudly proclaim, "Cincinnati has been, for many years, extensively and favorably known as the birthplace, if not the home of a school of artists."[2] During the 1840s, the creation of art academies, local art fairs, and the Western Art Union allowed Cincinnati to encourage the artistic careers of many who became prominent in the mid-nineteenth century: Hiram Powers (1805–1873), John Cranch (1807–1891), James Beard, Godfrey Frankenstein, T. Worthington Whittredge, Sonntag, and Duncanson.

At this time Cincinnati boasted that it was the "Athens of the West," a center for landscape painting that had produced an Ohio River valley landscape tradition.[3] In the diary of his journey across western America in 1851 to record the arts scene, Frank Blackwell Mayer (1827–1899) noted that, in Cincinnati, "The painters are mostly landscape Artists and the beautiful country by which they are surrounded supplies them with ample material for study & subject. The most eminent in landscape is Sonntag a native of Cincinnati. . . . His landscapes are remarkably fine, distinct, characteristic & truthful. Whittredge, Duncanson (a negro), also paint good landscape."[4]

This triumvirate of artists matured in Cincinnati in the 1840s and blossomed in the 1850s as major figures in American

landscape painting. All three artists developed their landscape styles in Cincinnati and established a foundation for landscape painting in the Ohio River valley that endured through the nineteenth century. The artists undoubtedly knew one another in the small but rapidly expanding cultural circles of Cincinnati. They participated in the Western Art Union, exhibited at local shops, and competed with one another for the prominent patrons—Nicholas Longworth, Reuben Springer, and Charles Stetson. Yet they did not form a conscious group or movement distinct from the major artistic trends of the eastern centers of New York, Boston, and Philadelphia. Nonetheless, due to their close proximity in the tightly knit cultural environment of the region, their work evolved along the same lines.

All three artists—Whittredge, Sonntag, and Duncanson—began their careers in the skilled trades as house, sign, and scenic painters in the early 1840s. Their artistic development was limited by the access Cincinnati provided to art academies, original artworks by eastern and European artists, and exhibition venues at local expositions. However, through popular periodicals, engraved prints, and the exhibitions at the Western Art Union, all three artists became aware of and aspired to paint in the popular landscape style of the eastern Hudson River School artists. Within their own circles, Godfrey Frankenstein, a founder and president of the short-lived Cincinnati Academy of Fine Arts, was a landscape painter. Also, their colleague Benjamin McConkey had briefly studied with Thomas Cole and spread an enthusiasm for his works that culminated in the acquisition of Cole's *Voyage of Life* (1846, National Gallery of Art) by a local private collector. This was the

first painting by the "father of American landscape painting" to enter a Cincinnati collection, and its arrival was a major cultural event. It was immediately placed on public display in 1847, further stimulating the interests of local artists and patrons in landscape painting.[5]

With the encouragement of patronage and the stimulus of Cole's art, Whittredge, Sonntag, and Duncanson embarked on a series of sketching trips—to West Virginia for Whittredge in 1845, to Kentucky for Sonntag in 1847, and to the Upper Peninsula of Michigan for Duncanson in 1848—to provide them with the necessary material for painting landscape compositions in their Cincinnati studios. After his trip to West Virginia, Whittredge created one of his most

ambitious paintings to date, the culminating achievement of his early career in Cincinnati, *Crow's Nest* (1848, Fig. 18).[6] The painting depicts one of the artist's favorite sketching spots off the Ohio River in West Virginia. Its style suggests the influence of Cole in the dappled touch on the hillside, reminiscent of Cole's *Schroon Mountain* (1838, Cleveland Museum of Art).

Sonntag's paintings of richly detailed wilderness scenes with gnarled tree trunks (Figs. 19–20) reflect the same sources in the work of Cole. Sonntag was particularly impressed by Cole's *Voyage of Life* and created a monumental cycle of four paintings, *The Progress of Civilization* (1847, location unknown), based upon Cole's allegorical series. Although Sonntag's

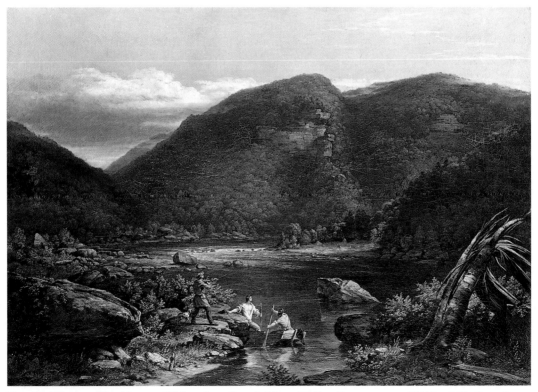

Fig. 18. Thomas Worthington Whittredge, *Crow's Nest,* 1848, oil on canvas, 39¾" × 56". Detroit Institute of Arts, gift of Mr. and Mrs. William D. Biggers.

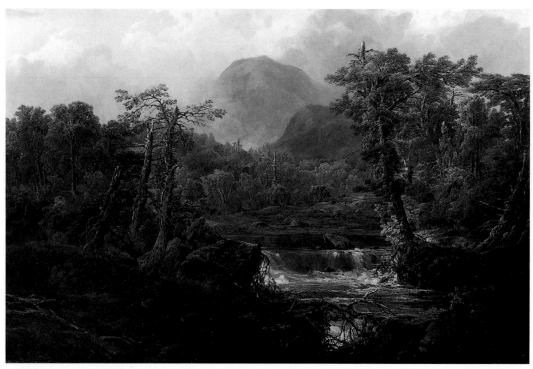

Fig. 19. William L. Sonntag, *Landscape,* 1854, oil on canvas, 32″ × 48″. Cincinnati Art Museum, gift of Mrs. Harold Kersten.

ambitious canvases are now lost, their importance was immediately recognized by the local press, which proclaimed them to have "increased his already exalted reputation as an artist."[7] This series established him as a serious landscape painter and, after Whittredge departed for Europe in 1849, as "the most eminent in landscape" in Cincinnati.

After Duncanson's commission to paint *Cliff Mine* and his sketching tours of the Upper Peninsula, he realized the great potential for the patronage of landscape painting. Among Cincinnati's community of landscape painters, he sought the works of Frankenstein, Whittredge, and Sonntag to stimulate his ideas. With the departure of Whittredge in 1849, Sonntag became Duncanson's primary inspiration, and in January 1850 the young African-American moved into a studio adjoining Sonntag's,

where the two artists became close friends. Under Sonntag's guidance, Duncanson's art improved dramatically, and within weeks he attracted the attention of the local press with his new work. In a review of local art activities, the *Daily Cincinnati Gazette* focused on Sonntag as "the most productive of our landscape painters" but noticed, "In the room adjoining Sonntag's, at Apollo building, Duncanson, favorably known as a fruit painter, has recently finished a very good strong lake view."[8] His compositions, motifs, and overall technical development in the early 1850s are directly related to Sonntag's example and influence. However, Sonntag also borrowed from Duncanson's decade of experience in creating a studio environment for his clients. Junius Sloan, a young white artist who was Duncanson's apprentice, wrote to a friend noting that

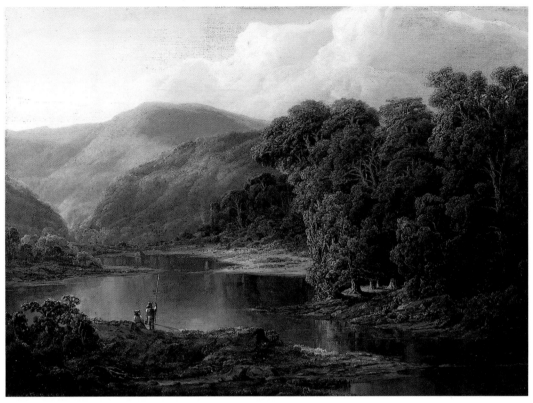

Fig. 20. William L. Sonntag, *Landscape,* 1854, oil on canvas, 16″ × 22″. Cincinnati Art Museum, gift of Alfred T. Goshorn.

"Sonntag entered the rooms opposite us on the same floor,—colored the walls, carpeted, and fitted up nearly the same as we are."[9] During the early 1850s Sonntag's preeminence and his greater experience dominated the artistic relationship between him and Duncanson; however, by the end of the decade Duncanson was to surpass his mentor in artistic ability and critical acclaim.

Following Sonntag's example, Duncanson began a series of sketching tours along the Ohio River valley in the summers from 1850 to 1852. Traveling up the Ohio River through Pennsylvania, and down to North Carolina, Duncanson studied the landscape, sketching source material for his studio paintings. After his first tour, he prepared eleven landscape paintings

for the Western Art Union exhibition in the fall of 1850. These paintings constituted a formal declaration of his entry into the field of landscape painting. At their exhibition the press remarked, "The paintings by our native artists, the brothers Frankenstein, Duncanson and White, are among their best productions."[10] The landscapes painted after the young artist's second summer tour earned even greater praise from the critics when they were exhibited at the same location the following year. A reviewer remarked, "One of R. S. Duncanson's best pictures— we like it better than any landscape he has in the Gallery . . . is a view on the French Broad, North Carolina . . . the picture is one which pleases all who examine it."[11]

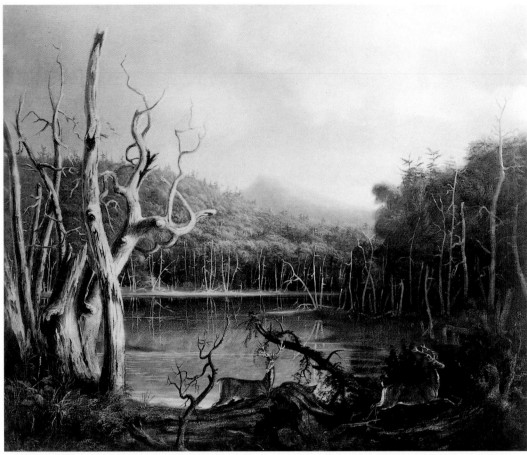

Fig. 21. Thomas Cole, *Lake with Dead Trees*, 1825, oil on canvas, 27″ × 34″. Allen Art Museum Oberlin College, gift of Charles F. Olney.

Blue Hole, Flood Waters, Little Miami River (1851, Plate 3) may have been one of the paintings Duncanson exhibited at the 1851 Art Union show. Painted within a year after he moved into the studio adjoining Sonntag's, this painting demonstrates the tremendous strides Duncanson made in his year as an understudy. *Blue Hole* is certainly among the artist's finest works and a herald of his future prospects as a landscape painter. The converging diagonals of the receding riverbanks create a tight compositional unity that focuses on the center of the landscape in a manner that recalls Cole's *Lake with Dead Trees* (1825, Fig.

21). The compositions of the two paintings are similar, and Duncanson must have known Cole's work before painting *Blue Hole,* perhaps through the broad press coverage that Cole's Memorial Exhibition of 1848 received.

In contrast to the sublime scene of devastated floodlands in Cole's *Lake with Dead Trees,* Duncanson's serene, picturesque *Blue Hole* bespeaks his pastoral vision of nature with anglers enjoying the fruits of the flooded riverbed. The scene appears to be a straightforward, bucolic one with men fishing in a picturesque landscape. However, daily confrontations with the trauma of being

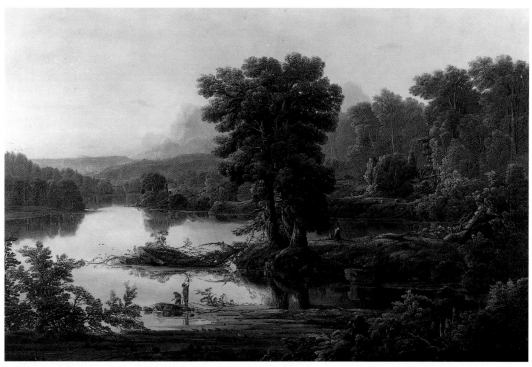

Fig. 22. William L. Sonntag, *Scene on the Little Miami River,* 1853, oil on canvas, 32″ × 48″. Cincinnati Art Museum, gift of Mary Kilgore Miller, Edmond E. Miller, and Rufus King.

black in antebellum America certainly influenced the artist's interpretation of the scene. From this perspective one can read in the scene Duncanson's artistic search for an ideal world free from racial prejudice, and perhaps, as Professor David Lubin has proposed, his longing to cross the flooded riverbed to freedom.[12]

When he painted the Little Miami River, a tributary of the Ohio River east of Cincinnati, Duncanson was pursuing an established Cincinnati landscape tradition. Miner K. Kellogg mentions the blue hole in his journal of 1833 as a site that was popular among the regional artists for its great beauty.[13] In fact, numerous regional artists, including Kellogg, Frankenstein, Sonntag, and Duncanson, painted the site, making it the subject most often depicted by Ohio River valley artists. Frankenstein's *Blue Hole, Little Miami River* (1838, Procter and Gamble) is

one of the earliest visual records of this scenic area. Sonntag's *Scene on the Little Miami River* (1853, Fig. 22), created two years after Duncanson's *Blue Hole,* offers a poignant comparison between the two artists' handling of a similar subject at this early stage of their relationship. In his typical manner Sonntag delineated each rock, leaf, and twist of bark in exacting detail, giving his painting a dry, linear quality. Duncanson intricately drew the foreground of his *Blue Hole* in Sonntag's manner and blatantly borrowed the motif of anglers along the shore from Sonntag's stock repertoire of staffage. However, while Sonntag's composition is loosely conceived with the river winding irregularly through the landscape, Duncanson effectively utilized the anglers' poles to heighten the diagonals in his tightly controlled composition. In addition, *Blue Hole* is more painterly in technique

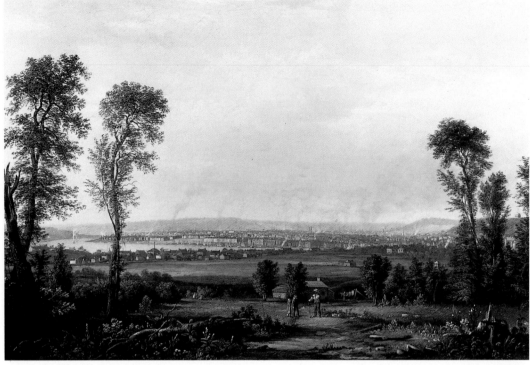

Fig. 23. Robert S. Duncanson, *View of Cincinnati, Ohio from Covington, Kentucky,* c. 1851, oil on canvas, 25" × 36". Cincinnati Historical Society.

with a naturalistic atmospheric effect that Sonntag lacked.

At about this time Duncanson created an unusual painting that prefigures some of his later work and offers the first visual indication of his attitudes toward the slavery question. Perhaps on commission, Duncanson painted *View of Cincinnati, Ohio from Covington, Kentucky* (c. 1851, Fig. 23) directly after an anonymous daguerreotype printed in *Graham's Magazine* in 1848 (Fig. 24).[14] The painting is unsigned and undated, but scholars have firmly attributed it to Duncanson on stylistic grounds and dated it to this period. Because the painting nearly replicates the print, scholars have speculated that Duncanson may have also made the daguerreotype. Although substantial evidence exists that the painter worked in daguerrean studios, including a description

of him in the 1853 *Cincinnati Directory* as a "daguerreotype artist,"[15] no identifiable examples of his work in this medium have been located.

Significant to the interpretation of *View of Cincinnati* is the point at which the painting digresses from the photographic print. Duncanson reproduced each topographical detail of the engraved cityscape with painstaking accuracy. However, he altered the staffage figures in the foreground of a man leaning on a rifle and directing a pair of children to depict a black man, without a rifle but carrying a scythe, waiting on the children. Duncanson also changed the woman hanging out laundry behind the ramshackle cabin behind them from white to black. In the distance a white couple leisurely lounges on the hillside enjoying the view of Cincinnati

Fig. 24. J. W. Steel, *View of Cincinnati, Ohio,* from an original daguerreotype in *Graham's Magazine* 2, no. 6 (1848): 352.

across the river. By depicting a couple of slaves laboring on the Kentucky side of the river in the service of a Caucasian family, the artist has poignantly contrasted the free white classes of the South with their laboring black slaves. In what appears to be a topographical scene, Duncanson subtly interjected his commentary condemning the practice of slavery on the Kentucky side of the river. It is ironic that the slaves need only glance across the river to see the booming economy of Cincinnati beckoning them to freedom and the opportunity for prosperity.[16]

Duncanson's ambitions grew after the critical success of the two Western Art Union exhibitions, and he decided to undertake a number of didactic historical

landscape paintings. Over the course of the next three years, his primary efforts would be historical works. Sonntag's *Progress* series and Cole's *Voyage of Life* provided models for Duncanson that emphasized the importance of moralizing content in painting. Traditionally, historical painting drew upon subjects from mythology, literature, scriptures, or history in order to convey noble human conduct as a didactic lesson. The hierarchy of genres established by European art academies served as an aesthetic paradigm for painting in the United States, influencing the popular belief that "historic painting . . . occupies the most exalted rank in the various departments of art."[17] In order for landscape painting to rise above the merely imitative functions of

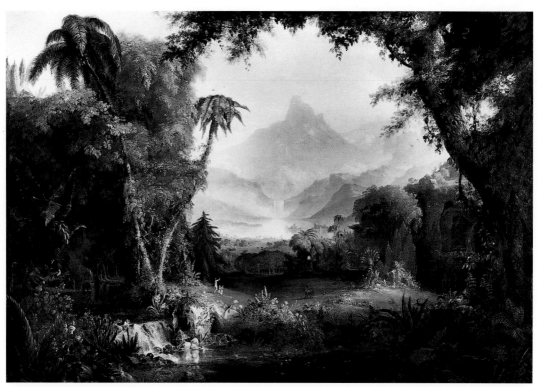

Fig. 25. Thomas Cole, *The Garden of Eden,* 1827–1828, oil on canvas, 38½″ × 52¾″. Amon Carter Museum, Fort Worth, Texas, 1990.10.

topography and scene painting, it was required to aspire to grand ideas. Cole had expressed his belief that an artist's works "ought not to be a dead imitation of things, without the power to impress a sentiment, or enforce a truth."[18]

Duncanson's first ambitious historical painting was *The Garden of Eden* (1852, Plate 4), copied after Cole's painting of the same title (1827–1828, Fig. 25). Cole's vision of Eden was prompted by John Milton's *Paradise Lost,* which was popular in early nineteenth-century America. Duncanson's idea to copy Cole's painting was stimulated early in 1851, probably by James Smillie's engraving after the picture. With this painting Duncanson aspired to establish his reputation as a painter of elevated landscape subjects. Without having drawn a single line, he announced his ambitions to his understudy, Junius Sloan, who received the news with much trepidation. Sloan remarked, "There is too much 'Dogone' in his character to paint such a subject—one which I do not wish to see attempted by any artist of my acquaintance." Sloan's descriptions of the painter provide an insight into his excitable, animated personality: "Duncanson is still driving away making ready for his 'Eden'— of which you may have heard him speak. . . . I scarcely need tell you more, at present—for to give you a full idea would be impossible, to obtain it you must sit by and listen to his words and watch his gestures, and cath [*sic*] the expression in his face."[19] Sloan's description conveys the anxiety and determination that marked Duncanson's ambitious character.

The artist worked on the painting throughout the spring of 1852 with the intention of touring it around the Midwest during the summer. The finished canvas was an immense five by seven feet, larger than Cole's, filled with luxuriant gardens full of exotic trees and richly colored flowers that framed a view of the pyramidal Mount of God. The gates of paradise stand in the middle ground guarded by the angel Gabriel, symbolized by the star between the pillars. This conception of paradise closely paralleled the description by Milton in *Paradise Lost* of a place dominated by "a rock of Alabaster, piled up in the clouds," with a "craggy cliff" for a profile. In June 1852, the press previewed the painting in Duncanson's studio before its touring exhibition. The *Gazette* reported to its readers that *Garden of Eden* was "beautiful and inspiring, shows careful study, and is far in advance of former works."[20]

The Garden of Eden's romantic ideas of God, nature, and man in the new world were easily recognizable to a nineteenth-century American audience. Contemporary writers immediately understood the association between the painting's literary source and the metaphorical implications to contemporary life. A reviewer revealed the noble purpose of the picture and commented, "The poet and the painter seek to embody their idea of the great, the good, and the beautiful, and this is the mission of the true artist." Viewing the painting, "one may not look upon the artist's idea of a perfect earth—Eden, the beautiful home of perfect man—without higher aspirations for the future, and the restoration of the pristine purity of life and beauty of earth, which is his birthright."[21] Implied in the latter comment is the millennialist association between the American wilderness and a

spiritual paradise. A number of Americans believed that primitive nature, untrammeled by man, was the original handiwork of God. By being close to nature, in body and spirit, they could be close to God. They attempted to structure their society in line with their perception of pure religious and moral imperatives, in order to create "the beautiful home of perfect man" in this wilderness garden. From the millennialist perspective, America had the potential to re-create the biblical paradise on earth and avoid the fate of previous decadent civilizations.[22] Thus, the exotic semitropical Eden depicted in Duncanson's painting is emblematic of America as the primitive wilderness garden, "a perfect earth."

Arcadia, paradise, or the Garden of Eden were popular subjects for American artists of this era. Duncanson in particular dealt extensively with these themes and seemed obsessed with creating visions of paradise. Often, as in Cole's *Dream of Arcadia* (1836, Denver Art Museum), which Duncanson also copied (c. 1852, Fig. 26), an explicit parallel was drawn between the imaginary lands depicted and America. This idea, complete with its metaphorical overtones, preoccupied Duncanson throughout his career and constituted the primary subject of his major historical-literary paintings, beginning with *The Garden of Eden* and *Dream of Arcadia*. The subject seems to have held special significance for him artistically, personally, and psychologically. As he confronted the daily ordeals of racial discrimination, the emotionally anxious Duncanson seems to have been drawn to depict a blissful land without the trials and tribulations of everyday life in the United States. His paintings not only conveyed conventional American attitudes toward the primeval garden of their

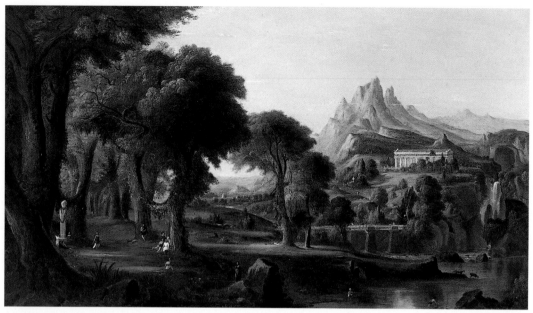

Fig. 26. Robert S. Duncanson, *Dream of Arcadia,* after Cole, c. 1852, oil on canvas, 24" × 42". Private collection, New York.

country but also signified Duncanson's search for the promised land of slave songs.

Only days after the pre-exhibition notice, Duncanson crated his *Garden of Eden* and traveled up the Ohio River to Pittsburgh to tour the painting. There it was received "as a work of genus [*sic*]."[23] Realizing the success of his first painting of a literary subject, the artist painted a smaller version for exhibition in the fall at the Art Union in Cincinnati. His second version of *The Garden of Eden* and Sonntag's copies after Cole's *Voyage of Life* (location unknown) were the focal points of the final Art Union exhibit in 1852. *The Garden of Eden* was highly praised and immediately recognized as Duncanson's "chef d'oeuvre,"[24] raising his status among the landscape painters of Cincinnati.

In concert with the Pittsburgh exhibition, Duncanson orchestrated a ceremonious presentation of the original *Garden of Eden* to the Reverend Charles Avery as a symbol of his appreciation for the Reverend's efforts on behalf of African-Americans. Several abolitionist periodicals realized the publicity potential of this presentation and ran the story. *Frederick Douglass' Paper* capitalized on the moment in a lengthy notice to its readers under the title "A Token of Gratitude." The journal reported that at the close of the exhibition Duncanson, "a talented young gentleman of color," offered *The Garden of Eden* to Avery "as a testimonial of respect and gratitude, for his munificent friendship towards the colored people of Pittsburgh and Allegheny." According to the journal, "Mr. Avery was taken quite by surprise, and seemed for a few moments at a loss what to say, but after a slight demur, he accepted it warmly and expressed his acknowledgements for the compliment."[25]

The abolitionist journalists seized this as another opportunity to demonstrate the civic and intellectual accomplishments of

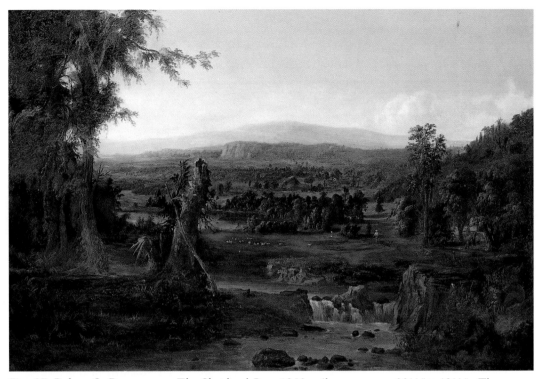

Fig. 27. Robert S. Duncanson, *The Shepherd Boy*, 1852, oil on canvas, 32½″ × 48¼″. The Metropolitan Museum of Art, New York, gift of Hanson K. Corning by exchange.

African-Americans. The artist was reputed to have declined an offer of the then large sum of eight hundred dollars in order to make the painting available to Avery in a ceremonious presentation.[26] The style of journalism in the article suggests that this event was probably dramatized, like *The Liberator* article cited earlier, in order to impress upon readers the cultural contributions of African-Americans and to generate compassion toward them. The article concluded with the question, "Who shall answer to this age and to posterity for the sin and shame of crushing a race, thus gifted with the power of genius, the delicacy of sentiment and the capacity for sublime moral development, of which this one act proves them capable?" In Duncanson's art and in his noble gesture, the abolitionist journalists discovered an exemplar of

African-Americans' intellectual and cultural capabilities.

Once the exhibition and presentation concluded, the artist concentrated on a sketching tour taking him to New York State, where he prepared studies for new paintings to be produced when he returned to his Cincinnati studio. Noteworthy among the paintings he created from this trip is *The Shepherd Boy* (1852, Fig. 27), which caught the attention of the local press. In September 1852 a Cincinnati critic visited Duncanson's studio to review the summer's work and wrote, "He has nearly finished a beautiful landscape of great artistic merit—'the Shepherd Boy.' We discover a decided improvement in Duncanson's last works."[27]

The Shepherd Boy demonstrates the influence of Sonntag in the composition of a river rapids leading through framing

trees to a distant mountainous vista, as can be seen in a comparison with Sonntag's 1854 *Landscape* (Fig. 19). Duncanson's finely delineated rendering of the trees, the rocks, and the river recalls Sonntag's technique; however, Duncanson's work is more broadly painted. In addition, although the paintings are similar in composition, their aesthetic moods are very different. *The Shepherd Boy* is picturesque in effect with foreground tree trunks and branches that twist around one another and a middle-ground plain dotted with vibrant tree groups stretching out to the distant mountains draped in a misty aura. This pastoral mood, reinforced by the shepherd tending his flock, is in marked contrast to the more threatening, sublime image of Sonntag's weathered tree trunks framing a river rushing through impenetrable woods. Man does not inhabit the sublime world of Sonntag's painting, whereas Duncanson's picturesque grassy plain is receptive to the pastoral motif of a shepherd and his grazing flock, a motif that would become standard staffage in his pastoral landscapes.

The technical achievements and the metaphorical content of Duncanson's *Garden of Eden* and *Shepherd Boy* attracted the attention of patrons and critics. In two brief years the artist's work had improved dramatically, and he had achieved a significant level of artistic accomplishment under the guidance of Sonntag. One need only compare *Carp River, Lake Superior* (1850, Fig. 17) to *Blue Hole* (1851, Plate 3) or *The Shepherd Boy* (1852, Fig. 27) to see the development of his style. At this point Duncanson's work was favorably compared to that of his mentor. Reviewing a painting by Sonntag in a local shop window two weeks after the notice on *The Shepherd Boy*, the *Gazette* noted, "We have no authoritative

information on the subject, but if we may be allowed to judge by the style, should pronounce the picture in question to be from R. S. Duncanson's easel."[28]

Some of the results of Duncanson's sketching tours were sent to Detroit for exhibition at the Gallery of Fine Arts of the Fireman's Hall in February 1852 and 1853. These exhibitions were the first art shows in Michigan history.[29] By participating in both exhibits Duncanson became recognized as a major figure in the visual arts of Detroit. Prior to these exhibits there were few artists in Michigan, and they were primarily portrait and genre painters. John Mix Stanley (1814–1872), the most notable early artist, painted portraits in Detroit for a few years, but left the city in 1837. During the period when Duncanson was in the city the few active artists included Frederick E. Cohen and Alvah Bradish (active 1837–1850s), who were genre and portrait painters, respectively. Among these artists only Duncanson made any significant contribution to the development of the visual arts in early Detroit.

Rev. James Francis Conover, an Episcopalian rector and ardent abolitionist, probably saw the artist's work at the Fireman's Hall exhibit of 1853, at which time he commissioned him to paint a scene from the popular Harriet Beecher Stowe novel *Uncle Tom's Cabin*. A transplanted Cincinnatian who had just moved to Detroit in 1853 to practice law and who eventually became the editor of two local newspapers, Conover would have been familiar with Duncanson's artistic reputation.[30] The painting Conover commissioned, *Uncle Tom and Little Eva* (1853, Plate 7), was the artist's only explicit treatment of an African-American subject and reveals his impassioned response to the subject of slavery.

Stowe's novel had become a major best-seller when it was published in 1852, with its dramatic melodrama attracting immense public attention to the plight of enslaved African-Americans. Stowe proclaimed the purpose of her novel in her preface: "The object of these sketches is to awaken sympathy and feeling for the African race, as they exist among us; to show their wrongs and sorrows, under a system so necessarily cruel and unjust."[31] Within a year stage productions of the book were sweeping the country, and by the end of the nineteenth century it had become one of the most popular books ever published.[32] Because of its tremendous popularity, Stowe's novel realized her intention to write a political tract that would persuade the mass of citizenry of the evils of slavery.

The Protestant theological beliefs that mark Harriet Beecher Stowe's literary works were nurtured during her childhood in Cincinnati by her father, Lyman Beecher, the noted Calvinist minister and theologian. In the close community of abolitionists and intellectuals, it is inconceivable that Duncanson would not have personally known Mrs. Stowe and the Beecher family while they lived in Cincinnati. Although *Uncle Tom's Cabin* was written shortly after Stowe's departure from Cincinnati, Duncanson, like most Americans, certainly read the novel and possibly saw a stage production. As an African-American, the painter would have personally sympathized with the "wrongs and sorrows" suffered by his enslaved brethren.

The moment portrayed in the painting was probably the deliberate choice of Conover, in concert with the artist. Instead of a more theatrical passage such as the freeing of the slaves or the flogging death of Tom, the artist and patron decided upon a contemplative moment from chapter 22. In this passage Eva is teaching Tom, a family slave, to read the Bible. In the moment depicted, she has dropped her Bible and is gazing toward the sky where the heavens open up before her. Pointing to her vision she proclaims to her faithful slave, "I'm going there . . . to the spirits bright, Tom. I'm going before long."[33] In this scene Stowe has dramatized the Protestant ethic of love and sacrifice as the means of personal and social salvation. While Eva is teaching her slave to read the words of God, an act of love and religious devotion, the critical turning point in the plot is introduced with the foreshadowing of her death. Salvation could be interpreted here as both spiritual salvation for Eva and physical emancipation for the slaves. For Duncanson and other African-Americans this scene represented the potential for salvation from slavery and oppression through their own religious faith, and the hope that slaveholders would respond to the basic moral tenets of their spiritual beliefs and abolish slavery.

By painting this subject Duncanson publicly announced his abolitionist sentiments and his hope for a religious basis for resolving the slavery question. In his painting, he reflected Stowe's sentiments as expressed in her preface: "The poet, the painter, and the artist, now seek out and embellish the common and gentler humanities of life, and, under the allurements of fiction, breathe a humanizing and subduing influence, favorable to the development of the great principles of Christian brotherhood."[34] The abolitionist circles dominated by religious figures such as Avery, Conover, and the Reverend Richard Rust (1815–1906) espoused religious moral justifications for the total emancipation of slaves. In constant communication with these abolitionists,

Duncanson shared their beliefs in the Protestant moral precepts behind manumission and explicitly expressed this in his *Uncle Tom and Little Eva*.

The moving scene depicted in the painting is set in a lush, semitropical landscape. Tom sits on a mossy bank holding little Eva's outstretched hand, and the pair is shrouded by trees draped with spanish moss and flowers. Bamboo arbors create a repeated arched pattern silhouetted against the richly colored sunset. The exotic terrain and ethereal sunset create the mood and convey a profound, religious solemnity that is appropriate to the narrative. This setting was drawn from the description in the novel of the view from the villa on Lake Pontchartrain, near New Orleans, where Tom and Eva beheld their vision.

> surrounded by light verandas of bamboo-work. . . . The common sitting room opened on to a large garden, fragrant with every picturesque plant and flower of the tropics, where winding paths ran down to the very shores of the lake, whose silvery sheet of water lay there, rising and falling in the sunbeams. . . . It is now one of those intensely golden sunsets which kindles the whole sky into one blaze of glory, and makes the water another sky.[35]

Duncanson deviated from the text only slightly, re-creating the many details of Stowe's novel with great assiduity and rendering them with a romantic sensitivity appropriate to the romantic religious mood of the narrative.

The artist's source for the composition and design of the painting was an engraving illustrating the original edition of *Uncle Tom's Cabin*.[36] The slave sits in the arbor holding Eva's hand and listening intently to her benediction from the Bible. The positioning of the figures and even the hat, turned upright at

Uncle Tom's side, are precisely the same as in Duncanson's painting. Yet Duncanson did introduce variations. He depicted Eva standing with a more dramatic gesture and expanded the landscape setting to include the distant view of Lake Pontchartrain to the left with sailboats that symbolize the voyage of life in mainstream American art and the passage to freedom for African-Americans.

Curiously, few paintings of this popular subject seem to have been painted. Contemporaries considered it a controversial subject that could result in severe reprisals from proslavery advocates who found the novel inflammatory. Like the activist James Birney, an artist could be subjected to mob violence and evicted from town, if found to be advocating antislavery principles. Among the few interpretations of this scene is a folk art painting by a Canadian, Ira Barton, from the mid-1850s entitled *Uncle Tom's Cabin* (Upper Canada Village, Morrisburg, Ontario).[37] This painting portrays the same moment in the narrative as does Duncanson's, but it is more closely tied to the original source and lacks the interpretative potential of *Uncle Tom and Little Eva*.

Since the painting was first viewed by the public, it has aroused considerable attention and controversy. The *Daily Cincinnati Gazette* of March 17, 1853, ran a special "Personal and Artistical" notice on the painting before it was completed: "Duncanson is putting finishing touches to another fine picture—called 'Uncle Tom.'" When the painting was reviewed at the end of the month, the *Cincinnati Daily Commercial* critic was not so impressed with the work, calling it an "AN UNCLE TOMITUDE.—Uncle Tom, according to the artist, is a very stupid looking creature, and Eva, instead of being

a fragile and fading floweret, is a rosy-complexioned, healthy-seeming child, not a bit ethereal."[38] This reviewer noted the artist's main technical weakness: his inability to master figure drawing, as shown by the clumsy and ill-proportioned figures of Tom and Eva. Interestingly, none of the press reviews refer to the subject of the painting and its political ramifications on the slavery question. Apparently, the press steered clear of the controversial subject of human bondage and the religious moral dilemma involved in this divisive issue. None of the contemporary accounts considered the providential blessing implied in the richly glowing sunset on the paradisiacal landscape, which represented the artist's and his patron's hope for a resolution to the slavery question through the spiritual application of love and sacrifice.

After completing the commission for *Uncle Tom's Cabin,* Duncanson prepared for his first tour of Europe. By this time he had emerged, with Sonntag, as one of the important landscape painters in Cincinnati and middle America. He had established himself as a painter of native scenery with *Blue Hole* and *Shepherd Boy* and as a designer of historical and literary landscape subjects with *The Garden of Eden* and *Uncle Tom and Little Eva.* Sonntag was still preeminent in landscape painting in Cincinnati. He had begun exhibiting in New York at the American Art Union in 1851 and at the Pennsylvania Academy of Fine Arts in 1853 and had attracted attention for his paintings in those artistic centers. However, in three short years Duncanson had progressed from an understudy of Sonntag's to the point of being favorably compared with his mentor and creating artworks with far greater social and cultural significance.

Duncanson and his friend Sonntag were clearly ready for their "grand tour" of Europe to finish their art education and refine their skills by studying the masters. Sonntag, the more successful artist, apparently made the journey on his own income, taking a student from his studio. Duncanson, on the other hand, had earned the attention of Nicholas Longworth, Cincinnati's leading art patron, and received his encouragement and support for his tour of Europe.

3

"The well-known decorative painter Duncanson"
Nicholas Longworth's Belmont Murals

*D*uncanson's remarkable progress as a landscape painter in the early 1850s caught the attention of Nicholas Longworth (1784–1863), a major landholder and horticulturalist, who was one of the wealthiest men in the United States and the primary arts patron in Cincinnati. Longworth possessed a great sense of civic and cultural pride, and over several decades he earned a reputation for sponsoring local artists who met two criteria: they had to have both talent and need. In addition, Longworth, typically a taciturn man in political affairs, was known to possess strict antislavery principles. One tale often recited contends that the landowner hid a runaway slave, Harvey Jones, in his cellar and then paid his Kentucky master to set the man free.[1] In the young African-American artist, Longworth could support both his cultural philanthropy and his abolitionist sentiments. At this time Longworth was building his art collection, and he desired to decorate the halls of his home, Belmont, with murals in emulation of great eastern mansions. Motivated by his abolitionist sympathies and Duncanson's experience as a housepainter and decorator, Longworth commissioned the artist to decorate his home with monumental landscape murals around 1850.

Longworth's commission was the largest project of the artist's career, consisting of eight huge landscape decorations in trompe-l'oeil French rococo frames (each approximately nine by seven feet), three over-the-door floral vignettes, and two patriotic eagles over the arched entrances of the cross halls at Belmont, now the Taft Museum (Figs. 28–30 and Plate 5). Duncanson's murals stand as the most ambitious and accomplished domestic mural paintings created in the United States before the Civil War. Longworth's commission was grandiose in its decorative intentions, and the resulting murals, painted directly on the dry white plaster of the walls in imitation of popular wallpaper designs, reveal a complexity of formal sources. They are unique among domestic decorations, whether wallpapered, stenciled, or painted, in antebellum America.

It is impressive that Duncanson, just emerging from his itinerant years, could execute a mural commission of this complexity. He did not create subsequent works on this scale; thus the murals stand as his largest artworks. In this commission, he combined his skills in interior decoration and landscape painting with his knowledge of contemporary wallpaper fashions. At this early stage of his artistic development the challenge of creating the Belmont murals bolstered his confidence, expanded his capabilities, and helped launch his career.

The Longworth and Taft family traditions claim that Longworth commissioned Duncanson to decorate the halls of his Cincinnati home around 1850. The

Fig. 28. Entry Foyer Baum-Taft House with murals by Robert S. Duncanson, Bequest of Mr. and Mrs. Charles Phelps Taft, Cincinnati. Photo by Tony Walsh.

murals are unsigned, and no contemporary documents on the commission exist. Local writers did not mention the murals, Longworth did not refer to them in his known letters, and the lavish descriptions of Belmont written for the celebration of Longworth's golden wedding anniversary in 1857 did not describe them.[2] In 1939 Comtesse Clara Longworth DeChambrun, a descendant of the Longworths, alluded to letters by Nicholas that cite the author of the murals as "the well-known decorative painter Duncanson,"[3] but the letters themselves have never been found. Despite this lack of contemporary documents, connoisseurship has consistently and firmly attributed the murals to the African-American artist.[4]

Longworth's patronage of Duncanson exceeded his commitment to other local artists, among them the neoclassical sculptor Hiram Powers and the painters T. Worthington Whittredge and Thomas Buchanan Read. Usually his support consisted of funds to send an artist east or to Europe to study. Although he did purchase the work of eastern and European artists for his collection, only on rare occasions did he purchase that of a Cincinnati artist. Thus, Longworth demonstrated great faith in Duncanson by entrusting the decoration of Belmont to him. If Longworth's abolitionist tendencies initially led him to support Duncanson's

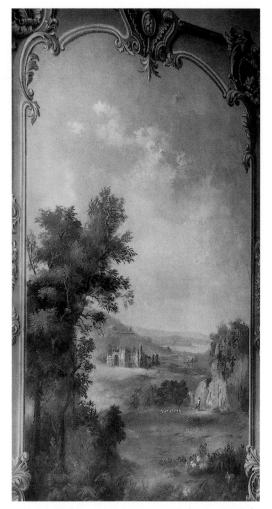

Fig. 29. Robert S. Duncanson, *Belmont Mural,*
cross hall, northeast wall, c. 1850–1852,
oil on plaster, 109¾″ × 77″. Bequest of Mr.
and Mrs. Charles Phelps Taft, The Taft
Museum, Cincinnati.

Fig. 30. Robert S. Duncanson, *Belmont Mural,*
cross hall, southeast wall, c. 1850–1852,
oil on plaster, 110⅛″ × 77⅝″. Bequest of Mr.
and Mrs. Charles Phelps Taft, The Taft
Museum, Cincinnati.

artistic efforts, after seeing the quality of
his work and experiencing the excited
enthusiasm with which Duncanson ap-
proached painting, the patron was
convinced of his artistic potential. In his
correspondence to Hiram Powers in
Italy, he often spoke about the arts in
Cincinnati and on several occasions
mentioned Duncanson. In one letter he
remarked, "One of our most promising
painters is a light mulatto by the name of

Duncanson. He is a man of great industry
and worth."[5] The wealthy patron obviously
believed the artist capable of this
monumental project.

The sequence of murals and overdoor
decorations is a well-orchestrated decorative
scheme. Idyllic landscapes of continental
scenery flank the entrance foyer. As
they progress down the front hall into the
cross hall, the scenes became increasingly
more rustic, picturesque, and reminiscent of

the Ohio River valley. Unlike many mural cycles, no obvious theme or narrative links the Belmont murals. Some panels allude to the "stream of life" or "voyage of life" theme, but it is not consistently conveyed throughout. Duncanson did not orchestrate the natural metaphors to depict the traditional allegorical theme of the cycle of nature or the seasons as did Cole in his *Voyage of Life*. Instead, the murals are arranged in a pictorial progression from classical pastoral landscapes to picturesque rural scenes. Perhaps this decorative scheme was intended to define the formality of the entrance hall with classical landscapes and separate it from the more informal domestic space of the cross hall with its rustic, rural scenes.

The views for the Belmont murals seem to reflect Longworth's appreciation for both European and regional landscapes. Often taking land in payment for his fees, as a young attorney he had amassed great tracts of real estate.[6] Although some of the murals may depict his lands or other sites in the Ohio River valley, none of the scenes are recognizable today. In addition, the sketches and studies for this project do not survive, making it difficult to identify the scenery and subjects in the murals. The landscape backdrop in Duncanson's later portrait of Longworth (Fig. 70), however, is clearly the slope of Mt. Adams with Longworth's vineyards, which would have been visible from Belmont, so it is certainly possible that the murals also represent some of his property.

The history of the Belmont murals is intricately intertwined with that of the house. Begun in 1820 for the original owner, Martin Baum, the grand federal style residence was purchased by Longworth in 1829 to house his growing family and estate.[7] At that time he wrote, "I have bought 'Belmont' which is large

enough to contain all the Longworth's in the nation."[8] Twenty years passed before Longworth commissioned the mural decorations to accompany his collection of paintings, sculptures, and decorative arts. The house served the family for almost two more decades. Following Longworth's death in 1863, Belmont was too large for the oldest son, Joseph, and his family.

By the time Joseph Longworth sold the house in 1869 to David Stinton, the murals were covered with wallpaper.[9] This ignominious fate befell the murals within the artist's own lifetime. Throughout the later nineteenth century, the murals were repeatedly covered with layers of patterned wallpaper and for almost sixty years were forgotten. Only in 1927, upon the donation of the estate to the city of Cincinnati, did Mrs. Charles Phelps Taft (David Stinton's daughter) mention that mural decorations, which she had never seen, were under the wallpaper in the entrance halls.[10] During the renovation of the building in 1931 (Fig. 31), the wallpaper was removed, unveiling this significant rediscovery in American art. The monumental murals were immediately recognized as the work of Duncanson.

Protected by varnish and several layers of wallpaper and paste, the landscape murals were in excellent condition. Repairing the landscapes required only minor inpainting to the skies in several panels (Fig. 32). Some of the other elements of the design did not endure as well. One floral vignette over the ballroom doorway had to be entirely repainted. Originally, three vignettes decorated a much larger doorway to the ballroom. Due to a structural change in the doorway, only portions of those vignettes remained when the wallpaper was removed (Figs. 33–34). Almost completely eradicated, the

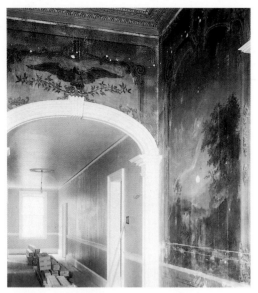

Fig. 31. The Charles Phelps Taft Home under renovation, c. 1930–1931, view of the cross hall looking north. Bequest of Mr. and Mrs. Charles Phelps Taft, The Taft Museum, Cincinnati.

flanking vignettes were covered with house paint during the restoration.

After restoration was completed in November 1932, the murals were revealed to the public and received with great enthusiasm.[11] In addition to their exceptional quality and scale, their decorative scheme is unprecedented in American painting. To fully appreciate the qualities of this monumental mural commission, one must consider the Belmont murals in relation not only to Duncanson's art but also to contemporary wallpaper decoration and domestic mural painting.

For the layout and decorative frames of the Belmont murals Duncanson creatively adapted his scheme from a combination of French and English wallpaper designs that were abundantly available in mid-nineteenth-century America.[12] Block-printed wallpaper designs of landscapes

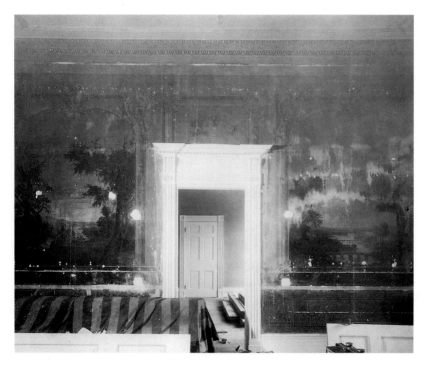

Fig. 32. The Charles Phelps Taft home under renovation, c. 1930–1931, view of slight damage to sky in two panels.

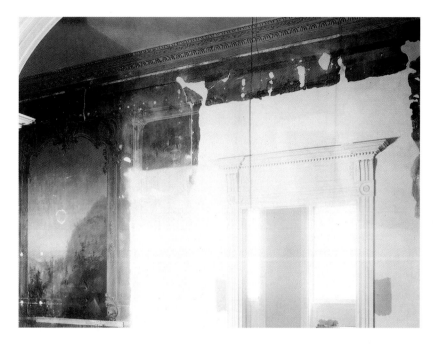

Fig. 33. The Charles Phelps Taft home under renovation, c. 1930–1931, wall to music room showing the old doorways covered up and evidence of three overdoor vignettes.

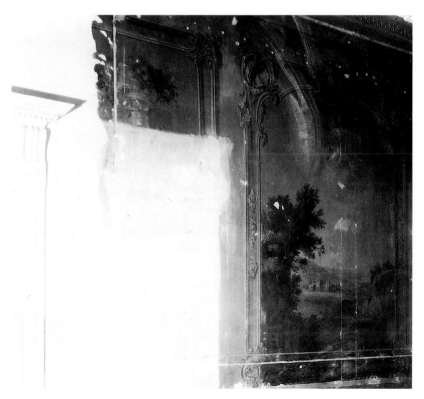

Fig. 34. The Charles Phelps Taft home under renovation, c. 1930–1931, wall to music room showing the old doorways covered up and evidence of three overdoor vignettes.

ordered with trompe
ry popular in the
derived the framing
from a pattern found in
Etie... ; book of wallpaper
designs from a.. ind 1850 (Fig. 35).[13] It is
obvious in photographs of the restoration
that a framed base, similar to that in
the wallpaper pattern, was originally used
below the wainscoting (Fig. 36).

English wallpapers had come into favor
in the United States in the late eighteenth
century.[14] The Stephan Van Rensselaer
house, formerly in Albany, New York (Fig.
37), was decorated with English wallpaper

demonstrating the use of landscape
vignettes around 1768. Duncanson em-
ployed a similar, but more tame, rococo
framing motif in the Belmont murals.
The English wallpaper vignettes were
printed in grisaille to present the illusion
of prints framed upon the wall. During
the middle of the eighteenth century,
it was popular to glue engraved prints on
the wall of a room and then add
wallpaper-pattern frames. This decoration
gave the appearance of a room of
framed prints and was the source of the
term *print room*.[15]

Only after 1800 did the French develop

Fig. 35. Etienne Delicourt, *Panel Set Wallpaper Designs,* c. 1850. Courtesy of the Cooper-Hewitt
Museum Library, Smithsonian Institution/Art Resource, New York.

the first full-color, continuous landscape views in imitation of mural paintings, and these immediately became the rage in wallpaper fashion. The most prevalent scenes were views of Italy and France; however, some views of America were also available.[16] The illusion created by the panoramic papers was one of a continuous, unframed space penetrating the wall. Duncanson's landscape murals, on the other hand, were bordered, stressing the verticality of the walls and mimicking framed paintings. This created the effect of a picture gallery with monumental landscape paintings elaborately framed. In this respect the Belmont murals are reminiscent of the English landscape vignettes in the Van Rensselaer home. From the evidence of the wallpaper samples that are preserved, however, Duncanson did not use any specific pattern as an exact source for his murals. He

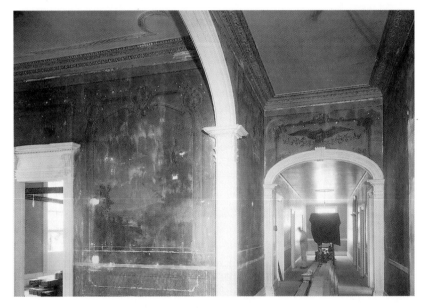

Fig. 36. The Charles Phelphs Taft home under renovation, c. 1930–1931, an entrance hall mural with pentimenti of previous borders below the wainscoting.

Fig. 37. Entry hall from the Van Rensselaer Manor house, Albany, New York, 1765–1769. The Metropolitan Museum of Art, gift of Mrs. William Bayard Van Rensselaer, in memory of her husband, 1928.

imaginatively created his own landscape compositions based upon his aesthetic interests and those of his patron.

The floral bouquets over the doorways are more closely identified with specific French wallpaper styles (Fig. 38). Bouquets by designers such as Jean Zuber were intended to be incorporated into framed vertical wall panels. In American households this French wallpaper design was often used for overmantels or to decorate fireboards.[17] One French design used on an American fireboard at Old Sturbridge Village, Massachusetts, from around 1800 provides the general prototype for the floral vignettes in the Belmont mural scheme (Fig. 39). This floral bouquet style is also found in the designs of early American domestic mural painters. Rarely was it used over entrances and doors as in the Belmont murals.[18]

For a brief period just prior to the mural commission, Duncanson painted still-lifes. Only seven are extant, earning him a reputation for his "fruit and fancy pictures" of 1849 and 1850 (Figs. 40–41). The artist exhibited still-life paintings in 1849 at both the Western Art Union and the Michigan State Fair, where he won a premium. In addition, he gained his only entry to the American Art Union in 1850 with a fruit still-life. The local press appreciated the artist's work in this genre: "The paintings of fruit, etc., by Duncanson, are beautiful, and as they deserve, have elicited universal admiration."[19] However, none of the artist's easel paintings are stylistically related to the Belmont floral vignettes. His pyramidal arrangements of fruit on a tabletop are formally tied to the American tradition of still-life easel painting, while the floral vignettes were designed from wallpaper patterns and painted in the style of interior decorations.

Duncanson created the landscape murals in the tradition of his former trade as a housepainter and decorator. Advertising themselves as painters and glaziers, these tradesmen were capable of painting a house, interior and exterior, and decorating it with murals, wood graining, and numerous finishes, including imitations of wallpaper.[20] Like Duncanson, most of these artisans had no fine arts training. Therefore, the execution of these works was usually crude and primitive. Although Duncanson's murals for Longworth formally derive from this tradition, they are much more accomplished, exhibit a greater sensitivity to landscape painting

Fig. 38. Overdoor Floral Vignette, *Belmont Murals,* c. 1850–1852, oil on plaster, 30⅛″ × 59¼″. Bequest of Mr. and Mrs. Charles Phelps Taft, The Taft Museum, Cincinnati.

aesthetics, and provide multiple levels of illusion that are absent from typical interior mural paintings.

Apprenticed in his youth as a painter and glazier, Duncanson was trained to execute interior decorations and wallpaper fashions and knew how to approach the Belmont project. Housepainters usually worked in teams and, for a project of this scale, Duncanson no doubt had assistants to help him. His letters to his friend and fellow artist Junius Sloan imply that Sloan wintered with the artist between 1850 and 1851, and Sloan may have served as an assistant on the murals.[21]

Although none of Sloan's surviving works resemble the murals, his hand would not necessarily be evident. Assistants in a decorative project often carried supplies, prepared the pigments, and painted only the main highlights, shadows, and perhaps the frames. Duncanson, as the principal artist on the project, would have drawn the designs and painted the majority of the landscapes and detail work. The assistants—who might have included the artist's brothers, who were in

the decorating business in Monroe, his understudy Sloan, or even his earlier partner John Gamblin—may have copied a pattern for the floral vignettes and frames, which would account for some of the detectable differences in paint handling between the vignettes and the landscape murals.

The murals were rendered in a technique common among domestic decorators. They were drawn directly onto the dry plaster wall after it had been sealed with a primer, probably lead white. The artist then painted in the landscapes over his sketches, working from the dark to the light areas, building up the paint from thin grounds to thicker details and highlights. Each layer of paint required drying time, depending on its thickness. This is basically the same technique that Duncanson used in easel painting, except on a much larger scale.

Painting eleven panels in this technique would require a great investment of time, despite the fact that the artist was described in several contemporary accounts as a quick painter. One British reviewer remarked, "He is one of the most

Fig. 39. French Floral Wallpaper on an American Fireboard, c. 1800. Old Sturbridge Village, Massachusetts.

rapid painters I have met with; his largest works have been begun and finished in ten days, perhaps not at work on them only, but on others during the same time."[22] For obvious reasons, it was an asset for house decorators to work very quickly. One itinerant housepainter claimed that he could "paint the entire walls of a parlor, with all of the several distances, and a variety of fancy scenery . . . and, a beautiful set of shade trees on the foreground, and finish the same complete in less than five hours."[23] This was certainly an exaggeration, or the artisan was a very sloppy painter.

A mural project of this complexity would have taken the artist many months to complete even with assistants. A landscape painter usually followed the seasons in his work, sketching during the summer and painting in the studio through the fall and winter. It is documented that Duncanson was on sketching tours during the summers of 1850, 1851, and 1852. Considering the scale of the project and his sketching schedule, it is logical to assume that the Belmont murals were probably painted over several winter seasons. Although the Belmont murals are not firmly dated, stylistic comparisons with the artist's easel paintings suggest that the mural commission was executed between 1850 and 1852.

The exceptions to this dating are the two eagle vignettes above the arched doorways in the transverse hall, which appear to be the earliest work on the murals (Fig. 42). Their style is completely different from that of Duncanson's easel paintings, such as *Vulture and Its Prey* (1844, Fig. 3). The artist's early painting of a vulture displays a primitive understanding of the eagle's anatomy that is similar to the vignettes. But the dynamic conception and brushwork in the vulture are absent from the vignettes and express an entirely different artistic temperament. In addition, the frames, the plain tan background, and the flattened volume of the eagles in the vignettes do not resemble the other panels in the mural decoration. This suggests that the eagle vignettes are not by the same hand and were not part of the same commission. Most likely, another artist or interior decorator painted these vignettes at

Fig. 40. Robert S. Duncanson, *Fruit Still Life,* 1849, oil on canvas, 13½″ × 18½″. Corcoran Gallery of Art, museum purchase, Washington, D.C.

a much earlier date as part of an independent decorative scheme in the cross halls, and it was not until later that Longworth decided to expand the mural decorations into the hallways.[24]

Comparing Duncanson's easel paintings to his mural paintings provides evidence for the sequence in which he may have executed the murals. As previously discussed, Duncanson experienced a dramatic artistic development under the guidance of Sonntag, and this progression is evident at Belmont. Generally, the murals in the transverse hall recall his work of the late 1840s, while the work in the entrance hall looks forward to his more mature paintings of the 1850s. The entrance hall murals are more accomplished in draftsmanship, paint handling, and composition, displaying the artist's increased

Fig. 41. Robert S. Duncanson, *Still Life,* 1849, oil on canvas, 16″ × 20″. Los Angeles County Museum of Art, gift of Mr. and Mrs. Robert B. Honeyman, Jr.

Fig. 42. Eagle Vignette, *Belmont Murals,* cross hall, oil on plaster, 33″ × 80⅜″. Bequest of Mr. and Mrs. Charles Phelps Taft, The Taft Museum, Cincinnati.

understanding of painting techniques acquired under Sonntag in the early 1850s.

Duncanson appears to have started the mural commission on the northeast side of the cross hall. The dramatic cliffside in this mural dwarfs the two men in the middle ground who gaze across an abyss to a high waterfall (Fig. 29). The tepee in the foreground introduces a wilderness scene more remote than in any of the other murals. This is the weakest panel in the mural scheme, which argues that it must be the earliest of the eight. The drawing of the figures and the handling of the foliated hillside betray this mural as one of the artist's less accomplished early works. The trees here are treated in the same manner as those in *Carp River, Lake Superior* (Fig. 17), painted in the summer of 1850, further suggesting that the artist may have begun the mural commission in the fall or winter of 1850.

Across the hall a cabin with a family at the door is nestled into a midwestern landscape (Fig. 43). In the distance is a group of buildings reminiscent of the warehouses one would find on the Cincinnati riverfront at that time. The family at the cottage door recalls the cabin scenes that dominated the series of *Seasons* from 1849 (Figs. 15–16). This picturesque mural also harks back to his 1845 genre subject, *Drunkard's Plight* (Fig. 7). Although the easel painting is melodramatic in its moralizing subject, the composition and subject link the two works. The trees and the cabin in the mural are much more convincingly rendered than those in the earlier easel paintings, implying that the panel was painted at a later date. This panel also demonstrates the artist's awareness of the English picturesque landscape painting tradition. The subject of a cottage nestled in the woods was popularized by

Thomas Gainsborough, whose *Cottage Door* pictures of the 1780s (Fig. 44) were engraved and widely distributed in mid-nineteenth-century America through prints and books. Duncanson was probably familiar with prints after Gainsborough's work and could have used the British artist's example as a general prototype for his treatment of the rustic cabin embraced by curving, picturesque trees.[25]

The theme of the pioneer's cabin in the woods appeared frequently in Duncanson's work and was an important motif in his image of the picturesque-pastoral American landscape. Throughout his career the settler's homestead represented the painter's ideal of man's peaceful coexistence with nature. This subject is the focus of several early landscapes including *The Catch / The Farmer's Apprentice* (1848, Fig. 13) and *Summer* and *Winter* and is most fully developed later in *The Rainbow* (1859, Plate 10). In these works the artist portrays a settler and his family enjoying the bounty of nature in the American frontier. The rural family in the mural is depicted casually conversing at the door of the cabin comfortably nestled into the trees at the edge of a wood. Life for them is carefree, without a hint of the labor or hardships that the typical pioneering family actually confronted in the wilderness. The theme of Duncanson's cabin mural recalls Cole's late works—such as in *Home in the Woods* (1847, Fig. 45)—in which American settlers reap the benefits of a tamed, domesticated wilderness.[26] Duncanson's imagery in the cabin mural can also be read as conveying his aspiration for a carefree existence for African-Americans in an arcadian natural paradise.

In the main entrance hall, three of the four landscape murals have a distinctively pastoral mood inspired by European

Fig. 43. Robert S. Duncanson, *Belmont Murals,* cross hall, northwest wall, c. 1850–1852, oil on plaster, 110″ × 77″. Bequest of Mr. and Mrs. Charles Phelps Taft, The Taft Museum, Cincinnati.

classical landscape painting. Whereas the
transverse hall murals are picturesque
rural scenes, the entrance hall murals shine
with the golden light of classical landscape
painting. The change in aesthetic sensibility
from the picturesque to the beautiful is
characterized by the differences between the
southwest mural in the cross hall and
the northeast panel in the entrance hall
(Figs. 46–47). Although in composition
these two murals are remarkably similar—
both show a river flowing from the
distance into the foreground, flanked by
balancing masses of trees—slight differences
in the handling of the trees, rocks, and

river change the entire mood of the
paintings.

The transverse hall panel (Fig. 46) is a
rocky riverscape that is unique among
the murals because it is devoid of references
to man. The focus of the composition is
the swiftly flowing river. Surging forth
from the distance, the river winds into the
foreground where it cascades into a
hidden ravine, only to reappear pouring
into the spectator's space. It breaks
the foreground plane and places the viewer
precariously in the middle of the rapids.
The haggard framing trees, cascading fall,
and rotting trunks present a forceful

Fig. 44. Thomas Gainsborough, *The Cottage Door*, c. 1780, oil on canvas, 48¼″ × 58¾″. The
Cincinnati Art Museum, given in honor of Mr. and Mrs. Charles F. Williams by their children.

image of a torrent in the wilderness. This mural panel is undoubtedly the most accomplished of those in the transverse hall.

In composition, the northeast entrance hall mural (Fig. 47) strikingly presents a tamer variation of this transverse hall scene. This suggests a possible sequence in the execution of the murals from the transverse hall to the entrance hall. A torrent in the previous design, the river in the entrance hall panel gently flows into the foreground and safely off to the left. Two trees with verdant foliage frame a view of buildings nestled in the rolling hillside. The rocky riverbank is accessible, and the mood is one of a harmonious natural reverie. The golden light emanating from the horizon bathes the scene with the idyllic glow of a classical landscape. Although the compo-

sition is almost the same as that of the mural in the transverse hall, the landscape motifs were idealized and the artist created a pastoral scene that echoes the mood of the other panels in the entrance hall.

The two murals flanking the main entrance of Belmont are directly inspired by the example of classical landscape painting. On the north side (Fig. 48), a grand estate is the focus of the painting and the stage for an anecdotal figure group boarding a boat. Tall stately trees anchor the left side of the panel, while a river winds into the luminous distance on the right. The buildings and arched bridge are purely fantastic and originate in the harbor scenes of J. M. W. Turner and Claude Lorrain. The mural's balanced composition, bathed in serene light,

Fig. 45. Thomas Cole, *Home in the Woods,* 1847, oil on canvas, 44″×66″. Reynolda House, Inc., Winston-Salem, North Carolina.

Fig. 47. Robert S. Duncanson, *Belmont Murals,* entrance hall, northeast wall, c. 1850–1852, oil on plaster, 108¾″ × 87¾″. Bequest of Mr. and Mrs. Charles Phelps Taft, The Taft Museum, Cincinnati.

Fig. 46. Robert S. Duncanson, *Belmont Murals,* cross hall, southwest wall, c. 1850–1852, oil on plaster, 110¼″ × 86¼″. Bequest of Mr. and Mrs. Charles Phelps Taft, The Taft Museum, Cincinnati.

falls into the classical tradition of landscape painting established by Claude in the seventeenth century and carried into the nineteenth century by Turner. The fantastic architecture and voyagers embarking reappear in Duncanson's work of the 1860s in his *Vale of Kashmir* series (1864, Plate 14), under the guise of an oriental romance. The motifs of boaters embarking, disembarking, or crossing a river are central in Duncanson's imaginary paradisiacal landscapes; as Lubin has theorized, they may signify the African-American artist's metaphor for the passage to freedom.

 The opposite mural flanking the front

entrance displays the greatest influence from the European masters of the classical landscape (Fig. 49). The perfectly balanced composition features a group of horse riders crossing a river that winds through a scene of idyllic serenity. On the riverbank in the middle ground the viewer witnesses a baptism that serves to anoint the spiritual serenity of the scene. The gentle zigzag flow of the river into the luminous horizon, the arched bridges, and the framing tree groups are typical of the classical landscape tradition. The artist was aware of classical prototypes for these compositions through the many printed volumes of masterworks circulated among artists. In this case, Turner's *Bridge in the Middle Distance* from the *Liber Studiorum* could have served as a source,

Fig. 48. Robert S. Duncanson, *Belmont Murals,* entrance hall, northwest wall, c. 1850–1852, oil on plaster, 109″ × 91¾″. Bequest of Mr. and Mrs. Charles Phelps Taft, the Taft Museum, Cincinnati.

Fig. 49. Robert S. Duncanson, *Belmont Murals,* entrance hall, southwest wall, c. 1850–1852, oil on plaster, 108″ × 87″. Bequest of Mr. and Mrs. Charles Phelps Taft, The Taft Museum, Cincinnati.

as could several other compositions in that portfolio. The *Liber Studiorum* was popularly studied by American artists as a compendium of landscape compositions, and Duncanson would have been familiar with it.

The fourth landscape and final panel in the entrance hall is the climax of the Belmont decorations and the most distinctive of the murals (Plate 5). Instead of the continental scenery of the other three entrance hall murals, this panel depicts an American wilderness with a swiftly flowing river framed by twisting tree trunks. The writhing trees arch over a group of pioneers who rest on a rocky prominence, witnessing the splendor of nature. The rich rose sunset crowns the horizon and endows the scene with an inspirational mood. Duncanson orchestrated the composition to crescendo into a powerful vision of providential blessing through nature. The pairs of trees at each side of the mural twist around each other in a natural dance and then rise up to form an arch that encircles the rich glow of divine presence on the wonders below. The bold hues of the sunset and the sensitive handling of the light set this panel apart from all the other murals. The artist's convincing rendering of the thick textures of the tree bark, the refined details of the foliage, and the sunset reveal a marked improvement in his paint handling from the earliest mural panel.

In this mural panel the artist discovered the expressive potential of weathered trees as a romantic landscape device. Gnarled, storm-blasted trees were familiar motifs in Hudson River School art, while their ultimate source was the tradition of English landscape painting. Intertwined tree trunks were described by the British aesthetician William Gilpin as a picturesque motif that endowed paintings with a lively pictorial effect and incited the imagination. Duncanson certainly knew Gilpin's texts through circulating periodicals, and his use of such trees in the mural panel demonstrates that he grasped their significance. These trees became an anchor for his picturesque views of the 1850s. In particular, the style and treatment in *The Shepherd Boy* (1852, Fig. 27) of the cascading river, framed by twisting trees, links the easel painting to the mural. The similarities in composition and technical details indicate that these paintings were created at about the same time and suggest a terminus date for the murals of around 1852.

The commission from Longworth had come at a crucial period in Duncanson's artistic development, challenging his abilities and forcing him creatively to combine his skills as a decorator and landscape painter. The Belmont murals are Duncanson's largest project and stand as the most ambitious and accomplished domestic mural paintings in antebellum America, combining the traditions of wallpaper fashions, domestic mural decoration, and the fine art of landscape painting. It was the success of this commission that led Longworth to support Duncanson on his first "grand tour" of Europe shortly after the completion of the mural scheme.

4

The Light of Europe

The "Grand Tour"

*B*eginning with the pioneering pilgrimage in 1768 of Benjamin West (1738–1820), American artists followed the long-honored tradition of making the "grand tour" of Europe to finish their art education. They believed that the European sojourn was necessary to their artistic fulfillment because it offered firsthand exposure to the European masters and provided a glimpse of the storied landscape of Europe. The land, particularly Italy, fascinated American landscapists with its historical associations that were absent from the virginal wilderness of the United States. The charms and culture of Europe were so compelling that many artists stayed, such as West, John Singleton Copley (1738–1815), and especially the neoclassical sculptors. For those who returned the experience of Europe refined their technical skills and chastened their artistic vision with the experience of the history of western culture.

Cincinnati artists followed the same tradition and sought the golden light of European skies, many never to return. Despite its importance as a commercial center, its stimulating artistic community, and its stable patronage, Cincinnati could not sustain a growing cultural network, forcing many artists to move east or to travel to Europe to further their careers. An article surveying the "Fine Arts in the West" in 1849 commented on the growth in the visual arts that had occurred in Cincinnati. However, it also lamented,

"The wealth of this section of the Union is not yet sufficient to bestow upon artists, much of what is popularly called 'patronage;' . . . This being so, not a few of them leave us, to seek better fortune elsewhere—some in the wealthier cities of the East, others in Europe."[1] This was certainly the case with Hiram Powers, who traveled to Italy in 1834 and remained there, and with Whittredge, who traveled to Europe in 1849 and only returned to America ten years later to settle in New York. Sonntag and Duncanson pursued a similar course, seeking the artistic inspiration and refinement that only Europe could offer.

By 1853 both Duncanson and Sonntag were widely regarded as the major landscape painters in the Midwest. With his Belmont murals and his first historical landscapes Duncanson had achieved a remarkable degree of artistic and critical success, especially for an African-American. The reputation of his mentor, Sonntag, had reached beyond Cincinnati to New York and Philadelphia, where he had begun exhibiting in 1851 and 1853 respectively, and where he was encouraged by steady patronage. Both artists had clearly climbed to the pinnacle of the Cincinnati cultural milieu and were ready to perfect their skills by studying in Europe. Their experiences on the continent sharpened their technique, expanded their range of subjects, and, most important, altered their conceptions of landscape painting. Accord-

ing to Duncanson this journey "shed a new light" on his vision of landscape painting.[2]

Following their European tours, Whittredge and Sonntag did not return to the Queen City. They remained in New York establishing studios and playing major roles in the emerging national school of landscape painting. Only Duncanson returned to settle in provincial Cincinnati. He felt a strong bond, even an obligation, to the city that had supported his early efforts. In one letter he noted that he "must not fag Cincinnati in the absence of Sonntag."[3] Furthermore, Duncanson was motivated to return because of the relative security he found among the large free colored population and the prevalent abolitionist patronage in Cincinnati.

Duncanson did not disappoint his Cincinnati patrons who were anxious to see the results of sponsoring their "most promising painter" on his grand tour. He was busily at work on his new Italian compositions when a local patron reported, "He gives extraordinary promise in these last pictures, and proves that he made good use of his eyes, in Italy, at least." The writer concluded his note disparagingly by expressing the abandonment commonly felt by Cincinnati artists and collectors: "Sontagg [sic], is still in N. York, and has not sent any of the results of his European studies out West."[4] Duncanson certainly realized the opportunity afforded to him when Sonntag did not return to Cincinnati. He eagerly accepted the role of the principal landscape painter in the Ohio River valley and, by the end of the decade, had achieved recognition as one of the finest landscape painters working in the western United States.

Duncanson was the first African-American artist to transcend the racial barriers of the art world and make

the traditional artistic pilgrimage to Europe.[5] This feat seemed remarkable to the mid-nineteenth-century audience that read accounts of the painter's tour in leading abolitionist journals. In July 1853 free persons of color met in Rochester, New York, to hold a "Colored Mens' Convention . . . for the purpose of considering their condition and devising ways and means for bettering it." Inaugurated with a rousing speech by Frederick Douglass, the conference began with delegates from different parts of the country reporting on the current conditions among free blacks in their area. After several sobering accounts on the social and economic status of free blacks in other parts of the country, the delegate from Cincinnati, John Mercer Langston, "sprang to the platform" to proudly proclaim the advances of free blacks in his city. Langston enumerated the successful employment of the free colored population of Cincinnati in the skilled trades, which was in marked contrast to the more desperate situation of free blacks in other areas of the country. In conclusion, he especially noted that Cincinnati had produced a black "artist in landscape painting, sent to Rome now for perfecting his education, and whose works, by the way, of very great merit, I saw when in Cincinnati, at their Art Union exhibition." One reporter at the convention found the accomplishments of Duncanson and his Cincinnati free colored compatriots admirable when considering that colored men had been "so long trodden underfoot, so badgered and pestered by all our society, so insulted and discouraged." In his eyes this "showed [African-Americans] to be gifted with every faculty that their Anglo-Saxon brother possesses."[6]

Sonntag and Duncanson left for Europe on April 26, 1853, in the company of

John Robinson Tait (1834–1909), another young Cincinnati landscape painter who had entered Sonntag's studio earlier that year as a student.[7] Due to his steady patronage, Sonntag was able to bear the burden of his own expenses. Duncanson, on the other hand, like Hiram Powers before him, received Longworth's sponsorship. Longworth wrote a letter of introduction for Duncanson to Powers in Florence: "This letter will be handed you, by Mr. Duncanson, a self taught artist of our City. He is a man of integrity, & gentlemanly deportment, and when you shall see the first landscape he shall paint in Italy, advise me of the name of the artist in Italy, that with the same experience can paint so fine a picture." The patron did not lavish undue praise upon the artist. He realized the painter's early stage of artistic development and concluded the letter by noting, "I believe Mr. Sonntag will accompany him. Mr. S. has a much larger practise, & is a very superior Landscape Painter, & of Honorable Character."[8] Nonetheless, Longworth had an acute eye for potential talent. In December 1853, when he had not heard from either Powers or the touring artists, he wrote asking, "Has [sic] our artists Sontag [sic] & Duncanson, yet visited your city. Sontag has had more practise & ranks highest. But I deem that Duncanson will leave him in the background."[9] This letter reflects the respect Longworth held for Duncanson as the promising landscape painter who had decorated his home, Belmont, and who would, as Longworth prophesied, eventually surpass his Caucasian colleague Sonntag.

The itinerary for the painters' European sojourn was one typically followed by many nineteenth-century artists. Landing in England, the artists spent the beginning of their tour studying the British landscape masters and visiting the museums and private collections of London. Duncanson was impressed with the British artists, stating, "I like the English Landscapes better than any in Erope [sic]." Here he also studied original paintings by the old masters in the great collection of Lord Ellsmere, which he considered "one of the finest in England." The works of Raphael, Michelangelo, and Guido Reni overwhelmed him with their mastery of design and drawing, his major technical weakness. The experience of seeing J. M. W. Turner's paintings left an indelible impression on the artist. After excitedly proclaiming the great works he discovered in England, Duncanson wrote that "last but not least" were "the landscapes of J. W. Turner. He was a Modern Phenomenon in the Art of Landscape. He was neither good nor bad, but singular, singular indeed—I could discribe [sic] to you his pictures by word of mouth, but not in black & white. Suffice it to say—he was a singular genios [sic]."[10] Upon seeing the brilliantly colorful and highly impastoed works of Turner for the first time, Duncanson, like most American artists who had known Turner only through prints and the descriptions of John Ruskin, was perplexed by their painterly bravura.

As did most artists on the grand tour, the painters took the overland route through France and the Swiss Alps to Italy, where they were to meet Powers in Florence. By August they were in Paris.[11] French art apparently did not make much of an impression on them, and they moved on to Italy within weeks. It was primarily the experience of Italy with its classical, Renaissance, and Baroque art and its landscape enriched by extensive historical associations that most excited the Cincinnati artists. They spent the remainder

of their trip there.

Upon their arrival in Florence, Sonntag and Duncanson apparently settled into the circle of American artists in Italy centered around Hiram Powers's studio.[12] Sonntag was so taken by Italy that he wanted to establish a residence in Florence and join the colony of American artists living there. For Duncanson, Italy was an artistic revelation: "Every day that brakes [sic], to my vision, sheds a new light over my path—what was once dark and misty is gradually becoming brighter. My trip to Europe has to some extent enabled me to judge of my own talent. Of all the Landscapes, I saw in Europe, (and I saw thousands) I do not feel discouraged."[13] Obviously, Duncanson suffered from no lack of self-esteem, and his months living in the American colony of artists in Italy bolstered his confidence.

By January 1854 the two artists were back in the United States, somewhat earlier than they had originally intended. While Sonntag remained in New York, Duncanson returned home to Cincinnati. Apparently he left Europe disappointed with the work of his colleagues. He confessed, "Now I will let you know why I returned so soon. I was disgusted with our artist in Erope [sic]. They are mean Coppyest [sic] producing pictures . . . all I wanted was to see, and I have seen. Someday I will return."[14] He eventually did fulfill his desire to return to Europe, but only after he had achieved recognition in America and could return to Europe with what he thought would be his masterpiece, comparable to those he had seen on this tour.

Duncanson, like most nineteenth-century Americans, was deeply fascinated with the history, culture, and landscape of Italy. In this country, as in no other, one

could see the great monuments and witness the course of Western civilization. For Duncanson it was primarily the experience of the ancient ruins that excited his imagination. These crumbling ruins embraced by the landscape and overgrown with vines and moss carried symbolic overtones of time erasing the accomplishments of great civilizations. This didactic content appealed to American landscape painters who sought elevating subjects to enhance their works. Cole introduced the English romantic motif of ruins and established the style and metaphorical content of ruins imagery in the United States after his first grand tour between 1829 and 1832. By the mid-nineteenth century Italian ruins had become an important subject of American landscape painting. Drawing upon Cole's precedent, Duncanson conveyed a range of mainstream aesthetic, cultural, and social notions concerning Italy, as well as some ideas of Italy's significance that were particular to him as an African-American artist.[15]

When Duncanson returned from Italy, he was armed with numerous sketches that he was prepared to paint up into canvases. One of the "beautiful Italian 'compositions'"[16] that he painted from sketches in his studio was *Time's Temple* (1854, Fig. 50). The painting's large size indicates that the artist had great ambitions for it to summarize his experiences of Italian ruins. The brooding scene is dominated by the ancient temple ruins atop a massive wall in the foreground. The barren tree trunk at the left, draped with moss, further enhances the melancholy mood of the picture. A plateau separates the ruins from the lake in the middle ground that laps the shore of a distant town and leads to the curtain of mountains on the horizon. The thick, moist atmosphere suspends the scene in

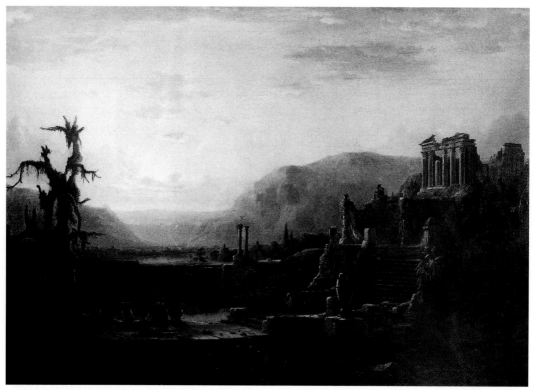

Fig. 50. Robert S. Duncanson, *Time's Temple,* 1854, oil on canvas, 34" × 59". Howard University Gallery of Art, Washington, D.C.

time, adding a touch of ideal serenity to the pervading fatalist mood. The painter bathed the scene with a golden glow that was typical of the classical Mediterranean landscape and a source of inspiration to artists in Italy since the time of Claude Lorrain.[17]

The crumbling ruins of a Greek temple covered with moss and ferns strikingly convey the romantic theme of the temporality of civilizations in the face of eternal nature. Even man's greatest creations are shown as meager works in comparison to the overwhelming power of nature. In this painting Duncanson followed in a tradition of depicting *memento mori* themes that stretches back to the landscapes of Claude and Nicholas Poussin in the seventeenth century, was popularized by the English in the

eighteenth century, and was introduced to America by Cole with *Aqueducts near Rome* (1832, Fig. 51) from his first grand tour of 1829–1832. Duncanson's *Time's Temple* is an imaginary composition that alludes to this romantic theme of temporality in its imagery and specifically refers to it in its title.

Time's Temple also alludes to a deeper level of meaning that reflects the idea prevalent among Americans that historical cycles governed the rise and decline of civilizations. The predominantly Protestant Americans drew parallels between the ruined monuments of ancient Rome and the fallen state of contemporary Italy, with a society that they believed was religiously, socially, and politically corrupt. The decline of the Roman empire was perceived to be a direct result of pagan

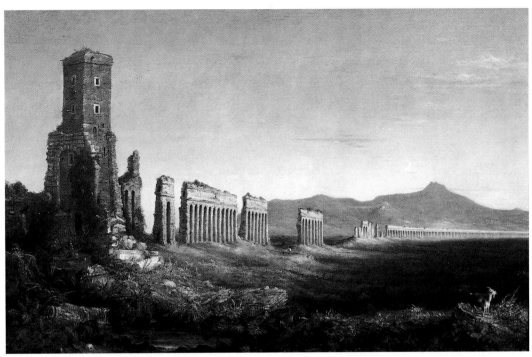

Fig. 51. Thomas Cole, *Aqueducts near Rome,* 1832, oil on canvas, 44½″ × 67½″. Washington University Gallery of Art, St. Louis, purchase, Bixby Fund, by exchange.

religious beliefs and an immoral life-style. Many Americans believed that they could avoid the historical cycle of growth, empire, and destruction that plagued earlier civilizations by pursuing a society based firmly in Protestant-Christian ethics and morals. Forging this new society in the primeval forests of God's creation, these Americans perceived themselves as the new "Adams" in the "Garden of Eden" with an opportunity to regain paradise.[18] By depicting the ruins of past pagan civilizations, artists were offering a warning to Americans that their society could suffer the same fate. Cole stated this important didactic message in his article on "Sicilian Scenery" from 1844: "Our only means of judging the future is the past. We see that nations have sprung from obscurity, risen to glory, and decayed. Their rise has in general been marked by virtue; their

decadence by vice, vanity, and licentious-ness. Let us beware."[19]

Time's Temple explicitly echoes this vital theme and at the same time conveys a particularly African-American perspective toward Italian ruins subjects. For Duncanson the ancient Romans were immoral not only because of their pagan religious beliefs, but also because they possessed slaves. In the course of expanding their vast empire the Romans enslaved their vanquished enemies and used their forced labor as the foundation for a luxurious life-style. Over the centuries of the Roman empire this led to the "vice, vanity, and licentiousness" that caused its decline and fall. In Time's Temple the African-American painter equated the fall of the Roman empire with the practice of slavery in the United States and offered a warning to Americans: "let us beware" of the evil of slavery, or the new nation

shall suffer the same fate.

Duncanson worked on *Time's Temple* through most of April and May; when it was publicly exhibited in June 1854, the local critics praised the artist's sensitive rendering of an elevated subject. One writer ecstatically proclaimed that *Time's Temple* "will perpetuate the name of the enthusiastic artist though he should never again take up the brush." Another reviewer insightfully noticed the improvement in the artist's technical abilities: "The light which the artist has succeeded in throwing on his pictures is most beautiful; this and the fine aerial and linear perspectives of the piece, stamp the whole as the best work of Mr. Duncanson."[20] More significant than his advances in composition, draftsmanship, and paint handling, Duncanson daringly ventured a classical landscape and successfully carried off a major romantic theme of the era.

Previously, this painting had been known as *Recollections of Italy;* however, the description found in a contemporary review of *Time's Temple* leaves no doubt that this is the same painting.

> *Time's Temple* is the name given to the picture. In the foreground are the very ancient ruins of a vast temple with imposing Corinthian columns, the approach is by massive steps, and the brave promise of the entranceway is well fulfilled by the colossal structure on the eminence above. On the second level—divided from the first by massive stone work, into which the tooth of time has deeply eaten, is a lake, in the shoreward waters of which are seen the shadows of an old city.[21]

The earlier title for this painting might have come from a confusion with a much smaller painting that was exhibited in Canada at the Art Association of Montreal in 1864 under the title *Recollections of Italy* (1864, Plate 16).

Encouraged by the success of *Time's Temple*, Duncanson steadily produced ideal historical subjects and European landscapes over the following two years. In the summer and fall of 1854 he painted a series of four works that he called *Eternity*, the *Tuscan Flower Girl*, *Pompeii*, and the *Rhine*.[22] None of these paintings survives, with the possible exception of *Pompeii*, which may be the painting of that name in the National Museum of American Art collection (Fig. 52). This may be the painting that was favorably reviewed in the fall of 1854 when it was displayed at a local frame and mirror shop. The review focuses on a view of the "Forum of Pompeii" where "in the background is seen the smoking cone of Vesuvius, at the foot the clear bosom of the Mediterranean."[23] The reviewer considered the painting to have the quality of "imaginative beauty so prominent in the productions of that painter," indicating the degree of respect the artist had earned in Cincinnati with the paintings resulting from his grand tour.

Ironically, although critics held Duncanson's work in high regard, little patronage was forthcoming. During his pilgrimage to Europe the Art Union had folded; upon his return, he bemoaned, "The Fine Arts are at a low ebb here at present." However, the favorable responses to his work bolstered his confidence, and his artistic ambitions continued to grow. He was even more determined to create an ambitious historical painting: "I have made up my mind to paint a great picture, even if I fail." He labored diligently over this task, and in the fall he noted, "I have a great deal of work to do and my friends say I am improving."[24] Based upon his experience in Europe, Duncanson was confident that he could create a historical landscape with a

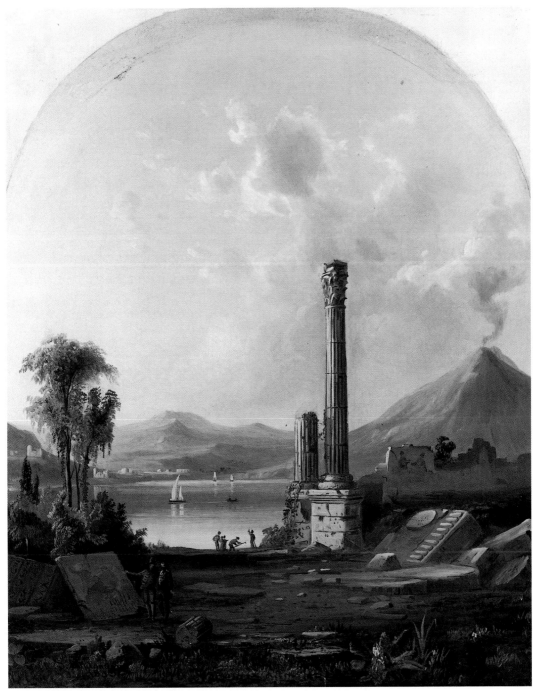

Fig. 52. Robert S. Duncanson, *Pompeii,* 1855, oil on canvas, 21″ × 17″. National Museum of American Art, Smithsonian Institution, Washington, D.C., gift of Richard Frates.

Fig. 53. Robert S. Duncanson, *Christian and Hopeful in the Land of Bula*, 1854, pen on paper, 2″ × 3¼″. Platt R. Spencer Papers, Newberry Library, Chicago.

significant didactic message. Despite the daunting odds against his success in this endeavor, he envisioned himself in competition with the European and American masters to make a great artistic statement. He had been considering the subject for his "great picture" since his return from Europe, and finally in the summer of 1854 he decided upon John Bunyan's immensely popular book *Pilgrim's Progress*.

Duncanson envisioned a huge, four-by-six-foot painting depicting the Celestial City protected by guardian angels as seen by Bunyan's protagonists Christian and Hopeful. In September 1854 he produced a small study for the painting, the only drawing extant from his hand (Fig. 53), outlining his ideas. The subject may have been suggested by a panorama of Bunyan's *Pilgrim's Progress* that the painter could have seen in Detroit in February 1853 while exhibiting at the Fireman's Hall before his trip to Europe.[25] The literary subject of Bunyan's *Pilgrim's Progress* was one that Cole had treated in his last, and largest, series, *The Cross and the World* (1846–1847, Albany Institute of Art, New York). *The Cross and the World*

remained unfinished at Cole's death and had been exhibited to great fanfare at his Memorial Exhibition at the American Art Union in 1848. Duncanson would have known about the series from the *Art Union Bulletin;* however, it is unlikely that he saw the paintings.[26] Cole's *Voyage of Life: Youth* (1842, Fig. 54), which Duncanson knew well, was a more direct compositional prototype. The artist certainly saw this series of allegorical paintings while it was on display at the Ladies' Gallery in Independence Hall in the fall of 1854 before entering a local private collection.[27] As in his other historical subjects, Duncanson emulated Cole's allegorical landscapes in creating his vision of winged angels guiding spiritual travelers toward an ideal city suspended in the clouds.

Duncanson did not realize this painting for two years. In the intervening time, while working out the problems of his major allegorical subject, he painted a number of European landscapes, including *Italianate Landscape* (1855, Fig. 55) and *Remembrance of a Scene near Auerbach* (1856, Fig. 56). Then, for three months in the summer of 1856 he concentrated

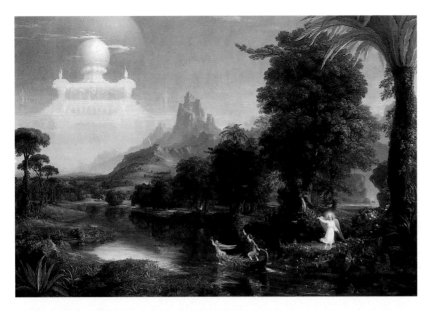

Fig. 54. Thomas Cole, *The Voyage of Life: Youth,* 1842, oil on canvas, 52⅞″ × 76¾″. National Gallery of Art, Washington, D.C., Alisa Mellon Bruce Fund, 1971.

Fig. 55. Robert S. Duncanson, *Italianate Landscape,* 1855, oil on canvas, 26½″ × 36¼″. California Afro-American Museum, Los Angeles.

exclusively on his "great painting." In September, he had finally completed *Land of Beulah* (location unknown) and placed it on public exhibition. The press proudly heralded the artist's accomplishment, claiming that it "far surpasses all his former efforts, brilliantly successful as some of them were."[28] Unfortunately, the

painting does not survive. Only the 1854 sketch suggests its appearance.

Duncanson's ambitious purpose and the critics' heady response to *Land of Beulah* indicate that it must have been an important landmark in the artist's development of historical landscapes. Drawn from Bunyan's description of the search by

Fig. 56. Robert S. Duncanson, *Remembrance of a Scene near Auerbach,* 1856, oil on canvas, 13½" × 18". National Museum of American Art, Smithsonian Institution, Washington, D.C., gift of Dr. and Mrs. Richard Wong.

Christian and Hopeful for the celestial city on their spiritual pilgrimage, the subject has obvious religious metaphors concerning the spiritual journey of life. In addition to the religious subject, the African-American artist was also representing the promised land of slave songs, free from the realities of existence in antebellum America. In terms of its visionary subject, *Land of Beulah* is remarkably similar to *Uncle Tom and Little Eva* (1853, Plate 7), in which Eva points to the heaven and proclaims, "I'm goin' there before long." Duncanson's *Land of Beulah* depicted the artist's conception of a heaven and made another contribution to his growing body of art revolving around themes of paradise.

After producing a series of American landscape scenes, Duncanson returned to the subject of Italian ruins later in the decade. He realized that a "great picture," in the academic sense, must contain an elevated historical or literary subject. In response to contemporary events he produced an ambitious Italian ruins landscape in the summer of 1859, *The Temple of the Sibyl* (Fig. 57). Purely imaginary in conception, the canvas focuses on the ancient Roman Temple of the Sibyl, which the artist has removed from its actual setting and placed in an arcadian midwestern landscape. The painting was grand in size and conception, and complete with romantic overtones and pastoral sentiments. But the artist was too far removed from his studies of Italy to create an entirely convincing work.

Fig. 57. Robert S. Duncanson, *The Temple of the Sibyl,* 1859, oil on canvas, 36″ × 60″. Formerly the Reverend Andrew H. Newman, Bellbrook, Ohio.

The foreground and background appear to be two different worlds—one Italy; the other the rural Ohio River valley—divided by an ancient wall. The local press appreciated the work but also noticed its inconsistencies: "The foreground is a little defective we think, but the rest of the painting is very fine and redolent of poetic conceptions." It is interesting that this reviewer found the picture lacking in the foreground, while another review in the same paper, on the same day, on the same page, expressed the opposite opinion. The second reviewer also liked *The Temple of the Sibyl*, saying it was "the best picture that this promising artist has painted." But, this author thought, "The second ground, and distance, are but feebly portrayed, and the leap from the first to the second ground is altogether too abrupt."[29]

Although the painting is visually awkward, perhaps Duncanson deliberately created a formal disparity between the foreground and background to convey a metaphorical meaning. He may well have been contrasting and comparing the ruins of the Roman empire with the Ohio landscape and offering a warning to Americans on the fate of decadent civilizations. Duncanson painted *Temple of the Sibyl* in 1859, after four years of painting American scenery and just prior to the outbreak of the Civil War. Emotions ran high at this time in the United States regarding states' rights and the expansion of slavery into newly annexed states. In his treatment of the ruins subject with its undertones of the slavery question, Duncanson prophesied the

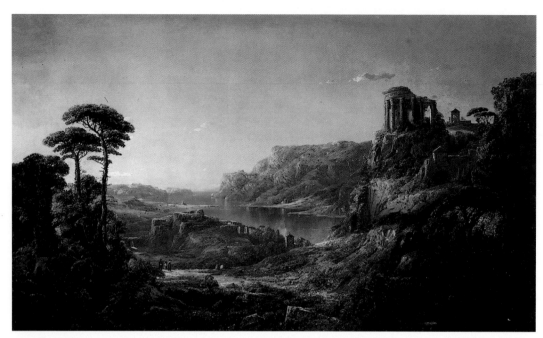

Fig. 58. William L. Sonntag, *Italian Lake with Classical Ruins*, 1858, oil on canvas, 35¾″ × 60″. Hood Museum of Art, Dartmouth College, Hanover, New Hampshire, gift of Annie B. Dore.

fate of the young nation about to embark on a long and bloody civil conflict.

Despite the critics' disagreement on the faults of the painting, both reviewers recognized that the profound moral content was the important aspect of *The Temple of the Sibyl*. In their eyes the historical subject reflecting on the demise of civilizations elevated the work above its "minor faults." The artist conveyed vital moral lessons through natural metaphors in keeping with an aesthetic dictum of the era. In his "Letters on Landscape Painting," published in William J. Stillman's popular art magazine *The Crayon*, Asher Durand promulgated this aesthetic creed when he stated that imitation is the "meanest purpose the artist can devote himself to, and is, in fact, no legitimate object of his labors. The province of painting, then, is not to imitate, but to suggest—not to reproduce, but to represent to the mind, or appeal to

the moral faculties—and in proportion as Art tends to the imitative, it is base though excellent, and as it aspires to the intellectual, and thence to the moral, it is noble."[30]

Although Duncanson had developed independently from Sonntag since their return from Europe, the African-American continued to turn to his former colleague for inspiration. *The Temple of the Sibyl* was drawn directly after Sonntag's most ambitious historical painting, *Italian Lake with Classical Ruins* (1858, Fig. 58), then known as *Dream of Italy*. Sonntag was in the habit of traveling to Cincinnati periodically between 1857 and 1860, and on one of these trips Duncanson learned about his large *Dream of Italy*. Duncanson certainly knew the 1858 version of the painting before creating his own, which is a close variation. Duncanson exhibited his composition in Cincinnati during June 1859, five months before

Sonntag unveiled his second version of *Dream of Italy* (1859, Corcoran Gallery of Art) to the New York public. The paintings by both artists focus on a circular temple and a balancing tree group linked by a line of ancient arched bridges. Although Sonntag was at the height of his popularity in New York, his *Dream of Italy* received mixed reviews when it was exhibited at the Düsseldorf Gallery, while Duncanson's painting earned accolades from the mid-American public.[31]

Unable to sell *The Temple of the Sibyl* in Cincinnati, Duncanson was prompted by the success of his previous historical paintings to tour this painting. He waited a year before traveling in September 1860 to Detroit, where the painting was placed on exhibition in a local shop and received rave reviews from the local press. The Detroit audience felt that it was "one of the most beautiful landscape paintings that has been exhibited in Detroit." The local critics pleaded, "Our amateurs should never permit this picture to leave Detroit."[32] Indeed, the picture was purchased by a local collector, John Hosmer, and prized as a major painting in exhibitions there throughout the nineteenth century.

Duncanson's pilgrimage to Europe on his grand tour was a significant event in the history of African-American art. The young Cincinnati painter became the first artist of African descent in the United States to tour Europe to finish his art education. As he traveled with Sonntag, Duncanson's experience of Europe "shed a new light" on his conception of art and his stature in the white European-American art world. After comparing his productions with those of his predecessors and of his contemporaries, Duncanson was supremely confident in his abilities. The tour encouraged his artistic ambitions and inspired him to create a "great picture" and return to Europe to rival the historical masters of art.

The paintings that Duncanson created after his trip to Italy characterize his personal conception of a "great picture" with an elevated moral message. His Italian views resonate with romantic metaphors that illuminate the complex mainstream American attitudes toward ancient Italy and the cycle of civilizations. These ideas were immediately recognized, appreciated, and praised by his white American audience. Furthermore, these paintings represent Duncanson's distinctive African-American perspective on ruins imagery representing the ultimate demise of slaveholding civilizations. In paintings such as *Time's Temple*, Duncanson warned Americans about the fate of immoral empires that practice human bondage. Later in the decade he returned to ruins imagery with *Temple of the Sibyl* to provide a profound prophesy of the ruin facing the United States if it could not resolve its pressing slavery question.

5

"The best landscape painter in the West"

*D*uncanson's "great pictures" of Italian ruins and literary subjects satisfied the Cincinnati art community's high expectations for him following his pioneering tour of Europe. After two years of painting European scenery, the African-American artist returned to romantic views of the Ohio River valley landscape, and by the end of the 1850s critics hailed him as "the best landscape painter in the West."[1] The aesthetic creed guiding his artistic pursuits during this period was found in a quote tacked upon the wall of his Cincinnati studio: "The mere imitation of the form and colors of nature is not art, however perfect the resemblance. True art is the development of the sentiments and principles of the human soul— natural objects being the medium of illustration."[2]

Although its source is not noted, the quote recalls Sir Joshua Reynolds's *Discourses* on truth and beauty in art and John Ruskin's theories published in his seminal book *Modern Painters*. The emphasis on conveying content, ideal beauty, and the spirit of nature appeared in several of Reynolds's *Discourses*. Duncanson probably read Reynolds, and the volumes may have been a source of inspiration for him; however, in the mid-nineteenth century Ruskin's ideas dominated critical artistic thought. Prior to the American publication of his book in 1860, Ruskin's ideas were promulgated in *The Crayon*. In fact, Asher Durand's "Letters on Landscape Painting" reflect Ruskin's proclamation that artists must study nature directly and through constant study develop the ability to distill "truth" from nature and endow natural beauty with the "sentiments and principles of the human soul."[3] Whether he became acquainted with them through the writings of Durand or others, Duncanson reflected Ruskin's ideas on "truth" and "sentiment" in his desire to create moods and meanings in his art. However, his work also harked back to the earlier academic ideas expressed by Reynolds and embodied in the work of Cole, who recommended elevating the natural beauties of nature with historical subjects and historical associations to the European landscape and its art traditions.

For several years following his tour of Europe, Duncanson was full of fresh ideas and worked excitedly to produce subjects inspired by his expanded awareness of history and the grand tradition. As the memory of the European experience faded in the late 1850s, he turned increasingly to scenes of his familiar countryside. In pursuit of a reconciliation between the scenes of nature he found at hand and the elevated historical subjects suggested by contemporary critics, he painted American views that resonate with a poetic mood and sentiment. These paintings simultaneously express the refinement of his artistic ideals, demonstrate his sensitivity to the important aesthetic issues of the period, and reveal contemporary conceptions of nature.

By the end of the decade political concerns of the impending civil conflict

had come to dominate Duncanson's thoughts. The United States Congress could not resolve the issues of slavery and states' rights, and public opinion on these subjects reached a feverish pitch. As an African-American living on the border of slavery, Duncanson was consumed with the current political dilemma. In response, he returned to a historical subject and commented on the current civic strife with the creation of his most ambitious historical landscape, *Land of the Lotus Eaters* (1861, Plate 11). The painting offers a resolution of his interest in romantic literature and edenic imagery and a statement on his attitudes toward the slavery question.

Following his trip to Michigan in the fall of 1856 to tour *The Land of Beulah,* Duncanson went on a sketching trip through the South before returning in December to Cincinnati. Just before

Christmas, the press noted he was painting an autumnal scene of North Carolina.[4] This brief sketching tour across the mid-Atlantic states seems to have rekindled his affinity for the American wilderness, and over the next three years he created some of his finest paintings of the American landscape. In these works, such as *Flight of the Eagle* (Fig. 59), he further developed his range of sentiments with a variety of sublime landscapes and pastoral views that convey meanings relevant to the cultural issues of the period. These he hoped would demonstrate the diverse range of his aesthetic sensibilities and be well received by his patrons and critics.

The winter of 1856–1857 was among the most productive for Duncanson. From the time he returned to Cincinnati in December, the local press was enthusiastically heralding a new painting from

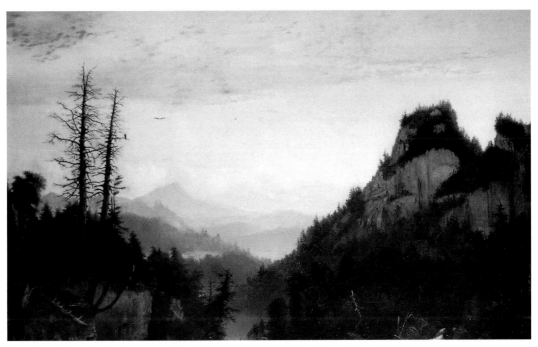

Fig. 59. Robert S. Duncanson, *Flight of the Eagle,* 1856, oil on canvas, 28″ × 44″. Dr. Walter O. Evans, Detroit.

his easel almost monthly.[5] In March, Duncanson unveiled to the public his most sublime view of the American wilderness, *Western Forest* (1857, Plate 9). Under a peaceful blue sky a gentle stream flows through a tortured landscape of writhing tree trunks and broken limbs—a serene moment following a violent tornado. Unlike Cole's *A Tornado* (1835, Corcoran Gallery of Art, Washington, D.C.), here one witnesses not the tornado itself, but the aftermath of its destruction. The gentle stream appears to be carrying healing waters through the wounded foreground, soothing the anguished trees that provide the expressive focus of the painting. The sublime gestural presence of the trees in the foreground is separated from the verdant background by the small rise in the middle ground. This compositional device formally divides the picture space, and it also separates the two contrasting moods of the painting, the sublime from the picturesque. This complex interweaving of composition and content marks *Western Forest* as one of the artist's most impressive achievements.

Western Forest represented the culmination of Duncanson's development of twisted, weathered, storm-blasted tree trunks as expressive romantic motifs. The landscape is completely devoid of the presence of man, and the trees, in fact, are the subject. Duncanson's conception of the trees is masterful, with their branches twisting like the limbs of tortured thespians dramatically acting out a role across the foreground stage. These motifs poignantly suggest the awe and respect the artist held for the powerful forces of nature and his complete absorption of expressive formal devices common to midcentury landscape painting. However, the sublimely gnarled and broken trunks are offset by the bucolic sky, stream, and pasture.

With the picturesque background and the "healing" waters, he simultaneously suggests the regenerative capabilities of nature. In effect, this painting portrays the cycle of birth, growth, and decay that is the course of nature. The contrast between the sublime foreground and the pastoral background also hints at the artist's troubled psyche, which would become increasingly evident in the next decade, leading to dementia and his eventual demise.

The painting was greeted with an especially enthusiastic response from the local critics. Following a visit to his studio one writer commented, "Duncanson has finished his *Scene in an American Forest,* which is said to be equal to any of his previous works." A few days later the same newspaper provided a full review and description of the painting, but mistakenly suggested that it represented the aftermath of a hurricane rather than a tornado: "Duncanson, the artist, has just finished a beautiful landscape, representing a forest after a hurricane, with its wrecks of trees and its streams, with the banks washed and broken by fierce torrents. . . . It is, however, to our apprehension, a striking and beautiful picture."[6] This succinct description could apply to no other painting by the artist from this period.

Western Forest brought Duncanson his first exposure to the international abolitionist community and was instrumental in spreading his reputation abroad. In April 1858 the expatriate American dramatic actress Charlotte Cushman was in Cincinnati for a theatrical engagement. While there, she saw an exhibition of Duncanson's pictures and was impressed with his accomplishments. She purchased *Western Forest* with the intention of presenting it to her friend the duchess of

Sutherland. The local art community was proud of its native son and proclaimed with understandable civic pride, "The *Western Forest* has been much admired by art-critics, and will be, no doubt, a most acceptable present to the lady for whom it is intended."[7]

Cushman was known to have antislavery sentiments, but her experience with Duncanson and his artistic accomplishments motivated her to actively assist young, struggling African-American artists. The actress was overwhelmed by the great artistic sensitivity demonstrated in Duncanson's complex *Western Forest,* and she wished to share her newfound awareness with her aristocratic acquaintances in England. In time, she became the most prominent patron and champion of African-American artists in the international art world. Subsequent to Duncanson, she assisted the sculptress Edmonia Lewis (1843–c. 1900) with her career in Italy, a relationship that is well documented.[8] Later, her connections with the European aristocracy would prove instrumental to Duncanson's successful tour of England in the mid-1860s, providing him entrée to aristocratic circles and helping him to secure patronage from Viscount Astor, the duchess of Sutherland, and the king of Sweden.

Western Forest harks back to Duncanson's relationship with Sonntag, particularly to paintings such as Sonntag's *Landscape* (Fig. 19), in its sublime mood and detailed attention to natural forms. The composition of expressive trees framing a woodland interior dissected by a stream is related to Sonntag's stylistic influence. Yet Duncanson's painting is much more accomplished, with the tortured trees creating an allegory on the natural cycle of life, endowing *Western Forest* with multiple layers of aesthetic moods and

meaning and an expressive power that are entirely absent from Sonntag's stylized *Landscape.* Sonntag's intensely detailed treatment of the natural forms appears contrived and stiff in comparison to Duncanson's, which is more natural and convincing.

After his grand tour Sonntag's primary residence was New York, where he established a successful studio for several decades and was an active participant in the National Academy of Design. Periodically he traveled to Cincinnati to exhibit and visit his former colleagues and patrons. Despite the lessons of Europe, Sonntag's style progressed little from the formulas that he developed in the late 1840s and early 1850s. Duncanson remarked with regret: "Sonntag is painting the same old pictures he painted three years ago."[9] While his techniques had improved and his range of subjects had expanded, Sonntag's work seemed to stagnate in the eyes of local critics. Local historian Charles Cist substantiated this when he criticized Sonntag in 1859: "His pictures are bold and imaginative, and exhibit a creative genius and ability, which, if chastened and moulded by a closer study of nature, would have raised him to the highest rank of his profession. He has been twice to Europe, without influencing his unfortunate style."[10] Sonntag's reputation had quite obviously diminished in the eyes of local critics when he did not return to reside in Cincinnati after his first trip to Europe. In Sonntag's absence, Duncanson progressed to a much higher stage of artistic accomplishment than his former mentor and rose in the esteem of the local critics and patrons.

Western Forest is a special painting in Duncanson's oeuvre, a rare portrayal of the sublime forces of nature. Usually Duncanson captured the more picturesque

and pastoral sentiments in nature with gently rolling hills and trees bathed in a pleasant warm light. The Cincinnati critics immediately noticed the uniqueness of *Western Forest,* saying, "It is, in many respects, a departure from his usual style, and cannot, therefore, be put into comparison with his other efforts."[11] More typical of his work is *Valley Pasture* (1857, Plate 8), which depicts a more domesticated landscape with a flock of sheep grazing along the banks of a lazy river. On the opposite shore a cabin, with smoking chimney, is nestled in the hills gently rolling off into the distance. A glowing light illuminates the richly foliated trees and the carpet of grass that covers the land. *Valley Pasture* conveys the serene, pastoral poetry that is predominant in the artist's landscapes.

The traditional pastoral motif of the shepherd with his flock is a keynote of this pastoral sentiment and one Duncanson used often. His paintings are usually populated with staffage figures relaxing and enjoying the landscape, whether they are fishing, picnicking, riding, or just gazing out across the land. These foreground figures are central to understanding the artist's work and provide insight into his character. The shepherd and the smoking cabin in *Valley Pasture* were standard metaphors for the pastoral sentiment in contemporary American landscape painting. The contemporary public immediately recognized them and conceived of them as evidence of a divine blessing upon American society for settling and domesticating the natural wilderness. The local press equated these references to the mood of romantic nature poetry and described the painting in those terms: "Duncanson is a poet, and his thoughts overflowing with poesy, are written

in the language of the heart upon his many pictures."[12]

Duncanson's patrons preferred these types of paintings, which expressed their belief in the landscape as a natural paradise made for man by God. Americans of this era firmly believed that God, nature, and man were inextricably bound by a covenant that was evident in the privileged relationship man had with God's handiwork, nature. James Jackson Jarves summarized Americans' pantheistic belief in the landscape as "the creation of the one God—his sensuous image and revelation, the investigation of which by science or its representation by art, men's hearts are lifted toward Him."[13] In Duncanson's work this is literally expressed in his paradisiacal subjects such as *The Garden of Eden* (1852, Plate 4) and *Land of Beulah* (1856). It is important to remember, though, that the same belief in the natural paradise on earth was not necessarily shared by an African-American artist desperately struggling in antebellum America. For Duncanson the imagery conveyed as well his longing for a fantastic paradise removed from the natural paradise his patrons believed could exist in the wilderness of America.

Duncanson attempted to imbue all his landscapes with the same degree of noble, poetic content that he had conveyed in his paintings of historical and literary subjects. In a survey of local artists in December 1859 the press found the artist painting a commissioned portrait in his studio. However, the reviewer paid more attention to an unfinished landscape painting: "Near him stood, unfinished, a wood and water scene, in which the foliage and the water, the shadow and the light are most excellently managed. If the picture is very elaborately finished, and it is of a kind to need it, it will be

a bijou of a painting."[14] Indeed this raw, unfinished piece was to become one of the artist's most fully realized statements of providential blessing for an arcadian existence in America, *The Rainbow* (1859, Plate 10).

The broad inviting foreground in *The Rainbow* allows the viewer easy access to the landscape with its staffage figures gazing expectantly toward the lovely rolling hills bathed in a warm light. The beauty of the painting is emphasized by the figures gesturing toward the dazzling rainbow that pours into the woods. The artist's technical command of light and natural forms is highly developed in this work. The delicate shafts of light that constitute the luminous rainbow, the highlights in the foreground, and the warm glow across the distant hills are some of his most accomplished passages, while the trees and foliage are rendered with a natural effect unprecedented in his paintings. Contemporary reviewers were moved by the painting. After describing it at great length, one Cincinnati writer commented, "We felt as if we could make almost any sacrifice to lay down by such a river and dream of that truth and beauty which the mind never evokes but in close proximity to nature's unsullied beauties."[15]

The rainbow conveys God's promise to mankind for eternal salvation and is the focus of the painting's meaning. With the rainbow the artist evoked an array of religious associations for American viewers of the 1850s concerning the relationship among man, nature, and God. Nature is portrayed here as a benevolent domicile receptive to domestication by settlers with their cabin nestled in the woods and their cattle grazing peacefully in the thick grasses along the river's edge. The painter proclaimed that the

pioneer was blessed by God when he anointed the cabin in this painting with the heavenly rainbow. Through the landscape, and its depiction, the artist could visualize the acts, works, and will of God. Durand announced in 1855 in his "Letters on Landscape Painting" that it is by "reverent attention to the realized forms of Nature alone that Art is enabled by its delegated power to reproduce some measure of the profound and elevated emotions which the contemplation of the visible works of God awaken."[16] Duncanson's *Rainbow* successfully transcribed this aesthetic attitude toward landscape painting for his midwestern audience.

Despite Duncanson's critical and popular success since his return from Europe, he experienced a hiatus in his creative energies in 1860. He continued to paint landscape scenery, but there was a noticeable lack of the poetic spirit that characterized his best pictures. During the summer of 1860 he allowed some writers to enter his studio and see the works he currently had in progress. The visitors were somewhat disappointed. One of two paintings was considered "excellent in conception and execution, while the other, as it now stands, is altogether unworthy of his reputation and skill."[17] After the period of intense creativity and productivity from 1857 through 1859, Duncanson must have confronted an impasse of unknown dimensions, perhaps due to personal, social, or political problems. Indicative of this difficulty is the fact that no major landscape paintings can be dated from the year 1860. Duncanson's latent artistic energy was not reignited until, in November, Frederic Edwin Church opened an elaborate display of his huge South American masterpiece *Heart of the Andes* (1859, Fig. 60) at the Pike's

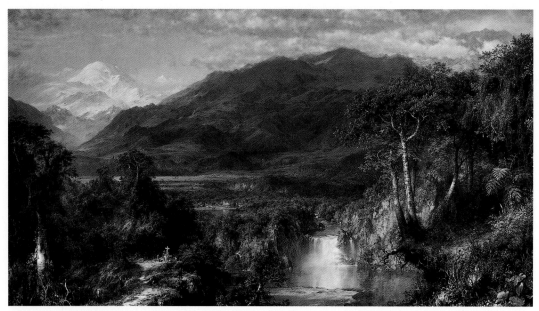

Fig. 60. Frederic E. Church, *Heart of the Andes*, 1859, oil on canvas, 66⅛″ × 119¼″. The Metropolitan Museum of Art, New York, Bequest of Mrs. David Dows, 1909.

Opera House in Cincinnati.

Church's painting had toured for one and a half years through New York, Boston, and Philadelphia, attracting much notoriety, and the Cincinnati public was prepared to accept it as a masterpiece.[18] The Cincinnati response echoed the tremendous praise the painting had received in the other cities. Church's mountainous, tropical landscape was expansive in conception and panoramic in size, containing a broad range of geological formations and exotic fauna. The painting was indicative of a shift among some artists toward exploring new territories and attempting to portray the vast extent of the sublime wilderness that Americans assumed was their domain through Manifest Destiny. Duncanson certainly saw Church's great picture and, like the rest of the country, was overwhelmed by it. The painting reenergized him, and almost immediately he began painting a tropical landscape similar in size and conception. Inspired by *Heart of the Andes*, Duncanson sought a historical theme in English romantic literature. Again he chose a paradisiacal subject, Alfred, Lord Tennyson's 1832 poem "The Lotus-Eaters." These twin sources laid the foundation for the largest and most elaborate easel painting of his career.

Duncanson envisioned a vast tropical landscape for his *Land of the Lotus Eaters* (1861, Plate 11), replete with streams, waterfalls, rocky outcrops, dense foliage, and a distant mountainous vista. The pervading idyllic mood is appropriate for the land that seduced Ulysses' men into bliss. In recounting this tale from Homer's *Odyssey*, Tennyson captivated the painter's imagination with rich metaphors that describe this paradise.

A land of streams! some, like a downward smoke,
Slow-dropping veils of thinnest lawn, did go;
And some thro' wavering lights and shadows broke,
Rolling a slumbrous sheet of foam below.

They saw the gleaming river seaward flow
From the inner land; far off, three mountain-
 tops,
Three silent pinnacles of aged snow,
Stood sunset flushed; and dewed with
 showery drops,
Up-clomb the shadowy pine above the woven
 copse.[19]

With a steady pentameter verse, conso-
nance, and literary metaphors, Tennyson
induced a slow and steady rhythm that
reflects the sedated pace on the island
inhabited by the lotus eaters. The sequences
of *S* sounds repeated regularly in this
passage soften the tone of the piece. Using
the stream imagery to convey the mood,
Tennyson introduced metaphors of sleep to
lull the reader with passages such as
"Rolling a slumberous sheet of foam." The
landscape painter responded to this
mood by composing a balanced picture
with gently cascading rivers and rounded
hilltops immersed in a dense tropical
atmosphere. The heavy, humid air and
drooping exotic vegetation also contribute
to the arcadian setting of the painting.

Duncanson sensitively portrayed
the moment in the narrative when the
natives bearing the narcotic flowers of the
lotus plant welcome Ulysses and his
men. By consuming the plant the sailors
enter a blissful state and, thus intoxicated,
do not want to leave the paradise they
have discovered on their return from the
battles of Troy. From the languid pool
in the foreground the landscape gently rises
in a series of plains marked by the flow
of the river moving through the richly
foliated land with fanciful, exotic ferns,
flora, and palms. The painter included
landmarks from Tennyson's poem—
"far off, three mountain tops, / Three
silent pinnacles of aged snow"—and
sensitively rendered the pastoral sentiment
of the poem.

Duncanson chose this passage from
Tennyson not only because of his preference

for paradisiacal subjects but also because
of its relationship to Homer's epic on
war. In selecting the scene, he prophesied
the forthcoming long and bloody Civil
War and offered an African-American's
perspective on the slavery issue and
the state of the nation. Begun in December
of 1860 when the Civil War seemed
imminent, and completed in May 1861
after the commencement of hostilities, the
painting depicts white soldiers resting
on the banks of a river in a tropical
landscape while being served by a train of
dark-complexioned natives. The tropical
landscape can be equated with the South,
where slaves wait on their masters, the
soldiers. The narcotic-induced apathy of
Ulysses' soldiers reflects a contemporary
criticism that the South had grown
complacent and dependent on slave labor
to support its economy and luxurious
standard of living. Behind the veil of the
romantic charms of exotic paradisiacal
scenery, Duncanson decried the life-style of
the slaveholding society and predicted a
decade of war and a decade of recovery for
the nation at a crossroads.

Public excitement over the artist's newest
masterwork was instilled by a series of
pre-exhibition announcements. The
Cincinnati Daily Enquirer proclaimed that
Land of the Lotus Eaters was "one of
the finest pictures that R. S. Duncanson,
the artist, has yet produced" and that
it was "beyond question a chef d'oeuvre of
art."[20] On May 30 the artist placed the
painting on display at Pike's Opera House,
the same building in which Cincinnatians
had enjoyed Church's *Heart of the
Andes*. Indeed, Duncanson was attempting
to compete with Church and encouraging
comparisons with the New Yorker's
famous canvas. The public clamored to see
the artist's huge literary painting when
the exhibition opened and raved about its
masterful qualities. The Cincinnati

newspapers carried extensive coverage of this major cultural event. Perhaps the most significant summary of the painting's importance appeared in the *Daily Cincinnati Gazette*: "Mr. Duncanson has long enjoyed the enviable reputation of being the best landscape painter in the West, and his latest effort cannot fail to raise him still higher in the estimation of the art loving public. He has not only wooed, but won his favorite muse, and now finds ample repayment for the labor of a lifetime, in the achievement of a more brilliant success than has attended most of his compeers."[21]

Other reviewers concurred in this assessment of the painting, waxing eloquently over its many beauties.[22] It did not escape the notice of the public that *Land of the Lotus Eaters* was drawn directly from Church's *Heart of the Andes,* which had taken the city by storm only a year earlier. The *Gazette* proclaimed, "The Lotus Eaters, at first glance, strongly reminds us of that chef d'oeuvre of landscape painting that elicited so much admiration from the delletanti [*sic*] here and elsewhere recently—the Heart of the Andes." The *Enquirer* several days later used a comparison with Church's painting to exhort the public to come out and see Duncanson's: "Duncanson's 'Land of the Lotus-Eaters' should not be allowed to leave the city without an inspection by those who were so enthusiastic in their praise of the former picture."[23]

Indeed, Duncanson's vision of a panoramic tropical landscape with vast spaces culminating in snow-crested mountains was fundamentally indebted to Church's painting. The arrangement of mountains and valleys descending into a central river basin that cascades into the foreground is similar in both works. In *Lotus Eaters,* however, Duncanson

shifted the central waterfall toward the left as he reinterpreted the vast spaces and dense tropical terrain of Church's painting into an idyllic mood appropriate to his literary source. *Lotus Eaters* does not convey the formidably sublime qualities that make Church's painting so overwhelming. The sharp detail and veracity of the geological and botanical forms that Church had derived from study and observation distinguish his painting from Duncanson's, whose palms, ferns, and flora are not natural and have a fanciful quality indicating that they were borrowed from other art, not nature.

Duncanson was equally indebted to the example of Church for the notion of touring his picture. Just as Church had circulated his *Heart of the Andes* across the United States, Duncanson envisioned exhibiting his painting around America, Canada, and through Europe to establish his reputation on an international scale. The reviews of *Land of the Lotus Eaters* noted that he was preparing to take the painting to Canada and then immediately to England, where it was predicted the picture would be purchased and establish the artist as an American master of the landscape: "With Mr. Duncanson . . . we take it that the acquirement of a most enviable reputation abroad is only a matter of travel and time. Let the art lovers of Gotham view and study the picture now on exhibition at the Opera House, and they will not hesitate to enroll the name of its author in the annals of artistic fame."[24]

Duncanson had aspired to international artistic acclaim since his return from Europe in 1854. While relishing the praise of his *Lotus Eaters,* he was busy in his studio creating a painting intended as a sequel to travel with it, *Western Tornado* (1861). Both in its idea and in its effect *Western Tornado* was a dramatic

contrast to *Lotus Eaters*. Although the painting is unlocated, descriptions in reviews indicate that its subject recalled the artist's successful *Western Forest*. Drawn from sketches taken from the site of a destructive tornado in Illinois, this picture was ominous in its re-creation of nature at its most sublime. It captured the storm as it was hurling trees from their roots and devastating the land.

One month after *Land of the Lotus Eaters* opened at the Opera House, *Western Tornado* was placed on exhibition beside it. A comparison with *Lotus Eaters* by the local press was inescapable. The sharp contrast between the two paintings dominated reviewers' impressions: "The awful grandeur of the painting struck the eye and the imagination with additional force, in the contrast afforded by the luxurious work of the 'Lotus Eaters,' which occupies a place by the side of the 'Tornado.' The soft and delicious repose of the former, like a narcotic dream, is a voluptuous relief to the furious excitement of the latter."[25] Similar in size and ambition, but diametrically opposed to *Lotus Eaters* in aesthetic mood, *Western Tornado* demonstrated the range of the artist's capabilities and talent. *Lotus Eaters* illustrated Duncanson's command of the beautiful-pastoral style with a literary subject, while *Western Tornado* was the epitome of the sublime, native landscape view on a grand scale. With this pair of complementary paintings the artist enhanced his opportunities for recognition abroad.

Duncanson certainly recalled the success of his earlier sublime view of a tornado in *Western Forest*—which was already in the collection of the duchess of Sutherland as a gift from Charlotte Cushman—and hoped to build upon his initial success with the English aristocracy with another,

similar painting. On a political level, *Western Tornado* also provided a pendant to *Lotus Eaters* as a comment on the current civil conflict. As opposed to the paradisiacal prophesy of *Lotus Eaters,* *Western Tornado* was painted during the heat of the war and represents the mass destruction that accompanies war. Unfortunately, the critics and press did not recognize the political significance of this pair of paintings, missing the African-American's veiled commentary on the brutality of slavery and war.

Duncanson revealed amazing ambition for an antebellum African-American artist, attempting to rival the European academic masters of history painting with a "great picture" and to place himself in comparison with such recognized American landscape painters as Frederic E. Church. Guided by a complex duality of aesthetic ideas, Duncanson sought to retain the elevated content of his historical paintings of Italian ruins and literary subjects while pursuing the Ruskinian notion of "truth to nature" through the noble sentiments expressed in his American landscape scenery. The artist created a body of American and historical landscapes in a variety of aesthetic modes that reveal the range of his talents, skill, and imagination. In these works he conveyed contemporary cultural beliefs concerning the relationship among man, God, and nature. In addition, a close reading of his paintings reveals an undercurrent of meaning that reflects the African-American's perspective on slavery and the Civil War. After a decade of working as a landscape painter, Duncanson had been proclaimed by the artistic community of critics, patrons, and the public as "the best landscape painter in the West." With this regional success he became determined to embark on international recognition.

6

"My heart has always been with the down-trodden race"
The African-American Artist and Abolitionist Patronage

*D*uncanson was especially fortunate to have lived and worked during an era of abolitionist sentiment. Throughout his career he was patronized by benefactors who assisted him in times of need. He regularly received aid from sympathetic individuals and abolitionist groups that respected his work and recognized the great difficulties confronting a freeman of color in the arts. Abolitionists supported his study and travel and purchased his paintings, primarily commissioned portraits. Most of the artist's extant portraits portray abolitionists who were his benefactors and whose cause he endorsed. In fact, abolitionist patrons constituted his principal support in the antebellum period and greatly enhanced his cultural opportunities.

In addition, Duncanson actively participated in abolitionist societies and their activities. On several occasions he donated paintings to support antislavery benefits. Notices of his work often appeared in the antislavery journals of the day, which championed his accomplishments and his contributions to African-American society. The journalists promoted him as an exemplar of the artistic capabilities of the African-American community in the United States. Later in life, Reuben, the painter's first son, accused him of "passing for white" in order to advance his social and economic stature. Emotionally wounded, Duncanson adamantly denied this charge, proclaiming: "My heart

has always been with the down-trodden race."[1] The cultural leader of the free colored population in Cincinnati, Duncanson revealed his own antislavery beliefs and substantiated his proclamation of sympathy with the plight of his fellow African-Americans as an ardent activist in abolitionist causes.

Duncanson had earned considerable recognition for his landscape paintings by 1861, but the need to maintain his family's standard of living continually forced him to work at other trades and at portraiture. This was not an uncommon predicament for artists living outside the major cities of Boston, New York, and Philadelphia during this era. The Cincinnati writer Charles Cist noted in 1851 that Cincinnati had nurtured a number of fine artists, but he criticized the lack of adequate patronage to support them.[2] This situation remained relatively unchanged through the 1850s, causing the *Cincinnati Daily Enquirer* in an annual review of artistic production in the city during 1859 to lament the aesthetic compromises forced upon artists by their patrons.

> In almost every studio we found a portrait on the stand and a picture—an unfinished picture—against the wall. The portrait they paint for bread, but the picture they paint for Art. For every picture painted there are ten portraits executed; and this fact alone is sufficient to prove that the Cincinnati artist is not encouraged by those who lavish wealth for purposes of ostentation,

which, while they are certificates of a full purse, are also indications of an empty head.[3]

The review severely criticized the mentality of the art-collecting public in Cincinnati, but this situation was not particular to Cincinnati; it was epidemic across the United States, where all but the most popular artists in the East suffered a lack of patronage. Few artists could specialize in the fine arts, and most supplemented their income by practicing a variety of trades.

In addition to the problems faced by most artists, Duncanson's career was complicated by the fact that he was a "freeman of color" living in antebellum America and working in the Anglo-American art world. Described in his passport as a "sallow"-complexioned man with brown eyes and hair (Fig. 61), Duncanson was classified by nineteenth-century social and legal standards as a "free colored person." In addition, the primary resources on the artist make constant reference to him as a fair-skinned mulatto, a distinction that carried important social consequences in ante-bellum America. At this time the term *mulatto* referred to anyone perceived to exhibit a mixture of Negro and Caucasian physical traits.[4] Generally, Americans of this era discriminated against any person, slave or freeman, who exhibited even the slightest hint of an African heritage. Due to social prejudices and legal restrictions, the rights of "freemen of color" were severely curtailed. An African-American artist's ability to prosper socially, economically, and culturally was directly affected by the limited opportunities Anglo-American society allowed. His chances for advancement were radically restricted compared to those available to a white tradesman or artist.

At the same time, it is well recognized that society regarded mulattoes more highly than their darker-complexioned African-American brothers throughout the Western Hemisphere. In this respect Duncanson's fair skin proved to be an asset providing him with better access to social, economic, and cultural activities, particularly through abolitionist sympathizers. Many white nineteenth-century Americans believed in their racial superiority and, conversely, the biological inferiority of African-Americans and Native Americans. Theories of monogenesis, polygenesis, and phrenology abounded during this era with "scientific" explanations for a hierarchy of races dominated by Caucasians, followed by Asians, and with Africans at the bottom, only slightly higher than primates. Some racists believed that through miscegenation and the infusion of Caucasian blood the inferior races could achieve a higher status on the biological ladder; thus mulattoes were considered superior to people with purely African ancestry.

In addition, the paternal sentiments of slave masters for their illegitimate children certainly played a role in the privileged status accorded mulattoes. Due to the southern system of training and educating favored mulatto slaves, mulattoes generally assumed a more privileged position in society when emancipated than did the more poorly prepared darker African-American slaves.[5] The tradition of favoring mixed-blood slaves with skills and an education is a legacy that marks the history of nineteenth-century African-American art. Like Duncanson, many early African-American artists began as tradesmen using skills acquired from the slavery system or were the beneficiaries of substantial abolitionist patronage. Because of their privileged social and economic

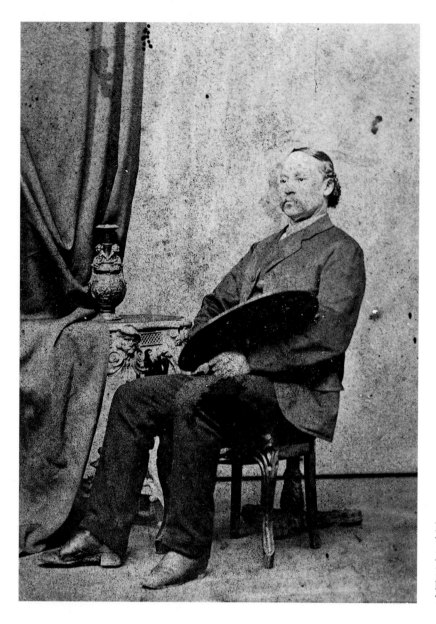

Fig. 61. J. W.
Winder, *Robert S.
Duncanson,* c.
1868, daguerreotype.
Private collection,
Toledo, Ohio.

status mulattos had greater opportunities
to rise from the skilled trades and to
aspire to the fine arts. Over several
generations the results of this trend are
evident among the few African-American
artists of the antebellum era.

Perhaps the most recognized early
American artist of African descent was
Joshua Johnson (1765–1830), a popular
Baltimore portrait painter. Johnson painted

the portraits of a number of leading
Baltimore citizens, one of his finest works
being *The James McCormick Family*
(c. 1804, Fig. 62). Johnson's primitive, folk-
art portraiture never reached the level of
accomplishment or achieved the widespread
public recognition of Duncanson's work.
The details surrounding Johnson's early life
are clouded; however, it is evident that
he was a former slave who possibly earned

Fig. 62. Joshua Johnson, *The James McCormick Family,* c. 1804, oil on canvas, $50^3/_{16}'' \times 69^7/_{16}''$.
Maryland Historical Society, Baltimore, gift of Dr. Thomas C. McCormick.

his freedom from indentured servitude
with his portraiture around 1800.
Like Duncanson, Johnson appears to have
been a mulatto; his racial identity was
alternately listed in federal and local
records as "white" or "colored."[6] He would
have been one of the first African-
Americans artists to benefit from the
preferential treatment often provided for
mulattoes.

The identity and work of very few other
African-American artists in the antebellum
era can be reconstructed to create a
picture of their careers and their roles in
the society and culture of the period.
Besides Johnson and Duncanson, the names
of Scipio Morehead (active 1770s),
Julien Hudson (active 1830–1840), Robert
M. Douglass, Jr. (1809–1887), and

Patrick H. Reason (1817?–1850?) appear
in the annals of history, but their extant
work is rare and did not make a significant
impact on the broader American art
world. A good example is Patrick Reason,
a freeman born of Haitian immigrants,
who was sponsored by the Anti-Slavery
League to study engraving in England.
Upon his return he gained recognition as
an illustrator of antislavery subjects
and a portrait draftsman of important
abolitionists. His most memorable work
was the illustration for the antislavery
slogan, "Am I not a man and a brother?"[7]
Little is known about his life and only
a modest body of illustrated work can be
assembled. Yet these works significantly
contributed to the abolitionist cause
and are instrumental to understanding the

Fig. 63. Edward Mitchell Bannister, *Approaching Storm,* 1886, oil on canvas, 40¼" × 60". National Museum of American Art, Smithsonian Institution, Washington, D.C., gift of William G. Miller.

African-American culture of the era.

A generation younger than Duncanson, Edward Mitchell Bannister (1828–1901) and Edmonia Lewis crossed the threshold from the antebellum era to the post-Reconstruction United States in their art careers. Their experiences confirm the pattern of greater accessibility to the arts for mixed-blood artists even into the third quarter of the nineteenth century. Bannister began as a tradesman and through a close-knit black abolitionist community in Boston worked to earn a considerable reputation as a New England landscape painter (Fig. 63). He learned the Barbizon style in Boston after seeing the work of William Morris Hunt, who introduced the French style to the United States in the 1850s and 1860s. Bannister was awarded a first-place bronze medal and a certificate at the Philadelphia Centennial Exposition for his *Under*

the Oaks (location unknown). The often-repeated story of how the Centennial authorities denied him access to the hall to receive his award poignantly conveys the racial prejudice and discrimination of the period.[8]

Like Duncanson, the sculptor Edmonia Lewis gained international recognition, and she spent the bulk of her career living and working in the American artists' community in Rome (Fig. 64). Originally from Ohio, Lewis was the daughter of a Chippewa Indian mother and an African-American father. She was among the first black women admitted to an American college in 1859, but racial controversy followed her, and she was denied her diploma at Oberlin College in 1863. She then moved to Boston, where abolitionists patronized her and supported her art studies in Europe. In Europe she met Charlotte Cushman, who a decade

earlier had patronized Duncanson, and Cushman promoted her work, introducing Lewis to the aristocracy.[9]

The major African-American artist of the later nineteenth century, Henry O. Tanner (1859–1937), confirms the pattern of greater social mobility in the arts for mixed-blood artists into the early twentieth century. Tanner experienced racial prejudice when, despite his fair complexion, he was denied formal instruction in painting until Thomas Eakins accepted him into the Pennsylvania Academy of Fine Arts. A delicate and sensitive artist, Tanner, like Duncanson and Lewis before him, was forced by the pressure of racial prejudice to travel to Europe in order to pursue his artistic ambitions. He spent the remainder of his life in Paris as an academic Salon painter of religious subjects (Fig. 65), returning to the United States only for occasional visits. After World War I, his reputation in the United States ascended and he became recognized as the leading African-American artist of the day. African-American leaders saw him as a father figure in the blossoming awareness of black culture during the Harlem Renaissance in the 1920s. Tanner's career closed an era when African-American artists worked within the Anglo-European art world and marked the dawn of the age of emerging black self-consciousness and cultural identity expressed in the ideas of Alain Locke concerning the "new negro."[10]

Johnson, Duncanson, Bannister, Lewis, and Tanner are arguably the most important African-American artists of the nineteenth century. The pattern presented by their careers of greater accessibility for mixed-blood African-Americans to the arts reflected the social and economic situation for African-Americans in other trades and professions as well. This trend continued after emancipation and

Fig. 64. Edmonia Lewis, *Hagar,* 1875, marble, 52⅝″ × 15¼″ × 17″. National Museum of American Art, Smithsonian Institution, Washington, D.C., gift of the Delta Sigma Theta Sorority, Inc.

Fig. 65. Henry O. Tanner, *Annunciation* 1898, oil on canvas, 57″ × 71¼″. Philadelphia Museum of Art, The W. P. Wilstach Collection.

through Reconstruction and was relatively consistent through the latter half of the nineteenth century. The situation only changed gradually over the several generations after the Civil War as newly freed slaves received better educations and as white Americans hardened in their racial prejudice against anyone visibly possessing African lineage, practicing discrimination socially and through the Jim Crow laws. With the change in social attitudes toward African-Americans and the absence of abolitionist and freedmen's organizations after Reconstruction, the opportunities for all African-Americans, regardless of complexion, ironically grew even more limited.

Among nineteenth-century African-Americans, Duncanson was the first to emerge as an artist and receive national and international recognition for his art. The patronage he received from abolitionist sympathizers and the attention given him by antislavery journals in the antebellum era aided his artistic aspirations immeasurably. Before Charles Avery's and Nicholas Longworth's patronage discussed previously, Henry N. Walker (1811–1886) of Detroit assisted Duncanson with financial support in the mid-1840s. Walker, a successful attorney, served in the state legislature at that time as a moderate politician with abolitionist sympathies. He realized the painter's

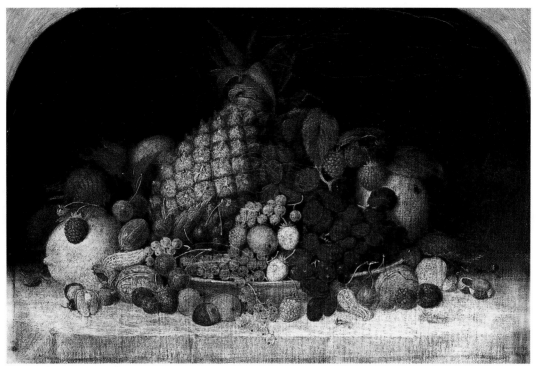

Fig. 66. Robert S. Duncanson, *Fruit Piece,* 1849, oil on canvas, 14″ × 20″. Detroit Institute of Arts, gift of the estates of Miss Elizabeth Gray Walker and Mr. Henry Lyster Walker.

impoverished state and provided him with $50.00, not a small sum at the time. By the end of the decade Duncanson had established a stable reputation for his work and had earned a premium at the Michigan State Fair in 1849 for a still-life painting. At this point, when his means had improved, he returned Mr. Walker's generosity by giving him a painting, *Fruit Piece* (1849, Fig. 66), which was later bequeathed to the Detroit Institute of Arts.[11]

After his return in January 1854 from the trip to Europe made possible by the generosity of Nicholas Longworth, Duncanson produced canvases for clients from his sketches of Europe, but it was not enough to sustain him. By May, he was working at Ball's Daguerrean Gallery retouching photographic portraits. James Pressley Ball was an African-

American artisan who began to experiment with daguerreotype processes in Cincinnati at the early date of 1845. After briefly struggling with a fledgling studio, he tried plying his trade on the road as an itinerant. In 1849 he returned to Cincinnati and opened what developed into the most popular photography studio in the Ohio River valley during the 1850s. His downtown location included labs, studios, and a large, splendidly adorned gallery that exhibited paintings and sculptures as well as daguerrean prints. The press reported a tremendous demand for Ball's portrait prints, resulting in "streams of visitors that are continually pouring into his spacious saloons, [who] show how wide spread is his reputation, and how successfully he has worked himself into popular favor." By 1857 Ball's Daguerrean Gallery was referred to

Fig. 67. Anonymous, *Ball's Daguerrean Gallery,* 1855, engraving, in J. Pressley Ball's *Splendid Mammoth Pictorial Tour of the United States.* 1855. Courtesy Cincinnati Historical Society.

with some hyperbole as "the finest gallery in the world."[12]

In Ball's ornate gallery Duncanson exhibited some of his Italian paintings within months after his return from Europe. An engraving of Ball's studio originally published in *Gleason's Pictorial* may depict some of these paintings on display (Fig. 67). In a review of the gallery, *Frederick Douglass' Paper* drew particular attention to six of the painter's works, including *The Shepherd Boy* (1852, Fig. 27), saying, "The depth and tone, the life and beauty of these paintings rank them among the richest productions of American artists."[13] In this way the abolitionist press drew national attention

to both the photographer and the painter as an important pair of African-American artists and profoundly endorsed their work.

Duncanson worked in Ball's studio for about four years. Photography was not a new endeavor for the painter. He had acquired experience in the field early in his career when he was involved with photographic processes in his 1844 series of "Chemical Paintings" with a partner named Coates. In addition, he had painted his *View of Cincinnati, Ohio from Covington, Kentucky* (c. 1851, Fig. 23), from an anonymous daguerreotype printed in *Graham's Magazine* from 1848 (Fig. 24). In these projects he

gained some experience with photographic techniques that proved useful in his work at Ball's Gallery.

Throughout the 1850s the painter explored daguerreotype processes, collaborating with Ball and other daguerrean studios in Cincinnati. In 1853 the Cincinnati directory even listed him as a "daguerreotype artist."[14] He developed a considerable reputation for "coloring" photographs in oils during this time. In 1857 a Cincinnati newspaper advertisement announced that Ball's photographs "are the town talk. Everyone pronounces them life-like and artistic, and creditable to the skill of Mr. Ball, as well as to the magic pencil of R. S. Duncanson, who does the coloring." Duncanson was so adept at coloring photographs that only one month later a competitor lured him away from Ball's Gallery. Robert Harlan proudly advertised his coup in order to attract customers: "Duncanson, a gentleman well-known in this city as a painter of high merit, is connected with this establishment."[15]

"Colored" prints constituted an important aspect of early photographic work. During this period of portrait photography, daguerreans often attempted to make their prints look like paintings. The finish and "artistic" appearance of paintings endowed early photographic portraits with aesthetic credibility. In fact, one writer described portrait photography in terms of "painting your face with sunbeams on the sensitive yet tenacious mirror."[16] This effect captivated a reviewer of Ball's Gallery, who noticed that the "photographs just finished by R. S. Duncanson . . . were equal in beauty of finish to the richest paintings on ivory." Not to be outdone, another reporter pronounced that Harlan's retouched photo portraits were "superior to the finest oil-paintings" because they combined the exacting realism of photography with the "artistic" finish of paintings.[17]

Typically, nineteenth-century photographic studios employed painters to hand-color photographs, paint backdrops, retouch negatives, and advise on posing figures for compositions.[18] From the reviews and notices published on Duncanson's daguerrean efforts, it appears that Ball and Harlan employed him exclusively to color and retouch photographs. Unfortunately, no "colored" photographs survive from this era in Cincinnati that might suggest Duncanson's work in this medium. All the known daguerreotypes attributed to Ball are strictly photographic works and provide no clues to the painter's contribution in the daguerrean studio.

From his landscape paintings and photographic work Duncanson managed to earn a stable living and was comfortable enough to start another family. His first wife, Rebecca, had died by the mid-1850s, and he married Phoebe, a young mulatto woman from Kentucky, probably around 1858. In February 1860 they had the first of two children, a son named Milton. The children from Duncanson's first marriage, Reuben and Mary, had grown, and Reuben had moved to Cincinnati, where he lived with his father and worked as a clerk.[19]

In the Fourth Street neighborhood where Duncanson and Ball lived as neighbors for many years and had their studios, there was a close-knit and fairly prosperous free colored community that included laborers, washerwomen, and a small colony of black and mulatto artists who, attracted by the reputations of the older artists, came seeking their guidance. Ball employed at least nine assistants in his Daguerrean Gallery in 1854, some of whom were

probably African-Americans. The artists also apprenticed younger black artists, providing board in their homes. Duncanson tutored a mulatto from Virginia named George W. Wilson, while Ball trained a black youth, James Goings, from Ohio, both of whom registered themselves as artists in the 1860 census.[20]

Close associates for most of the 1850s, Duncanson and Ball stood as the artistic leaders in landscape painting and portrait photography in the region. The fact that two African-American artists could dominate a major portion of Cincinnati's cultural life indicates the social atmosphere of the 1850s. Although on the border of slavery and tied economically to the South, Cincinnati served as a center for the free black population and a stronghold for abolitionists such as James Birney (1792–1857) and John Mercer Langston, the African-American antislavery attorney. In this environment, during the brief span of the 1850s, Duncanson and Ball, in addition to forming the nucleus for a group of aspiring black artists and artisans, actively participated in regional abolitionist circles.

In 1855, Ball publicly announced the unveiling of a panorama he called the "Mammoth Pictorial Tour of the United States Comprising Views of the African Slave Trade." A popular form of public entertainment in the 1850s, panoramas consisted of vast stretches of canvas that were unrolled before the eyes of an audience in a theater with stagehands creating light and shadow effects behind the scenery. Often, an orator provided an explanatory narration, and music and sound effects accompanied the scenery as well. The most successful panoramas of the age had the Mississippi River as their subject. The earliest, created by John Banvard (1815–?) in 1846, enchanted audiences by portraying the many mysteries found along the border of the vast, unknown frontier.[21]

Ball's panorama capitalized on the popularity of the Mississippi panoramas to portray the evils of human bondage. It began with views of native African villages and progressed to slave ships and the slave markets and plantations of America. The images and the commentary in an accompanying pamphlet implanted the antislavery message in the minds of the viewers. Ball sternly admonished Americans for their great hypocrisy: "Thus slavery, which at the beginning of our national existence was barely tolerated for the few years that it was supposed would be necessary to terminate its miserable existence now reigns supreme, and boldly demands recognition and protection wherever the flag of the Republic floats."[22] The panorama was extremely successful in the abolitionist community and toured the United States, including Boston.

Duncanson worked in Ball's studio at the time the panorama was produced and almost certainly played an active part in its planning and execution. Ball could not have executed a panorama of this scale without a painter's expertise. With the experience he had gained from painting houses, his murals for Belmont, and his series of large-scale touring paintings, Duncanson probably designed and painted the scenes. His collaboration on the antislavery panorama provides evidence for his aggressively and even evangelical abolitionist posture. In addition, the experience of creating a panorama influenced his later work, as can be seen in the panoramic format and the frontier iconography of *Waiting for a Shot* (1869, Fig. 72).

The artist participated in various other antislavery activities. In October 1855

he donated one of his paintings, which was reviewed as "the most creditable work which has emanated from his pencil," to the Anti-Slavery Bazaar to be sold to raise funds for the cause.[23] This gesture and his other activities exemplified his strong commitment to the abolitionist cause, to which he remained dedicated throughout his life. However, in order to secure patronage, Duncanson did not overtly treat African-American or slavery themes in his paintings—with the exception of *Uncle Tom and Little Eva* (1853, Plate 7). Most African-American artists of the antebellum era were shackled by the necessity of securing white patronage and did not deal with abolitionist subjects either. Instead, like Duncanson, they pursued genres and styles common to American art at the time with a distinctively African-American perspective that has to be discovered beneath the veil of mainstream aesthetics.

Perhaps the most enduring evidence of Duncanson's abolitionist stance rests in the numerous portraits that he painted of important white abolitionist leaders. While a variety of sympathetic patrons commissioned his portraits during the 1840s, his portraits of the 1850s are almost exclusively of abolitionists and prominent educators, men who championed the cause of emancipation for African-Americans. The list of his sitters reads like a who's who of Cincinnatians active in the antislavery movement: Robert Bishop (1777–1855), William Cary (1783–1862), Freeman Cary (1810–1888), Richard S. Rust, James Birney, and Nicholas Longworth. While some of these portraits are lost, printed references verify their existence. The artist enhanced each one with props to identify the sitter's profession and to recognize his contributions to African-American emancipation and education.

Duncanson created these portraits in two groups, the first around 1855, and the second in 1858. The first group of portraits included *James Birney* (c. 1855, location unknown), *Robert H. Bishop* (c. 1855, formerly the Ohio Military Institute), *Freeman C. Cary* (c. 1855, Fig. 68), and *William Cary* (1855, formerly the Ohio Military Institute).[24] Birney, the most widely recognized of the sitters, established the main abolitionist newspaper in Cincinnati, *The Philanthropist*. He attracted considerable attention when he freed his slaves in 1839, explaining in a published announcement entitled "American Slavery" his belief "that slave holding is inconsistent with natural justice, with the precepts and spirit of the Christian religion, and with the Declaration of American Independence." In 1840 and 1844, the Liberty party nominated Birney to run as its presidential candidate. Although the portrait of this fiery abolitionist is no longer extant, its existence is established in an early text on the history of Cincinnati.[25]

Robert Bishop, William Cary, and his son Freeman were each important educators who fostered the abolitionist movement in Cincinnati. Emigrating from Scotland in 1802, Bishop settled along the Ohio River valley, where he established schools and churches for African-Americans. The Miami University *Literary Register*, of which he was an editor, published in 1828 the following condemnation of slavery that echoes his sentiments: "The greatest and most threatening evil, which is, or ever has been connected with these states is the evil of slavery." An influential educator and abolitionist, Bishop helped found Miami University, the antislavery movement in Cincinnati, and, through his students, Birney's *Philan-*

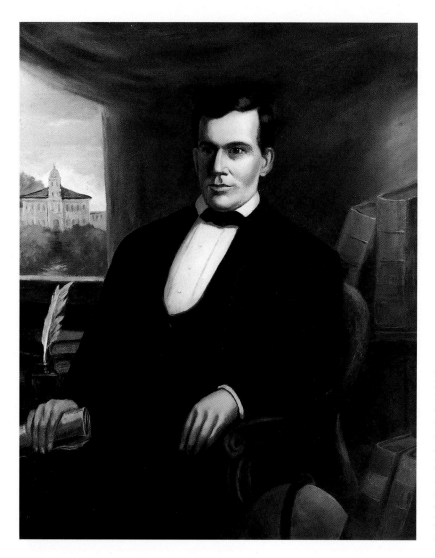

Fig. 68. Robert S. Duncanson, *Freeman C. Cary*, c. 1855, oil on canvas, 43⅜″ × 35¼″. National Museum of American Art, Smithsonian Institution, Washington, D.C., gift of Sol Koffler.

thropist magazine. Late in his life, Bishop left Miami University to help William and Freeman Cary—who had encouraged his abolitionist efforts—found Farmer's College, then known as "Cary's Academy." After Bishop's death, his biographer noted that Duncanson's portrait preserved his memory in a prominent place in the halls of "Cary's Academy."[26]

The full-length portrait of William Cary, the patriarch of the academy, conveys the stern countenance of this dedicated man. He is portrayed standing next to his desk, an emblem of his academic profession, in a pose and composition that prefigure Duncanson's portrait of Longworth. In the image of Freeman Cary the artist also captured the sitter's character along with his attributes. Cary is portrayed working at his desk with papers in his grasp and writing instruments on the table. An opened curtain allows a view of Farmer's College through the window in the background. The standard formula for portraits at this time—borrowed from the English and formalized in America by Copley, Charles Wilson Peale (1741–1827), and Gilbert Stuart (1755–1828)—

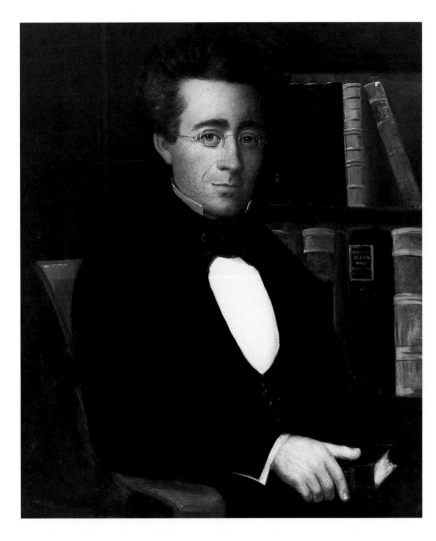

Fig. 69. Robert S. Duncanson, *Richard Sutton Rust I,* c. 1858, oil on canvas, 30″ × 25″. Private collection, Cincinnati.

consisted of a figure in a three-quarter pose seated at a desk. In Duncanson's portrait, the view out the window makes a direct reference to Cary's role as a founder of Farmer's College, and the writing instruments indicate his intellectual pursuits as an educated man of letters. One of Duncanson's best portrayals of a sitter, Cary's figure has a sense of flesh, volume, and character that reveals the personality of the man, characterized in a historical study of the college as "a man of strong, rugged force, physical and mental. . . . And yet he was impulsive and passionate at times."[27]

The second group of abolitionist portraits includes *Richard Sutton Rust I* (c. 1858, Fig. 69) and *Nicholas Longworth* (1858, Fig. 70). Rust was an avid supporter of the abolitionist movement. While a student, he, along with a hundred other students, was expelled from the Phillips Academy in Andover, Massachusetts, for establishing an antislavery group. Pursuing his education elsewhere, he earned a living on the lecture circuit delivering antislavery speeches. After receiving a Doctor of Divinity from Ohio Wesleyan University in 1858, he was appointed the first president of Wilberforce

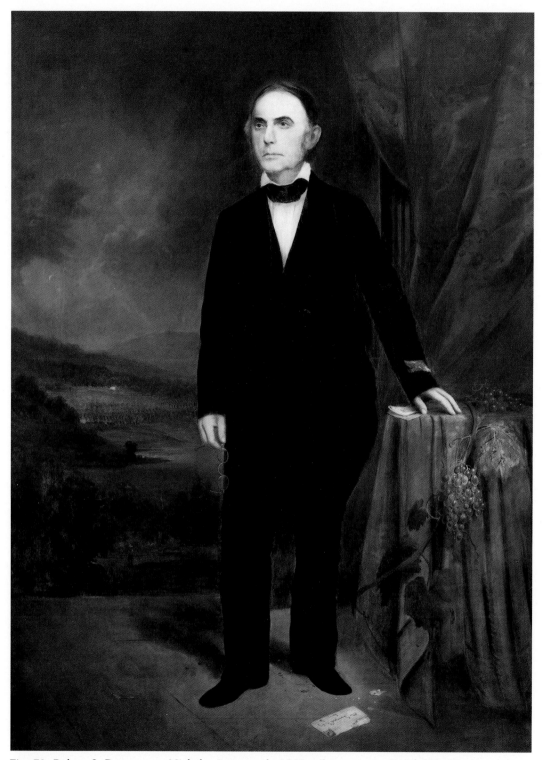

Fig. 70. Robert S. Duncanson, *Nicholas Longworth,* 1858, oil on canvas, 84″ × 60″. Cincinnati Art Museum, lent by the Ohio College of Applied Science, Cincinnati.

Fig. 71. Gilbert
Stuart, *George
Washington,* the
"Lansdowne
Portrait," 1796, oil
on canvas,
96″ × 60½″. Penn-
sylvania Academy of
Fine Arts,
Philadelphia.

College, a school for black students. The Rusts hosted weekly dinners at their Cincinnati home that were attended by the region's educators, abolitionists, artists, and family friends. As a leading African-American member of Cincinnati society and an active abolitionist, Duncanson regularly participated in these soirees.[28]

Duncanson's portrait commemorates Rust's appointment at Wilberforce, portraying the scholar in his library with copies of Homer's *Iliad,* Milton's *Paradise Lost,* and William Cullen Bryant's *Poems.* Like the writing instruments on Freeman Cary's desk, these books represent Rust's intellectual pursuits as an important educator. They also record some of Duncanson's many literary sources for his paintings. Milton's *Paradise Lost* was the source for his first historical painting, a copy of Cole's *Garden of Eden.* Homer provided the original source for Tennyson, who motivated Duncanson to paint his most ambitious literary landscape, *Land of the Lotus Eaters.* And Bryant was the literary counterpart for most American landscape painters of this era with his romantic nature poetry. In his portrait of Rust, Duncanson not only preserved an image of this important abolitionist and educator but also illustrated his own choice of inspirational literary sources.

The portrait of Nicholas Longworth is Duncanson's most impressive and ambitious portrait, due to its scale, accomplishment, and the importance of the subject. This lifesize portrait conveys the businessman's esteemed position in Duncanson's life, as well as in the Cincinnati social and economic elite. Placed in a "grand manner" interior with elegant drapery,[29] Longworth stands next to a table bearing the famous Catawba grapevine that he developed. The view behind the curtain

reveals the land behind his home where his vineyards produced the grapes for his popular wine. The painter borrowed the compositional format and pose from Gilbert Stuart's famous "Lansdowne Portrait" of George Washington (1796, Fig. 71), which inspired a host of American portraits. Stuart portrayed the first president gesturing over the desk of his office, while carrying a sword symbolizing his dual role as the political leader of the Republic and its commander in chief.

Longworth stands in a pose similar to Washington's but without the dramatic gesture of the right hand, to permit a full view of his property and vineyards behind the gathered drapery. Instead of a sword and a column, traditional symbols of power in Stuart's portrait, Duncanson utilized the fields and grapes to symbolize that the source of Longworth's wealth, power, and influence was not military, but economic. The artist refrained from the traditional aristocratic references to power and social stature found in Stuart's work in order to present his patron as a practical, hardworking American shorn of aristocratic attributes. He balanced the stern countenance of Longworth by including the personalized envelope on the floor addressed to "N. Longworth, Esq., Cin O" and by depicting his patron's unusual habit of pinning notes to his sleeve. In this ambitious homage to one of his most significant patrons, Duncanson equated Longworth's importance with that of the father of the country, while revealing his personal attributes.

At this point in his career, Duncanson occupied a preeminent position in African-American arts of the mid-nineteenth century. His artistic accomplishments marked the transition of African-Americans from artisans to artists, and his national

recognition revealed new horizons for other young African-American artists such as Bannister and Lewis. The fact that his paintings did not overtly reflect the African-American experience of the nineteenth century does not imply that he was avoiding treating the subjects and issues of African-American culture or, as Cedric Dover suggested, had renounced his racial heritage to live the elitist existence of the black bourgeoisie.[30] His abolitionist activities, his portraits of the leading abolitionists of the region, and his collaboration with Ball on the antislavery panorama document his dedication to the cause of emancipation.

Duncanson did, however, lead a double existence as an African-American working in the white art world. His paintings do conform to the mainstream landscape aesthetics of the period and express the artistic ideals of American culture. This caused him great psychological stress and may have fostered his mental collapse. When Duncanson's son Reuben accused him of "passing for white," Duncanson vehemently proclaimed, "Mark what I say here in black and white I have no color on the brain all I have on the brain is paint." In complete contradiction to the evidence of his earlier antislavery activities, Duncanson denied concern with racial issues and claimed to pursue higher intellectual ideals: "I care not for color: 'Love is my principle, order is the basis, progress is the end.'"[31] Duncanson's statement reveals his clouded understanding of his position as an African-American artist in American culture.

7

"I have made up my mind to paint a great picture"
Exile and International Acclaim

*I*n 1854 Duncanson declared emphatically, "I have made up my mind to paint a great picture." To the artist and his contemporaries a "great picture" meant a large-scale historical landscape painting with elevating content, one that was widely publicized and exhibited to the admiration of throngs of people for an admission fee. Duncanson's ambition reflected his desire to proclaim his mastery of the highest branch of art in the academic hierarchy of genres—history painting.[1] Throughout the 1850s he produced numerous ambitious pictures with didactic themes drawn from the Bible, American and British literature, ancient Italian ruins, and American history. With these works he attempted to rival the European academic history painters and the American masters of the touring picture, Cole and Church. It was bold for an African-American artist to aspire to such a high stature in the white art world, and he did so with determination. He had built a regional reputation with his historical landscape paintings, and now he sought international acclaim with his most ambitious "great picture," *Land of the Lotus Eaters* (1861, Plate 11).

Lotus Eaters embodied Duncanson's ambition to succeed and the ideals to which he aspired in the creation of a grand historical painting. The sensational response in Cincinnati to it and its pendant, *Western Tornado* (1861), further encouraged Duncanson to tour his great works to reach a broader audience. A Cincinnati writer provided a clue to the artist's tenacity when he remarked, "It has been the steady determination of the artist, Mr. Duncanson, to take it [*Lotus Eaters*] to Europe at an early day, where, too, we are safe in prognosticating it will remain, for the wealthy connoisseurs of that hemisphere will not suffer such a gem of art to recross the Atlantic."[2]

The touring exhibition picture had a long tradition entrenched in nineteenth-century American art. Artists created touring pictures in order to reap financial rewards and reach a mass audience, in response to the lack of sustained patronage and exhibition opportunities. The first such works were John Trumbull's Revolutionary War paintings and John Vanderlyn's panorama of Versailles (1816, Metropolitan Museum of Art, New York). Their success in these enterprises led many other artists to produce their own exhibition pictures, initiating a host of historical exhibition pictures that toured the country during the 1840s and 1850s. These exhibition pictures became popular as entertainment among all levels of American society; in fact, there were so many such works that authorities passed laws to regulate their exhibition.[3] In Duncanson's time the premier exhibition pictures were Cole's *Course of Empire* (1833–1836, New-York Historical Society) and *The Voyage of Life* (1840, Munson-Williams-Proctor Institute) and Church's

Niagara (1857, Corcoran Gallery of Art). Duncanson directly experienced the tradition of the touring exhibition picture when he saw Church's *Heart of the Andes* (1859) in Cincinnati. Following the example of Church, who toured several paintings through the United Kingdom, Duncanson aspired to international recognition for his "great picture" and sought the critical acclaim of the English audience.

Duncanson had envisioned an international tour of *Lotus Eaters* before he placed it on display in Cincinnati in June 1861. In a preexhibition announcement he outlined his itinerary to a journalist who reported that the painting would be on display only eight days, "after which it will be taken to Canada and exhibited there. In about six months, it and the Western Tornado will be sent to London and disposed of."[4] However, the sensational response to his paintings delayed the artist's plans. He left them on display in Cincinnati for over a month, until July, before shipping them to Canada.

In November 1861, Duncanson exhibited his two "great pictures" in a downtown Toronto studio for the modest admission fee of twenty-five cents. Toronto at this time was a growing cultural and economic center, but it had previously not been a site for exhibiting touring pictures. Thus it offered Duncanson an unseasoned community where he could test a foreign audience's response to his paintings.[5] Unfortunately, no reviews appeared to indicate the response of the Toronto public to the exhibition. Yet the reaction must have been positive, because the exhibit initiated a decade-long relationship between the artist and an enthusiastic Canadian audience. Apparently "an accidental circumstance" prevented him from immediately realizing his travel plans for Europe.

Instead he returned home by January 1862, leaving his paintings in Canada.[6] The nature of the "accidental circumstance" remains unknown; however, the sudden change in his itinerary may have been caused by the Civil War.

Back in his Cincinnati studio the artist busily prepared a third large-scale painting for his international tour, *Prairie Fire* (1862, location unknown). Local writers hoped that this picture would remain in Cincinnati: "It is probable that 'The Prairie' will find a home in our city, as there are already two gentlemen offering to purchase it." However, it was also destined for Canada. Like *Western Tornado, Prairie Fire* must have been a truly sublime work. A reviewer described it as showing "the Grand Prairie at night. The fire is sweeping through the tall weeds and grass with frightful rapidity, and a herd of buffalo are running for refuge to a lagoon in the foreground."[7] As did *Western Tornado, Prairie Fire* suggests the artist's preoccupation with subjects of mass destruction in response to the terrible reality of the Civil War.

Although the painting is lost, the description of the prairie fire with clouds of smoke and stampeding animals suggests a later picture by the artist entitled *Waiting for a Shot* (1869, Fig. 72). Duncanson's contemporary from St. Louis, Carl F. Wimar (1828–1862), specialized in such subjects and had painted several famous burning prairie scenes with stampeding buffalo at this time. It is not clear how Duncanson came to know Wimar's work, but several scholars have speculated that he also painted a copy (location unknown) after Wimar's famous *Buffalo Hunt* (1860).[8]

As the Civil War moved into its second year it disrupted cultural life in the United States. For an African-American

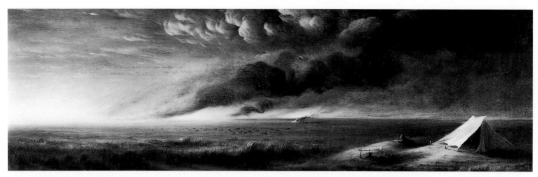

Fig. 72. Robert S. Duncanson, *Waiting for a Shot,* 1869, oil on canvas, 12″ × 38½″. Richard Manoogian, Detroit.

artist living on the border of the conflict, everyday life was filled with even greater racial tension than usual. In the summer of 1862 the war forced many artists to curtail their creative work and cancel their annual summer sketching trips. A Cincinnati arts reviewer noted: "The summer, which is usually a season when artists love to roam through the country—taking a sketch here, and painting a beautiful scene there, to be treasured up for some future work—has been peculiarly unfortunate for them this year. The war in the South, the fear of being arrested for endeavoring to evade the draft, and many other considerations consequent on the war, have prevented them from traveling so much as usual."[9]

Duncanson seems to have been more adventuresome than most artists and was an exception to this trend. Perhaps being an African-American on the border of the Confederacy led him to travel north, away from the war. He spent the month of September sketching on the upper Mississippi River, whence he traveled to Toronto to exhibit another group of his paintings.[10] Upon his return, he worked in his studio painting canvases from his sketches of the upper Mississippi. The paintings from this trip, each identified with an exact location, help recreate the route that the artist followed on

his sketching tour. He traveled up the Mississippi River to Minnesota, where he captured picturesque sites for *Maiden's Rock, Lake Pepin, Minnesota* (1862, Fig. 73), two versions of *Falls of Minnehaha* (1862, Plate 12), *Minnenopa Falls* (1862, Fig. 74), and *Mt. Trempeleau* (1862, Cincinnati Public Schools). In September he visited Toronto and then traveled by way of Montreal to New Hampshire, as is evident in his painting *Lancaster, New Hampshire* (1862, private collection). He probably completed his trip by traveling through Vermont, New York, and Pennsylvania in a full circle back to Cincinnati. On this trip Duncanson remained firmly in Union territory, steering clear of his former southern touring spots in West Virginia and North Carolina.

When he returned to Cincinnati in October, he immediately set to work on commissions for the two views of the falls at Minnehaha. Minnehaha Falls was a popular picturesque site for artists who toured the Mississippi River valley, such as Seth Eastman (1808–1875), John F. Kensett, and Albert Bierstadt, among others.[11] Cincinnati critics considered Duncanson's first version of Minnehaha, for a local collector named L. C. Hopkins, a fine piece, but believed the second version, "for a gentleman of

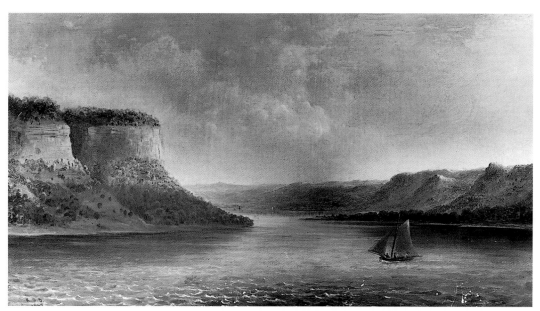

Fig. 73. Robert S. Duncanson, *Maiden's Rock, Lake Pepin, Minnesota,* 1862, oil on canvas, 12″ × 21¾″. Mead Art Museum, Amherst College, gift of William Macbeth, Inc.

Boston," to be even better. The local press remarked, "The work is of great merit, and finished with all the skill and beauty which characterizes this artist's works. The falling waters appear to be actually endowed with life and motion, and it is difficult to divest oneself of the idea that it is nature itself we are gazing at. A second view of the same scene but from a different stand point, is in process of completion, which we consider a decided improvement."[12]

The finer of the two extant canvases, now in a private collection in Massachusetts (Plate 12), must be the second version, painted for the Boston patron. In this version the artist manipulated the course of the river and framed the falls with the serpentine contour of an expressive tree trunk on the right. He rendered the falls and the foliage with great sensitivity, creating a more sophisticated effect than in the first work, which shows evidence of labored handling. In both paintings a lone Indian woman

sits at the base of the falls gazing into the waters. Contemporary viewers would have recognized her as Minnehaha, Hiawatha's future bride, from Longfellow's popular poem *The Song of Hiawatha* (1855), sitting before the falls that bear her name.

> With him dwelt his dark-eyed daughter,
> Wayward as the Minnehaha,
> With her moods of shade and sunshine,
> Eyes that smiled and frowned alternate,
> Feet as rapid as the river,
> Tresses flowing like the water,
> And as musical a laughter:
> And he named her from the river,
> From the water-fall he named her,
> Minnehahah, Laughing Water.[13]

The noble Indian girl sits entranced by the "laughing waters" listening to nature tell her the tales of her native people. Duncanson would have related to this poem, not only because it was an immensely popular piece of romantic

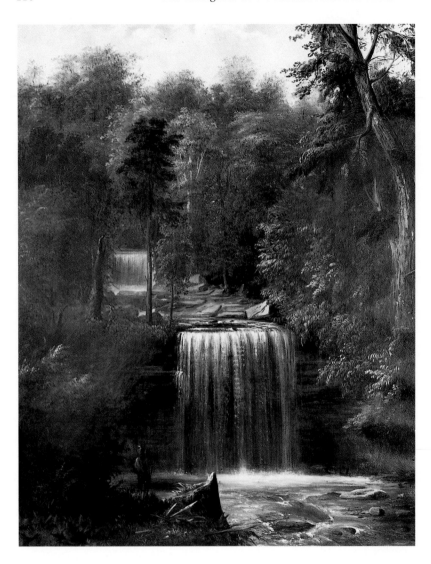

Fig. 74. Robert S. Duncanson, *Minnenopa Falls,* 1862, oil on canvas, 20″ × 16″. The Procter and Gamble Company, Cincinnati.

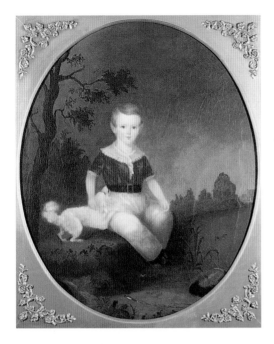

Plate 1. Robert S. Duncanson, *Portrait of William J. Baker,* 1844, oil on canvas, 27⅝″ × 22¾″. Baker-Hunt Foundation, Covington, Kentucky.

Plate 2. Robert S. Duncanson, *Cliff Mine, Lake Superior, 1848,* 1848, oil on canvas, 28¾″ × 42″. F. Ward Paine, Jr., Portola Valley, California.

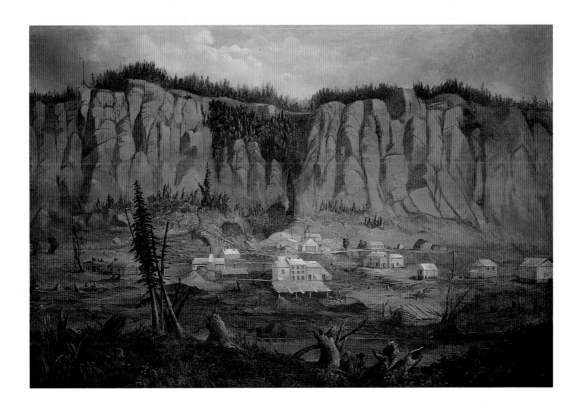

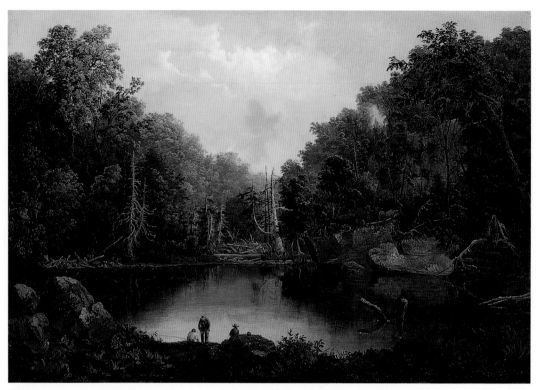

Plate 3. Robert S. Duncanson, *Blue Hole, Flood Waters, Little Miami River,* 1851, oil on canvas, 29¼″ × 42¼″. Cincinnati Art Museum, gift of Norbert Heerman and Arthur Helbig.

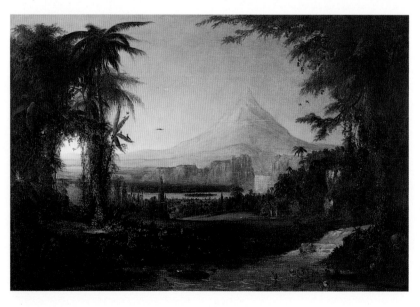

Plate 4. Robert S. Duncanson, *The Garden of Eden,* 1852, oil on canvas, 32½″ × 48″. High Museum of Art, lent by the West Foundation, Atlanta.

119

Plate 5. Robert S. Duncanson, *Belmont Mural,* entrance hall, southeast wall, c. 1850–1852, oil on plaster, 109″ × 92″. Bequest of Mr. and Mrs. Charles Phelps Taft, The Taft Museum, Cincinnati.

Plate 6. Robert S. Duncanson, *Romantic Landscape,* 1853, oil on canvas, 16¼″ × 28⅛″. Private collection, Massachusetts.

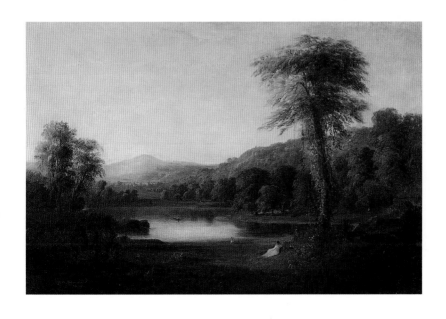

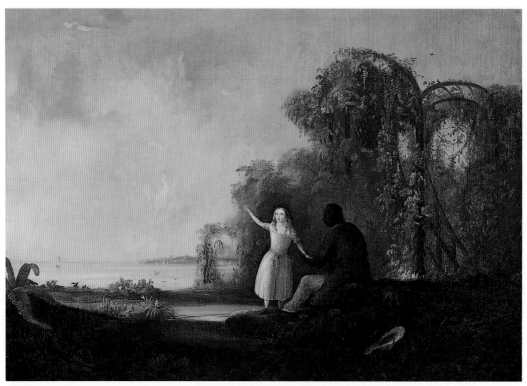

Plate 7. Robert S. Duncanson, *Uncle Tom and Little Eva,* 1853, oil on canvas, 27¼″ × 38¼″. Detroit Institute of Arts, gift of Mrs. Jefferson Butler and Miss Grace Conover.

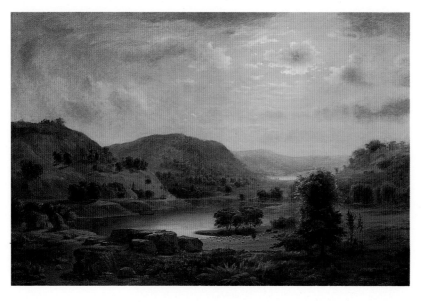

Plate 8. Robert S. Duncanson, *Valley Pasture,* 1857, oil on canvas, 32¼″ × 48″. National Museum of American Art, Smithsonian Institution, Washington, D.C., gift of Melvin and Alan H. Frank.

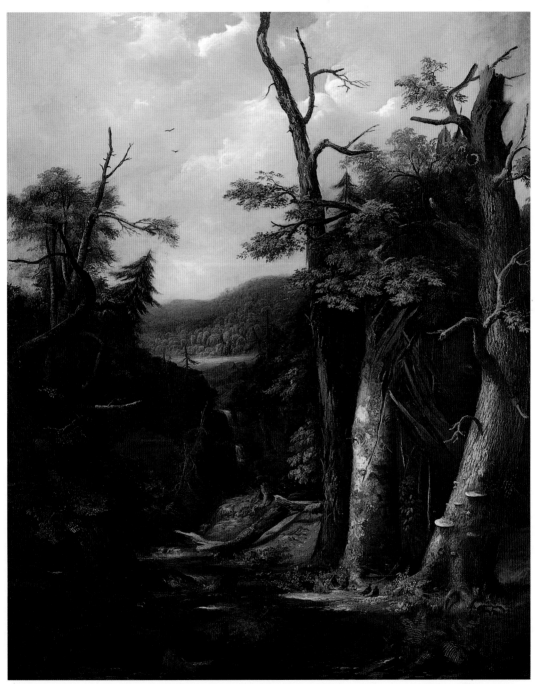

Plate 9. Robert S. Duncanson, *Western Forest,* 1857, oil on canvas, 54″×42″. Private collection, Cincinnati.

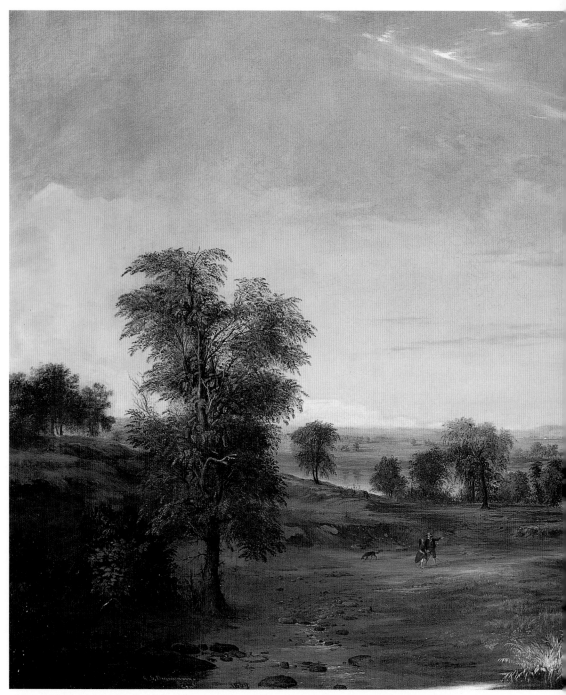

Plate 10. Robert S. Duncanson, *The Rainbow,* 1859, oil on canvas, 30″ × 52¼″. National Museum of American Art, Smithsonian Institution, Washington, D.C., gift of Leonard Granoff.

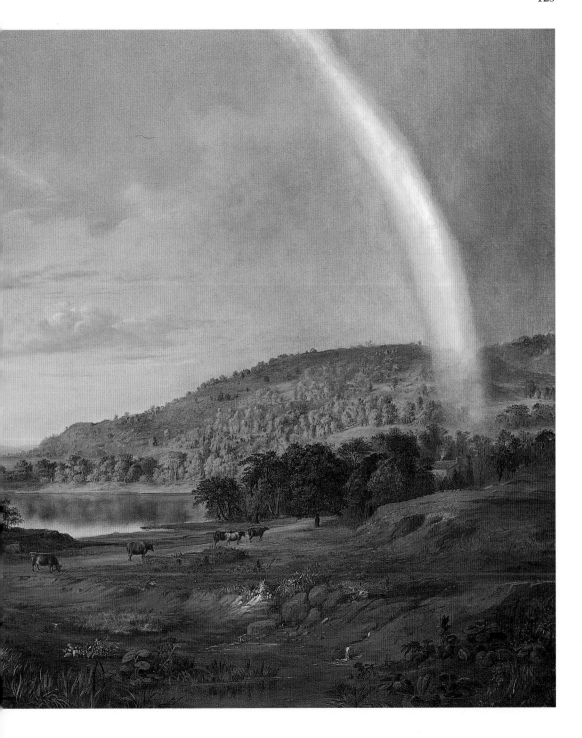

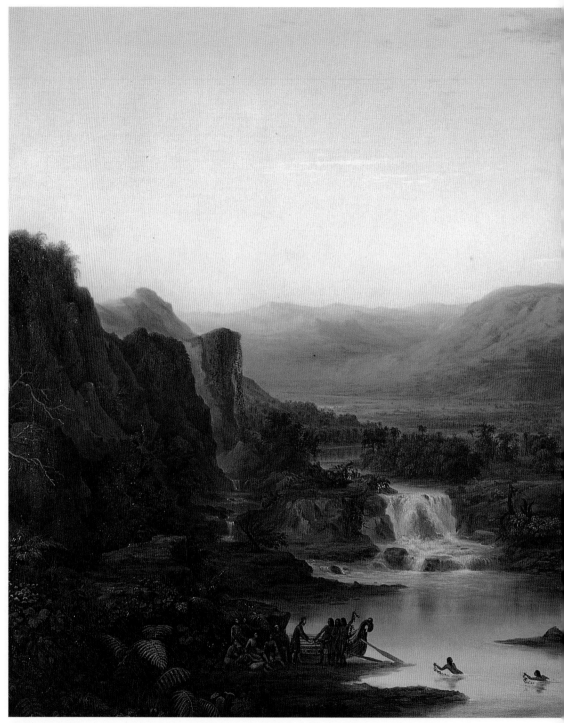

Plate 11. Robert S. Duncanson, *Land of the Lotus Eaters,* 1861, oil on canvas, 52¾″ × 88⅝″. Collection of His Royal Majesty, the King of Sweden.

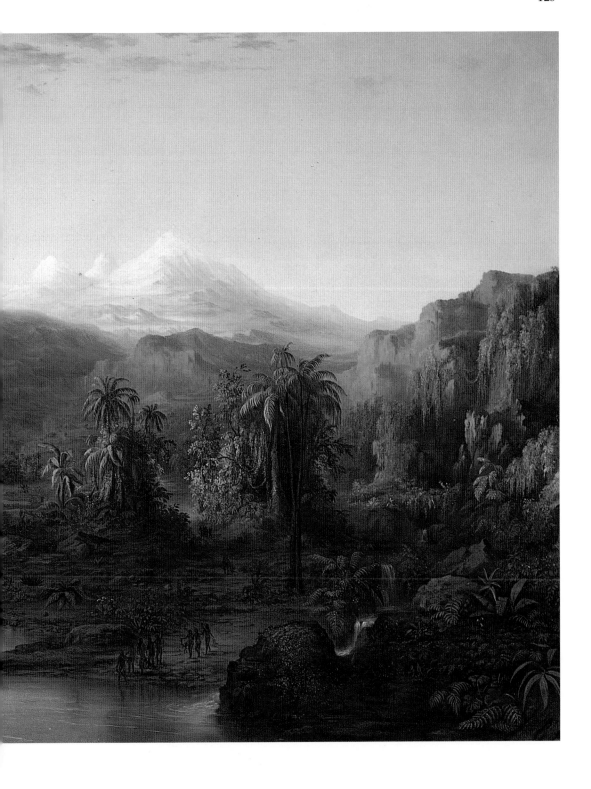

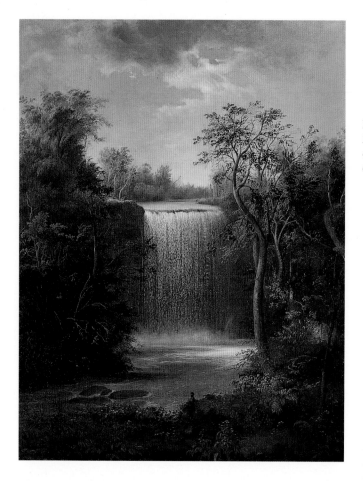

Plate 12. Robert S. Duncanson, *Falls of Minnehaha,* 1862, oil on canvas, 36″ × 28″. Private collection, Massachusetts.

Plate 13. Robert S. Duncanson, *Landscape with Brook,* 1859, oil on canvas, 10″ × 16″. Private collection, Massachusetts.

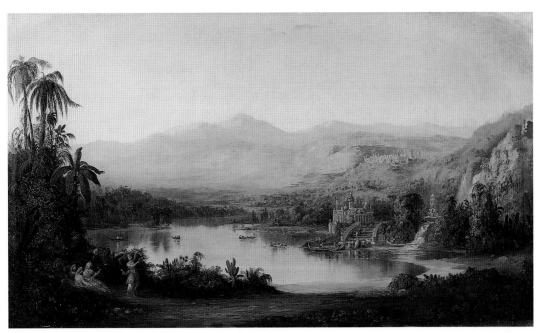

Plate 14. Robert S. Duncanson, *Vale of Kashmir*, 1864, oil on canvas, 17¾″ × 30″. Private collection, Massachusetts.

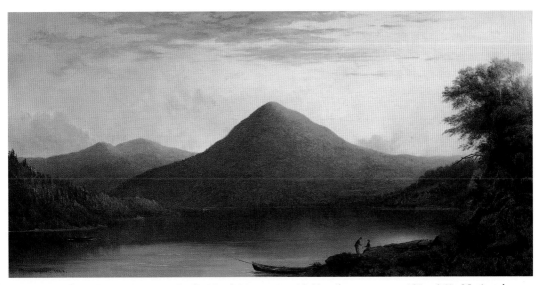

Plate 15. Robert S. Duncanson, *Owl's Head Mountain*, 1864, oil on canvas, 18″ × 36″. National Gallery of Canada, Ottawa, gift of Louis Bertrand.

128

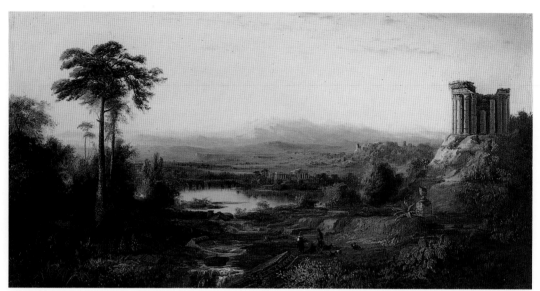

Plate 16. Robert S. Duncanson, *Recollections of Italy,* 1864, oil on canvas, 21″ × 39¾″. Wadsworth Atheneum, Hartford, The Dorothy Clark Archibald and Thomas L. Archibald Fund.

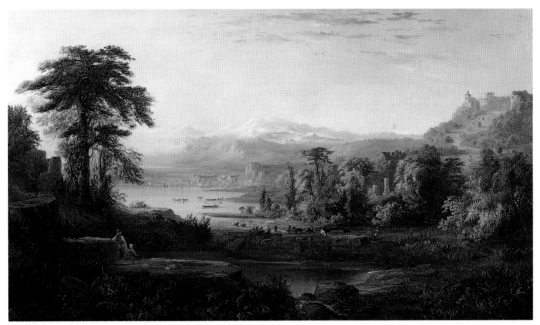

Plate 17. Robert S. Duncanson, *Dream of Italy,* 1865, oil on canvas, 21″ × 32″. Private collection, New York.

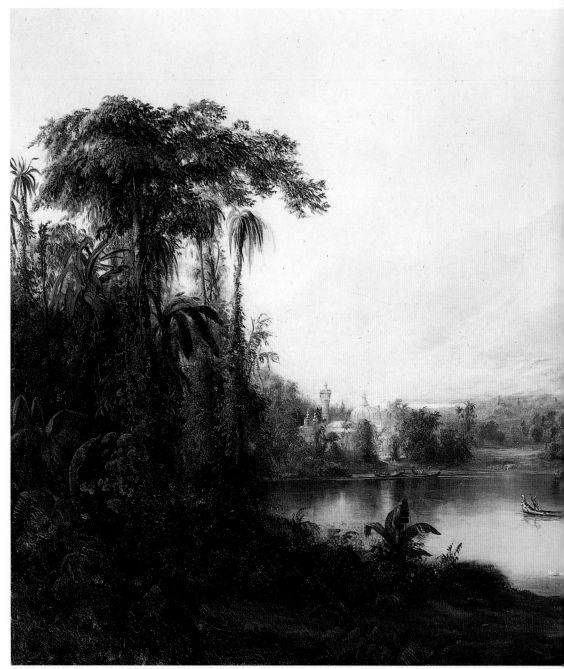

Plate 18. Robert S. Duncanson, *Vale of Kashmir*, 1867, oil on canvas, 28¾" × 52". Manoogian Foundation.

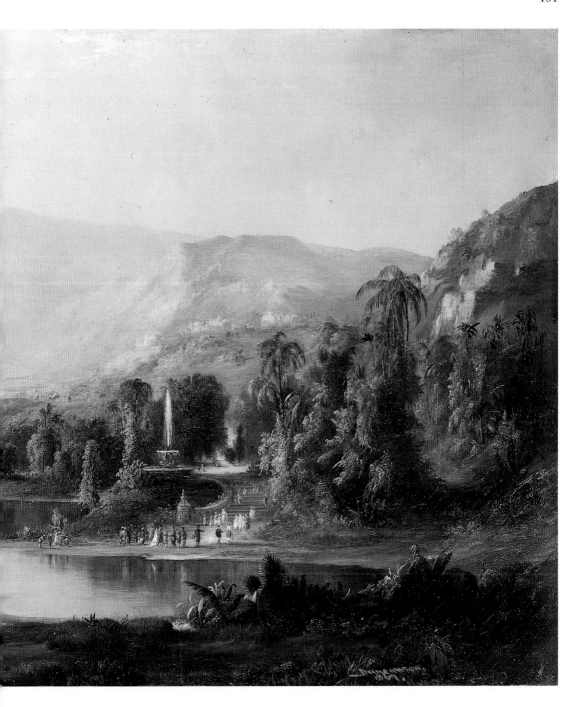

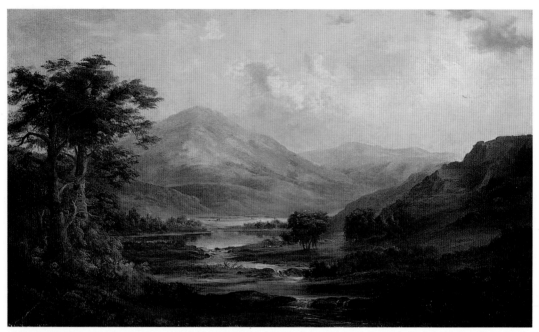

Plate 19. Robert S. Duncanson, *Scotch Landscape*, 1871, oil on canvas, 29¾″ × 50″. National Museum of American Art, Smithsonian Institution, Washington, D.C., gift of Robert Tessier and James Bauld.

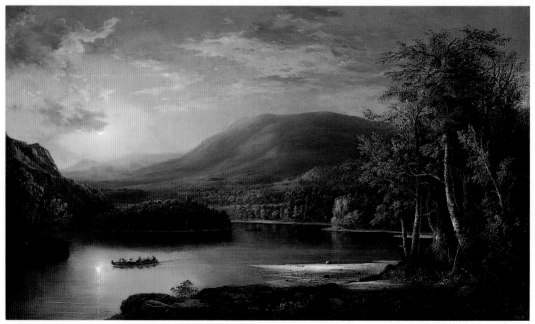

Plate 20. Robert S. Duncanson, *Ellen's Isle, Loch Katrine*, 1871, oil on canvas, 29½″ × 50″. Detroit Institute of Arts, gift of the estate of Ralzemond D. Parker.

literature, but also because of its portrayal of the vanishing noble race of Native Americans. African-Americans and Native Americans were similarly ostracized and oppressed by Anglo-American society. In this painting the African-American artist parallels the fate of the black race with that of the Indians, and he equates his abolitionist activities to the spirits calling upon Hiawatha to work on behalf of his own people. Duncanson would have been aware of this popular picturesque site in Minnesota through the landscape painting tradition, but, unlike his contemporaries, he represented the literary tradition associated with the site through the Indian woman and thereby conveyed an African-American content.

Stifled by the Civil War, most Cincinnati artists were confined to their studios. At this time a local group of artists including James Beard, Henry Mosler (1841–1920), and C. T. Webber (1825–1911) met under the aegis of the Cincinnati Sketch Club to promote artistic exchange and to stimulate the creation of literary artworks. Despite being an African-American during this time of intense civil and racial strife, Duncanson was the most prominent artist among the group and mixed freely with the white artists. The club had met periodically in the late 1850s, was suspended briefly in 1860, and reemerged as a forum for local artists in 1861.[14] Artists' clubs were a vital part of the cultural milieu in mid-nineteenth-century America. The Cincinnati Sketch Club was modeled on the New York Century Association, which was originally founded as the Sketch Club in 1847. Among the Century Association's founders were Cole and Durand, who joined "to draw closer the bonds of social intercourse between those who should be better known to each other and . . .

promote the advancement of Arts and Letters which is in accordance with the progressive Century in which we live." Echoing its New York counterpart, the Cincinnati Sketch Club met for "the furtherance and perfection of all that is beautiful in art" and "the education and improvement of conceptive talents among the artists themselves."[15]

As opposed to the Century Association's emphasis on outdoor sketching, the Cincinnati Sketch Club concentrated on interpretations of literary subjects. This was due, in part, to the Civil War and its restrictions on travel. During this difficult period, the Sketch Club provided an increasingly important source for the exchange of artistic ideas. A different artist hosted each bimonthly club meeting, to which each participant contributed a sketch on a predetermined literary subject. At the conclusion of the session, the host kept the sketches as a memento of the occasion. In its earlier days critics had accused the club of "degenerating into an association of debauchees." In time, however, the artists agreed to prohibit ladies and liquor at the meetings and settled into some productive sessions.[16]

Among the subjects selected for the sketching sessions were Lord Byron's *Childe Harold's Pilgrimage*, Thomas Moore's *Lalla Rookh,* and John Milton's *Comus.* The preference for English romantic authors indicates the literary tastes of the local artists, which were typical of Americans of this era. The club decidedly influenced Duncanson's literary tendencies for the remainder of his life. During the 1860s, as a result of his participation in the Sketch Club, he painted a series of historical subjects from English romantic literature in addition to his views of native scenery. In March 1862 he com-

pleted a full-length figure of Calliope for
the Wabash College Calliopean Society,
a painting now known as *Faith* (1862, Fig.
75).[17] The artist interpreted the Greek
goddess of heroic poetry as a female figure
wearing a toga, sandals, and a wreath
and gesturing toward the heavens.

Motivated by the commission for
Calliope, Duncanson created his first and
only female nude figure painting, *Eve*
(c. 1862, Fig. 76). He portrayed Eve as an
idealized, full-length figure standing in
a lush semitropical paradise reaching above
to the apple tree while contemplating
whether she should eat the forbidden fruit
in her hand. Eve's pose is very similar
to that of Calliope in *Faith;* however, the
nude is much more convincing and delicate
in its rendering. Nude figure paintings
were rare in early American painting.
Duncanson's *Eve* was painted after the
famous neoclassical sculpture *Greek Slave*
(1844, Yale University Art Gallery) by
fellow Cincinnatian Hiram Powers. Eve's
pose, figure proportions, and features
are precisely those of Powers's sculpture;
Duncanson simply altered Eve's gesture and
endowed her with long flowing hair.
Powers's *Greek Slave* was one of the first
well-known neoclassical nude sculptures in
America, and Duncanson definitely
would have known the piece—from its
triumphal tour of the United States
(including Cincinnati), from the engraving
published in *Art Journal*, or from his
visit to Powers's Florentine studio in 1853,
where a plaster of *Greek Slave* was
kept on display. In his first and only
painting of a female nude, Duncanson
attempted to rival the great American
neoclassical sculpture with an impressive
nude figure drawn from a biblical subject.
By creating a parallel between Powers's
Greek Slave and the original sin, the
African-American artist was also making a

veiled reference to the sin of slavery
during the heat of the Civil War.

During this period of activity in the
Sketch Club, Duncanson also portrayed
Oenone (1863, location unknown),
based on Tennyson's poem of the same
name. He submitted *Oenone* to the Great
Western Sanitary Fair of 1863, where
his rendering of Oenone's agony aroused
great empathy from the viewers, who
asked, "What other criterion can we
have . . . of a great picture than its power
to move men's minds as do the words
of eloquence?"[18] Such an impassioned
response reveals the artist's success at
evoking the intellectual content of poetry,
"ut pictura poesis," in his historical
paintings with literary subjects. The
painting also evokes Duncanson's veiled
response to the dramatic effects of the Civil
War. *Oenone,* who mourns the loss of
her children, reflects Duncanson's sense of
tragic loss at the deaths of his fellow
Americans through the war.

Like most northerners, Duncanson
probably believed that a Union victory
would be swift and the war would
be brief. Yet it had dragged on for two
years and taken a tremendous toll in
American lives. For a time late in 1862 it
even appeared that the Confederacy
was on the threshold of victory. As the
war waged on into 1863 the bleak
prospects for peace and the deteriorating
racial situation in Cincinnati increasingly
worried the artist. He had already
expressed his desire to tour his paintings
through England, and one source remarked
that he "intended coming to this country
[England] for a home."[19] Pressured by
the uncertainty of the war against slavery,
and driven by his ambition to tour his
"great pictures" through Europe,
Duncanson again crossed the border into
Canada, whence he could easily embark

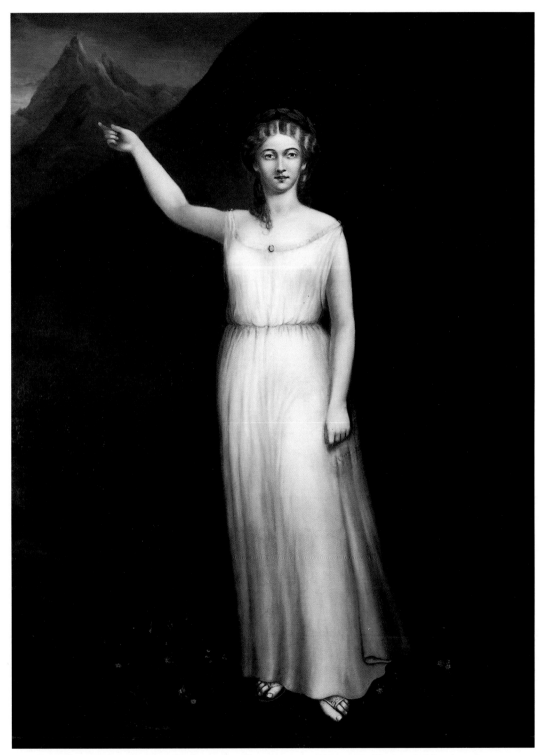

Fig. 75. Robert S. Duncanson, *Faith,* 1862, oil on canvas, 80″ × 64″. National Afro-American Museum and Cultural Center, Wilberforce, Ohio, gift of Mr. and Mrs. Robert L. Bates.

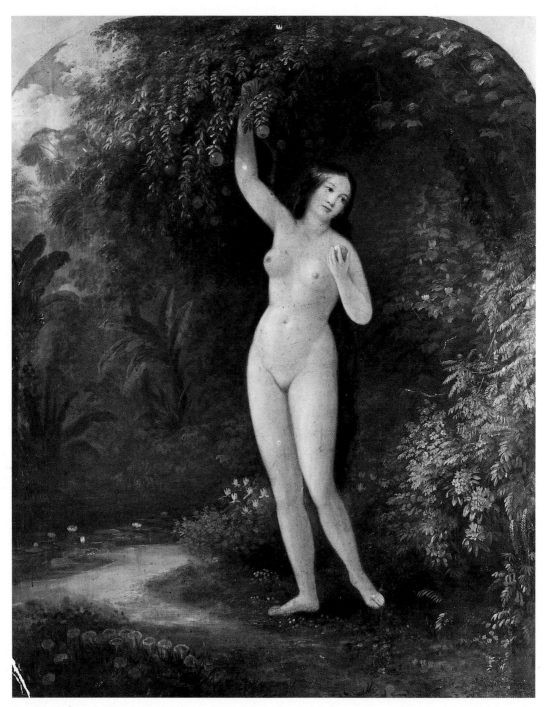

Fig. 76. Robert S. Duncanson, *Eve,* c. 1862, oil on canvas, 30″ × 25″. Douglas Himmelfarb, Los Angeles.

for England. He planned to remain briefly in Canada, exhibit his paintings, and continue on to England. His primary purpose in traveling through Canada at this time of unrest was to avoid the necessity of filing for a diplomatic passport, which was required of "free persons of color" in the United States.[20]

Duncanson arrived in Montreal by September 1863 (Fig. 77). The Canadian art community eagerly received him, and he immediately became an integral part of the local art culture. Although he intended to stop only briefly, he stayed much longer than he anticipated, living in Montreal for two years, from 1863 to 1865. The Canadians treated him with a great respect and regarded him as a leading artist from the United States. As an African-American, Duncanson was unaccustomed to such a warm reception. A contemporary Cincinnati reviewer noted that, in Montreal, "his color did not prevent his association with other artists and his entrance into good society." Ironically, none of the contemporary Canadian sources even mentioned his African heritage. Immediately upon his arrival the prestigious William Notman Photographic Gallery engaged Duncanson and exhibited his "beautiful paintings," *Lotus Eaters* and *Western Tornado*.[21] With this exhibition Duncanson stimulated the development of landscape painting in Canada at a time when Canadians were seeking a national cultural identity. Subsequently, a number of young Canadian artists emerged whose focus on the landscape was directly influenced by Duncanson.

Duncanson arrived at a critical moment in the cultural history of Canada. The 1860s witnessed a period of rising nationalism that culminated in Confederation in 1867, and the arts were beginning to

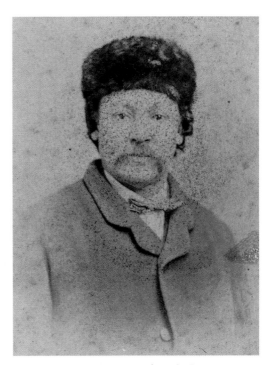

Fig. 77. N. J. Mitchell, *Robert S. Duncanson,* c. 1863–1865, daguerreotype. Private collection, Outremont, Canada.

flourish with a newly discovered enthusiasm. During this era Canadians realized that their landscape was a distinctive aspect of the commonwealth's cultural identity. The Great Exhibition of 1860 commemorating the opening of Montreal's Victoria Bridge provided a stimulus for this cultural development and the foundation of the Art Association of Montreal. In addition, the Notman Gallery provided a nucleus for a number of artists and a resource for aspiring collectors and served as the focus for the development of a visual arts culture in Montreal.[22]

When Duncanson arrived in Montreal, William Notman (1826–1891) was regarded as the most influential cultural figure in Canada. Notman had been practicing photography for six years; due to the lack of competition, his studio was enormously popular for its portraits as

Fig. 78. William Notman. *City and Harbour of Quebec, after Robert S. Duncanson,* 1863, daguerreotype. Notman Archives, McCord Museum, McGill University, Montreal.

well as landscape photography and stereoscopic work. Notman's cultural position was assured when he was dubbed "Photographer to the Queen" after presenting his deluxe "Prince of Wales" portfolio of stereoscopic views of Canada to the Prince in 1860 at the commemoration of the Victoria Bridge. In 1863, shortly after Duncanson's arrival, Notman began preparing his landmark photographic portfolio, *Photographic Selections,* which he published "to foster the increasingly growing taste for works of art in Canada, and to meet a demand which cannot otherwise be generally supplied, consequent on the scarcity in these Provinces of choice original works of art, or even of proof engravings of the old or modern masters."[23] Notman's portfolio represents a statement of the artistic ambitions of Canadians at this crucial moment in Canadian cultural history.

Photographic Selections contained a compendium of images photographed from engravings after the works of established European artists whom Canadians recognized as "old masters." The "modern

masters" in the portfolio included two from the United States, Frederic Edwin Church, whose *Heart of the Andes* was the frontispiece, and Duncanson, who was represented by photographs of his *Land of the Lotus Eaters* and *City and Harbour of Quebec* (1863, Fig. 78). The text accompanying these photographs illuminates the African-American's stature at this early point during his years in Montreal: "Mr. Duncanson has been for some time a resident in Montreal; where he has met with that success and encouragement in his profession as a landscape painter, which he was entitled to expect as the painter of the Lotus Eaters." The Montreal public enthusiastically received the portfolio, especially Duncanson's works. The *Montreal Herald* proclaimed, "Duncanson's Land of the Lotus Eaters.— This great picture from Alfred Tennyson's loved poem of the same name . . . has been photographed by Notman, and is surely one of the best which we have seen from that prolific retailer of representative skill; and we have no hesitation in pronouncing it a perfect triumph of

photographic art."[24]

Photographic Selections also attracted the attention of English critics. The London *Art-Journal* praised it for including "some of the best photographic pictures we ever saw." Citing Duncanson as a Canadian artist, the English reviewer took particular note of his *Land of the Lotus Eaters* as "highly poetical and imaginative in character, reminding us not a little of some of John Martin's most beautiful and picturesque designs; Mr. Duncanson is evidently an artist of more than ordinary talent."[25]

Even at this early stage in his residence in Montreal, Duncanson clearly had influenced some Canadian painters. *Photographic Selections* included works by only two Canadians, C. J. Way (1834–?) and John A. Fraser (1838–1898), who were represented by one illustration each. Both artists were employed by Notman's studio, which suggests a commercial motivation behind their inclusion in the portfolio. Without a previous tradition of landscape painting, it is surprising that both Way's and Fraser's paintings depict North American scenery. The photographs after paintings by these two local artists clearly show the influence of landscape painters from the United States, particularly Duncanson. Evidently Duncanson influenced these local artists with his canvases exhibited at the Notman Gallery only a few months earlier.

By the time of his departure two years later, Duncanson's grand historical paintings and his landscapes of Canadian scenery had fostered the first native landscape painting school. A survey of the artist's work in Canada within the context of the cultural environment of Montreal indicates the dramatic influence he had on a number of emerging landscape painters. Interestingly, the overwhelming impression of the Canadian wilderness, and the prevailing landscape-photography aesthetic of the regional artists, also affected the African-American's work in a subtle manner. He developed toward a more realistic rendering of landscape scenery that is directly attributable to his contact with the Canadian artists.

While living in Canada, Duncanson maintained his usual artistic habits, sketching in the summer and working up canvases in the fall for exhibition in the winter and spring. He brought his ambitious historical paintings on tour to Canada, but his attention was primarily captivated by the spectacular Canadian landscape. During both his summers in Canada, Duncanson sketched the scenery between Montreal and Quebec in Canada East, now Quebec Province. Four of his six identifiable Canadian landscapes depict the Quebec City locale: *City and Harbour of Quebec, On the St. Anne's, East Canada* (1863–1865, Fig. 79), *Lake St. Charles, near Quebec* (1864, Fig. 80), and *Lake Beauport* (1865, Fig. 81). The other two identifiable landscapes are *Mount Royal* (1864, Fig. 82) and *Owl's Head Mountain* (1864, Plate 15). The former, the artist's only extant watercolor, depicts a tree-lined path with a view up to Mont Real (Mt. Royal), which crowns Montreal Island. The more dramatic *Owl's Head Mountain* captures a romantic view on scenic Lake Memphremagog, a popular sketching spot for Canadian artists east of Montreal. The locations of these six scenes constitute a logical touring circuit for Duncanson. From his base in Montreal, he most likely traveled east up the St. Lawrence River to Quebec, south to Lake Memphremagog, and then west back to Montreal.

Conscious of his Canadian patrons'

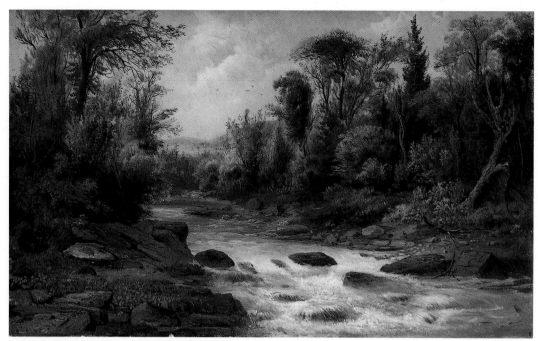

Fig. 79. Robert S. Duncanson, *On the St. Anne's, East Canada,* 1863–1865, oil on canvas, 9⅛″ × 15″. National Museum of American Art, Smithsonian Institution, Washington, D.C., gift of Herbert Drown.

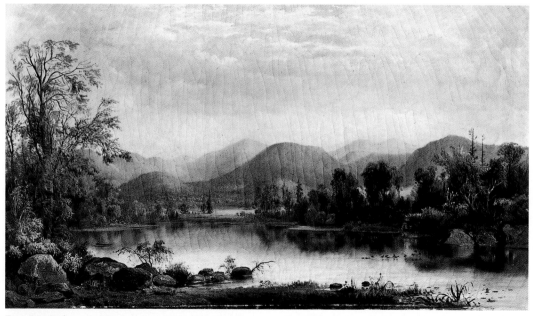

Fig. 80. Robert S. Duncanson, *Lake St. Charles, near Quebec,* 1864, oil on canvas, 16″ × 28″. Musée du Quebec, gift of William M. Connor.

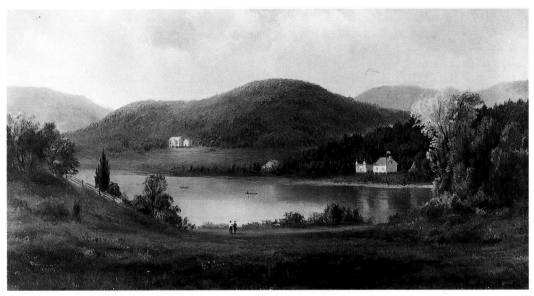

Fig. 81. Robert S. Duncanson, *Lake Beauport with the Old Bigaoutte Hotel and the Old Chapel,* 1865, oil on canvas, 12″ × 22″. Musée du Quebec, purchase.

interest in scenes of their countryside, Duncanson painted many well-known locations, such as the *City and Harbour of Quebec* and *Lake Beauport,* enhancing them with historical associations. Among his earliest Canadian works, *City and Harbour of Quebec* remains unlocated, but its image is preserved in Notman's *Photographic Selections* (Fig. 78). The panoramic sweep of the landscape surrounding Quebec is topographically and architecturally accurate. The artist's rendering and choice of viewpoint pleased Notman, "for perhaps from no other spot could so magnificent a view of the city and harbour of Quebec be obtained; and he has literally succeeded." The painting depicts a number of historical monuments that evoked strong nationalist sentiments and captured the attention of Canadian viewers, who immediately associated the scene with the eighteenth-century battles between the French and the English that established them as an English commonwealth: "The picture will always possess an interest. The

old citadel, with its crowning battlements, ever recalling to mind the glorious deeds of the heroic Wolfe and Montcalm, stands as a sentinel to protect the commerce of the St. Lawrence. What a goodly sight!"[26] Duncanson played to Canadians' burgeoning nationalist sentiments with this and other landscapes (Figs. 83–84).

While in Canada the artist continued to execute historical paintings like those that had initially established his Canadian reputation. He created several imaginary compositions, with subjects from romantic literature and from his Italian sketchbooks. One of the first literary subjects that he painted in Canada was *Vale of Kashmir* (1864, Plate 14), inspired by Thomas Moore's popular epic romance *Lalla Rookh.* The artist also returned to his most ambitious statement on European ruins, *Temple of the Sibyl* (1859, Fig. 57), as a source for his most successful Italian ruins paintings, *Recollections of Italy* (1864, Plate 16) and *Dream of Italy* (1865, Plate 17). Whereas Cincinnati

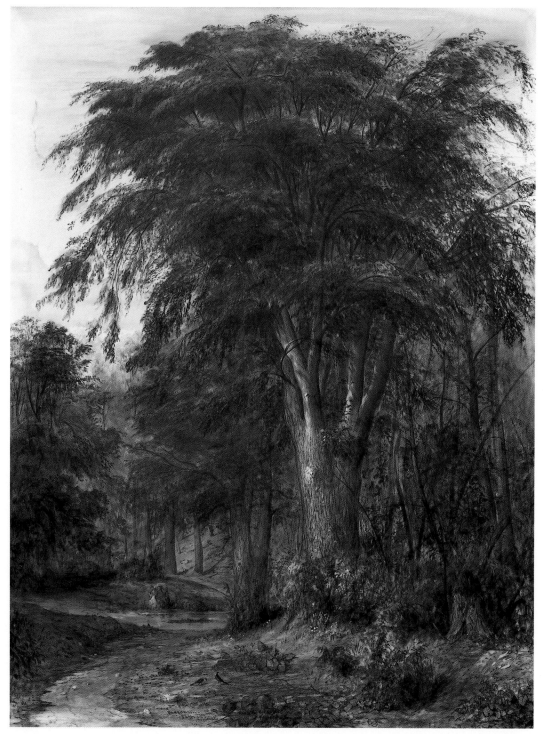

Fig. 82. Robert S. Duncanson, *Mount Royal,* 1864, watercolor on paper, 36¾" × 28¼". National Gallery of Canada, Ottawa, purchase.

Fig. 83. Robert S. Duncanson, *River with Rapids,* c. 1864, oil on canvas, 29″ × 24″. Art Gallery of Ontario, gift of Mort Lesser in memory of Jean Evelyn Lesser, 1985, Toronto.

Fig. 84. Robert S. Duncanson, *Canadian Landscape,* 1865, oil on canvas, 9¾" × 17". North Carolina Museum of Art, Raleigh, gift of Peter A. Vogt.

reviewers had criticized *Temple of the Sibyl* for its sharp division between foreground and background, Duncanson resolved this problem in *Recollections of Italy.* With the fallen ruins of a building's cornice, the artist leads the eye steadily to the middle-ground lake, uninterrupted by a dividing wall, and across to distant ruins silhouetted against a curtain of purple mountains. Duncanson derived this transitional motif of the fallen stones from his earlier *Pompeii* (1855, Fig. 52), painted shortly after his first trip to Italy. Not having been in Italy for over a decade, he relied heavily on his earlier sketches for the new composition.

Shortly after the artist's arrival, the Art Association of Montreal met to elect officers and plan its second exhibition after a hiatus of almost four years since the Great Exhibition in 1860.[27] The Art Association opened its Second Conversazione on February 11, 1864, with nearly two hundred paintings featuring works

from prominent private collections of European art and a few established local artists. The Second Conversazione boosted the visual arts in Montreal to a new height. The *Montreal Herald* proudly boasted, "No one who has lived a few years in Montreal could fail to remark the great advance which has been made in the number and character of the pictures possessed by our collectors."[28]

Duncanson was prominently featured in the Second Conversazione with two of his "great pictures," his famous *Lotus Eaters* and *Prairie Fire.*[29] Among the largest works in the Conversazione, his paintings presented to Canadians two grand visions of nature: the pastoral historical composition of *Lotus Eaters* and the sublime North American grandeur of *Prairie Fire.* The local reviews of the exhibition focused on the artists "who either by birth or adoption we rank as Canadian artists."[30] This group included Duncanson, whom the press regarded

as a major figure among the regional artists. The consideration of Duncanson as a Canadian may have been due to the fact that he maintained a residence in Montreal, and local reviewers desired to claim the famous artist as their own. However, it may also imply the artist's own growing doubts about his American citizenship in this foreign land where his racial heritage was not an impediment. A few other artists from the United States exhibited in the Conversazione, including Martin Johnson Heade and William Hart (1823–1894), but they did not receive any press coverage.

Although Duncanson had already begun to make an impact on Canadian artists C. J. Way and John A. Fraser within the first month of his arrival, the Second Conversazione demonstrated that Canadian art was still dominated by the Düsseldorf genre painting style of German immigrants William Raphael (1833–1914) and Cornelius Krieghoff (1815–1872), which was very popular in the 1850s and early 1860s.[31] The centerpiece of the exhibition was *Bonsecours Market* (location unknown), in which Raphael, a local artist, applied the Düsseldorf style he learned in his homeland to a detailed depiction of the central marketplace in Montreal. At the time, his work was proudly proclaimed as "a genuine Canadian picture in every sense of the word."[32] However, a stylistic transformation would be evident in the next Art Association exhibition in the following year.

The success of the February 1864 exhibition prompted the Art Association to host another in February 1865. For the Third Conversazione, Duncanson entered eight paintings comprising six views of popular Canadian sites and two imaginary compositions, including *Vale of Kashmir;* one of the Canadian views was a

watercolor, possibly *Mount Royal.*[33] The press did not receive this exhibition as enthusiastically as it had the previous Conversazione. The exhibition only warranted coverage on page two of the newspaper, where the critics expressed their disappointment: "We will not say that the hall was as well supplied with works of art as it was on the last occasion, but we are happy to say there is in the present exhibition still much to invite attention." Again the press singled out Duncanson for recognition, drawing special attention to his *Falls of the Chaudiere:* "In this picture there is a freshness and sparkle in the water altogether charming and natural."[34] This painting may have been a variation of Duncanson's later *Canadian Falls* (1865, Fig. 85), which possesses a similar "freshness and sparkle in the water" and was a subject he repeated later from a different viewpoint in *A Wet Morning on the Chaudiere Falls* (1869, Fig. 103).

The impact of Duncanson's artistic influence on the paintings in this exhibition was significant. The centerpiece of the exhibition, Otto R. Jacobi's (1812–1901) *Emigrants Pioneering West* (1865, Fig. 86), was directly inspired by Duncanson's *Lotus Eaters.* Motivated by Duncanson's romantic landscape painting, Jacobi would become one of Canada's most significant artists of the 1860s and 1870s. *Emigrants Pioneering West* drew the spotlight in a review of the exhibition that described it as "a work of surprising excellence [that] would in any country possess vast historic interest, but in this Canada of ours must have more than elsewhere."[35] As Duncanson did with his *City and Harbour of Quebec,* Jacobi capitalized on Canadian nationalist sentiment with an ambitious historical landscape. At this time the Canadian

Fig. 85. Robert S. Duncanson, *Canadian Falls,* 1865, oil on canvas, 20⅛″ × 16″. National Gallery of Canada, Ottawa, gift of Jean F. Duquet.

Fig. 86. William Notman, *Otto Jacobi's Emigrants Pioneering West,* plate 27 in *Notman's Photographic Selections,* 1865, albumen print, 5 ⁶/₁₆″ × 10 ¹¹/₁₆″. National Gallery of Canada, Ottawa.

population was growing rapidly and steadily expanding westward as immigrants poured in from both Europe and America.[36] The dramatic sunset on the horizon casts a divine glow over the group of pioneers, symbolically bestowing them with providential blessing for their western journey. Obviously, Jacobi had attempted to rival Duncanson's *Land of the Lotus Eaters,* featured in the previous year's exhibition, by preparing his own historical painting based on a similar composition and with a similar panoramic scale for the 1865 exhibit.

Duncanson's example diverted Jacobi from his previous Düsseldorf academic style. Shortly after emigrating to Montreal in 1860, Jacobi produced paintings such as *Falls of the Ste. Anne, Quebec* (1865, Fig. 87), which precisely replicates one of Notman's photographs (Fig. 88).[37] The exacting realism, photographic focusing, and tightly cropped composition demonstrate the photographic eye with which Jacobi approached landscape painting. Under Duncanson's influence, Jacobi abandoned this photographic realism to

paint more romantic views of the Canadian landscape. Duncanson's landscapes continued to affect Jacobi long after the African-American's departure from Canada. A comparison of Jacobi's picturesque *Canadian Autumn* (1870, Fig. 89), which characterizes his mature style, with Duncanson's *On the St. Anne's, East Canada* (1863–1865, Fig. 79) and *Canadian Landscape* (1865, Fig. 90) demonstrates this influence.

Duncanson's work made a lasting impact on other important Canadian landscape painters. Early in his stay in Montreal, he accepted a pupil, Allan Edson (1846–1888), who worked as a clerk in A. J. Pell's art gallery from 1863 to 1865. Edson's obituary noted, "At an early age Allan Edson displayed considerable talent in landscape sketching. While still in his boyhood, he came to Montreal and studied under the late Mr. Duncanson." In Edson's brief career as an artist, Canada recognized him as one of its greatest landscape painters. His youthful works such as *The Pike River, near Stanbridge* (c. 1864, Fig. 91) mirror the compositional

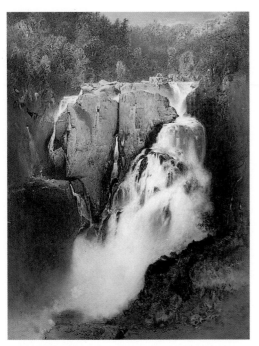

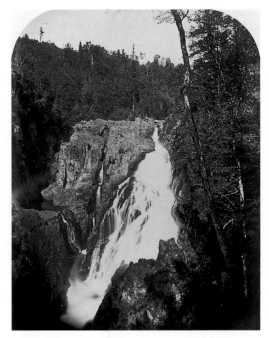

Fig. 87. Otto R. Jacobi, *Falls of the Ste. Anne, Quebec,* 1865, oil on canvas, 30″ × 23⅛″. Art Gallery of Ontario, Toronto, gift of Thomas Jenkins, 1927.

Fig. 88. William Notman, *Ste. Anne Falls near Quebec,* plate 33 in *Notman's Photographic Selections,* 1865, albumen print, 9″ × 6⅝″. National Gallery of Canada, Ottawa.

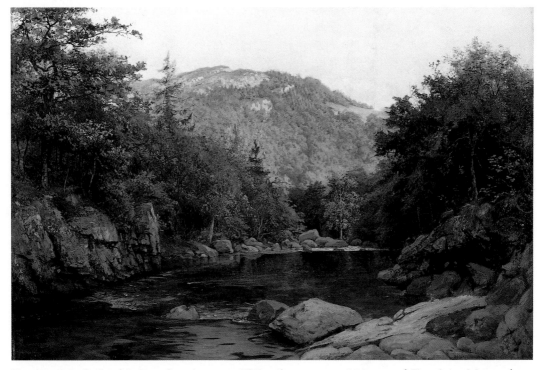

Fig. 89. Otto R. Jacobi, *Canadian Autumn,* 1870, oil on canvas. Museum of Fine Arts, Montreal.

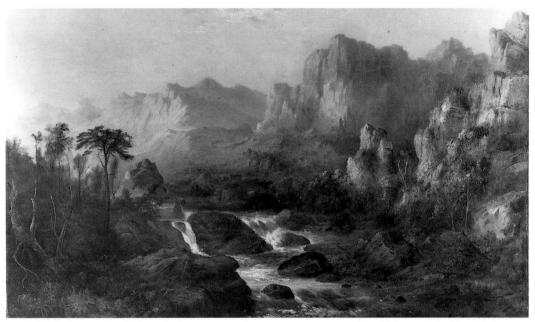

Fig. 90. Robert S. Duncanson, *Canadian Landscape,* 1865, oil on canvas, 30″ × 50″. Eric Wentworth, Washington, D.C.

devices and style of his instructor. The colorful, evocative sky and the overall composition emulate the romantic landscape painting style of Duncanson in his *Sunset Study* (1863, Fig. 92).[38]

The American painter profoundly affected Edson's subsequent work such as his great *Mount Orford, Morning* (1870, Fig. 93). Rising from the dense, verdant Canadian forest, the rounded head of Mt. Orford peers out from behind the thick cloud bank. The misty, mysterious atmosphere is enhanced by the romantic metaphors of the torn tree trunks and the abandoned boat on the shore of Lake Memphremagog below the imposing mountain—all motifs derived from Duncanson's landscapes. A comparison with Duncanson's *Owl's Head Mountain* (1864, Plate 15), also a scene on Lake Memphremagog, reveals the similarities. The composition, picturesque details, and dramatic sky of *Mt. Orford* confirm

that Edson absorbed Duncanson's style and aesthetics.

At the same time, the influence of Canada's primitive wilderness landscape and the landscape-photography aesthetics of Notman can be seen in Duncanson's work of the mid-1860s. In pursuing a more realistic rendering of his landscape views and moving away from imaginary compositions and fantastic subjects, Duncanson was following Ruskin's dictum to study nature closely and through its realized forms reveal its soul and sentiments. This is most evident in his paintings of popularly recognizable Canadian sites, such as *City and Harbour of Quebec, Lake St. Charles,* and *Lake Beauport.* In addition to their topographical accuracy, these works share a greater sense of naturalism than his earlier landscapes.[39]

Notman was one of the first Canadian artists to consider the landscape a

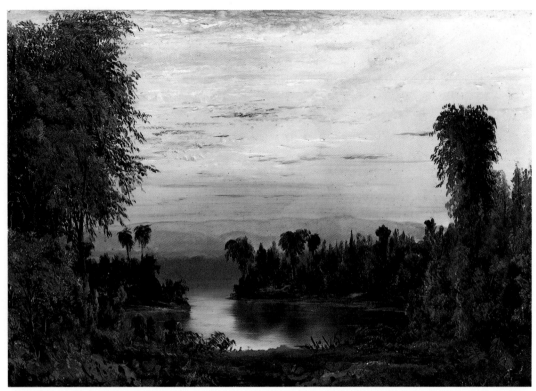

Fig. 91. A. Allan Edson, *The Pike River, near Stanbridge,* c. 1864, oil on board, 9″ × 13″. National Gallery of Canada, Ottawa, gift of Edgar and Elizabeth Collard, Montreal, 1977.

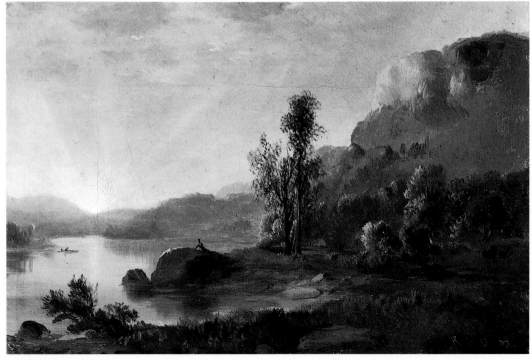

Fig. 92. Robert S. Duncanson, *Sunset Study,* 1863, oil on canvas, 7″ × 10⅛″. Montreal Museum of Fine Arts, gift of Miss C. Burroughs, Quebec.

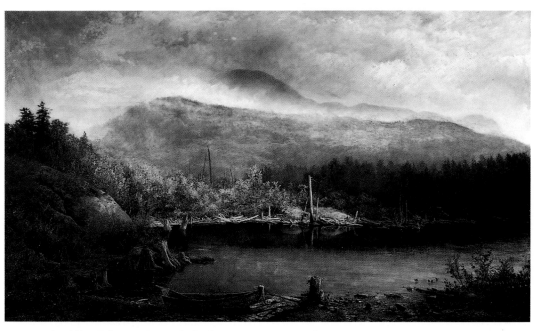

Fig. 93. A. Allan Edson, *Mount Orford, Morning,* 1870, oil on canvas, 36½" × 60⅛". National Gallery of Canada, Ottawa.

suitable subject matter, and his vision of the landscape inspired other Canadian artists.[40] The influence of their landscape-photography aesthetics can also be seen in Duncanson's work. At an early point in his association with Notman, the painter copied a Notman stereograph from the "Prince of Wales" portfolio of 1860 (Fig. 94), in the manner of Jacobi, for his *Waterfalls of Montmorency* (1864, Fig. 95). Duncanson had seen the falls on several occasions, and even painted his *City and Harbour of Quebec* from the falls. But a photograph provided the source for *Waterfalls of Montmorency,* rather than sketches executed on location. The viewpoint of the falls, the tree-crested top, and the two subsidiary falls to the left precisely replicate the stereograph. The artist simply generalized the features of the rocky face and added a typical picturesque foreground. His strict attention to accurately reproducing the topography of the site recorded in Notman's photograph

confirms his interest in the photographer's perspective on the landscape.

From the time of his arrival in Montreal, Canadians recognized Duncanson as the most accomplished landscape painter in their country. In addition to his dramatic influence on Montreal artists such as Otto Jacobi and Allan Edson, the pervasive effect of the African-American's paintings is confirmed by the continuous growth in the number of landscapes exhibited in the annual Art Association exhibitions through the decade. After Duncanson helped popularize landscape painting in Canada, American landscape painters, including Durand, the brothers William and James MacDougal Hart, and Kensett, were increasingly represented at the Art Association exhibitions and in the local galleries. Sonntag began to show works at the Art Association exhibition of 1867 and was also represented by the dealer A. J. Pell. Later, Albert Bierstadt traveled to Canada, where he had a

Fig. 94. William Notman, *Montmorency, Quebec,* c. 1860, stereograph. Notman Archives, McCord Museum, McGill University, Montreal, Canada.

decisive influence on Lucien O'Brien (1832–1899) and the landscape style of the Royal Canadian Academy of Arts.[41]

The combination of a nationalistic identification with the landscape and the example of Duncanson and other landscapists from the United States fostered the formulation of a Canadian school of landscape painting, centered on Jacobi, Edson, Fraser, and O'Brien, that continued throughout the nineteenth century. Certainly, Duncanson played a decisive role in the movement's formative stages during his two fruitful years in Canada. In 1833 a Quebec art critic had lamented, "Our native painters have not devoted some part of their time to . . . the scenery of Canada."[42] By the 1870s numerous Canadian artists had discovered the native landscape as an expression of their national character.

After two seasons in Montreal, Duncanson finally departed for his original destination, England, in the summer of 1865. Allan Edson and C. J. Way

also traveled to England at this time and were very likely in Duncanson's company.[43] During his residence in Montreal he had assembled a group of ambitious paintings in preparation for the English audience. In addition to *Lotus Eaters* and *Western Tornado* he painted "a replica of the 'Lotus-Eaters,' a view of 'Niagara,' 'The Prairie on Fire,' and 'Oenone'. . . . All of these paintings are of nearly the same dimensions as the 'Lotus-Eaters.'"[44] His journey began with his participation in the Dublin International Exhibition of 1865, where he exhibited *Lotus Eaters* and *Chaudiere Falls near Quebec* as a Canadian artist.[45] In the fall of 1865 he toured *Lotus Eaters* and his other large-scale paintings through Glasgow, while sketching the famous picturesque sites in the Scottish Highlands, before moving on to London.

Early in 1866 Duncanson unveiled his *Land of the Lotus Eaters* to the London art world. One critic was so moved by the painting as to forgo his typical English

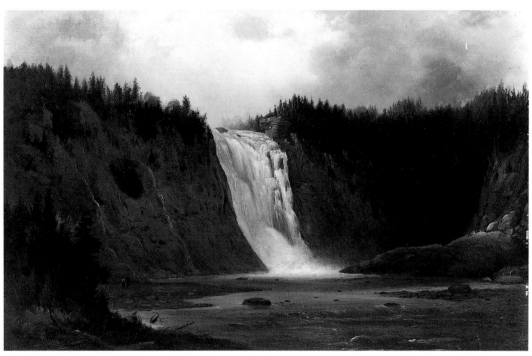

Fig. 95. Robert S. Duncanson, *Waterfalls of Montmorency,* 1864, oil on canvas, 18″ × 27¾″. National Museum of American Art, Smithsonian Institution, Washington, D.C., gift of Dr. Norbert Fleisig.

nationalism and proclaim: "America has long maintained supremacy in landscape art; perhaps, indeed, its landscape artists surpass those of England: certainly we have no painter who can equal the works of Church; and we are not exaggerating if we affirm that the production under notice may compete with any of the modern British school." In his description of the painting the reviewer noted the qualities that immediately captivated the imaginations of the English audience: "The picture is full of fancy. It is a grand conception, and a composition of infinite skill; yet every portion has been studied with the severest care . . . this painting may rank among the most delicious that Art has given us, but it is also wrought with the skill of a master in all, even the minutest of its details."[46] Thus Duncanson realized his most cher-

ished artistic aspiration—to be recognized internationally as a "master."

The English hosted numerous touring exhibits by American landscape artists in the mid-nineteenth century, and they were extremely popular with their audiences. Church exhibited his *Niagara* (1857, Corcoran Gallery of Art) to great applause in 1857. During the mid-1860s McLean & Co., on Haymarket, actively exhibited the large works of American landscape painters. Although the review of Duncanson's exhibit mentions no location, McLean's may have served as the site. Just prior to his exhibit in London, the gallery hosted a group of Church's works, *Cotopaxi* (1862, Detroit Institute of Arts), *Chimborazo* (1864, Museum of Fine Arts), and *Aurora Borealis* (1865, National Museum of American Art). Shortly after Duncanson's London debut,

Bierstadt showed his monumental painting *Rocky Mountains* (1863, Metropolitan Museum of Art, New York) at McLean's. These exhibits were so popular with the English that Bierstadt returned two years later to display a work the London *Art-Journal* referred to as *Domes of the Yosemite*.[47]

The poet laureate, Alfred, Lord Tennyson, had received from Canada one of Notman's proof photos of *Land of the Lotus Eaters* and responded with an invitation for the painter to visit him at his home on the Isle of Wight. Addressing him as "one of my Canadian kinsmen," Tennyson welcomed the artist and his painting: "Come whence it may, your landscape is delightful; and though not quite my lotus land, is a land in which one loves to wander and linger."[48] Duncanson certainly must have been gratified to receive Tennyson's personal approval for his interpretation of *Lotus Eaters*.

While in London, the artist explored the major museums and collections. In the South Kensington Museum (now the Victoria and Albert) he encountered a former associate from Cincinnati, the Reverend Moncure D. Conway. The artist described to Conway his extensive travels and accomplishments of the previous two years. The journalist reported the details back to Cincinnati in an article that discussed the painter's relation to Canada, England, and the international artistic audience. "He gained much of culture and encouragement in Canada, retouched his *Lotus Eaters,* produced one or two still better paintings, and set out for England. In Glasgow and other Scottish cities he exhibited his paintings with success. He has been invited to come to London by various aristocratic personages, among other, by the Duchess of Sutherland and the Duchess of Essex, who will be his patrons."[49]

This article reconfirms the artist's prolific activities in Canada and clarifies his aristocratic social connections in England. Conway recounted the artist's audience with Tennyson and expressed a typical American's surprise at the social mixing of an African-American artist with the aristocratic poet laureate: "Think of a negro sitting at the table with Mr. and Mrs. Alfred Tennyson, Lord and Lady of the Manor, and Mirror of Aristocracy, and so forth." During this period English abolitionist sympathies were highly charged by the American Civil War. Although many English supported the Confederacy for economic reasons, they were appalled by the enslavement of Africans, a practice they had abolished in the Caribbean many decades earlier. The painter attracted considerable attention among the English as an exemplar of an African-American's capabilities in the arts. The English aristocracy avidly patronized him and recognized him as one of the important American landscape painters of the day.[50]

Duncanson's connection with the network of English aristocratic abolitionists was greatly facilitated through the help of Charlotte Cushman, who had earlier bought Duncanson's *Western Forest* as a gift for the duchess of Sutherland. Through Cushman, the artist was introduced to other members of the aristocracy, including the king of Sweden, the marquis of Westminster, and Viscount Astor.[51] Unfortunately, it is not known how many of these acquaintances purchased Duncanson's works for their collections. Only one of the "great pictures" that the artist took with him to England from Canada is currently known to reside in a European collection, *Land of the Lotus Eaters*.[52] *Western Forest* was also

discovered in a European collection, and today has returned to its city of origin, having been acquired by a private collector in Cincinnati. The other seven-foot paintings—*Western Tornado* (1862), *Prairie Fire* (1863), *Niagara* (1863), and *Oenone* (1863)—remain unlocated and may still be extant, hidden in the private collections of Europe.

The artist stayed in England for only one year. By the winter of 1866–1867 he had set up another studio back in Cincinnati on Fourth Street. It is difficult to explain why he would have returned home after experiencing international acclaim in foreign lands where his art, not his race, was the important issue. In the summer of 1863 he had exiled himself from the civil and racial strife of the United States, seeking international acclaim for his historical landscapes. For several years Canadians claimed him as a citizen. Prior to his tour of the British Isles, an English art critic anxiously announced that the famous African-American landscape painter had intended to expatriate to London.[53] Yet he returned to the United States after a relatively short time. Perhaps the cessation of the Civil War and the success of his European endeavor encouraged him to return home. Far from his family, perhaps the strain of his oncoming illness made life increasingly difficult for the artist to manage. After exhibiting his most ambitious productions in Canada, Scotland, and England and earning the accolades of their critics, he returned to the comfort of his family and home. From his Cincinnati studio he could exhibit his new Scottish scenes with the confidence of a master who had won international artistic laurels.

8

The Lure of Scotland

After three years of self-imposed exile from the Civil War, Duncanson returned to Cincinnati a prominent artist who had achieved international acclaim. His experiences in Canada, Scotland, and England had altered his representation of the landscape. Influenced by Canadian landscape photography, by the rewards of international patronage, and by his awareness of the latest developments of Ruskinian aesthetic theory, the artist evolved toward more natural, and less allegorical, landscapes. Over the subsequent five years Duncanson attempted to incorporate Ruskin's "truth to nature" dictum in his work by reducing the obviously picturesque and composed props in his landscapes. Yet he also continued to pursue his more academic interest in the historical landscapes or "great pictures" that had earned him such success. He was continuing to evolve a synthesis of the academic ideals of didactic subjects with his interest in capturing the sentiment and soul of nature through a direct study of the landscape.

Duncanson's tours of the Scottish Highlands attracted his attention to the rugged Scottish terrain and reaffirmed his affinity for English romantic authors. Reading Sir Walter Scott's *Waverley Novels* while traveling through Scotland particularly excited the painter's imagination with the literary-historical associations of the picturesque Scottish countryside. Upon his return, he revealed his enchantment with the land and lore of Scotland in a series of major landscapes that culminated

his career. In these works he depicted scenic spots in Scotland that were ripe with historical and literary associations. Picturesque tours of the Scottish Highlands had been popular since the late eighteenth century when William Gilpin wrote guides for tourists seeking the popular sites of the region. Following well-worn routes, the landscape painter visited the locations made famous by Scott, where he sketched numerous views. Back in his studio he developed these sketches into larger, more ambitious paintings enlivened by staffage figures that alluded to his literary sources. Unlike his earlier paintings based on literature, the landscapes of this late period progressed well beyond literal translations of written sources. He sensitively evoked the literary sources with a new Ruskinian-inspired naturalism to create images in which the landscape functions to convey the sentiments of the literature with few literary props.

In a few of his more exotic historical paintings of this period, Duncanson evolved toward a resolution between his academic literary landscapes and Ruskinian naturalism. Fantastic and paradisiacal subjects had always preoccupied him— beginning with his *Garden of Eden* and climaxing with *Land of the Lotus Eaters*— as a vehicle to express his desire for an ideal world. In the late 1860s he pursued this genre with a passion inspired by Thomas Moore, which resulted in a series of five paintings based on Moore's epic *Lalla Rookh*. The literary paintings of the late 1860s motivated by Moore and

Scott are distinguished from the earlier fantastic images of a tropical paradise by their heightened realism, refined detail, and less obvious use of compositional conventions.

In the final two years of his career, Duncanson's style evolved again, and his landscapes exhibited a new and startling transcendental serenity expressed in his sensitive handling of light. Throughout his career his paintings, whether landscape views or historical subjects, had always tended toward the pastoral. In his final works the light of luminous skies, glowing on the horizon and reflected in shimmering pools, established a calm and contemplative mood that seemed to constitute the primary subject of his paintings. He transformed the sentiment of his works from the picturesque to an idyllic mood of classical landscape aesthetics. This style reached a culmination in *Ellen's Isle, Loch Katrine* (1871, Plate 20), in which the associational value of the scenery sets the stage for a narrative, which is represented through expressive natural forms and a brilliantly luminous sky.

Armed with numerous sketches of Scottish scenery, Duncanson opened a new Cincinnati studio in the fall of 1866 and began to produce paintings from the sketches of his Scottish journey for his local patrons. He resumed his position, vacated for three years, as the primary landscape painter in the region. He joined with other artists to found the Associated Artists of Cincinnati and its accompanying School of Design. The group formed for the purpose of "providing the means for a more thorough knowledge of Art, and rendering it available to the many students in our midst, by keeping in operation Life and Antique Schools." Ultimately, the association hoped to establish a permanent art school and

gallery for the Ohio River region and "to make Cincinnati what it should be— the Art center of the Great West."[1]

Early in 1867 the Associated Artists hosted its first exhibition with the hope of raising funds for the School of Design. As one of the major exhibitors, Duncanson contributed five Scottish scenes and a copy of his popular *Lotus Eaters*. Four of the six paintings had been sold before the exhibition opened, indicating the popularity of his Scottish works. The exhibition catalog listed the artist's *Coilantogle's Ford* (1867, location unknown) with a quote from Scott's epic poem *Lady of the Lake* (1810) to identify the literary source for the painting.[2] Because the popular works of Sir Walter Scott had helped to inspire Duncanson's views of these famous Scottish sites, their reception was even more enthusiastic.

Loch Achray and Ben Venue (1867, Fig. 96) remains the largest painting extant from this exhibition. The dense, inhospitable foreground surrounding Loch Achray frames a view to the distant mountain of Ben Venue. Although the picture contains no direct literary allusions, educated nineteenth-century spectators readily associated this site with Scott's *Lady of the Lake*. This ruggedly picturesque location in the Highlands was the setting for the adventurous courtship of a Lowland lord, James Fitz-James, with Ellen Douglass, the daughter of a Highland lord. The naturalistic details of tangled shrubbery and the distinctive profile of Ben Venue indicate that Duncanson's image resulted from on-site sketches on which he overlaid imaginative literary allusions.

Duncanson painted many small Scottish views to satisfy the great demand for these works. Averaging six by twelve inches, these depictions of picturesque sites in the Scottish Highlands included

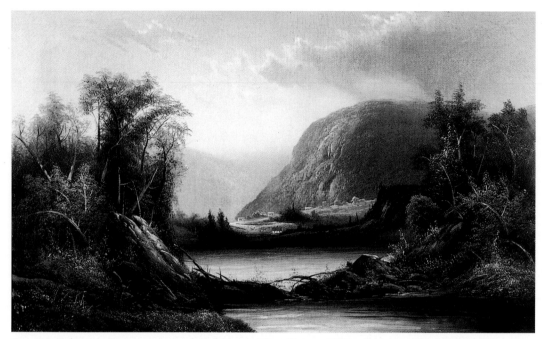

Fig. 96. Robert S. Duncanson, *Loch Achray and Ben Venue*, 1867, oil on canvas, 24¼″ × 36″. Robert L. Bates Collection, Dayton, Ohio.

Cottage Opposite Pass at Ben Lomond (1866, North Carolina Central University, Durham), *Highland Scenery, the Pass at Leny* (1866, present location unknown), *Loch Long, Scotland* (1867, Fig. 97), and *Rising Mist* (1867, Fig. 98). Their small size suggests that they could have been painted on location. On his tour of the Highlands the painter seems to have carried portable canvases on which he sketched the famous sites. He carefully inscribed several of the works with notations of a specific location, suggesting that they are accurate renderings sketched in plein air. However, the canvases are finished rather than loosely rendered, indicating that he probably added additional details after returning to his Cincinnati studio.

The stimulus for each of these paintings was the artist's romance with the image of the Scottish landscape created by Sir Walter Scott, who enamored audiences in

both England and the United States with his tales and directly influenced the development of the romantic historical novel in the United States. Americans held him in such high esteem that they posthumously honored him with a statue in New York's Central Park in 1872. On this occasion the poet William Cullen Bryant, speaking on behalf of the American public, anointed Scott "a genius of a new order." With his historical novels Scott provided his readers with an escape into a fanciful world full of picturesque beauties, noble deeds, and chivalric romance. Historians have described his tales as "rather of a rustic Arcadian sort."[3] This rural fantasy appealed to Duncanson and was the quality that he emphasized in his paintings of the sites made famous by Scott.

In many of these Scottish landscapes Duncanson introduced specific allusions to the literary works of Scott that confirm

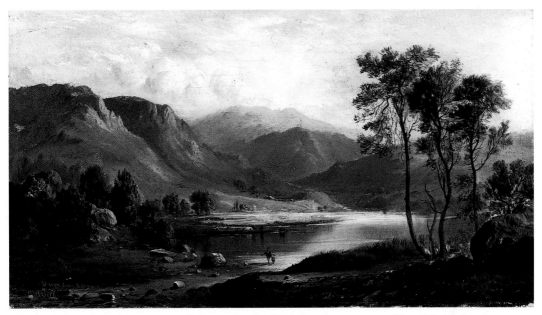

Fig. 97. Robert S. Duncanson, *Loch Long, Scotland,* 1867, oil on canvas, 7″ × 12″. National Museum of American Art, Smithsonian Institution, Washington, D.C., gift of Donald Shein.

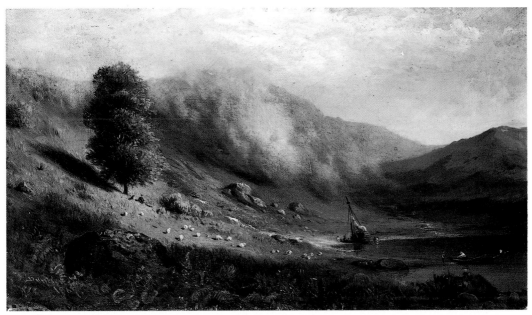

Fig. 98. Robert S. Duncanson, *Rising Mist,* 1867, oil on canvas, 7″ × 12″. Cincinnati Art Museum, gift of Mrs. George M. Stearns in memory of George M. Stearns.

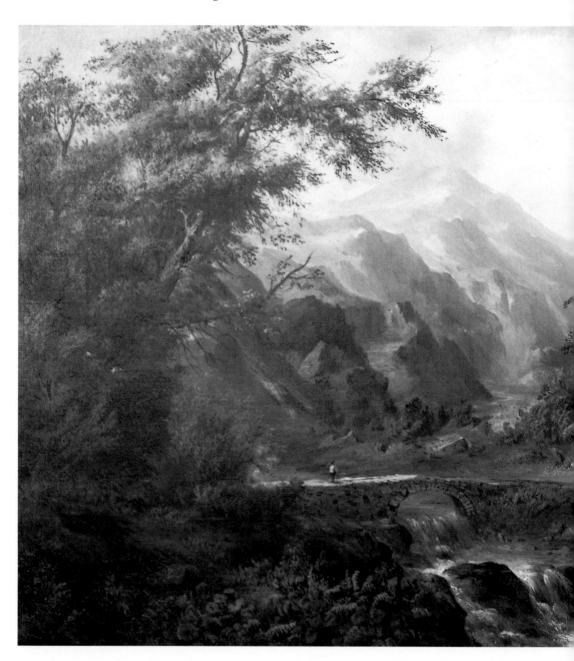

the allure of Scott's rustic Arcadia for the painter. In *Pass at Leny* (1867, Fig. 99) he depicted a site in the Highlands noted for its rugged mountains at the border between the Scottish Highlands and Lowlands. The artist had painted his small sketch of *Highland Scenery, the Pass at Leny* in 1866, but it bears little resemblance to the later work. In the larger, finished studio painting he arranged a foreground brook, a bridge, a pair of horsemen and other figures to introduce a distant view of the famous pass. This figure group evoked associations with Lord Monteith's entourage as it approached the pass in *A Legend of Montrose* (1819)

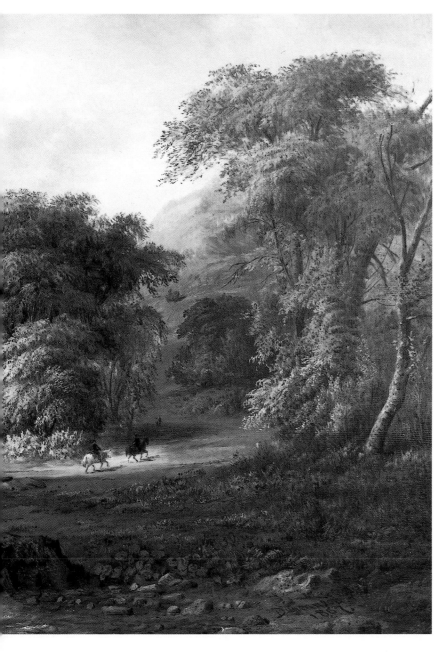

Fig. 99. Robert S. Duncanson, *Pass at Leny,* 1867, oil on canvas, 17¾" × 29¾". The Procter and Gamble Company, Cincinnati.

from the *Waverley Novels.* The author precisely described the young gentleman and his two servants as they began their ascent up the pass. In footnoting his introduction, he informed the reader, "The beautiful pass of Leny, near Callender, in Monteith, would, in some respects, answer the description." The text described,

"The broken path which they pursued with some difficulty, was in some places shaded by ancient birches and oaktrees, and in others overhung by fragments of huge rock. . . . In present times, a scene so romantic would have been judged to possess the highest charms for the traveller; but those who journey in days of doubt

and dread, pay little attention to picturesque scenery."[4] Duncanson alluded to this passage when he depicted the approach to the pass where the horsemen ride by a grove "shaded by ancient birches and oaktrees." Off in the distance the rocky precipices and outcrops bespeak the dangerous journey ahead. The anecdotal motifs and landscape setting recall Scott's narrative, but, more important, the painter visually re-created the suspenseful mood of the tale. Scott noted the contrasting moods of the scene as romantic, charming, and picturesque, yet also dark for "those who journey in days of doubt and dread." The painter responded by composing a rustic foreground with a dashing stream and vibrant trees for a picturesque effect, while the mountainous background presents a jagged and formidable barrier that implies sublime dangers in the pass ahead.

Unlike his earlier landscapes with their overt and elaborate literary subjects, *Pass at Leny* subordinates the narrative element and the staffage figure groups to the rugged landscape that dominates the painting. The figural props rely on their association with the riders in Lord Monteith's party for their extrapictorial meaning. The subtle introduction of the literary subject allows the primitive and rustic quality of the Scottish Highlands to take on additional meaning. In *Pass at Leny* Duncanson synthesized a naturalistic "truth to nature" with his ambition to create literary-historical paintings.

The painter did not entirely abandon his fanciful historical landscapes. In *Vale of Kashmir* (1867, Plate 18), painted the same year as *Pass at Leny,* he re-created an earlier literary theme for his third and most ambitious version of a scene from Thomas Moore's epic poem *Lalla Rookh.* The fact that Duncanson repeatedly returned to Moore's work is indicative of its status as the most popular of the British orientalist poems of the romantic era.[5] In turn, the great popularity of the poem was symptomatic of the allure, during the romantic era, of exotic orientalizing subjects that allowed Anglo-Europeans to explore fantastic visions of unknown lands and people. Over the decade the fantasy of Moore's poem captivated Duncanson and motivated him to execute five paintings based on it. The first came after the Cincinnati Sketch Club chose the subject in March 1863 for one of its bimonthly projects. Critics considered these sketches to "rival, in poetic sentiment, the most exquisite of the poet's matchless numbers."[6] Duncanson's Sketch Club study (1863, private collection, Detroit) provided the basic compositional formula and motifs for the more finished painting of the same subject from 1864 (Plate 14). The exotic, tropical landscape in the 1867 *Vale of Kashmir* is an appropriate setting for the oriental romance and recalls the artist's earlier literary landscapes. Yet the 1867 work is a less literal rendering of Moore's text, indicating Duncanson's tendency toward greater naturalism.

Lalla Rookh relates the story of a beautiful Persian princess's journey to marry the king of Lesser Bucharia. Within that narrative are four oriental tales in verse, told to entertain the princess during her long journey. The final tale, "The Light of the Haram," provided the source for this painting, particularly the concluding passages describing the disembarkation of the wedding party. The poet's description of this earthly paradise is

the point of departure for the painting:

> Who has not heard of the Vale of Cashmere,
> With its roses the brightest that earth
> ever gave,
> Its temples, and grottos, and fountains as
> clear
> As the love-lighted eyes that hang over their
> wave?[7]

The painter illuminated the panoramic landscape with a richly glowing sunset and bejeweled it with splashing fountains and fantastic temples. The serene light of the setting sun bathes the land in an idyllic glow that reflects off the shimmering surface of the lake. Moore's concluding narrative describes the valley as the quintessence of paradise on earth with its gorgeous plant life, peace among the people, and every earthly delight. This may be Duncanson's quintessential image of an imaginary paradise free from the emotional and social problems of his own life.

The procession ascending the temple steps in the middle ground marks a climactic moment in *Lalla Rookh*. The nuptial party has arrived at its final destination, where the princess will meet her groom. "After sailing under the arches of various saloons, they at length arrived at the last and most magnificent, where the monarch awaited the coming of his bride; and such was the agitation of her heart and frame, that it was with difficulty she walked up the marble steps, which were covered with cloth of gold for her ascent from the barge."[8] The painting does not precisely depict Moore's text, but it was undoubtedly inspired by this passage.

A comparison with the 1864 version of *Vale of Kashmir* (Plate 14), which Duncanson painted during his residence in Montreal, reveals the changes in the artist's stylistic approach to literary subjects. In the 1864 version a group of minstrels in the foreground adds a musical dimension to the paradise. These figures refer to a passage in the poem where "a lovely Georgian maid" sings a ballad that exalts the pleasures of the land: "oh! if there be an Elysium on earth, / It is this, it is this."[9] The singing and strumming musicians in the painting introduce the viewer to the Elysium that they inhabit and gesture toward the main subject of the painting, the wedding party on the opposite shore, the members of which ascend a staircase to the palace. In the 1867 version the artist removed the musicians, and the figural group is ascending, not toward the temple, but into an exotic landscape. The saloon formerly at the top of the stairs is obscured behind the palms on the far shore of the lake. Thus this version, the largest of the series, plays down the literary theme in favor of depicting the tropical landscape.

Duncanson's conception of the exotic and panoramic landscape setting of *Vale of Kashmir* was ultimately derived from his "great picture," *Land of the Lotus Eaters*. The success of the 1867 *Vale of Kashmir* prompted him to paint a fourth version in 1870 (Fig. 100). This painting virtually replicates the 1867 version in scale and subject and exhibits the same degree of artistic accomplishment. Duncanson's repetition of this subject four times over a seven-year period indicates that the fantastic, paradisiacal subject was important to him and alluring to his patrons, who avidly acquired these works.

Duncanson followed *Vale of Kashmir* with a large-scale landscape called *The Water Nymphs (The Surprise)* (1868,

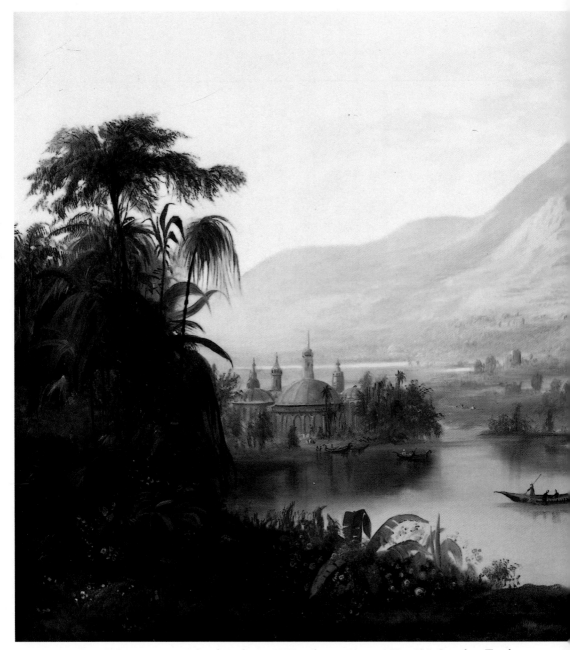

Fig. 100. Robert S. Duncanson, *Vale of Kashmir*, 1870, oil on canvas, 26″ × 49″. Lagakos-Turak Gallery, Philadelphia.

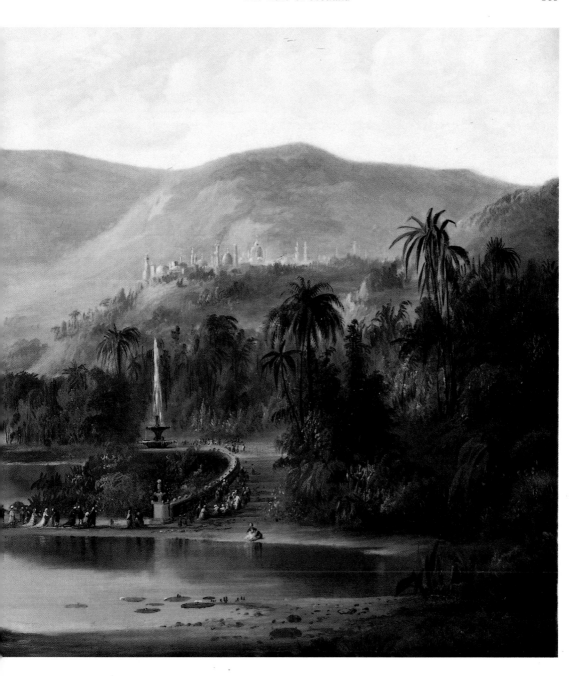

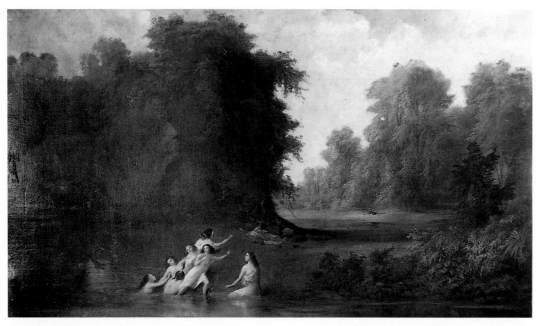

Fig. 101. Robert S. Duncanson, *The Water Nymphs (The Surprise)*, 1868, oil on canvas, 34″ × 56″. Howard University Gallery of Art, Washington, D.C.

Fig. 101), an unusual image in many respects. An enigmatic painting to interpret, *Water Nymphs* focuses on a group of frightened women bathing in a pond nestled in a sedate, picturesque wood. At the right is a view across a distant pond with a couple relaxing. The two halves of the picture are compositionally separated and have entirely different moods; the women scrambling for the water's edge are in sharp contrast with the quietly reposing couple in the distance. Hidden in the foliage at the left is the disruptive element of the composition, a wolf, whose head thrusts out of the bushes and frightens the bathers.

The agitated activity in *Water Nymphs* suggests more than a mere anecdotal significance for the figure group; however, a specific literary source for this painting remains unknown. The theme of bathing nymphs in flight has a long tradition, with its source in the ancient Greek myth of Diana and her attendants fleeing

the gaze of Actaeon. The artist's literary background suggests that he probably had such a specific scene in mind when he created this work. In fact, he could have seen a version of this subject by Gainsborough—*Diana and Actaeon* (c. 1784–1785)—in Buckingham Palace while socializing with the British aristocracy on his recent tour of England. However, *Water Nymphs* is not a mythological scene. The painting has a modern ambience with the contemporary clothing and landscape setting, removing it from direct association with the traditional iconography. The painting is so unusual for Duncanson's oeuvre that one must ask what the significance of this imagery was for the artist. The voyeuristic undertones of the painting suggest a Freudian interpretation that perhaps the artist had repressed sexual problems. His only nude female figure painting, *Eve* (c. 1862, Fig. 76), indicates his interest in the female figure, and a close examination

of *Water Nymphs* reveals a reverse of Eve's pose in the central figure who clutches her drapery to cover her exposed body.

Unlike his other paintings of this period, *Water Nymphs* focuses on a narrative event. The lush picturesque landscape does not reflect the bathing nymphs' fright, and the pastoral background with picnicking figures contrasts with the foreground activity. The gestures of the scurrying women provide the only links between the two halves of the painting. While the foreground is unusual among the artist's work, the background typifies his earlier picturesque-pastoral compositions, including *Romantic Landscape* (1853, Plate 6). In *Water Nymphs* the painter attempted to combine his picturesque-pastoral landscape style with an evocative narrative, but without success. The disturbing content of this painting marks it as a perplexing work. The contrast between the agitated foreground and the pastoral background implies the tremendous psychological pressures that the artist confronted and foreshadows his tragic dementia.

Despite the psychological or perhaps personal difficulties intimated by *Water Nymphs*, Duncanson remained active in the cultural life of Cincinnati. Unfortunately, the Associated Artists of Cincinnati did not survive beyond its inaugural year, 1867. The following year the Academy of Fine Arts filled the vacancy left by the Associated Artists and benefited from the inclusion of art dealers and businessmen in its administration. The academy held its first exhibit early in 1868 in a gallery established by the mirror, frame, and picture dealer William Wiswell above his shop. The success of the exhibit encouraged the association to hold a second one at the end of the year. Duncanson displayed only one painting at each

of these exhibits, a view of *Spokane Falls* and *Morning in the Highlands,* respectively. Perhaps his restricted showing related to the fact that he had entered three paintings in the Chicago Academy of Design exhibition at the same time.[10] However, it seems that he suffered another creative lull in 1868—similar to the one he experienced in 1860—that was probably related to the onset of his debilitating mental illness. In order to revive his mental stability and artistic sensibilities, Duncanson retired to the country for an extended sketching tour.

After three years of producing paintings from his Canadian and European sketchbooks, Duncanson revisited the Mississippi River and Canada in the summer of 1869, retracing the path he took in 1862. Three very different paintings resulted from this trip, the last of which launched him into the final phase of his career. The first of these paintings was another view of scenic Lake Pepin, *Valley of Lake Pepin, Minnesota* (1869, Fig. 102). As opposed to the earlier *Maiden's Rock, Lake Pepin, Minnesota* (1862, Fig. 73), this serene scene is uninterrupted by man and is dominated by the delicate blue sky and soft clouds. The low horizon line and the lack of framing motifs allow the landscape to expand indefinitely. Once he reached Canada, the artist returned to a picturesque site to sketch for a dramatic picture of *A Wet Morning on the Chaudiere Falls* (1869, Fig. 103). The rushing waves break over the jagged rocks, creating a sublime impression of nature's power. The beautiful rainbow under the falls does not soften the dramatic effect of the landscape, which is crowned by a threatening sky that symbolizes the storm that was brewing in the artist's mind.

While in Canada he renewed his artistic

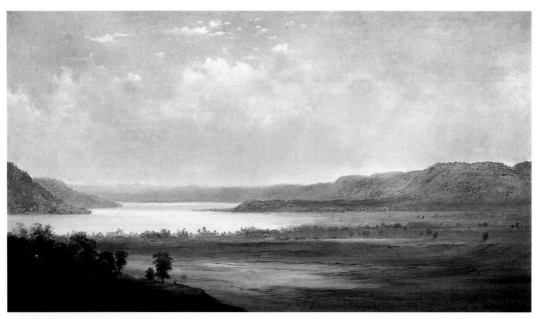

Fig. 102. Robert S. Duncanson, *Valley of Lake Pepin, Minnesota,* 1869, oil on canvas, 12″ × 21¾″. Cleveland Museum of Art, gift of William Macbeth.

contacts and left a painting titled *Mt. Orford* behind to be displayed at the Art Association of Montreal exhibition in February 1870.[11] When he returned to Cincinnati he worked from his new Canadian sketches to paint canvases for the local Academy of Fine Arts Exhibition for 1870. His primary entry that year was *Serpentine River, Canada East,* which may be the painting now known as *View of the St. Anne's River* (1870, Fig. 104).[12] In this painting cows drink along the shore of the river that gently winds into the distance, where rolling hills dissolve in the light on the horizon. The transcendental light casts a tranquil mood over the land and creates a beautifully pastoral scene, an entirely different approach from his 1863 painting *On the St. Anne's, East Canada* (Fig. 79). The rushing river rapids and colorful autumnal foliage endow the 1863 picture with a picturesque quality, in contrast to the idealized forms and pastoral mood of the later work.

The differences among the three paintings from Duncanson's 1869 sketching trip clarify the stylistic transformation evident in his two views of the St. Anne's River. In *A Wet Morning on the Chaudiere Falls* the artist incorporated picturesque conventions in the wedge-shaped foreground and scraggly trees leading to a dynamic view of a cascade and rocky outcroppings crowned by a stormy sky. On the other hand, *Valley of Lake Pepin, Minnesota* is a quiet, serene scene free of picturesque conventions and dominated by the delicate, cloud-filled, blue sky. A triangular foreground leads the eye into the painting, which opens out horizontally and gently rolls into the luminous distance along the river and the sloping hills on the horizon.

Unlike his earlier picturesque compositions with framed views and receding diagonals, *Valley of Lake Pepin* has a more natural treatment of light and an open-ended composition such as is found in the work of Duncanson's contemporary

Martin Johnson Heade. Heade's views of the marshlands of New Jersey and Massachusetts, which were very popular in the 1860s, exemplify this open-ended, unframed compositional structure and may have provided the stimulus for Duncanson's use of the format. During the post–Civil War period, Heade and other landscape painters emphasized light as a unifying element and as a medium for bathing the landscape with emotion. The light in Duncanson's landscapes of the late 1860s has a transcendental quality, similar to the effect achieved by Heade, and likewise conveys the sentiment of the landscape. As Thomas Cole had proclaimed in his essay on "American Scenery," light is "the soul of all scenery."[13]

The composition, paint handling, and, most particularly, the unifying light in *View of the St. Anne's River* reflect the transformation in Duncanson's vision of the landscape. The undisturbed, shimmering surface of the river and the golden glow of the sunlight blanket the scene with tranquility and repose. Stylistically, the painting is comparable to John Kensett's *Upper Mississippi* (1855, Fig. 105). Kensett had traveled to the upper Mississippi River valley in 1854 and created several paintings from this trip, among these *Minnehaha Falls* (c. 1855, Longfellow House, Cambridge, Massachusetts) and *Upper Mississippi*, which depicts Lake Pepin.[14] Duncanson had painted both of these sites in 1862, and Lake Pepin a second time in 1869. Kensett's travels on the upper Mississippi may have served as the inspiration for Duncanson to sketch these areas and provided an example for his new style, which was first evident in *Valley of Lake Pepin*. The serene light illuminating the peaceful *Upper Mississippi* is handled with an imperceptible touch that dissolves the painterly presence of the artist in

the image. Duncanson created a similar effect with his tight handling of the mirror-smooth surface of St. Anne's River bathed in golden light.

Motivated by the aesthetic transformation that occurred during his 1869 sketching tour, Duncanson returned to Canada once again in the summer of 1870, sketching along his familiar circuit and returning through the Great Lakes states. Back in Cincinnati two months later, he was "once more in his studio and hard at work,"[15] but not producing views of Canada. Rather he embarked on a series of paintings of Scotland that extended over the final year of his active career (Plates 19–20). These paintings have suggested to art historians that Duncanson must have made another trip to the British Isles around this time.[16] However, the contemporary documents consistently place him in North America throughout the year. In October 1870 he exhibited a copy of his *Lotus Eaters* at the Great Exposition in Cincinnati. Throughout the fall and winter he occupied himself painting another pair of ambitious historical subjects for a national tour: *Paradise and the Peri* (1871, location unknown) and *Ellen's Isle, Loch Katrine* (1871, Plate 20).[17]

The completion of these two historical paintings consumed a great deal of Duncanson's time extending into the summer of 1871. The annual notice on the travel schedule of Cincinnati artists in the summer of 1871 remarked that usually artists would be out on sketching tours "filling their sketchbooks and portfolios with material to be worked up in the winter. This summer, however, those few who leave the city will do so for but brief visits, their engagements not permitting any of them to be absent for any considerable length of time." Duncanson was no exception. He took a trip to the Kanawha valley in West Virginia, one

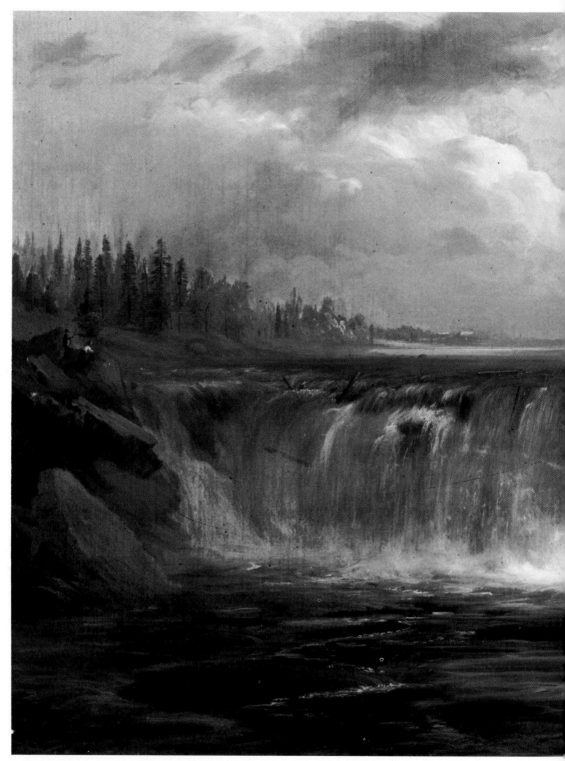

Fig. 103. Robert S. Duncanson, *A Wet Morning on the Chaudiere Falls,* 1869, oil on canvas, 30⅛″ × 44″. National Gallery of Canada, Ottawa, gift of Denise Pelland.

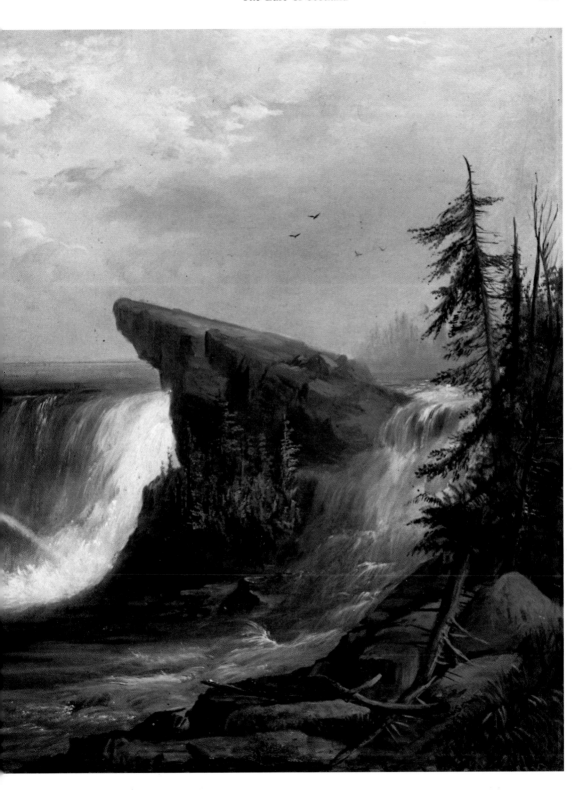

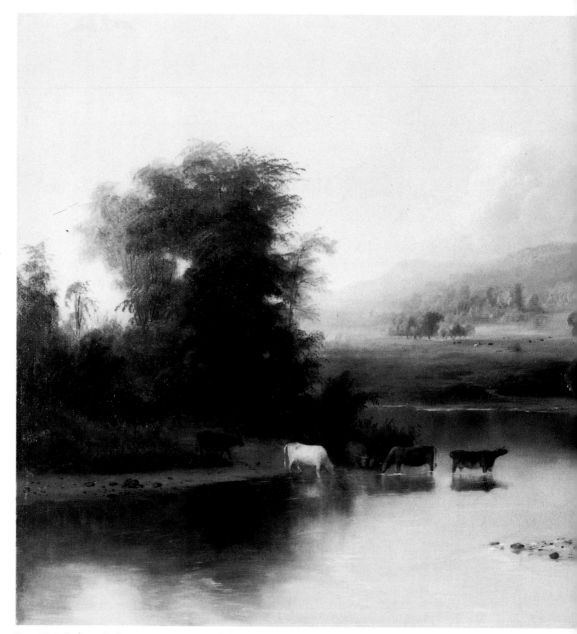

Fig. 104. Robert S. Duncanson, *View of the St. Anne's River,* 1870, oil on canvas, 21″ × 40″. St. Louis Art Museum, St. Louis, Missouri, purchase.

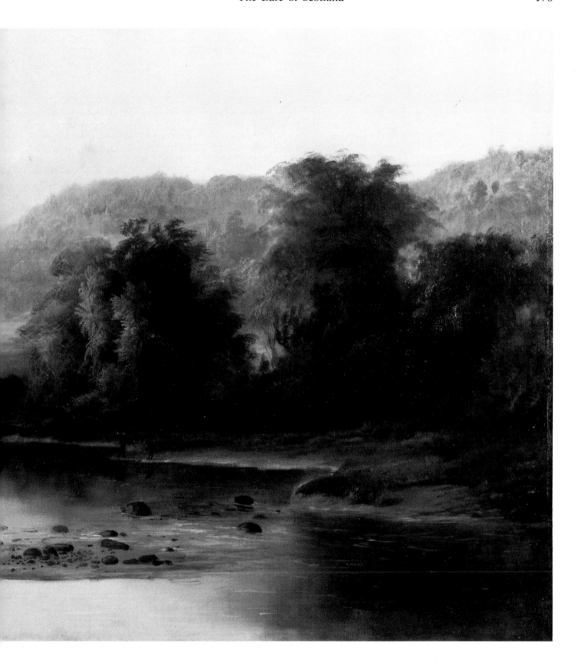

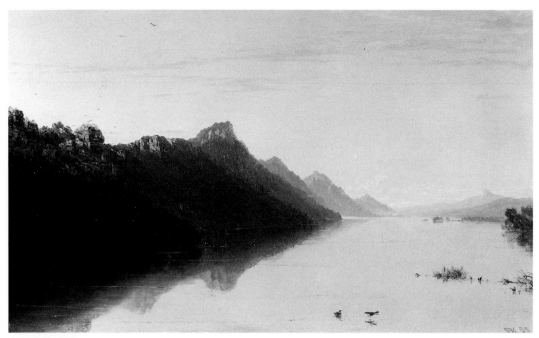

Fig. 105. John F. Kensett, *The Upper Mississippi*, 1855, oil on canvas, 18½" × 30½". St. Louis Art Museum, St. Louis, Missouri, purchase, Eliza McMillan Fund.

of Sonntag's favorite sketching sites, for only a few weeks. Studio work overwhelmed him. The newspaper reported that he had "a charming view on St. Anne's River, below Quebec" on display at a local shop (perhaps *View on the St. Anne's River*). Primarily, he was concentrating on a copy of Church's *Heart of the Andes* (on commission from a local patron), *Paradise and the Peri,* and *Ellen's Isle.* The press considered his copy after Church to "exceed the original from which it is painted."[18] In this copy Duncanson made explicit his debt to Church.

Duncanson's last ambitious paintings of literary subjects, *Paradise and the Peri* and *Ellen's Isle,* herald the synthesis of his aesthetic aspirations and his new style. Painted and exhibited as pendants, they summarized his stylistic transformation and presented two realms of his literary imagery, the imaginary and the naturalistic. The Cincinnati critics declared *Paradise and the Peri* "perhaps the best effort of the

artist's life" and said, "In *Ellen's Isle* the artist has probably produced the chef d'oeuvre of his life."[19]

Unfortunately, an irate citizen vandalized *Paradise and the Peri* when it hung in the sheriff's office of the Detroit City Hall in 1876. Although the painting apparently survived the damage, its current location is unknown and little information survives concerning its appearance.[20] This large, six-by-four-foot painting was the fifth work inspired by Thomas Moore's *Lalla Rookh* and relates the attempts of a peri (a spirit of the air) to enter the heavenly kingdom. Apparently the painting followed the text closely.[21] The *Detroit Free Press* described it as "an original and pleasing work. . . . The atmospheric effects are startlingly original." But another journalist scathingly criticized the artist's ability to paint the human figure, although he complimented Duncanson's sensitivity in the landscape: "While we are almost prepared to pronounce all of Duncanson's

figure and creative attempts comparative failures, we are equally ready to hail him master in the reproducing of Nature upon canvas." Evidently the staffage figure was only a minor part of this painting. The primary intention "of the artist was to give reality to his idea of paradise."[22] The spirit attempting to enter heaven held profound meaning for the African-American artist, who equated his own desire to enter paradise with that of the peri. In this painting, the artist made his final excursion into paradisiacal subjects, again revealing his obsession with edenic themes.

As opposed to the exotic literary subject of *Paradise and the Peri, Ellen's Isle, Loch Katrine* (Plate 20) was a naturalistic landscape pregnant with literary allusions. In this painting Duncanson achieved what many admirers of his art consider to be a pinnacle of aesthetic and technical accomplishment. The image was his most subtle synthesis of a literary subject in a landscape setting. In addition, it held special significance for the African-American painter.

For the subject of *Ellen's Isle,* Duncanson returned to Sir Walter Scott's popular epic poem *The Lady of the Lake,* which had inspired his earlier Scottish landscapes, beginning in 1867 with *Coilantogle's Ford* and *Loch Achray and Ben Venue* (Fig. 96). Surprisingly, Scott's poem was not only immensely popular with the Anglo-American audience, it also held great significance to the contemporary African-American community. Frederick Douglass had taken his surname from the Highland lord in Scott's poem, and, later, W. E. B. Du Bois remembered the poem fondly from his youth and referred to it in his speeches as the "sort of world we want to create for ourselves and America."[23] In addition, the imagery of boats crossing the water in a tranquil landscape represented for

Duncanson and other African-Americans the passage to freedom over the River Jordan to heaven referred to in slave songs. From its inception, Duncanson had planned culminating his tour of this painting with a presentation of his "chef d'oeuvre" to the abolitionist and statesman Senator Charles Sumner as an expression of gratitude for his work on behalf of the black race.[24] Because of its special veiled significance for the African-American community, *Ellen's Isle* was a symbolically important gift to the abolitionist Sumner.

In *Ellen's Isle,* Duncanson sensitively portrayed the picturesque Highlands scenery that provided the setting for Scott's *Lady of the Lake*. The epic poem intertwines Scottish legends of Highland and Lowland wars with the theme of three men embattled over the love of a woman, Ellen Douglas. Duncanson depicts Ellen's island home isolated on Loch Katrine and intimately nestled into the rugged Highlands that surround it. The golden sunlight sheds a pastoral glow over the thick forests and rugged mountains. The lake spreads like a smooth sheet of light across the landscape, penetrated only by a boat that passes at the point where the sun dramatically reflects off the lake. Although the painting depicts no particular passage in the epic poem, most nineteenth-century spectators would immediately have associated the location with Scott.

Duncanson sensitively conveyed Scott's vision of the land when he created his painting, even though he omitted any specific references to the text. The author introduced the scene by describing the golden light shining on the lake with its beautiful, pastoral effect:

And thus an airy point he won,
Where, gleaming with the setting sun,
One burnish'd sheet of living gold,
Loch Katrine beneath him roll'd.

Then he remarked on the picturesque qualities of the formidable mountains wildly overgrown with brush and trees:

> High on the South huge Ben-venue
> Down on the lake in masses threw
> Crags, knolls, and mounds, confus'dly hurl'd,
> The fragments of an earlier world.
> A wildering forest feathered o'er
> His ruined sides and summit hoar.[25]

The painter conveyed the spirit of the scenery, majestically synthesizing the beautiful and the picturesque elements of nature with the literary source under the serene glow of the setting sun.

Ellen's Isle represents the artist's finest technical achievement. His painterly refinement is evident in the intricate rendering of the details in the trees and ferns in the foreground that he gradually generalized with the atmospheric perspective into the distance. The pastel-tinted mountains add a touch of complementary color that subtly dissolves in the golden light on the horizon. With a transparent touch, the painter delicately brushed onto the canvas the rays of light and the mirror-smooth surface of the lake, which is one of his most accomplished passages. The serene, even transcendental quality of the light recalls *View on the St. Anne's River, Canada* and is the culmination of his stylistic transformation during this period.

The first notice of *Ellen's Isle* appeared in June 1871 when a reviewer commented that the artist "has about completed a Scotch scene, 'Ellen's Isle.'"[26] In August, Duncanson exhibited the painting at Wiswell's Gallery in Cincinnati with *Paradise and the Peri* and the copy of *Heart of the Andes*. After a successful month of exhibition in Cincinnati, he crated the paintings for exhibition "in the leading cities of the country." At that time the artist's brother John Dean died, and he traveled to Monroe, exhibiting his paintings there for several days before taking them to Detroit.[27] By September the Western Art Association of Detroit was exhibiting *Ellen's Isle,* which attracted considerable notice among the local cultural circles. The *Detroit Free Press* exclaimed, "'Ellen's Isle,' from Sir Walter Scott's 'Lady of the Lake,' is a superb work, and during the first day of the exhibition attracted a great deal of admiration."[28]

Following this successful exhibition, Duncanson took *Ellen's Isle* to Boston to culminate his tour with a presentation of the painting to Sumner. Sumner reluctantly accepted the gift, only after repeated appeals from the artist. The painting was publicly exhibited in Washington, D.C., before being placed in Sumner's home. Sumner bequeathed the painting with his entire collection to the Museum of Fine Arts in Boston, where it was exhibited the year following his death in 1874. A decade later the painting was returned to the Duncanson family, as Sumner had stipulated in his will.[29]

In *Ellen's Isle,* Duncanson achieved a synthesis of his aesthetic ambitions and a meaningful content for his Anglo-American patrons and the African-American cultural community. Unfortunately, at this time his debilitating mental illness became increasingly evident. The perplexing content of *Water Nymphs* had provided a clue to the disturbing condition that led to his creative lull in 1868. By 1870 his poor health prevented him from working regularly, forcing the prolonged creation of his finest works over a twelve-month period. At the time of his greatest achievement, Duncanson's patrons, critics, and audience became acutely aware of his tragic condition.

9

A Spiritualist in Stormy Seas
Final Years

*A*fter successfully exhibiting *Ellen's Isle* in Boston and Washington, D.C., Duncanson had solidified his critical and popular reputation across the United States. The Cincinnati press ran a notice that reflects the contemporary regard for his work: "Duncanson['s] . . . place among the great landscape painters of the day is now indisputed [*sic*]."[1] His grand historical paintings were quoted at the then incredible prices of $15,000 for *Paradise and the Peri* and $8,000 for *Ellen's Isle*. One contemporary claimed that the artist originally intended to paint three additional pictures and tour them with *Ellen's Isle* through England, as he had done with his *Land of the Lotus Eaters* five years earlier.[2] However, the tragedy of his personal life did not allow him to realize these plans.

The artist completed his tour of *Ellen's Isle* with a sketching trip through Canada, returning to his Cincinnati studio in November 1871. In his studio, he continued to paint the range of subjects with which he had earned his reputation: American and Scottish landscapes, historical pictures, and scenes of Italian ruins. He produced a copy of his famous *Ellen's Isle* for a local patron and followed this with a group of American and Scottish landscapes, including *Scotch Landscape* (1871, Plate 19) and *Landscape with Cows Watering in a Stream* (1871, Fig. 106). At the same time he painted variations and copies from his earlier sketches of Italy, such as

Vesuvius and Pompeii (1870, Fig. 107) and *Pompeii* (1871, Fig. 108). With the exception of the Italianate works, these final paintings demonstrate the depth and breadth of his accumulated artistic accomplishments. In addition to revealing his command of formal and technical qualities, they resonate with the transcendental spirit that dominated his works after the 1869 and 1870 Canadian sketching excursions. A serene mood characterizes the artist's conception of a poetic sentiment in these landscapes.

Yet, at the same time that Duncanson achieved his ultimate aesthetic expression in the serene literary landscapes, he was suffering from a tragic mental disorder. Since his early days in Cincinnati the painter was known to be an anxious, excitable, and animated personality. In the 1860s, he developed a malady that increased in severity, leading to extended periods of artistic inactivity and great difficulty in his personal life. By 1870 his condition had become so advanced that it was painfully obvious to his patrons and the larger artistic community. He experienced sudden and dramatic swings in temperament and suffered from delusions, hallucinations, and violent outbursts. He had also become a spiritualist and was convinced that he was possessed by the spirits of past artists. Yet in between phases of these traumatic mental disturbances, he would resume his creative work and produce beautifully serene images,

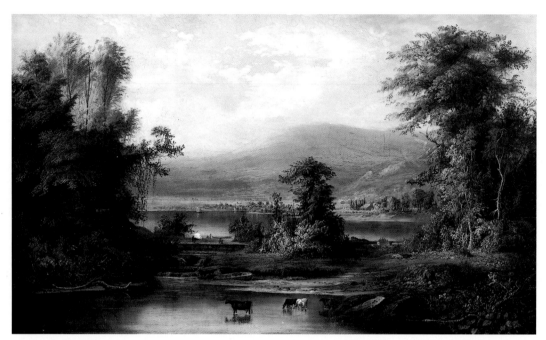

Fig. 106. Robert S. Duncanson, *Landscape with Cows Watering in a Stream,* 1871, oil on canvas, 21⅛″ × 34½″. Jointly owned by the Metropolitan Museum of Art, New York, and Lawrence A. Fleischman.

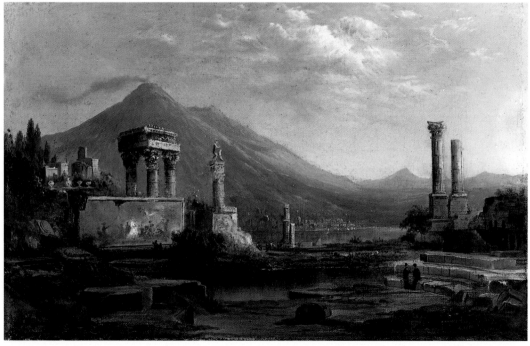

Fig. 107. Robert S. Duncanson, *Vesuvius and Pompeii,* 1870, oil on canvas, 10″ × 15⅝″. National Museum of American Art, Smithsonian Institution, Washington, D.C., gift of Joseph Agostinelli.

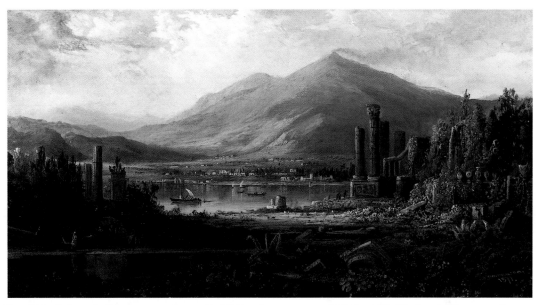

Fig. 108. Robert S. Duncanson, *Pompeii,* 1871, oil on canvas, 10¼″ × 18″. National Museum of American Art, Smithsonian Institution, Washington, D.C., gift of Lawrence Koffler.

such as *Ellen's Isle,* that were in stark contrast to the terrible forces tearing at his mind. The artistic evidence of his serious mental condition appears in a small body of seascapes that seem to represent the spiritualist tossed about in stormy seas.

Although the serenely beautiful landscapes certainly dominated his productions of this period, these mysterious, stormy seascapes reveal an entirely different mood and sentiment. The jagged, rocky coasts, stormy skies, and violently thrashing waves in these turbulent paintings suggest the sublime power of the oceans and hint at a deeper psychological meaning for the artist. The first of these marines was *Seascape* (1864, Fig. 109), painted during his emigration to Canada. Six years later he began a series of three more, painted between 1870 and 1871, that express the turbulent changes he was experiencing: *Dog's Head, Scotland,* (1870, Fig. 110); *Sunset on the New England Coast* (1871, Fig. 111); and *A Storm off the Irish Coast,* (1870, Fig. 112).

Duncanson designed each of the seascapes with a simple, but dynamic, composition centered on the horizon line, which is interrupted by a wedge of rocks and tossing waves. The *Seascape* of 1864 established this compositional formula, which he revived later in *Dog's Head, Scotland.* In the later painting, the wedge of rock echoes a triangular foreground stage where fishermen pull in their nets. A brilliant light bathes the rocky shore and silhouettes the rock profile of the canine's head. The waves lightly break upon the beach without threatening the fishermen or the distant ships. The composition for these seascapes may have been influenced by the seascapes that Gainsborough introduced at the British Royal Academy in the 1780s. He followed that debut with a series of works, particularly *Fishermen Dragging Nets* (1781, private collection, England), that established the compositional formula for the intersecting wedges of the shore, sea, rocks, and sky. It is entirely possible

Fig. 109. Robert S. Duncanson, *Seascape,* 1864, oil on canvas, 18″ × 36″. Art Gallery of Ontario, purchase, with assistance from Wintario, 1979.

that Duncanson saw these works while touring the aristocratic estates of England; certainly a strong similarity exists between the works of the two artists.

Radically different in mood from *Dog's Head* are the early *Seascape* and the later *Sunset on the New England Coast* and *Storm off the Irish Coast.* Although the compositional formulas of the stormy seascapes relate to *Dog's Head,* these sublime paintings dramatically feature violently crashing seas under stormy skies illuminated by a brilliant spiritual light on the horizon. The artist provides no foreground stage from which to view the scene. The perspective suspends the spectator over the ocean with the waves dynamically splashing out of the pictorial frame. The vast expanse of space, the immense power of the ocean, and the formidable walls of rocks dwarf the tiny ships and threaten their survival. On the horizon a brilliant light breaks through the threatening clouds to proclaim a divine promise of salvation after the turmoil. These three paintings present a grim view of the awesome force of

nature found in the sea. Their turbulent, threatening sublimity was previously unknown in the artist's work.

With these marines Duncanson contributed to the post–Civil War revival of the sublime seascape, along with artists Bierstadt, Church, Heade, and Fritz Hugh Lane (1804–1865).[3] With their barren foregrounds and their turbulent mood, however, the African-American's three sublime seascapes constituted a radical departure from the more conventional work of his contemporaries. These characteristics appeared only later in the work of marine specialists such as William Trost Richards (1833–1905) and Alfred Thompson Bricher (1837–1908) in paintings such as *The League Long Breakers Thundering on the Reef* (1887, The Brooklyn Museum of Art) and *Monhegan Cliff, Maine* (c. 1896, Virginia Museum of Arts), respectively.[4] Although Duncanson did not employ the crisp and precise representation of natural forms typical of these "New Path" or American Pre-Raphaelite artists, his work established a precedent for the radically simple

Fig. 110. Robert S. Duncanson, *Dog's Head, Scotland,* 1870, oil on canvas, 26″ × 51⅛″. Museum of Fine Arts, Boston, purchase, Emily L. Ainsley Fund.

compositions and the sublime sentiment found in the later artists' works.

The style, subject, and sentiment of Duncanson's three marine paintings convey a disturbed personality lurking behind their creation. What is most unusual is that this mood found expression almost solely in the seascapes. This contrast between the styles and sentiments of his late luminous landscapes and his paintings of stormy seas reflects the disturbing conflict within the artist's mind and foreshadows the tragedy of his final years. Apparently, Duncanson felt a repressed psychological connection with the sea that was expressed in the brooding quality of these paintings. He had experienced the ocean only during his journeys to Europe, although he painted his earliest seascapes during his exile in Canada, when he first saw coastal scenery. *Sunset on the New England Coast* and *A Storm off the Irish Coast* depict particular sites that relate to his travels to England, although they were not painted until years later. Clearly, his earlier experiences of the sea

left an imprint of awe and fear on his mind that he expressed only later in these images. The immeasurable distances and restless force of the ocean apparently left him feeling overwhelmed by the omnipotent power of God and nature. Man, represented by minuscule ships, is an insignificant presence and is forbiddingly isolated on the vast sea, facing alone the overwhelming power of nature. To be sure, such motifs appear often in marine paintings, but in Duncanson's case they evidently symbolized the terrible struggle in his mind that would eventually destroy him.

The onslaught of Duncanson's dementia became publicly evident during the prolonged period from 1870 to 1871 when he was attempting to complete *Paradise and the Peri* and *Ellen's Isle.* The press reported that the artist had become a "spiritualist" and was possessed by the spirit of a female master-artist, who assisted him in creating his paintings. Two Cincinnati newspapers exchanged the local gossip on the artist's illness. The

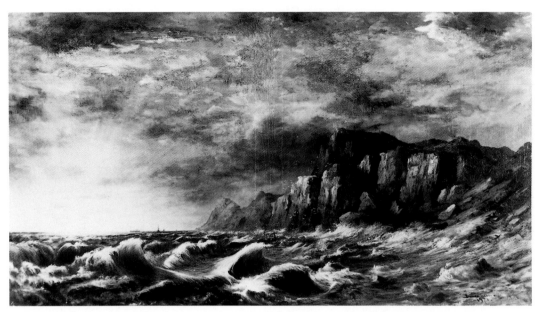

Fig. 111. Robert S. Duncanson, *Sunset on the New England Coast,* 1871, oil on canvas, 36⅛" × 66". Cincinnati Art Museum, gift of Mrs. Gilbert Bettman.

Daily Cincinnati Commercial reported, "A 'Friend and Pupil' of Robert S. Duncanson informs us that only in his work of Paradise and the Peri did Mr. Duncanson imagine himself aided by a spirit. He was a Spiritualist, and believed himself aided in that work by a lady friend." The rival paper, the *Cincinnati Daily Enquirer,* retorted with its own source on the issue: "A 'Friend and Pupil,' who writes the *Commercial* that the only picture Duncanson claimed to have had 'assistance'—i.e. superhuman aide— upon was 'Paradise and the Peri,' is mistaken. The dead artist frequently made the same statement to the writer in regard to 'Loch Katrine.' Indeed, evidences of mental derangement were painfully abundant to Mr. Duncanson's admirers at the time these pictures were on view and subsequently."[5]

Throughout Duncanson's career, his friends recognized him as eccentric, susceptible to flights of imagination and intense obsessions. Contemporary accounts record him as an anxious person with great ambition, who was moody and prone to swings of temperament. Early in his career, Junius Sloan remarked on Duncanson's excitable personality after listening to one of his emphatic descriptions of his paintings. Sloan wrote, "To give you a full idea would be impossible, to obtain it you must [sit] by and by and listen to his words and watch his gestures, and catch the expression on his face." When Sloan had not received a letter from Duncanson for a length of time, he wrote, "I wish that he could use this pen as he sometimes does his tongue, in animated descriptions." During his career, Duncanson continually professed his obsession with rivaling the masters of art: "I have made up my mind to paint a great picture, even if I fail."[6] In addition to his obsessive artistic ambitions and eccentric personality, Duncanson con- fronted the daily trauma of racial strife and discrimination, which must have caused a tremendous psychological burden.

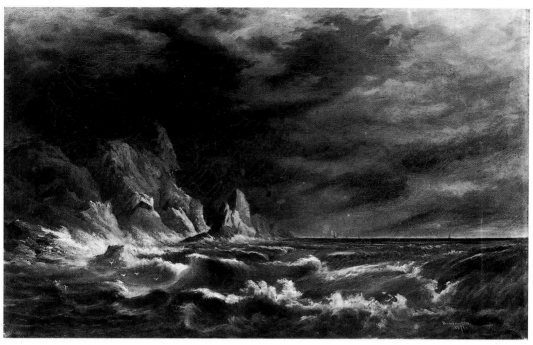

Fig. 112. Robert S. Duncanson, *A Storm off the Irish Coast,* 1871, oil on canvas, 21″ × 33″. Detroit Institute of Arts, gift of the estate of Ralzemond D. Parker.

This combination of factors could suggest that the strain and pressures on his sensitive personality might have led the artist to his mental illness and eventual collapse.[7]

The history of art is filled with accounts of painters, such as Hugo Van der Goes, Annibale Carracci, and Vincent Van Gogh, whom biographers and scholars have considered saturnine, temperamental, and eccentric. Since antiquity people commonly associated these personality traits with the creative genius that motivated these painters and recognized that this sometimes resulted in a "madness" to which the artists succumbed. More recently, historians have applied psychological and scientific analysis to interpret the painters' behavior and to diagnose their illnesses.[8] Their theories offer a diagnosis of Duncanson's dementia and suggest a physiological cause for his illness.

Although no contemporary doctor diagnosed Duncanson's illness, modern medicine would classify the artist's behavior as psychotic, characterized by a disorganized personality with an impaired perception of reality. Duncanson apparently suffered from a particular psychosis identified as schizophrenia, which is a distortion of reality marked by delusions, hallucinations, and a fragmented personality. The painter's obsessive, temperamental behavior and his assumption of a separate personality support such a diagnosis. For Duncanson, like most of the other painters marked by saturnine characteristics, the physiological cause of his illness can be traced to lead poisoning. Since the early eighteenth century the toxic effects of lead in painters' pigments have been identified as a professional hazard and associated with painters' maladies. This is especially the case for housepainters, whose primary

medium was the lead white used to whitewash houses. In a recent article John F. Moffitt has explained Hugo Van der Goes's possession by evil spirits and Annibale Carracci's disturbed personality as symptomatic of their extensive use of lead whites to prepare panel paintings and frescoes. Although by the mid-nineteenth century the hazards of lead were known and the amount of lead found in artists' pigments was less than in earlier centuries, lead poisoning was still a concern because of its cumulative effect. Duncanson's exposure during his years as an apprentice housepainter to massive quantities of lead white would have had a toxic effect that would have increased as he continued to grind his colors and prepare his grounds for canvases. Furthermore, recent scientific research has discovered that lead poisoning has a greater effect on blacks than it does on other racial groups, leading to higher levels of hypertension, stress, and anxiety. These traits definitely marked Duncanson's personality early in his career and became more pronounced as the lead accumulated in his bloodstream. Eventually, the toxins caused a traumatic disruption of his personality and his assumption of spirit possession.[9]

Apparently the artist's psychotic behavior became increasingly pronounced throughout 1872 and began to severely affect his mental and physical health.[10] He maintained a residence in Cincinnati, but no studio. He produced little or no work through that year, but managed to have enough paintings to open an exhibit in Detroit in October. While hanging his works in the exhibition, he suffered a seizure and collapsed.[11] His family immediately had him interned at the Michigan State Retreat, where his radical behavior required that he be confined.

The oral history on the artist's illness asserts that his moody behavior led to extreme violence. One commentator close to the family claimed that his "last days were clouded, in Ohio and Michigan, leading finally to violent insanity, in which, with his great strength, he would tear apart his confining bars."[12]

The artist's wife, Phoebe, immediately moved to Detroit to be near her sick husband at the Michigan State Retreat. Situated in a quiet area outside urban Detroit, the retreat functioned as a sanatorium, as opposed to the more typical prison-like confinement accorded patients with mental illness in this era.[13] Mrs. Duncanson visited her husband there regularly until December. At that time, it appeared to the Sisters of Charity, who administered the sanatorium, that the artist's condition worsened each time he saw his wife. The nuns then forbade her to see him unless he improved. Phoebe still received reports from the Sisters and wrote to her mother-in-law, Mary Harlan: "The sister in charge of him said today that he has been entirely unconfined since last Thursday, and is very quiet and natural. His physical health has improved and he eats and sleeps, and walks in the hall, with other quiet ones." She confessed that the burden of his sickness weighed heavily upon her and admitted that the prognosis for his recovery was not optimistic: "I do not know what opinion the Drs now have of Robert, but I wont allow myself to have any hope for fear I may be disappointed. I made up my mind for the worst long ago."[14]

Only four days after the favorable report, on December 21, 1872, Duncanson suffered a relapse and died at the sanatorium. Unfortunately, the records of the retreat do not survive to provide a diagnosis of the illness, and a certificate

does not exist to confirm the precise cause of death.[15] Within days of his death, services were held in Detroit and his body was taken to Monroe, where he was buried. The artist probably rests in the family plot in Woodland Cemetery in an unmarked grave. Unfortunately, no documents survive to designate his grave site, and today only two tombstones remain in the large family plot, one for Duncanson's father, John Dean, and another for his sister Margaret.[16] Because Margaret died seven years after Robert, it is reasonable to assume that he lies there with his family members.

The Cincinnati, Detroit, and Monroe communities mourned the painter's death and published eulogies in praise of his artistic accomplishments and his character. In his hometown of Monroe, where he began in the painting trade that would eventually kill him, the press fondly remembered him as "an artist of considerable distinction" who "painted many pictures of rare merit and beauty." A Detroit newspaper was more emphatic in its praise. After extensively reviewing the highlights of his career, it proclaimed him "a celebrated artist." The Detroit article also provides some insight into Duncanson's normally congenial personality, remarking that he was "a man of modest disposition, and a gentleman who was greatly esteemed by all who knew him He was an artist of rare accomplishments, and his death will be regretted by all lovers of his profession, and by every American who knew him either by reputation or personally."[17]

In Cincinnati, Duncanson's home for over three decades, his loss had a great impact on the cultural community. After his death a large group of artists gathered to consider assistance for his widow and to draft a memorial state-

ment. Organized by C. T. Webber, the artists published the following testimonial.

> Resolved, that his long life of arduous toil, and continuous effort to elevate the aims and uses of landscape art, command our admiration, and though endowed by nature with the high poetic conceptions and eminently successful in placing his chosen branch of art beyond the plane of merely imitative, he deserves the greater appreciation that he never forgot the kindly word and generous sympathy for the humblest beginner who sought advice from the rich storehouse of his experience.[18]

This memorial offers a sensitive reflection on the man who worked to overcome tremendous adversity and earn a reputation as the leading artist in the region. Ironically, the artists neglected to note in their tribute Duncanson's remarkable achievement as an African-American who toiled as an anonymous housepainter and broke through the racial barriers to earn international acclaim in the white art world for his landscape paintings.

Shortly after the artist's death, his work fell into obscurity. Even at the height of the critical reception of his work, the taste for his style of painting had already begun to decline. The painter received a scathing review for his submissions to the Cincinnati Exposition of 1871. The critic wrote at length on the importance of Cincinnati as a center for producing "a greater number of artists in proportion than any other city in the Union," but he lamented that Cincinnati "starved out" her best artists. When he reviewed Duncanson's copy of his *Lotus Eaters,* the writer lambasted the painting, the artist's literary ambitions, and his entire approach to landscape painting:

> We have always regretted to see genius wasted on "ideal" landscapes, even when painted by the master-hands of Cole,

Church, or even Schirmer. We doubt if art ever transcends the real. Especially in landscapes a study of nature as she is is indispensable. A so-called composition, "made up" of impossible peaks, pumpkin colored skies, of rivers flowing from nowhere and falling into nothing, of trees and rocks that would puzzle a naturalist, do not make a landscape, and insult the poet they are intended to illustrate. We feel like being more severe with a painter like Mr. Duncanson, whose later productions show that he can do better. "Ellen's Isle" is worth a dozen "Lands of the Lotus Eaters" and "Vales of Cashmere."[19]

This critic vehemently denounced the painter's fanciful literary works, which Duncanson considered his most ambitious paintings, as trivial and trite. Had Duncanson read this review, it certainly would have severely disappointed the already moody and emotionally troubled artist.

Several years after Duncanson's death, one of his most impressive late pictures, *Ellen's Isle,* was disparagingly reviewed. In an 1874 article on the Sumner bequest then displayed at the Museum of Fine Arts in Boston, a critic was generally disappointed in Sumner's collection. In particular, the writer expressed dissatisfaction with *Ellen's Isle,* which was "good so far as the middle distance and water are concerned. But the sky is false in tone,—too blue." The negative tone of this review was symptomatic of the shift in the aesthetic sensibilities of post–Civil War America.[20] In 1880, only eight years after Duncanson's death, the Cincinnati Centennial Exposition completely excluded his work from the art section.[21]

The divisiveness of Civil War forced citizens in the United States to reevaluate their nationalistic pride and reconsider their national cultural identity. During the 1870s American aesthetics reflected this changing national attitude. While the paintings of Church, Bierstadt, and

Kensett still retained a popular audience, their appeal to connoisseurs was waning. The younger generations of American artists who studied in Europe chose not England and Italy but the more progressive academies of Paris and Munich. American collectors turned away from acquiring works by American artists and shifted to European masters who had established international reputations. William Morris Hunt (1824–1879) returned from a trip to France in 1868 and promoted Barbizon style paintings that proved very attractive to many American collectors and artists. A significant stylistic transition resulted from this introduction of Barbizon and other European styles, as is evident in the works of American artists such as Hunt, Edward M. Bannister, Eastman Johnson (1824–1906), George Inness (1825–1894), and Winslow Homer (1836–1910). Their works emphasize a poetic introspection about the landscape expressed with generalized forms and painterly brushwork. This change in aesthetic tastes caused Americans to abandon their commitment to the Hudson River School style, and, like many other artists, Duncanson's work and his vaunted reputation declined and were nearly forgotten for almost a century.

Duncanson's remarkable artistic achievements and international reputation during his lifetime marked an important stage in the emergence of the African-American artist from the roles of craftsman and tradesman to active participation in the international Anglo-European art world. From his humble beginnings as a housepainter, his career was shaped by the inequities of the slave system and Anglo-American society's preferential treatment of mulattoes and mixed-blood individuals. The limited opportunities he experienced as a mulatto, and the

patronage he received resulting from the rising abolitionist sentiments of the 1840s and 1850s, established the trend for black artists throughout the nineteenth century. Due to his incredible determination and innate talent, Duncanson overcame the ordeals of oppression and became the first African-American artist to rise to prominence in the Anglo-European art world. His legacy blazed the trail for subsequent African-American artists— Edmonia Lewis, Edward M. Bannister, and Henry O. Tanner—and eased their passage into the arts and their acceptance by the international cultural community.

Over the two decades he worked as a painter of landscapes, Duncanson evolved a distinctive style that synthesized his interest in conventional landscape aesthetics with Ruskinian naturalism and the elevated academic ideals of literary and historical painting. At the height of his career he was recognized as the "best landscape painter in the West" and the leading cultural figure in the Ohio River valley.[22] His interpretation of the landscape set the aesthetic standards for painting in the Ohio River valley and established him as a vital extension of the Hudson River School style practiced by his contemporaries in the east, Church, Bierstadt, Heade, and Kensett. It was an unprecedented achievement for an African-American artist to have reached such a level of popular and critical appreciation in antebellum America.

Because of the pressures of patronage and critical reception, Duncanson's paintings dealt with issue of contemporary aesthetics and did not overtly treat his concerns with slavery and other current African-American social and political problems. Because of his fair complexion and his ambition to succeed in the Anglo-European art world, his son and later historians accused him of "passing for white." However, the prevailing evidence acknowledges that the artist was an ardent antislavery activist. In his only obvious treatment of a slavery subject, *Uncle Tom and Little Eva* (1853), he conveyed his aspirations for a religious resolution to the evil of human bondage. Significantly, a close reading of his landscape subjects— especially his edenic images, literary landscapes, and Italian ruins scenes— reveals his aspirations for an ideal world for blacks in America and his condemnation of slavery. His art and accomplishments were regularly championed by the abolitionist journals of the day, which heralded him as an exemplar of the cultural capabilities of African-Americans. He actively worked on antislavery projects such as James P. Ball's slavery panorama and donated his paintings to raise money for the cause. His heart was sincerely with "the down-trodden race."

At the conclusion of his career Duncanson was transforming his vision of the landscape with a transcendental light and a refined, precise touch. Unfortunately, the lead poisoning that was a legacy of his apprenticeship as a house-painter claimed his life in the midst of this stylistic evolution. During the last two years of his life—as he created some of his greatest works—he grappled with a tremendous psychological burden that affected his artistic production. Poisoned by toxins and psychologically distressed, he died at an important transitional stage of his career. Due to the changing cultural tastes of the time, his work fell into obscurity after his death. This unfortunate fate befell an artist who was regarded during his lifetime as the most important landscape painter working in the western United States and who was a crucial figure marking the emergence of the African-American artist.

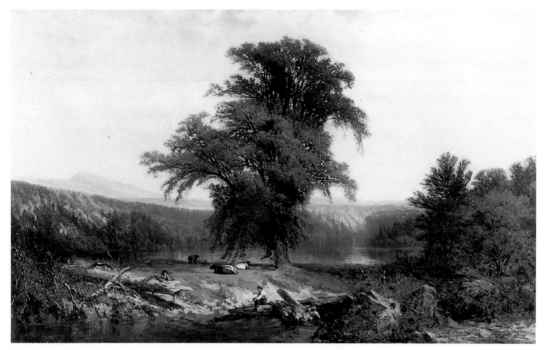

Fig. 113. Robert S. Duncanson, *Resting,* 1869, oil on canvas, 28″×45″. Cincinnati Financial Corporation.

CATALOG OF ARTWORKS

ABBREVIATIONS

For complete publication information on these works and others cited in the Catalog, see the Bibliography.

AAM 1864 Art Association of Montreal. *Second Conversazione.*

AAM 1865 Art Association of Montreal. *Third Conversazione.*

CAM 1955 Cincinnati Art Museum. *Rediscoveries in American Painting.*

CAM 1972 McElroy, Guy. *Robert S. Duncanson: A Centennial Exhibition.* Exhibition, Cincinnati Art Museum.

CAM 1979 Cincinnati Art Museum. *The Golden Age: Nineteenth Century Cincinnati Artists Represented in the Cincinnati Art Museum.*

CDE *Cincinnati Daily Enquirer*

Cist 1851 Cist, Charles. *Cincinnati in 1851.*

DCC *Daily Cincinnati Commercial*

DCG *Daily Cincinnati Gazette*

DDP *Detroit Daily Post*

DDU *Detroit Daily Union*

DFP *Detroit Free Press*

DIA 1949 Detroit Institute of Arts. *Exhibition of Works of Painters in Detroit before 1900.*

Dover 1960 Dover, Cedric. *American Negro Art*

Driskell 1976 Driskell, David C. *Two Centuries of Black American Art.* Exhibition, Los Angeles County Museum of Art.

Driskell 1985 Driskell, David C. *Hidden Heritage: Afro-American Art, 1800–1950.* Exhibition, Bellevue Art Museum, Washington, D.C.

Dwight 1953 Dwight, Edward H. "Art in Early Cincinnati."

Dwight 1955 Dwight, Edward H. "Robert S. Duncanson." *Bulletin of the Historical and Philosophical Society of Ohio* 13, no. 3 (July 1955): 203–11.

Howard U 1967 Porter, James A. *Ten Afro-American Artists of the Nineteenth Century.* Exhibition, Howard University Gallery of Art.

Janson 1982 Janson, Anthony F. "The Cincinnati Landscape Tradition."

Ketner 1983 Ketner, Joseph D., II. "Robert S. Duncanson (1821–1872): The Late Literary Landscape Paintings." *American Art Journal* 15, no. 1 (Winter 1983): 35–47.

Ketner 1987 Ketner, Joseph D., II. "Robert S. Duncanson (1821–1872)." In *Artists of Michigan from the Nineteenth Century*, ed. J. Gray Sweeney.

Ketner 1988 Ketner, Joseph D., II. "The Belmont Murals in the Taft Museum."

McElroy 1972 McElroy, Guy. "Robert S. Duncanson: A Problem in Romantic-Realism."

McNairn 1980 McNairn, Alan. "American Paintings in the National Gallery of Canada, Ottawa."

MC *Monroe Commercial*

MET 1976 Perry, Regina A. *Selections of Nineteenth-Century Afro-American Art.* Exhibition, Metropolitan Museum of Art, New York.

MET 1987 Metropolitan Museum of Art, New York. *American Paradise: The World of the Hudson River School.*

MFA 1972 Museum of Fine Arts, Boston, and the National Center of Afro-American Artists. *19th Century Afro-American Artists: Duncanson and Bannister.*

NCCU 1984 Museum of Art, North Carolina Central University. *Duncanson: A British-American Connection.*

	Exhibition.	1985	Duncanson in Montreal, 1863–
NMAA	Hartigan, Lynda Roscoe. *Sharing*		1865."
1985	*Traditions: Five Black Artists in*	Reid 1979	Reid, Dennis. *Our Own Country*
	Nineteenth-Century America.		*Canada.*
	Exhibition, National Museum of	Sanitary	1863 *History of the Great*
	American Art, Washington, D.C.	Fair	*Western Sanitary Fair.*
Parks	Parks, James Dallas. *Robert S.*	Taft 1988	Taft Museum, Cincinnati.
1980	*Duncanson: 19th Century Black*		*Nicholas Longworth: Art Patron*
	Romantic Painter.		*of Cincinnati.*
Porter	Porter, James A. "Robert S.	WAU	Western Art Union, Cincinnati,
1951	Duncanson: Midwestern		exhibitions from 1849 to
	Romantic-Realist."		1852, and the *Record of the*
Pringle	Pringle, S. Alan. "Robert S.		*Western Art Union.*

The following catalog lists all documented artworks that have been attributed by connoisseurship and scholarship to Robert S. Duncanson. The artworks are arranged in chronological order, with undatable works at the end of the list. Each entry includes the known provenance and all known literary references to each artwork through the summer of 1992. Unfortunately, it has not been possible to include changes in ownership or additional artworks brought to my attention after that date. The list is not intended to be a catalogue raisonné, but a prolegomenon to serve as the basis for future identification and authentication.

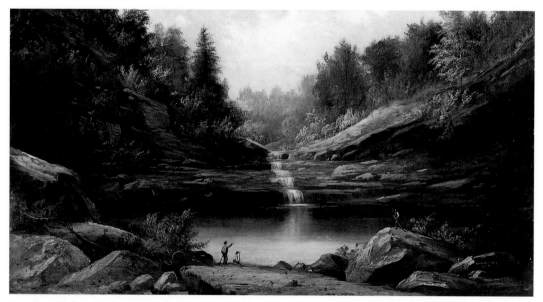

Fig. 114. Robert S. Duncanson, *Mountain Pool,* 1870, oil on canvas, 11¼″ × 20″. National Museum of American Art, Smithsonian Institution, Washington, D.C., gift of Dr. Richard Frates.

CATALOG

1. *Portrait of a Mother and Daughter,* 1841, oil on canvas, 30″ × 25″. Verso upper right: "R. S. Duncanson Pinxit 1841 Cincinnati." Fulton County Arts Council, Hammonds House, Atlanta, Ga.

Provenance: Ottis T. Hammonds, Atlanta, ?– 1987; Fulton County Arts Council, 1987–.

2. *Roses Still Life,* c. 1841, oil on canvas, 24″ × 19″. Lower center: "R.S.D." National Museum of American Art, Smithsonian Institution, Washington, D.C., gift of Leonard and Paula Granoff.

Provenance: Nelson Drummond, Cincinnati, ?–1976; Leonard and Paula Granoff, 1976; Museum of African Art, Washington, D.C., 1976–1983; National Museum of American Art, 1983–.

Literature: NMAA 1985, p. 52, fig. 9.

3. *Transportation in Early Cincinnati,* 1842, oil on canvas. Formerly in the Robert Miller Collection, Cincinnati.

Literature: CAM 1972, p. 41; Duncanson file, Francis Waring Robinson Papers, Detroit Institute of Arts.

4. *Trial of Shakespeare,* 1843, oil on canvas, 30″ × 40″. Lower right: "R. S. Duncanson 1843." Formerly in the Douglass Settlement House, Toledo, Ohio.

Provenance: Gano family, Mt. Healthy, Ohio, 1843–?; Frank C. Wright, Mt. Healthy, Ohio, c. 1913; Douglass Settlement House, c. 1951.

Literature: F. C. Wright, "Masterpiece Rescued from Oblivion of Attic," *Cincinnati Commercial Tribune,* October 3, 1913; Wendell P. Dabney, *Cincinnati's Colored Citizens;* James A. Porter, *Modern Negro Art,* p. 43; Porter 1951, pp. 108, 146, fig. 3; CAM 1972, p. 41; Parks 1980, p. 4.

5. *Roses Fancy Still Life,* c. 1843, oil on canvas, 10¾″ × 15⅛″. Lower left: "R.S.D." National Museum of American Art, Smithsonian Institution, Washington, D.C., gift of Alan M. Gilstein and William J. Piccerelli.

Provenance: Capt. Andrew K. Robinson, Cincinnati, c. 1843–1933; Americantiques, Glendale, Ohio, c. 1933–1976; Beck/Artists' Materials, Buffalo, New York, c. 1976; Alan M. Gilstein and William J. Piccerelli, c. 1976; Museum of African Art, Washington, D.C., 1976–1983; National Museum of American Art, 1983–.

6. *Mt. Healthy, Ohio,* 1844, oil on canvas, 28″ × 36¼″. Verso lower right: "R. S. Duncanson Aug. 1844." National Museum of American Art, Smithsonian Institution, Washington, D.C., gift of Leonard Granoff.

Provenance: private collection, Romeo, Mich., ?–c. 1976; Leonard Granoff, c. 1976; Museum of African Art, Washington, D.C., 1976–1983; National Museum of American Art, 1983–.

Exhibition: NMAA 1985, no. 6, pp. 56–57, fig. 15.

7. *Vulture and Its Prey,* 1844, oil on canvas, 27⅛″ × 22¼″. Lower right: "R. S. Duncanson 1844." National Museum of American Art, Smithsonian Institution, Washington, D.C., gift of Harold Deal.

Provenance: private collection, Romeo, Mich., ?–c. 1976; Harold Deal, Hickory, N.C., c. 1976; Museum of African Art, Washington, D.C., 1976–1983; National Museum of American Art, 1983–.

Literature: Ketner 1988, p. 57.

8. *Portrait of William J. Baker,* 1844, oil on canvas, 27⅝″ × 22¾″. Verso: "R. S. Duncanson Pinxit, Cincinnati, 1844, Age 3 Years." Baker-Hunt Foundation, Covington, Ky.

Provenance: Baker family, Covington, Ky., 1844–.

Exhibition: NCCU 1984, no. 7, illus. p. 11.

9. *Ruins of Carthage,* 1845, oil on canvas, 19½″ × 28″. Lower right: "R. S. Duncanson 1845." Formerly the Harriet Beecher Stowe House, Cincinnati.

Provenance: Philip Grandin, Cincinnati, c. 1845–?; Mrs. H. E. Grandin, Huntington Beach, Calif.; Miss Marie Dickore, Cincinnati; Warren County Historical Museum, Lebanon, Ohio, c. 1951; Harriet Beecher Stowe House, c. 1972.

Literature: Cist 1851; Porter 1951, pp. 109–10, 146; CAM 1972, p. 41.

10. *Drunkard's Plight,* 1845, oil on board, 15¼″ × 19¾″. Lower right: "Duncanson Pinxit 1845." Detroit Institute of Arts, gift of Miss Sarah Sheridan.

Provenance: James A. Roys, Detroit, c.

1845–1904; Ella Grace Roys, Detroit, 1904–1944; Detroit Institute of Arts, 1944–.

Exhibitions: DIA 1949; Detroit Institute of Arts, *Michigan Painters before 1900;* Howard U. 1967; MFA 1972; CAM 1972, no. 1; MET 1976.

Literature: A. S. Cavallo, "*Uncle Tom and Little Eva,* a Painting by Robert S. Duncanson," p. 24; Porter 1951, pp. 107–8, fig. 4; Dover 1960, p. 25, pl. 18; *Boston Sunday Globe,* January 9, 1972; *Peabody, Massachusetts, Times,* January 19, 1972; *The Phoenix,* January 26, 1972, p. 29; Ketner 1988, p. 59.

11. *William Berthelet,* 1846, oil on canvas, 30″ × 25″. Verso: "R. S. Duncanson 1846." Detroit Institute of Arts, gift of William T. Berthelet.

Provenance: Joseph Berthelet, Detroit, 1846–?; William Thomas Berthelet, Milwaukee, Wisc., ?–1952; Detroit Institute of Arts, 1952–.

Exhibitions: Howard U. 1967; MFA 1972; CAM 1972, no. 3, p. 7, fig. 2; MET 1976.

Literature: Porter 1951, pp. 122–25, 148, fig. 14; CAM 1972, no. 3, p. 7; Elsa Honig Fine, *The Afro-American Artist: Search for Identity,* p. 49, pl. 73.

12. *Henri Berthelet* (attributed to R.S.D.), c. 1846, oil on canvas, 30″ × 25″. Detroit Institute of Arts, gift of Miss Mary Stratton.

Provenance: Henri Berthelet, Detroit, 1846; William Thomas Berthelet, Milwaukee, Wisc., ?–1952; Detroit Institute of Arts, 1952–.

Exhibitions: CAM 1972, no. 2, p. 7, illus. p. 19; MET 1976.

Literature: Porter, 1951, pp. 122–25, 148, fig. 13.

13. *Mrs. Edward Porter Campbell* (Margaret Murphy), 1846, oil on canvas, 19⅝″ × 16½″. Private collection, Andover, Mass.

Literature: Inventory of American Paintings, no. 93070002; Parks 1980, p. 37, illus. p. 43.

14. *Mrs. Luke Cooper* (Sarah Murphy), 1847, oil on canvas. Private collection, Lawrence, Kans.

Literature: Inventory of American Paintings, no. 93070001; Sarah Murphy letter, Robinson Papers, Detroit Institute of Arts.

15. *Elizabeth Longworth Potter* (attributed to R.S.D.), c. 1847, oil on canvas. Private collection, Montgomery, Ohio.

Literature: CAM 1972, p. 41.

16. *Cliff Mine, Lake Superior, 1848,* 1848, oil on canvas, 28¾″ × 42″. Lower right: "R. S.

Duncanson"; titled on verso. F. Ward Paine, Jr., Portola Valley, Calif.

Provenance: Calumet and Hecla Co., Boston, 1848–?; F. Ward Paine, Sr., Boston, ?–1960; F. Ward Paine, Jr., Portola Valley, Calif., 1960–.

Exhibitions: Sadayoshi Omoto and Eldon van Liere, *The Michigan Experience,* no. 7, pp. 14–15, 59–60, illus. p. 61; Ketner 1987, pp. 62–63, pl. 6.

Literature: Donald Chaput, *The Cliff Mine: America's First Great Copper Mine* (Kalamazoo: Sequoia Press, 1971), illus. on dustcover.

17. *Mayan Ruins, Yucatan,* 1848, oil on canvas, 14″ × 20″. Lower center: "R. S. Duncanson 1848." Dayton Art Institute, purchase with funds provided by the Daniel Blau Endowment.

Provenance: Empire Art Galleries, Mt. Kisco, N.Y., 1970s; Sotheby's sale, December 6, 1984, lot 24; Dayton Art Institute, 1984–.

Literature: CAM 1972, p. 42; Sotheby's sale, December 1984, lot 24; *CDE,* December 22, 1985, p. G-5.

18. *Malay Yucatan,* 1848, oil on canvas, 14″ × 20″. Lower center: "R. S. Duncanson 1848." Empire Gallery, Mt. Kisco, N.Y.

Literature: CAM 1972, p. 42.

19. *The Catch / The Farmer's Apprentice,* 1848, oil on canvas, 18″ × 24″. Lower right: "R. S. Duncanson 1848"; verso: "The Farmer's Apprentice." Private collection, East Harwich, Mass.

Provenance: Edward Shein, Seekonk, Mass., c. 1984; private collection, East Harwich, Mass., 1985–.

Exhibition: Driskell 1985, no. 9.

20. *Man Fishing,* 1848, oil on canvas, 25″ × 30″. Lower right: "R. S. Duncanson." Dr. Walter O. Evans, Detroit.

Provenance: Edward Shein, Seekonk, Mass., c. 1984; private collection, East Harwich, Mass., 1985–.

Exhibition: Driskell 1985, no. 10.

21. *Portrait of a Man,* 1848, oil on canvas, 30″ × 24″. Verso: "R. S. Duncanson 1848." Galerie Americana, Chicago.

22. *Abandoned Mill Scene,* c. 1848, oil on canvas, 30¼″ × 21¾″. Lower left: "Duncanson." Private collection, Cincinnati.

Provenance: Robert Rice Galleries, Houston, ?–1986; Leonard Rinaldo, Houston, 1986–1987; private collection, Cincinnati, 1987–.

Exhibition: Taft 1988.
Literature: Taft 1988, p. 22.

23. *Still Life,* 1849, oil on canvas, 16" × 20".
Lower right: "R. S. Duncanson 1849." Los
Angeles County Museum of Art, gift of Mr. and
Mrs. Robert B. Honeyman, Jr.
 Provenance: Victor Spark, New York,
c. 1972; R. B. Honeyman, ?–1983; Los Angeles
County Museum of Art, 1983–.

24. *Fruit Piece,* 1849, oil on canvas, 14" × 20".
Lower right: "R. S. Duncanson 1849."
Detroit Institute of Arts, gift of the estates of
Miss Elizabeth Gray Walker and Mr. Henry
Lyster Walker.
 Provenance: Henry Nelson Walker, Detroit,
c. 1849–?; Walker family, Detroit, ?–
1957; Detroit Institute of Arts, 1957–.
 Exhibitions: Detroit Art Loan, *Catalogue of
Art Works Exhibited,* no. 210, p. 24;
CAM 1955, no. 26; Howard U. 1967; MFA
1972; CAM 1972, no. 17, illus. p. 27.
 Literature: Porter 1951, pp. 117, 152, fig. 11;
Dwight 1953; Romare Bearden and Harry
Henderson, *Six Black Masters of American Art*
(New York: Zenith Books Doubleday &
Co., 1972), pp. 28–29; CAM 1972, p. 41;
Detroit Institute of Arts, Duncanson file, loan
receipt XXX; William Gerdts, *Painters of
the Humble Truth: Masterpieces of American
Still Life,* p. 11, illus. 5.23; Ketner 1988, p. 56.

25. *Fruit Still Life,* 1849, oil on canvas,
13½" × 18½". Corcoran Gallery of Art,
museum purchase, Washington, D.C.
 Provenance: Corcoran Gallery of Art, 1968–.
 Exhibitions: MFA 1972; CAM 1972, no.
5, illus. p. 20; NCCU 1984, no. 4; Driskell
1985, no. 11.
 Literature: Dwight 1953, p. 11; NMAA
1985, pp. 52–53, fig. 10.

26. *Fruit Fancy Still Life,* 1849, oil on canvas
mounted on panel, 15⅜" × 23½". Lower
right: "R. S. Duncanson 1849." Mr. & Mrs.
Robert L. Bates, Dayton, Ohio.
 Provenance: E. Wiswell, Cincinnati; Mrs.
Francis J. Maltby, Covington, Ky.; Nelson
Drummond, Cincinnati, ?–1983; Robert Bates,
Dayton, Ohio, 1983–.
 Exhibitions: WAU 1849, no. 38; Dayton Art
Institute, Ohio, 1987.

27. *The New World,* 1849, oil on academy
board, 7¼" × 10". Verso: "The New World by
R. S. Duncanson Cinti 1849 OH." Formerly
Frank Patria, Detroit.
 Provenance: Frank Patria, Detroit, ?–c. 1972.

28. *Summer,* 1849, oil on canvas, 11½" × 16".
Mr. and Mrs. Meyer P. Potamkin.
 Provenance: Fred Dawes, Jamaica, Wisc.,
1850–?; E. N. Pike, Detroit, ?–1985; William
Doyle Galleries, 1985; Mr. and Mrs. Meyer P.
Potamkin, 1985–.
 Exhibition: WAU 1850, no. 480.
 Literature: *DCG,* April 23, 1850, p. 2;
Western Art Journal 2, no. 1 (April 1850): n.p.

29. *Winter,* 1849, oil on canvas, 11½" × 16".
Lower right: "R. S. Duncanson 1849."
Mr. and Mrs. Meyer P. Potamkin.
 Provenance: Fred Dawes, Jamaica, Wisc.,
1850–?; E. N. Pike, Detroit, ?–1985; William
Doyle Galleries, 1985; Mr. and Mrs. Meyer P.
Potamkin, 1985–.
 Exhibition: WAU 1850, no. 480.
 Literature: *DCG,* April 23, 1850, p. 2;
Western Art Journal 2, no. 1 (April 1850): n.p.

30. *Watermelons and Peaches,* c. 1849,
pastel on paper, 14" × 22". Formerly William
Kemper Collection, Seattle, Wash.
 Literature: CAM 1972, p. 41; Parks 1980,
p. 37.

31. *Carp River, Lake Superior,* 1850, oil on
board, 8" × 10". Recto: "R. S. Duncanson
1850"; verso: "R. S. Duncanson 1850 Carp
River, Lake Superior Cincinnati, Ohio."
Sotheby's sale no. 1142, October 25, 1985, lot
11.
 Provenance: W. B. McLellan, Waynesville,
Ohio, 1850–?.
 Exhibition: WAU 1850, no. 4170.

32. *Landscape with Hawk,* c. 1850, 15" × 22",
oil on canvas. Private collection, Erlanger, Ky.
 Provenance: Bernard Moeller, Cincinnati,
?–c. 1972; private collection, Erlanger, Ky.,
c. 1972–.
 Literature: Parks 1980, illus. p. 53.

33. *John Northrop* (attributed to R.S.D.),
c. 1850, oil on canvas, 23" × 18". Campus
Martius Museum of the Ohio Historical
Society, Marietta, Ohio, gift of Mrs. A. C.
Bournique.
 Literature: CAM 1972, p. 42.

34. *The Belmont Murals,* c. 1850–1852, oil on
plaster, eight panels approximately 9' × 7'.
The Taft Museum, Cincinnati.
 Literature: *CDE,* November 26, 1931;
Cincinnati Times-Star, March 8, November 29,
December 17, 1932; *Cincinnati Post,* November
29, 1932, p. 1; Walter Siple, "The Taft
Museum," pp. 7–8; Clara Longworth De-

Chambrun, *Cincinnati: The Story of the Queen City* (New York: Scribner's, 1939), p. 113; Cincinnati Institute of Fine Arts, *Catalogue of the Taft Museum*; Porter 1951, pp. 110–19, 148, figs. 5–10; Dwight 1955, pp. 206, 208; CAM 1972, pp. 8–9, 37, figs. B, C, 4a, 4b, 4c, 4d; Parks 1980, p. 10; Janson 1982, p. 17; Ketner 1988.

35. *Blue Hole, Flood Waters, Little Miami River,* 1851, oil on canvas, 29¼″ × 42¼″. Lower right: "R. S. Duncanson / Cinti O 1851." Cincinnati Art Museum, gift of Norbert Heerman and Arthur Helbig.
 Provenance: Norbert Heerman and Arthur Helbig, ?–1926; Cincinnati Art Museum, 1926–.
 Exhibitions: Museum of Modern Art, New York, *Romantic Painting in America* (New York: Museum of Modern Art, 1944), no. 80, p. 65; DIA 1949; Cincinnati Art Museum, 1949, no. 22; CAM 1955, no. 23; University of California, Los Angeles, *The Negro in American Art,* 1966, p. 21; Howard U. 1967, p. 13; Public Education Association, New York, *The American Vision,* 1968, no. 90, pl. 90; CAM 1972, no. 6, pp. 7–11, illus. p. 21; CAM 1979, no. 29; MET 1987, pp. 194–96.
 Literature: Alain Locke, *The Negro in Art* (Washington, D.C.: Associates in Negro Folk Education, 1940), p. 15; Porter 1951, pp. 119–20; Dover 1960, p. 26, pl. 17; J. Durrell to Philip Adams, December 4, 1964, Duncanson file, Cincinnati Art Museum; James T. Flexner, *Nineteenth Century American Painting* (New York: Putnam, 1970), p. 75; McElroy 1972, pp. 87, 143, 169, pl. 18; Richard J. Boyle, "From Hiram Powers to Laser Light," *Apollo* (April 1971): 308, fig. 5; John Wilmerding, ed., *The Genius of American Painting* (New York: Morrow, 1973), p. 143, illus. p. 144; Driskell 1976, p. 40, fig. 34; CAM 1979, pp. 43–44, pl. 29; Janson 1982, p. 17, fig. 6; NMAA 1985, p. 58, fig. 16.

36. *View of Cincinnati, Ohio from Covington, Kentucky,* c. 1851, oil on canvas, 25″ × 36″. Cincinnati Historical Society.
 Exhibitions: CAM 1972, no. 7, p. 11, illus. p. 21; Taft 1988.
 Literature: *Graham's Magazine* 32, no. 6 (June 1848): 352; Janson 1982, p. 17, fig. 5; Daniel Hurley, *Cincinnati: The Queen City* (Cincinnati: Cincinnati Historical Society, 1982), pp. 36–37; NMAA 1985, pp. 54, 56, fig. 12; Taft 1988, p. 22.

37. *Western Hunter's Encampment,* c. 1851, oil on canvas, 22½″ × 30″. Formerly Wendell P. Dabney, Cincinnati.
 Literature: Cist 1851, p. 126; Porter 1951, pp. 118–19, no. 6; Francis W. Robinson Papers, Detroit Institute of Arts.

38. *The Garden of Eden* (after Cole), 1852, oil on canvas, 32½″ × 48″. Lower left: "R. S. Duncanson 1852." High Museum of Art, lent by the West Foundation, Atlanta.
 Provenance: artist, 1852; Rev. Charles Avery, Pittsburgh, 1852–c. 1870; William Shinn, Pittsburgh, c. 1870; Alexander McLennan, Louisville, Ky., c. 1940; West Foundation, 1983–.
 Exhibitions: WAU 1852; Pittsburgh Art Gallery, 1870, no. 59.
 Literature: *DCG,* June 11, 1852, p. 2; August 24, 1852, p. 2; October 15, 1852, p. 2; November 9, 1852, p. 2; November 20, 1852, p. 2; November 27, 1852, p. 2; December 4, 1852, p. 2; *Frederick Douglass' Paper,* August 6, 1852, p. 3; Porter 1951, pp. 128, 148; Sotheby's sale no. 5055, June 2, 1983, lot 60.

39. *Pennsylvania Landscape,* 1852, oil on canvas, 16″ × 26½″. Lower left: "R. S. Duncanson 1852." Dr. and Mrs. Harmon W. Kelly, San Antonio, Tex.
 Literature: *DCG,* August 24, 1852, p. 2.

40. *Duck Shooting,* 1852, oil on canvas, 24″ × 36″. Lower left: "R. S. Duncanson 1852." New Jersey State Museum, Trenton, N.J.
 Provenance: artist's family, 1852–c. 1890s; Albert Duncanson, Seattle, c. 1900–c. 1960; Mrs. Ruth Showes, Cincinnati, c. 1960–c. 1980; Mrs. Judy Carter, Cincinnati, c. 1980–1986; New Jersey State Museum, 1987–.

41. *The Ford,* 1852, oil on canvas, 17½″ × 26½″. Danforth Museum of Art, Framingham, Mass., gift of Lawrence and Beverly Koffler.
 Provenance: Ralph van Maitre, Edenton, N.C., ?–c. 1980; Lawrence Koffler, Providence, R.I., c. 1980–1982; Danforth Museum of Art, 1982–.
 Literature: CAM 1972, p. 41.

42. *The Shepherd Boy,* 1852, oil on canvas, 32½″ × 48¼″. Lower left: "R. S. Duncanson 1852." The Metropolitan Museum of Art, New York, gift of Hanson K. Corning by exchange.
 Provenance: private collection, Kentucky, ?–c.

1972; Carl Solway, Cincinnati, c. 1972–
1975; Metropolitan Museum of Art, 1975–.

Exhibitions: J. P. Ball's Daguerrean Studio,
Cincinnati, April 1854–1855; American
Federation of the Arts, *The Heritage of
American Art, Paintings from the Collection of
the Metropolitan Museum of Art,* 1975–
1976; Ketner 1987, p. 64, illus. 8.

Literature: *DCG,* September 22, 1852, p. 2;
Frederick Douglass' Paper, May 5, 1854, p.
1; *Provincial Freeman* (Toronto), June 3, 1854,
p. 2; *Ball's Splendid Mammoth Pictorial
Tour of the United States,* n.p.; CAM 1972, p.
41; Natalie Spassky, *American Paintings in
the Metropolitan Museum of Art,* 2:83–84;
Ketner 1988, p. 62.

43. *Dream of Arcadia* (after Cole), c. 1852, oil
on canvas, 24″ × 42″. Lower center: "R. S.
Duncanson C.O." Private collection, New York.

44. *Landscape with Waterfall,* 1853, oil on
canvas, 41⅜″ × 55½″ oval. Lower center:
"R. S. Duncanson 1853." The Procter
and Gamble Company, Cincinnati.

45. *Uncle Tom and Little Eva,* 1853, oil on
canvas, 27¼″ × 38¼″. Lower left: "R. S.
Duncanson 1853." Detroit Institute of Arts, gift
of Mrs. Jefferson Butler and Miss Grace
Conover.

Provenance: Rev. James F. Conover, Detroit,
1853–1902; Conover family, Detroit, 1902–
1949; Detroit Institute of Arts, 1949–.

Exhibitions: Michigan State Fair, 1865; DIA
1949; Detroit Public Library, Centenary
Exhibition of Uncle Tom's Cabin, October 8–
November 15, 1952; Detroit Historical
Museum, Negro Culture Exhibition, 1952;
Denver Art Museum, Art Tells the Story, March
1–April 26, 1953; CAM 1955; John Herron
Art Museum, Indianapolis, Romantic America,
January 8–February 5, 1961; The Flint
Institute of Arts, Michigan Art Yesterday and
Today, April 11–May 5, 1963; Bowdoin
College Museum of Art, Brunswick, Maine,
The Portrayal of the Negro in American
Painting, May 15–September 6, 1964; Howard
U. 1967; School District of Philadelphia,
Afro-American Artists, 1800–1969, December
5–8, 1969; La Jolla Museum of Art, La
Jolla, Calif., Dimensions of Black, February
14–March 29, 1970; MFA 1972; CAM
1972, no. 8, pp. 11–12, illus. p. 23; Driskell
1976, no. 25; NCCU 1984, no. 12, p. 6;
Ketner 1987, pp. 63, 211, pl. 8.

Literature: *DCG,* March 17, 1853, p. 2; *DFP,*

April 21, 1853, p. 2; Porter, *Modern Negro
Art,* pp. 43–46; Porter 1951, pp. 128–29, 147,
fig. 20; Cavallo, "*Uncle Tom and Little
Eva,*" pp. 21–25; Detroit Public Library,
"Centenary of Uncle Tom's Cabin," no. 140,
p. 47; Dwight 1955, p. 206; Joy Hakanson,
"Reform Art," *Detroit News Pictorial Magazine,*
November 23, 1958; Dover 1960, pp. 25,
84; Sister M. Killian Kenny, "A History of
Painting in Michigan: 1850 to World War II,"
pl. 6, p. 23; "North of the River," *Apollo,*
June 1972, pp. 501–2; Fine, *The Afro-American
Artist,* pp. 50–51; Arthur Hopkin Gibson,
Artists of Early Michigan, p. 95; Parks 1980,
pp. 11–14; NMAA 1985, pp. 54–55, fig. 13.

46. *Romantic Landscape,* 1853, oil on
canvas, 16¼″ × 28⅛″. Lower left: "R. S.
Duncanson 1853." Private collection,
Massachusetts.

Provenance: Henry Fuller, New York; private
collection, Massachusetts.

Exhibitions: Howard U. 1967; Currier
Gallery of Art, Manchester, N.H., 19th Century
American Paintings from the Collection of
Henry M. Fuller, September 18–October 17,
1971; CAM 1972, no. 9, illus. p. 23; City
College of New York, Evolution of Afro-
American Artists, 1800–1900; Cummer Gallery,
Jacksonville, Fla., Mid-19th Century American
Painting from the Collections of Henry M.
Fuller and William H. Gerdts.

47. *Time's Temple,* 1854, oil on canvas,
34″ × 59″. Lower left: "R. S. Duncanson 1854."
Howard University Gallery of Art, Washington,
D.C.

Provenance: Victor Spark, New York; James
V. Herring, Washington, D.C.; Howard
University Gallery of Art.

Exhibitions: artist's studio, 4th St.,
Cincinnati, June–August 1854; Howard U.
1967; MFA 1972; CAM 1972, no. 10, illus.
p. 22; Marcel Roethlisberger, *Im Licht
von Claude Lorrain: Landschaftsmalerei aus
drei Jahrhundert,* pp. 278–79, no. 193; Driskell
1985, no. 12.

Literature: William Miller to Isaac Strohm,
April 11, 1854, Newberry Library, Chicago;
DCC, June 10, 1854, p. 2; July 1, 1854,
p. 2; Porter 1951, pp. 130–31, 150, fig. 21.

48. *Christian and Hopeful in the Land of Bula,*
1854, pen on paper, 2″ × 3¼″. Platt R.
Spencer Papers, Newberry Library, Chicago.

Provenance: Junius R. Sloan; Robert Spencer;
Newberry Library.

Literature: Duncanson to J. R. Sloan, August 21, 1854, Spencer Papers; James A. Porter, "Robert S. Duncanson" (1954), p. 235; Ketner 1983, p. 38, figs. 2–3.

49. *Rhine,* c. 1854, oil on canvas, 27¼″ × 42¼″. National Museum of American Art, Smithsonian Institution, Washington, D.C., gift of Sol and Lillian Koffler.
Provenance: William E. Wiswell, Cincinnati, 1854–?; Sol & Lillian Koffler, ?–1976; Museum of African Art, Washington, D.C., 1976–1983; National Museum of American Art, 1983–.
Exhibition: William Wiswell Looking Glass & Picture Frame, Cincinnati, 1854.

50. *Pompeii,* 1855, oil on canvas, 21″ × 17″. Lower left: "R. S. Duncanson 1855." National Museum of American Art, Smithsonian Institution, Washington, D.C., gift of Richard Frates.
Provenance: D. P. Wooley, New York; Hirschl and Adler Galleries, New York, 1972; Edward Shein, Seekonk, Mass., c. 1972–1975; Richard Frates, c. 1975–1976; Museum of African Art, Washington, D.C., 1976–1983; National Museum of American Art, 1983–.
Exhibitions: William Wiswell, Cincinnati, 1854?; CAM 1972, no. 11, illus. p. 24; Barbara Novak, *The Arcadian Landscape: Nineteenth Century American Painters in Italy,* fig. 18, illus. p. 24; Driskell 1976, no. 27, p. 124; The Brooklyn Museum, 1977; NMAA 1985, no. 7, p. 60, pl. 4.

51. *Italianate Landscape,* 1855, oil on canvas, 26½″ × 36¼″. Lower left: "R. S. Duncanson 1855." California Afro-American Museum, Los Angeles.
Provenance: Sotheby's, New York, 1984; California Afro-American Museum, 1985–.
Exhibition: Driskell 1985, no. 13, fig. 6.

52. *Freeman C. Cary,* c. 1855, oil on canvas, 43⅜″ × 35¼″. National Museum of American Art, Smithsonian Institution, Washington, D.C., gift of Sol Koffler.
Provenance: Ohio Military Institute, Cincinnati; Cincinnati Art Museum, ?–c. 1972; Edward Shein, Seekonk, Mass., c. 1972–1975; Sol Koffler, 1976; Museum of African Art, Washington, D.C., 1976–1983; National Museum of American Art, 1983–.
Exhibition: Driskell 1976, no. 26.
Literature: Porter 1951, pp. 127, 149, fig. 18; NMAA 1985, fig. 11, p. 53.

53. *William Cary,* 1855, oil on canvas,

84″ × 60″. Lower right: "Duncanson 1855." Formerly the Ohio Military Institute, Cincinnati.
Literature: Porter 1951, pp. 127, 149, fig. 17; CAM 1972, p. 42.

54. *The Hiding of Moses,* 1855, oil on canvas, 72″ × 60″. Formerly YWCA, Cincinnati.
Provenance: Dr. Otto Juetner, Cincinnati; Goldie Mitchell, Cincinnati; YWCA, Cincinnati, destroyed in 1984.
Literature: Porter 1951, pp. 137–38, 147, fig. 25; CAM 1972, p. 42.

55. *Robert H. Bishop,* c. 1855, oil on canvas. Formerly the Ohio Military Institute, Cincinnati.
Literature: A. B. Huston, *Historical Sketch of Farmer's College* (Cincinnati: Students' Association of Farmer's College, 1906), p. 33; Porter 1951, pp. 125, 149, fig. 15; CAM 1972, p. 42.

56. *Margaretta Baker* (attributed to R.S.D.), c. 1850–1855, oil on canvas, 27½″ × 22¾″. Baker-Hunt Foundation, Covington, Ky.
Provenance: Baker family, Covington, Ky., c. 1855–1922; Baker-Hunt Foundation, 1922–.
Literature: Harry R. Stevens, *Six Twenty* (Covington, Ky.: Baker-Hunt Foundation, 1942), p. 30.

57. *Portrait of a Young Boy,* c. 1855, oil on canvas, 51⅛″ × 36″. DeVant Crissey, Smyrna, Ga.

58. *Flight of the Eagle,* 1856, oil on canvas, 28″ × 44″. Lower left: "R. S. Duncanson 1856." Dr. Walter O. Evans, Detroit.
Provenance: Mary L. Ran, Cincinnati, 1985–1987; June Kelly, New York, 1987–1990; Dr. Walter O. Evans, Detroit, 1990–.
Literature: *Walter O. Evans Collection of African American Art* (Savannah: Walter O. Evans, King-Tisdell Foundation, 1991), p. 16, fig. 1 p. 34.

59. *Remembrance of a Scene near Auerbach,* 1856, oil on canvas, 13½″ × 18″. Verso: "Remembrances of a Scene Near Auerbach, Granddukedom Hessin Ger., R. S. Duncanson, Cin. O. 1856." National Museum of American Art, Smithsonian Institution, Washington, D.C., gift of Dr. & Mrs. Richard Wong.
Provenance: Dr. William P. Barnes, Cincinnati, c. 1972; Edward Shein, Seekonk, Mass., c. 1972–c. 1978; Dr. & Mrs. Richard Wong, 1978; Museum of African Art, Washington, D.C., 1978–1983; National Museum of American Art, 1983–.

Exhibitions: CAM 1972, no. 12, illus. p. 24; NMAA 1985, no. 8, p. 58, pl. 3.

60. *Sunset Landscape with Sheep* (attributed to R.S.D.), c. 1856, oil on canvas, 32¼″ × 44⅛″. National Museum of American Art, Smithsonian Institution, Washington, D.C., gift of Sol and Lillian Koffler.

Provenance: DeVant Crissey Gallery, Smyrna, Ga., c. 1972; Edward Shein, Seekonk, Mass., c. 1972–1977; Sol and Lilian Koffler, 1977; Museum of African Art, Washington, D.C., 1977–1983; National Museum of American Art, 1983–.

Literature: CAM 1972, p. 42.

61. *Mrs. James Drew,* 1856, oil on canvas. Private collection.

Literature: Parks 1980, p. 39, illus. p. 55.

62. *Western Forest,* 1857, oil on canvas, 54″ × 42″. Lower center: "R.S. Duncanson 1857." Private collection, Cincinnati.

Provenance: artist, 1857; Miss Charlotte Cushman, 1858–; Duchess of Sutherland, England, 1858–?; Viscount Astor, Cliveden, Berkshire; Richard Green Ltd., London, ?–c. 1970; private collection, Cincinnati, c. 1970–.

Exhibitions: CAM 1972, no. 13, frontispiece; MET 1976; St. Louis Art Museum, *Currents of Expansion: Painting in the Midwest, 1820–1940,* no. 40, p. 28, illus. p. 29; Ketner 1987, pp. 64–66, pl. 7.

Literature: *DCC,* March 9, 1857, p. 2; March 26, 1857, p. 2; *CDE,* April 28, 1858, p. 3; Parks 1980, pp. 21, 22.

63. *Valley Pasture,* 1857, oil on canvas, 32¼″ × 48″. Lower left: "R. S. Duncanson Cin. O. 1857." National Museum of American Art, Smithsonian Institution, Washington, D.C., gift of Melvin and Alan H. Frank.

Provenance: Wendell P. Dabney, Cincinnati, –1950s; Douglas Collins, Massachusetts, c. 1968–1975; Edward Shein, Seekonk, Mass., 1975; Melvin and Alan H. Frank, 1975; Museum of African Art, Washington, D.C., 1975–1983; National Museum of American Art, 1983–.

Exhibitions: Museum of Fine Arts, Springfield, Mass., 1970; High Museum of Art, Atlanta, 1974; The Brooklyn Museum, New York, 1977; NMAA 1985, no. 9. p. 61, fig. 19.

Literature: Porter 1951, pp. 132–33, 150, fig. 22; Sotheby's sale no. 2758, November 6, 1968, lot 184.

64. *Couple and Child by a Lake,* 1858, oil on canvas, 12″ × 17″. Lower right: "R. S. Duncanson 1858." National Museum of American Art, Smithsonian Institution, Washington, D.C.

Provenance: Museum of African Art, Washington, D.C., 1979–1983; National Museum of American Art, 1983–.

65. *Nicholas Longworth,* 1858, oil on canvas, 84″ × 60″. Lower left: "R. S. Duncanson 1858." Cincinnati Art Museum, lent by the Ohio College of Applied Science, Cincinnati.

Provenance: Nicholas Longworth, Cincinnati, 1858–?; F. P. Wolcott, Cincinnati, ?–1896; Ohio Mechanics Institute, Ohio College of Applied Sciences, 1896–.

Exhibitions: Howard U 1967; CAM 1972, no. 14, p. 13, illus. p. 25; MET 1976; CAM 1979, no. 30, pp. 15, 129; Taft 1988.

Literature: Porter 1951, pp. 126–27, 149; Dwight 1955, p. 207; Dover 1960, illus. p. 84; Russell Adams, *Great Negroes Past and Present* (Chicago: Afro-American Publishing Co., 1964), p. 156; Louis L. Tucker, "Hiram Powers and Cincinnati," *Cincinnati Historical Society Bulletin,* January 1967, illus. p. 28; McElroy 1972, pl. 31; Bearden and Henderson, *Six Black Masters,* 1972, illus. p. 29; Fine, *The Afro-American Artist,* illus. p. 51; CAM 1979, pp. 15, 129; Taft 1988, p. 17.

66. *Richard Sutton Rust I,* c. 1858, oil on canvas, 30″ × 25″. Private collection, Cincinnati.

Provenance: private collection, Cincinnati, 1858–.

Exhibition: CAM 1972, no. 15, p. 13, illus. p. 26.

67. *Peaceful Valley,* 1858, oil on canvas, signed and dated. Formerly George Baer Collection, Cincinnati.

Literature: Francis W. Robinson Papers, Detroit Institute of Arts.

68. *The Temple of the Sibyl,* 1859, oil on canvas, 36″ × 60″. Lower right: "R. S. Duncanson Cinti Ohio 1859." Formerly the Reverend Andrew H. Newman, Bellbrook, Ohio.

Provenance: John Hosmer, Detroit, c. 1865–1876; Hugh Carmichael, Glendale, Ohio, c. 1951; Rev. Andrew H. Newman, c. 1972.

Exhibitions: Duhme's Jewelry Store, Cincinnati, June 1859; William Bond's Store, Detroit, September 1860; Michigan State Fair, February 1865; Buffalo Fine Arts Academy, 1869, no. 85; Detroit Art Association,

Catalogue of the First Exhibition; CAM 1972, no. 16, p. 13, illus. p. 12.
Literature: *CDE,* June 22, 1859, p. 2; *Detroit Daily Tribune,* September 20, 1860, p. 1; Porter 1951, pp. 131–32, 150, fig. 21a.

69. *The Rainbow,* 1859, oil on canvas, 30″ × 52¼″. Lower left: "R. S. Duncanson Cinti 1859." National Museum of American Art, Smithsonian Institution, Washington, D.C., gift of Leonard Granoff.
Provenance: Edward Shein, Seekonk, Mass., 1972–1974; Leonard Granoff, 1975; Museum of African Art, Washington, D.C., 1975–1983; National Museum of American Art, 1983–.
Exhibitions: NCCU 1984, no. 6, p. 15; NMAA 1985, no. 10, p. 61, fig. 20.
Literature: *CDE,* January 17, 1860, p. 2.

70. *Landscape with Brook,* 1859, oil on canvas, 10″ × 16″. Lower right: "R. S. Duncanson Cinti O. 1859." Private collection, Massachusetts.

71. *Allegorical Figure,* 1860, oil on canvas, 28½″ × 36″ oval. Lower left: "R. S. Duncanson 1860." Galerie Americana, Chicago.

72. *Jessie Northrop,* c. 1860, oil on canvas, 53″ × 42″. Verso: "Jessie Northrop by Robert S. Duncanson." Campus Martius Collection of the Ohio Historical Society, Marietta, Ohio.
Provenance: Northrop family, Ohio; Mrs. A. L. Bournique, Campus Martius Collection.
Literature: CAM 1972, p. 42.

73. *Land of the Lotus Eaters,* 1861, oil on canvas, 52¾″ × 88⅝″. Lower right: "R. S. Duncanson 1861." Collection of His Royal Majesty, the King of Sweden.
Provenance: artist, 1861–1866; Collection of His Royal Majesty, the King of Sweden, c. 1905–.
Exhibitions: Pike's Opera House, Cincinnati, May–June 1861; Joseph's Jewelry Store, Toronto, November 1861; William Notman Studio, Montreal, September 1863; AAM 1864, no. 109; Dublin International Exposition, 1865; London, January 1866; copy exhibited at Associated Artists of Cincinnati, 1866, no. 28; copy exhibited at Exposition, Cincinnati, September 1871.
Literature: *DCG,* May 30, 1861, p. 2; June 3–4, 1861, p. 2; *Toronto Globe,* November 5, 1861; *CDE,* May 26, 28, June 4, 7, 9, 23, 1861; March 5, 1862; *Photographic Selections by William Notman*; *Art-Journal* (London) n.s. 3 (1864): 58–59, 113, n.s. 6 (1866): 93;

Notman Archives, McCord Museum, McGill University, Montreal; Porter 1951, pp. 133–36, 141; CAM 1972, pp. 13–14; Bearden and Henderson, *Six Black Masters,* pp. 37–39; Reid 1979, pp. 41–44, fig. 10; Parks 1980, pp. 19, 22; Janson 1982, p. 17; Ketner 1983, pp. 38–41, fig. 1; NCCU 1984, pp. 12–13; NMAA 1985, pp. 62–63; Pringle 1985, pp. 30–33, fig. 3.

74. *Western Tornado,* 1861, oil on canvas. Location unknown.
Exhibitions: Pike's Opera House, Cincinnati, June 1861; Joseph's Jewelry Store, Toronto, November 1861; Notman's Gallery, Montreal, September 1863.
Literature: *DCG,* May 30, 1861, p. 2; *CDE,* June 26, 1861, p. 2; June 28, 1861, p. 2; *Montreal Herald,* September 22, 1863, p. 3; *Art-Journal* n.s. 3 (1864): 113; Reid 1979, p. 41; Pringle 1985, pp. 30–31.

75. *Western Landscape* (1861) oil on canvas, 9″ × 15″. Lower center: "R.S.D. 1861." Private collection, Detroit.

76. *Italian Landscape,* 1861, oil on canvas, 10″ × 8″. Lower center: "R.S.D. 1861." Private collection, New York.

77. *Italian Landscape,* 1861, oil on canvas, 10″ × 8″. Lower center: "R.S.D. 1861." Private collection, New York.

78. *Faith,* 1862, oil on canvas, 80″ × 64″. Lower left: "R. S. Duncanson Cin. O. 1862." National Afro-American Museum and Cultural Center, Wilberforce, Ohio, gift of Mr. & Mrs. Robert L. Bates.
Provenance: Wendell P. Dabney, Cincinnati, c. 1900–c. 1950s; private collection, Cincinnati, c. 1950s–1968; Robert Bates, Dayton, Ohio, 1968–1988; National Afro-American Museum and Cultural Center, 1988–.
Literature: *CDE,* March 15, 1862; Porter 1951, pp. 136, 147, fig. 24; Dwight 1955, p. 139.

79. *Prairie Fire,* 1862, oil on canvas. Location unknown.
Exhibition: AAM 1864, no. 35.
Literature: *CDE,* March 5, 1862, p. 2; *Montreal Herald,* February 12, 1864, p. 1; *Art-Journal* n.s. 3 (1864): 113; Reid 1979, pp. 42–43; Pringle 1985, p. 31.

80. *Maiden's Rock, Lake Pepin, Minnesota,* 1862, oil on canvas, 12″ × 21¾″. Lower left: "R.S.D. 1862"; verso: "Maiden's Rock,

Lake Pepin, Minn. Painted by R.S. Duncanson Cinti, Ohio." Mead Art Museum, Amherst College, Amherst, Mass., gift of William Macbeth, Inc.

Provenance: Tuttle's Book Shop, Rutland, Vt., 1945; William Macbeth, Inc., New York, 1947; Amherst College.

Exhibition: CAM 1972, no. 18.

81. *Falls of Minnehaha,* 1862, oil on canvas, 36″ × 28″. Lower left: "R.S.D. 1862 Cinti O." Private collection, Massachusetts.

Provenance: Private collection, Boston, 1862–?; Richard Green Gallery, London, 1972; Edward Shein, Seekonk, Mass., 1972–c. 1976; Lewis Glaser, c. 1976–c. 1980; Francine Aron and Robert Aron, Cranston, R.I., c. 1980–1989; private collection, Massachusetts.

Exhibitions: Driskell 1976, no. 30; NMAA 1985, no. 11.

Literature: *DCG,* October 22, 1862, p. 1; *Art-Journal* n.s. 3 (1864): 113; *Antiques,* April 1974, p. 687; Rena Neumann Coen, *Painting and Sculpture in Minnesota, 1820–1914,* pp. 41–43, pl. 15.

82. *Minnehaha Falls,* 1862, oil on canvas, 20″ × 16″. Verso: "Minnehaha Falls, Minnesota, painted by R.S. Duncanson 1862." Howard University Art Gallery, Washington, D.C.

Provenance: L. C. Hopkins, Cincinnati, 1862–?; William F. Bailey, Fernbank, Ohio; Mr. Ralph Van Maitre, Edenton, N.C., ?–1972; Edward Shein, Seekonk, Mass., 1972–1974; Irwin Sparr, New York, 1974; Howard University Art Gallery.

Exhibitions: Pike's Opera House, Cincinnati, October–November 1862; CAM 1972, no. 19.

Literature: *DCG,* October 22, 1862, p. 1; *Art-Journal* n.s. 3 (1864): 113.

83. *Minnenopa Falls,* 1862, oil on canvas, 20″ × 16″. Verso: "Minnenopa Falls, Minnesota River painted by R.S. Duncanson 1862." The Procter and Gamble Company, Cincinnati.

Provenance: William Bailey, Fernbank, Ohio; van Maitre family, Edenton, N.C., ?–1974; Edward Shein, Seekonk, Mass., 1974; Henry Gates, Providence, R.I., 1974–c. 1984; Procter and Gamble Company, 1984–.

Exhibition: CAM 1972, no. 20.

84. *Mt. Trempeleau,* 1862, oil on canvas, 21″ × 32½″. Lower right: "R.S.D. 1862." Cincinnati Public Schools.

85. *Lancaster, New Hampshire,* 1862, oil on canvas, 20″ × 16″. Lower left: "R. S.

Duncanson 1862"; verso: "Lancaster, N.H. from Guild Hall, Vt. painted by R.S. Duncanson Cin., O., 1862." Allan Shawn Feinstein, Cranston, R.I.

Provenance: William F. Bailey, Fernbank, Ohio; van Maitre family, Edenton, N.C., ?–1974; Allan Shawn Feinstein, 1974–.

Exhibition: CAM 1972, cat. 21.

86. *American Scene,* 1862, oil on canvas, 24″ × 36″. Atelier Dore, San Francisco.

87. *Eve,* c. 1862, oil on canvas, 30″ × 25″. Douglas Himmelfarb, Los Angeles.

88. *Vale of Kashmir,* 1863, oil on canvas, 9″ × 16″. Lower left: "R. S. Duncanson 1863." Private collection, Detroit.

Literature: *CDE,* March 24, 1863, p. 3.

89. *On the St. Anne's, East Canada,* 1863–1865, oil on canvas, 9⅛″ × 15″. Lower left: "R. S. Duncanson 1865"; verso center: "On the St. Anne's, C.E. / R.S.Duncanson Montreal 1863." National Museum of American Art, Smithsonian Institution, Washington, D.C., gift of Herbert Drown.

Provenance: private collection, Canada, ?–1978; Edward Shein, Seekonk, Mass., 1978; Herbert Drown, 1979; Museum of African Art, Washington, D.C., 1979–1983; National Museum of American Art, 1983–.

Exhibitions: AAM 1865, no. 65; NMAA 1985, no. 12, p. 61, fig. 22.

Literature: Pringle 1985, p. 35, fig. 5.

90. *Niagara Falls,* 1863, oil on canvas. Formerly E. C. Middleton, Cincinnati.

Exhibition: Sanitary Fair 1863, no. 81.

Literature: Edward Radford, "Canadian Photographs."

91. *Oenone,* 1863, oil on canvas. Formerly E. C. Middleton, Cincinnati.

Exhibitions: Sanitary Fair 1863, no. 77, pp. 409–10.

Literature: Radford, "Canadian Photographs."

92. *Sunset Study,* 1863, oil on canvas, 7″ × 10⅛″. Lower right: "R.S.D. 63." Montreal Museum of Fine Arts, gift of Miss C. Burroughs, Quebec.

Provenance: Miss C. Burroughs, Montreal, ?–1943; Montreal Museum of Fine Arts, 1943–.

Exhibition: Reid 1979, no. 24.

Literature: John Steegman, *Catalogue of Paintings* (Montreal: Montreal Museum of Fine Arts, 1960), no. 781, p. 14; Reid

1979, pp. 44, 96, fig. 37.

93. *City and Harbour of Quebec,* 1863, oil on canvas. Location unknown.
 Literature: *Photographic Selections by William Notman* (Montreal, 1865); Notman Archives, McCord Museum, McGill University, Montreal; Reid 1979, p. 42; Pringle 1985, pp. 31, 33–34, fig. 4.

94. *On the Back River,* 1863, oil on canvas. Location unknown.
 Literature: Notman Archives, McCord Museum, McGill University, Montreal; Pringle 1985, p. 35, fig. 7.

95. *Picnickers by a Lake,* 1863, oil on canvas, 16″ × 22″. Lower left: "R.S.D. 1863." Paul Young Funeral Home, Mt. Healthy, Ohio.
 Provenance: Miss T. C. Noble, Mt. Healthy, Ohio, ?–c. 1950s; Paul Young, Mt. Healthy, Ohio, c. 1950s–.

96. *Waterfalls of Montmorency,* 1864, oil on canvas, 18″ × 27¾″. Lower left: "Duncanson Montreal 1864"; verso: "Waterfalls of Mt. Marenci, 9 mi. below Quebec." National Museum of American Art, Smithsonian Institution, Washington, D.C., gift of Dr. Norbert Fleisig.
 Provenance: artist, 1864; Gilbert LaBoiteaux, Mt. Healthy, Ohio, 1864–?; Miss T. C. Noble, Mt. Healthy, Ohio; Frank Stout, Mt. Healthy, Ohio, ?–1976; Dr. Norbert Fleisig, 1976; Museum of African Art, Washington, D.C., 1976–1983; National Museum of American Art, 1983–
 Exhibition: CAM 1972, no. 23.

97. *Vale of Kashmir,* 1864, oil on canvas, 17¾″ × 30″. Lower right: "R. S. Duncanson 1864 Montreal." Private collection, Massachusetts.
 Provenance: O. S. Wood, Montreal, c. 1865; Dr. Charles Mandell, Providence, R.I., c. 1970s; private collection, c. 1980–.
 Exhibitions: AAM 1865, no. 103, p. 23; Driskell 1976, no. 31, illus. p. 84.
 Literature: Reid 1979, p. 43; Ketner 1983, pp. 39–42, fig. 6; NMAA 1985, p. 63; Pringle 1985, p. 39.

98. *Recollections of Italy,* 1864, oil on canvas, 21″ × 39¾″. Lower left and lower center: "R. S. Duncanson 1864 Montreal." Wadsworth Atheneum, Hartford, Conn., The Dorothy Clark Archibald and Thomas L. Archibald Fund.
 Provenance: Private collection, London,

?–1987; Montgomery Gallery, San Francisco, 1987–1989; E. Thomas Williams, 1989–1992; Wadsworth Atheneum, 1992–.

99. *Owl's Head Mountain,* 1864, oil on canvas, 18″ × 36″. Lower left: "Duncanson 1864." National Gallery of Canada, Ottawa, gift of Louis Bertrand.
 Provenance: J. C. Baker, Stanbridge, Canada, 1865–?; Louis Bertrand, ?–1976; National Gallery of Canada, 1976–.
 Exhibition: Reid 1979, no. 4.
 Literature: Reid 1979, p. 44, fig. 11; McNairn 1980, p. 1013; Pringle 1985, p. 34, 39, fig. 13.

100. *Mount Royal,* 1864, watercolor on paper, 36¾″ × 28¼″. Lower center: "Duncanson 1864 Montreal." National Gallery of Canada, Ottawa, purchase.
 Provenance: Dominion Gallery, Montreal, 1960; National Gallery of Canada, 1960–.
 Exhibition: AAM 1865, no. 89, p. 29.
 Literature: McNairn 1980, p. 1013; Pringle 1985, p. 39, fig. 11, back cover.

101. *Seascape,* 1864, oil on canvas, 18″ × 36″. Lower left: "Duncanson 1864 Montreal." Art Gallery of Ontario, Musée des Beaux-arts de l'Ontario, purchase, with assistance from Wintario, 1979.

102. *Lake St. Charles, near Quebec,* 1864, oil on canvas, 16″ × 28″. Lower left: "1864 R. S. Duncanson." Musée du Quebec, gift of William M. Connor.
 Provenance: W. M. Connor; Musée du Quebec.
 Exhibitions: Musée du Quebec, Cornelius Krieghoff et le XIXe siècle: La peinture au Quebec de 1830–1880, June 12–September 22, 1985.
 Literature: Reid 1979, p. 44; Pringle 1985, p. 39, fig. 14.

103. *Autumn Scene,* 1864, oil on canvas, 12″ × 24″. Lower left: "R. S. Duncanson 1864." Queen City Club, Cincinnati.

104. *Landscape with Lake,* 1864, oil on canvas, 14¼″ × 24⅝″. Lower left: "R.S.D. 1864." National Museum of American Art, Smithsonian Institution, Washington, D.C., gift of Dr. Charles H. Mandell.
 Provenance: Dr. Charles Mandell, Providence, R.I., ?–1978; Museum of African Art, Washington, D.C., 1978–1983; National Museum of American Art, 1983–.
 Exhibition: NMAA 1985, no. 13, fig. 23.

105. *Lake View with Figures,* 1864, oil
on canvas, 7″ × 12″. Signed lower left. Private
collection, Providence, R.I.

106. *Tropical Landscape with Figures,* 1864, oil
on canvas, 7″ × 12″. Lower right: "Duncanson
1864." Babcock Galleries, New York.

107. *River with Rapids,* c. 1864, oil on canvas,
29″ × 24″. Lower left: "R. S. Duncanson."
Art Gallery of Ontario, Musée des Beaux-arts
de l'Ontario, gift of Mr. Mort Lesser, Port
Hope, Ontario, in memory of Jean Evelyn
Lesser, 1985.

108. *Canadian Landscape,* 1865, oil on canvas,
30″ × 50″. Lower right: "Duncanson 1865."
Eric Wentworth, Washington, D.C.
 Provenance: private collection, Denver, Colo.;
Ira Spanierman Gallery, New York, ?–1987;
Cincinnati Art Galleries, 1987–1988; private
collection, Atlanta, 1988; Eric Wentworth,
1988–.

109. *Canadian Falls,* 1865, oil on canvas,
20⅛″ × 16″. Lower right: "Duncanson 1865."
National Gallery of Canada, Ottawa, gift
of Jean F. Duquet.
 Provenance: Jean F. Duquet, Neuville,
Quebec, ?–1976; National Gallery of Canada,
1976–.
 Exhibition: AAM 1865, possibly *Falls of the
Chaudiere,* no. 64, p. 21.
 Literature: McNairn 1980, p. 1013; Pringle
1985, pp. 46–47, fig. 20.

110. *Lake Beauport with the Old Bigaoutte
Hotel and the Old Chapel,* 1865, oil on canvas,
12″ × 22″. Lower left: "Duncanson 1865."
Musée du Quebec, purchase.
 Provenance: Jean-Paul Lemieux; Musée du
Quebec.
 Literature: Reid 1979, p. 44; Pringle 1985,
p. 39, fig. 15.

111. *Canadian Landscape,* 1865, oil on canvas,
9¾″ × 17″. Lower left: "Duncanson 1865
Montreal." North Carolina Museum of Art,
Raleigh, gift of Peter A. Vogt.
 Exhibition: NCCU 1984, no. 1.
 Literature: Pringle 1985, p. 47, fig. 16.

112. *Dream of Italy,* 1865, oil on canvas,
21″ × 32″. Lower left: "Duncanson 1865."
Private collection, New York.
 Provenance: Robert Mann, Hull, Canada;
J. C. Mann, Pointe Claire, Canada; Edward
Shein, Providence, R.I., Berry-Hill Gallery, New
York, 1985; private collection, New York,
1986–1992; Wadsworth Atheneum, 1992–.

Exhibitions: Museum of African Art,
Washington, D.C., 1980; John W. Coffey,
*Twilight of Arcadia: American Landscape
Painters in Rome, 1830–1880,* no. 14, p. 57.
 Literature: Berry-Hill Galleries, *American
Paintings III* (New York: Berry-Hill Galleries,
1985), p. 23

113. *Mountain Landscape with Cows and
Sheep,* 1866, oil on canvas, 28½″ × 48½″.
Lower left: "R. S. Duncanson 1866." Ronald
Deal, Hickory, N.C.
 Provenance: William A. Earls to William T.
Earls, Cincinnati, –1974; Edward Shein,
Seekonk, Mass., 1974; Ronald Deal, 1975–.
 Exhibition: CAM 1972, no. 24, p. 15,
illus. p. 28.

114. *Cottage Opposite Pass at Ben Lomond,*
1866, oil on canvas, 12″ × 20″. Lower
left: "Duncanson '66." Museum of Art, North
Carolina Central University, purchase.
 Exhibition: NCCU 1984, no. 2.

115. *Highland Scenery, the Pass at Leny,* 1866,
oil on board, 6″ × 11⅞″. Formerly Atlanta
University.
 Provenance: artist, 1866–1867; private
collection, Mt. Auburn, Ohio, 1867–c. 1950s;
Atlanta University, c. 1970s.
 Literature: *CDE,* January 4, 1953; Inventory
of American Paintings, no. 70650004;
Duncanson file, Taft Museum, Cincinnati;
Francis W. Robinson Papers, Detroit Institute of
Arts.

116. *Pass at Leny,* 1867, oil on canvas,
17¾″ × 29¾″. Lower right: "Duncanson 1867."
The Procter and Gamble Company, Cincinnati.
 Provenance: Mrs. T. H. Tubman, Syracuse,
N.Y., c. 1951; private collection, Hickory,
N.C., ?–1983; Procter and Gamble, 1983–.
 Literature: Porter 1951, pp. 139–40, 151, fig.
26; Ketner 1983, pp. 42–44, fig. 9.

117. *Loch Long, Scotland,* 1867, oil on canvas,
7″ × 12″. Lower left: "Duncanson 1867";
verso: "Loch Long, Scotland, Duncanson 1867."
National Museum of American Art, Smithsonian
Institution, Washington, D.C., gift of Donald
Shein.
 Provenance: Mrs. Gibson Youngblout,
Cincinnati, ?–c. 1976; Donald Shein, Provi-
dence, R.I., 1977; Museum of African
Art, Washington, D.C., 1977–1983; National
Museum of American Art, 1983–.
 Exhibitions: Driskell 1976, no. 32; NMAA
1985, no. 14, p. 63, fig. 24.

118. *Loch Achray and Ben Venue,* 1867, oil on canvas, 24¼" × 36". Lower left: "R. S. Duncanson Cinti. O. 1867." Robert L. Bates Collection, Dayton, Ohio.

Provenance: Samuel T. Harris, Cincinnati, 1867–?; Harold Inskeep, Cincinnati; Nelson Drummond, Cincinnati, ?–1983; Robert L. Bates, 1983–.

Exhibitions: *Catalog of the First Annual Exhibition of the Associated Artists of Cincinnati, 1866–1867,* no. 32; Dayton Art Institute, Ohio, 1985.

119. *Rising Mist,* 1867, oil on canvas, 7" × 12". Lower left: "Duncanson 1867." Cincinnati Art Museum, gift of Mrs. George M. Stearns in memory of George M. Stearns.

Provenance: George M. Stearns, Cincinnati, ?–1975; Cincinnati Art Museum, 1975–.

Exhibition: CAM 1979, no. 31, p. 44.

120. *Vale of Kashmir,* 1867, oil on canvas, 28¾" × 52". Lower right: "Duncanson 1867 Cin. O." Richard Manoogian, Detroit.

Provenance: Elizabeth Jergens, Los Angeles, Calif., c. 1972; Richard Manoogian.

Exhibition: CAM 1972, no. 25, p. 15, illus. p. 29.

Literature: Ketner 1983, p. 42, fig. 7.

121. *The Water Nymphs (The Surprise),* 1868, oil on canvas, 34" × 56". Lower right: "R. S. Duncanson 1868." Howard University Gallery of Art, Washington, D.C.

Provenance: Samuel Thomas; Phillip Renner, Cincinnati; Howard University Gallery of Art.

Exhibitions: Howard U. 1967; MFA 1972; CAM 1972, no. 26, p. 15, illus. p. 30.

Literature: Porter 1951, pp. 140–41, fig. 27; Parks 1980, pp. 22–23; Ketner 1983, p. 45, fig. 10.

122. *Landscape with Men and Boats,* 1868, oil on canvas, 18" × 30". Lower left: "Duncanson 1868." Ronald Deal, Hickory, N.C.

Provenance: Dr. William P. Barnes, Cincinnati, c. 1955–c. 1972; Ronald Deal, c. 1980–.

Exhibition: CAM 1972, no. 27, illus. p. 30.

Literature: Dwight 1955, illus. p. 204.

123. *Woodland Pool,* 1868, oil on canvas, 15¾" × 14½". Private collection, Cincinnati.

Provenance: private collection, Cincinnati, 1868–.

Literature: CAM 1972, p. 42.

124. *The Caves,* 1869, oil on canvas, 36" × 30¾". Lower left: "Duncanson 1869."

Private collection, Cincinnati.

Provenance: private collection, Cincinnati, 1869–.

125. *A Wet Morning on the Chaudiere Falls,* 1869, oil on canvas, 30⅛" × 44". Lower right: "Duncanson 1869"; verso upper right: "A Wet Morning on the Chaudier Fall's." National Gallery of Canada, Ottawa, gift of Denise Pelland.

Provenance: Dennis Pelland, Winnipeg, Canada, ?–1978; National Gallery of Canada, 1978–.

Literature: Reid 1979, p. 44; Pringle 1985, pp. 46–47, fig. 21.

126. *Valley of Lake Pepin, Minnesota,* 1869, oil on canvas, 12" × 21¾". Lower left: "R.S.D. 1869"; verso: "Valley of Lake Pepin, Minn., painted by R.S.D." Cleveland Museum of Art, gift of William Macbeth.

Provenance: Tuttle's Book Shop, Rutland, Vt., 1945; William MacBeth, Inc., New York, 1945–1947; Cleveland Museum of Art, 1947–.

Exhibitions: Howard U. 1967; MFA 1972; CAM 1972, cat. 22, illus. p. 26; Driskell 1976, no. 33; Coen, *Painting and Sculpture in Minnesota,* p. 42, fig. 35.

Literature: Porter, "Robert S. Duncanson," p. 220.

127. *Resting,* 1869, oil on canvas, 28" × 45". Lower center: "R. S. Duncanson 1869". Cincinnati Financial Corporation.

Provenance: private collection, New York State, ?–c. 1986; Cincinnati Art Galleries, 1986; Cincinnati Financial Corporation, 1986–.

128. *Waiting for a Shot,* 1869, oil on canvas, 12" × 38½". Lower right: "Duncanson 1869"; verso: "Waiting for a Shot R. S. Duncanson 1869." Richard Manoogian, Detroit.

Provenance: Warren Griffin, Atlanta, ?–c. 1972; Edward Shein, Seekonk, Mass., c. 1972; Alexander Gallery, New York, 1972–c. 1980; Richard Manoogian.

Exhibition: CAM 1972, no. 28, p. 15, illus. p. 31.

129. *View of the St. Anne's River,* 1870, oil on canvas, 21" × 40". Lower right: "Duncanson 1870"; verso: "View of St. Annes River Canada R.S.D. 1870." St. Louis Art Museum, St. Louis, Mo., purchase.

Provenance: artist; P. T. Barnum; Mrs. Agnes Barnum, Manchester, Mo., ?–1910; Father Xavier Reker, Mexico, Mo., 1910–1966; St. Louis Art Museum, 1966–.

Exhibitions: CAM 1972, no. 31, p. 11, illus. p. 33; St. Louis Art Museum, The Black Presence in Art, October 3–November 10, 1974; MET 1976.

Literature: City Art Museum (St. Louis) *Bulletin* 2, no. 6 (March–April 1967): 3; *Antiques,* April 1968, p. 534; Parks 1980, p. viii; Pringle 1985, p. 48, fig. 22.

130. *Mount Trempe l'Oue on the Upper Mississippi,* 1870, oil on canvas, 20″ × 33″. Lower left: "Duncanson 1870 Cin." Cincinnati Art Galleries.

131. *Dog's Head, Scotland,* 1870, oil on canvas, 26″ × 51⅛″. Lower right: "Duncanson 1870." Museum of Fine Arts, Boston, purchase, Emily L. Ainsley Fund.

Provenance: artist, P. T. Barnum; Mrs. Agnes Barnum, Manchester, Mo., Father Xavier Reker, Mexico, Mo., 1910–?; Theodore Haar, Jefferson City, Mo., ?–1970; Museum of Fine Arts, 1970–.

Exhibitions: MFA 1972; CAM 1972, no. 30, p. 15, illus. p. 32.

Literature: Porter 1951, pp. 142, 151; Parks 1980, pp. vii–viii, illus. p. 57.

132. *Lough Leane,* 1870, oil on canvas, 20″ × 39¼″. "Duncanson 1870." Private collection, Providence, R.I.

Provenance: P. T. Barnum; Mrs. Agnes Barnum, Manchester, Mo., Father Xavier Reker, Mexico, Mo., 1910–?; Theodore Haar, Jefferson City, Mo., ?–c. 1973; private collection, Providence, R.I., c. 1973–.

Exhibitions: CAM 1972, no. 33, p. 15, illus. p. 35; Driskell 1976, no. 34, illus. 125.

Literature: Parks 1980, pp. vii–viii.

133. *Landscape in Scotland,* 1870, oil on canvas, 10¾″ × 19″. Mr. and Mrs. Meyer P. Potamkin.

134. *River Landscape,* 1870, oil on canvas, 26″ × 40″. "Duncanson 1870." Private collection, Providence, R.I.

135. *A Storm off the Irish Coast,* 1871, oil on canvas, 21″ × 33″. Detroit Institute of Arts, Friends Collection, gift of the estate of Ralzemond D. Parker.

Provenance: artist's family, Detroit, 1870–c. 1874; Ralzemond D. Parker, Detroit and Washington, D.C., c. 1874–1983; Detroit Institute of Arts, 1983–?.

136. *Landscape,* 1870, oil on canvas, 30″ × 50″. Private collection, Philadelphia.

137. *Mountain Pool,* 1870, oil on canvas, 11¼″ × 20″. Lower right: "Duncanson 1870." National Museum of American Art, Smithsonian Institution, Washington, D.C., gift of Dr. Richard Frates.

Provenance: Dr. William P. Barnes, Cincinnati, ?–c. 1972; Dr. Richard Frates, c. 1972–1978; Museum of African Art, Washington, D.C., 1978–1983; National Museum of American Art, 1983–.

Exhibitions: CAM 1972, no. 29, illus. p. 31; NMAA 1985, no. 15, p. 58, fig. 17.

138. *Vesuvius and Pompeii,* 1870, oil on canvas, 10″ × 15⅝″. Lower right: "Duncanson 1870." National Museum of American Art, Smithsonian Institution, Washington, D.C., gift of Joseph Agostinelli.

Provenance: Wiebold Studio, Terrence Park, Ohio; Joseph Agostinelli, ?–1980; Museum of African Art, Washington, D.C., 1980–1983; National Museum of American Art, 1983–.

Exhibition: Taft 1988.

Literature: Taft 1988, p. 23.

139. *Landscape in Scotland,* 1870, oil on canvas, 10¾″ × 19″. Lower right: "R. S. Duncanson 1870." Mr. and Mrs. Meyer Potamkin.

140. *Vale of Kashmir,* 1870, oil on canvas, 26″ × 49″. Lower right: "Duncanson 1870." Lagakos-Turak Gallery, Philadelphia.

141. *Winter Landscape with Cabin,* 1870, oil on canvas, 20½″ × 39½″. Lower right: "Duncanson 1870." Derrick Joshua Beard Fine Arts, San Francisco.

142. *Paradise and the Peri,* 1871, oil on canvas, 72″ × 48″. Formerly the Detroit Institute of Arts.

Provenance: C. L. Andrews, Detroit, 1871–c. 1903; Detroit Institute of Arts, c. 1903–1918; sold at auction November 29, 1918.

Exhibitions: Wiswell's Hall, August 1871; Western Art Association, Detroit, 1871.

Literature: *CDE,* June 25, 1871, p. 4; July 30, 1871, p. 8; August 12, 1871, p. 8; August 20, 1871, p. 8; August 27, 1871, p. 8; *MC,* September 14, 1871, p. 3; *DFP,* September 16, 1871, p. 1; December 27, 1876; *DDP,* September 16, 1871, p. 4; September 29, 1871, p. 4; *DDU,* September 14, 1871, p. 1; September 16, 1871, p. 4; Porter 1951, pp. 136, 137, 147; Detroit Institute of Arts, Francis W. Robinson Papers.

143. *Ellen's Isle, Loch Katrine,* 1871, oil on canvas, 29½″ × 50″. Lower right: "R.S. Duncanson Cinti. O. 1871." Detroit Institute of Arts, gift of the estate of Ralzemond D. Parker.

Provenance: artist, 1871; Charles Sumner, Virginia, 1871–1874; Museum of Fine Arts, Boston, 1874–1884; Mrs. Phoebe Duncanson, 1884–1888; Ralzemond Parker, Detroit, 1888–?; Ralzemond D. Parker, Washington, D.C., ?–1983; Detroit Institute of Arts, 1983–.

Exhibitions: Wiswell's Gallery, Cincinnati, August–September 1871; Monroe, Mich., September 1871; Western Art Association, Detroit, 1871; Museum of Fine Arts, Boston, 1874, no. 29; Howard U. 1967; CAM 1972, no. 32, p. 15, illus. p. 34.

Literature: *CDE,* June 25, 1871, p. 4; July 30, 1871, p. 8; August 12, 1871, p. 8; August 20, 1871, p. 8; August 27, 1871; September 24, 1871, p. 4; November 26, 1871, p. 5; *MC,* September 14, 1871, p. 3; *DFP,* September 15 & 16, 1871, p. 1; *DDU,* September 16, 1871, p. 4; *DDP,* September 16, 1871, p. 4; *DCC,* December 27, 1872, p. 8; *Pacific Appeal* (San Francisco), November 14, 1874, p. 1; *The Aldine* (Virginia), February 1875, p. 277; James A. Porter, "Versatile Interests of the Early Negro Artist," p. 21; Porter 1951, pp. 140, 151; Elleine Stones to James Porter, February 11, 1953, Burton Historical Collection, Detroit; Ketner 1983, pp. 45–46, fig. 11; NMAA 1985, p. 63; Pringle 1985, p. 48, fig. 24; Ketner 1987, pp. 66–67.

144. *Pompeii,* 1871, oil on canvas, 10¼″ × 18″. Lower right: "Duncanson 1871"; verso: "Vesuvius Pompei & Belgreco Presented to Miss Moore by R.S. Duncanson 1871 Cinti. O." National Museum of American Art, Smithsonian Institution, Washington, D.C., gift of Lawrence Koffler.

Provenance: Miss Moore, Cincinnati, 1871–?; Lawrence Koffler, 1977; Museum of African Art, Washington, D.C., 1977–1983; National Museum of American Art, 1983–.

Exhibitions: Driskell 1976, no. 35; Brooklyn Museum, 1977; NMAA 1985, no. 18, p. 60, fig. 18.

Literature: *CDE,* November 26, 1871, p. 5.

145. *Scotch Landscape,* 1871, oil on canvas, 29¾″ × 50″. Lower right: "Duncanson 1871." National Museum of American Art, Smithsonian Institution, Washington, D.C., gift of Robert Tessier and James Bauld.

Provenance: Robert Tessier, 1976; Museum of African Art, Washington, D.C., 1976–1983; National Museum of American Art, 1983–.

Exhibitions: Driskell 1976, no. 36, illus. p. 125; NCCU 1984, no. 10; NMAA 1985, no. 17, p. 63, fig. 25.

146. *Scottish Landscape,* 1871, oil on canvas, 20″ × 36″. Lower right: "R. S. Duncanson 1871." Private collection, Cincinnati.

Exhibitions: NCCU 1984, no. 9, illus. p. 18; Taft 1988.

Literature: Taft 1988, p. 24.

147. *Sunset on the New England Coast,* 1871, oil on canvas, 36⅛″ × 66″. Lower right: "Duncanson 1871"; verso: "Sunset on the New England Coast Duncanson." Cincinnati Art Museum, gift of Mrs. Gilbert Bettman.

Provenance: Mrs. Gilbert Bettman, Cincinnati, ?–1943; Cincinnati Art Museum, 1943–.

Exhibitions: CAM 1979, no. 32, illus. p. 130; NCCU 1984, no. 11, illus. p. 9.

Literature: Porter 1951, pp. 143, 151, illus. p. 143; McElroy 1972, p. 170, pl. 74; CAM 1972, p. 42; Janson 1982, p. 18.

148. *Landscape with Cows Watering in a Stream,* 1871, oil on canvas, 21⅛″ × 34½″. Lower right: "Duncanson 1871." Jointly owned by the Metropolitan Museum of Art, New York, and Lawrence A. Fleischman.

Provenance: Mrs. Margaret Williams, Cincinnati; Paul North, Columbus, Ohio; Kennedy Gallery, New York, ?–1974; Metropolitan Museum of Art, 1974–.

Exhibition: MET 1976, pl. 11.

Literature: MET 1985, pp. 84–85.

149. *Romantic Landscape,* 1871, oil on canvas, 7⅛″ × 19″. Verso upper left: "R. S. Duncanson 1871 Cinti. O." National Museum of American Art, Smithsonian Institution, Washington, D.C., gift of Carroll Greene, Jr.

Provenance: Carroll Greene, Jr., New York, c. 1968; Museum of African Art, Washington, D.C., 1968–1983; National Museum of American Art, 1983–.

Exhibition: NMAA 1985, no. 16, p. 64, pl. V.

Literature: CAM 1972, p. 42.

150. *Eventide,* 1871, oil on canvas, 11″ × 17″. Verso: "painted by R. S. Duncanson 1871." Formerly private collection, Philadelphia.

Literature: J. W. C. Cromwell, "An Art Gallery and Museum Not in the Guidebook," *New National Era,* October 1874, p. 2;

Porter, "Versatile Interests," illus. p. 16; Porter 1951, pp. 144, 151; CAM 1972, p. 42.

151. *Heart of the Andes* (after Church), 1871, oil on canvas, 28″ × 52″. David David, Inc., Philadelphia.

152. *Two Men and a Boat,* n.d., oil on canvas over paperboard, 15½″ × 26¼″. National Museum of American Art, Smithsonian Institution, Washington, D.C., gift of Ronald Deal.
 Provenance: Ronald Deal, Providence, R.I., ?–1976; Museum of African Art, Washington, D.C., 1976–1983; National Museum of American Art, 1983–.

153. *Landscape,* oil on canvas, 10″ × 16″. Dr. Walter O. Evans, Detroit.

154. *Landscape with River and Cascade,* oil on canvas, 10¼″ × 16¼″. Signed recto; verso: "View of . . ." Private collection, Cincinnati.

155. *Fall Fishermen* (attributed to R.S.D.), n.d., oil on canvas, 30″ × 40″. Butler Institute of American Art, Youngstown, Ohio.
 Provenance: Dana E. Tillou Gallery, Buffalo, N.Y.; Daniel Lord, Erie, Pa.; Butler Institute of American Art, 1969–.
 Literature: CAM 1972, no. 37.

156. *Untitled* (attributed to R.S.D.), oil on canvas on plywood, 30″ × 40″. Private collection, Philadelphia.

Provenance: Alex Simpson, Philadelphia, ?– c. 1956; private collection, Philadelphia, c. 1956–.

157. *River Scene* (attributed to R.S.D.)., oil on canvas, 32¼″ × 44¼″. Formerly DeVant Crissey Gallery, Smyrna, Ga.
 Provenance: Murdoch M. Williams, Yellow Springs, Ohio, c. 1972; DeVant Crissey Gallery, c. 1976.
 Exhibition: CAM 1972, no. 35, illus. p. 36.

158. *Catskill Scene with Indian Camp* (attributed to R.S.D.), oil on canvas, 42¾″ × 48⅝″. San Diego Museum of Art, Calif.

159. *Landscape with Ruin* (attributed to R.S.D.), oil on canvas, 28¼″ × 32¼″. Private collection, Del Mar, Calif.

160. *Untitled Landscape* (attributed to R.S.D.), oil on canvas, 24″ × 32″. Private collection, Hamilton, N.Y.

161. *Landscape with Stream* (attributed to R.S.D.), oil on canvas, 10″ × 22″. Private collection, Hyattesville, Md.

162. *Landscape with Indians* (attributed to R.S.D.), oil on canvas, 10″ × 16″. Mary Ran Gallery, Cincinnati.

163. *Landscape with Stream,* oil on canvas, 32″ × 25″. Lower left: "Duncanson." Derrick Joshua Beard Fine Arts, San Francisco.

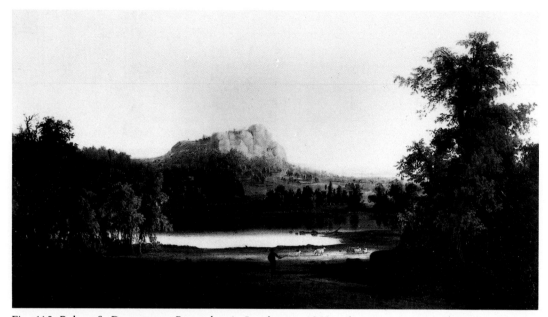
Fig. 115. Robert S. Duncanson, *Pennsylvania Landscape,* 1852, oil on canvas, 16″ × 26½″.
Dr. and Mrs. Harmon W. Kelly, San Antonio, Texas.

NOTES

INTRODUCTION

1. *Daily Cincinnati Gazette,* May 30, 1861, p. 3.

2. Anthony F. Janson, "The Cincinnati Landscape Tradition," 11.

3. See chap. 7, "Superior and Inferior Races," in Reginald Horsman, *Race and Manifest Destiny* (Cambridge: Harvard University Press, 1981).

4. James Oliver Horton, "Shades of Color: The Mulatto in Three Antebellum Northern Black Communities," *Afro-Americans in New York Life and History* 8, no. 2 (July 1984): 37–59.

5. For more information on British aesthetic theories and American landscape painting see Joseph D. Ketner and Michael J. Tammenga, *The Beautiful, the Sublime, and the Picturesque: British Influences on American Landscape Painting* (St. Louis: Washington University Gallery of Art, 1984).

6. See Roger B. Stein, *John Ruskin and Aesthetic Thought in America, 1840–1900* (Cambridge: Harvard University Press, 1967), for the most complete study of Ruskin's influence on aesthetics in the United States.

7. See Sarah Burns, *Pastoral Inventions: Rural Life in Nineteenth-Century American Art and Culture* (Philadelphia: Temple

University Press, 1989), and J. Gray Sweeney, "The Agrarian Paradise," in *Themes in American Landscape Painting* (Grand Rapids: Grand Rapids Museum of Art, 1977), 70–101, for further discussions of the iconography of the domesticated American landscape in painting of this period.

8. David Lubin introduced this idea in a paper, "The Black Artist in White Face: Robert Duncanson's Double Coded Landscapes," presented at the College Art Association, Chicago, February 1992, and in conversation with the author; the paper will appear in his *Picturing a Nation: Art and Social Change in 19th-Century America* (New Haven: Yale University Press, forthcoming 1993).

9. James Jackson Jarves from *Art Hints* (1853) quoted in Barbara Novak, *Nature and Culture: American Landscape and Painting, 1825–1875* (New York: Oxford University Press, 1980), 207.

10. Robert S. Duncanson to Junius Sloan, August 3, 1854, Platt R. Spencer Papers, Newberry Library, Chicago.

11. *Montreal Herald,* February 8, 1864, p. 3.

12. See the Bibliography for citations on these publications and others.

1. "Portraits . . . historical and fancy pieces of great merit"
Apprenticeship and Itinerant Beginnings

1. Duncanson's few surviving letters to Junius Sloan from the 1850s (Spencer Papers) and to his son Reuben, from 1871

(private collection, Cincinnati, Ohio), reveal an anxious, excitable person who professed to seek artistic success. This is

confirmed in letters by others, particularly those from Junius Sloan to Robert Spencer (Spencer Papers), that describe Duncanson's animated character and ambition. Other references to Duncanson by Nicholas Longworth (letters to Hiram Powers, August 29, 1851, June 20, 1852, April 18, 1853, Powers Papers, Cincinnati Historical Society) and the contemporary press suggest that these were widely recognized character traits.

2. *Detroit Daily Advertiser,* February 2, 1846, p. 2.

3. The U.S. censuses from 1790 to 1820 document Charles Duncanson's move north. An obituary dated January 13, 1828 (Stanley J. Reynolds Papers, Waterloo Library and Historical Society, New York), and U.S. census records provide his life dates.

4. Horton, "Shades of Color," 4–5. See also Ira Berlin, *Slaves without Masters: The Free Negro in the Antebellum South* (New York: Pantheon Books, 1974); Robert Brent Toplin, "Between Black and White: Attitudes toward Southern Mulattoes, 1830–1861," *Journal of Southern History* 45, no. 2 (May 1979): 185–200; and Joel Williamson, *New People: Miscegenation and Mulattoes in the United States* (New York: The Free Press, 1980), for detailed studies of freemen and mulattoes in the United States.

5. Deed records, County Courthouse, Monroe County, Mich., 1836–1837, Z, 56; 1838, CC, 79; 1845, KK, 153; 1847, MM, 194. See also James E. DeVries, *Race and Kinship in a Midwestern Town: The Black Experience in Monroe, Michigan, 1900–1915,* 14. Dennis Au has surmised from U.S. census records, deed records, and newspaper accounts that the Duncanson clan arrived in Monroe around 1830.

6. Nina Fletcher Little, *American Decorative Wall Painting 1700–1850* (New York: E. P. Dutton & Co., 1972), xix–xx. *Fancy painting* and *fancy pictures* were terms widely in use at this time with a range of meanings. For housepainters and decorators "fancy painting" implied a free-hand painting of interior decorative motifs such as wood graining and floral patterns, as opposed to stencil work. For easel painters a "fancy picture" denoted a genre painting, often small in scale, like a cabinet picture, with a fanciful figural subject that was intended to entertain its owner and decorate his walls, particularly in the parlor or drawing room. Duncanson painted numerous "fancy pictures" in the 1840s, and this term is applied to those works in contemporary accounts and later in this text.

7. *Monroe Gazette* 1, no. 32 (April 17, 1838): 3. The ad ran periodically until April 9, 1839. I am grateful to Dennis Au, assistant director, Monroe County Historical Museum, Monroe, Mich., for uncovering this article and Duncanson's family connections to Monroe. See Au's contributions to DeVries, *Race and Kinship.*

8. Much of the information concerning the life and professions of the Duncanson family in Monroe is derived from DeVries, *Race and Kinship,* and from Dennis Au. Other facts were provided by a review of the U.S. censuses in New York, Michigan, and Ohio from 1790 to 1900. In the case of Robert Duncanson, his death date of 1872 is well documented, but his birth date is difficult to determine precisely. Unfortunately, birth records were not required in New York State before 1880. The U.S. census records did not record the names and ages of dependents before 1850, making it impossible to identify the children included in John Dean

Duncanson's early census records. The year of Robert Duncanson's birth has been narrowed to 1821 from the 1860 census that records his age as thirty-eight and a letter written by Duncanson on June 29, 1871, in which he notes, "I have lived to the age of fifty years." However, obituaries from December 1872 record his age as fifty-five at the time of death. To further complicate the problem, Duncanson's passport application from 1853 lists his age as thirty, suggesting he was born in 1822–1823 (see also Lynda Roscoe Hartigan, *Sharing Traditions: Five Black Artists in Nineteenth-Century America*, 66, n. 5).

9. Dean's commission is recorded on a receipt dated March 1841, Township of Monroe (Monroe County Historical Society). The U.S. census began to note the trades of citizens in 1850, providing much information on the businesses of the brothers. In addition, the *Michigan State Gazetteer and Business Directory* notes the Duncanson clan of painters in the 1856–1857, 1860, 1865, 1867–1868, 1875, and 1877 editions. The 1877 *Michigan State Gazetteer*, 634, notes "Louis P. Duncanson" (Lucius B.) as a "painter." Two paintings by Lucius exist in the possession of family descendants and the Monroe County Historical Museum.

10. The principal newspapers during this era, the *Monroe Gazette* and *Commercial*, contain numerous advertisements for painters and decorators.

11. April 1839 was the last date Duncanson advertised the painting firm with Gamblin. His earliest known painting, *Portrait of a Mother and a Daughter* (Hammonds House, Fulton County Arts Council, Atlanta), is inscribed on the verso, "R. S. Duncanson Pinxit 1841 Cincinnati." Therefore, one can assume that

he settled in the Cincinnati area circa 1840. See Cincinnati Art Museum, *The Golden Age: Nineteenth Century Cincinnati Artists Represented in the Cincinnati Art Museum*, 13, for a discussion of the Cincinnati cultural environment of this period.

12. Duncanson family tradition claims that Mary Graham (later Mary Harlan) was the mother of Robert Duncanson's first wife. The 1850 census notes two children, Reuben P. Duncanson, age six, and Mary Duncanson, age four, in the Graham household, as well as Rebecca Graham, age twenty-four. Despite the fact that Rebecca's surname is given as Graham, she may have been Robert Duncanson's first wife. Although no records verify that marriage, it is known from the 1860 census that Duncanson had by then remarried and was living in Cincinnati with his new wife, Phoebe, who had given birth to a child, Milton, aged only ten months. In the same census Reuben and Mary Duncanson are still living with the Grahams in Mt. Healthy, and Rebecca Graham is no longer listed anywhere, lending credence to the supposition that she died in the 1850s.

13. F. C. Wright, the nephew of Gilbert LaBoiteaux, first publicized these stories at the turn of the century (*Cincinnati Enquirer*, December 24, 1924), and they are still told by Frank Stout, the current local historian. The oral history can be substantiated by the fact that several paintings by Duncanson were passed down through the LaBoiteaux family along with the tales.

14. See Cincinnati Art Museum, *The Golden Age*, 13, and the *Catalog of the Second Annual Exhibition of Painting and Statuary by the Section of Fine Arts of the Society for the Promotion of Useful Knowledge*.

15. See James A. Porter, "Robert S.

Duncanson: Midwestern Romantic-Realist," fig. 3, for a reproduction of *Trial of Shakespeare*. The Douglass Settlement House, Toledo, owned the painting in the 1950s, but it has remained unlocated since its publication by Porter.

16. *Daily Cincinnati Gazette,* July 11, 1844, p. 2.

17. Ibid., March 19, 1844, p. 2.

18. *Detroit Free Press,* December 16, 1845, p. 2.

19. *Detroit Daily Advertiser,* February 2, 1846, p. 2.

20. The Detroit Institute of Arts currently possesses all five paintings. The portraits of Henri, William, and Louis are in the art collection, while the portrait of Joseph and the double portrait of his wife and son are in the Friend's collection. The latter two paintings were displayed in 1952 at a Detroit Institute of Arts exhibit, *Michigan Painters before 1900,* and attributed to Duncanson. The descendants of the Berthelet family donated the five family portraits.

21. Louis Berthelet's portrait is especially distinctive, with an informal pose and colorful landscape background that are completely atypical of Duncanson's style but suggest the work of the regional artist Horace Rockwell (1811–1877) from Fort Wayne, Indiana, where Louis lived at the time. The double portrait is a linear, primitive painting that lacks Duncanson's painterly touch.

22. On the genre painting tradition in the United States see Patricia Hills, *The Painter's America* (New York: Praeger Publishers, 1974); Ron Tyler et al., *American Frontier Life* (New York: Abbeville Press, 1987), 6, 10, 14–15; and Elizabeth Johns, *American Genre Painting: The Politics of Everyday Life* (New Haven: Yale University Press, 1991).

23. *Detroit Free Press,* April 29, 1846,

p. 3. See J. Gray Sweeney, *Artists of Michigan from the Nineteenth Century* (Muskegon, Mich.: Muskegon Museum of Art, 1987), 56, pl. 10, for a reproduction of Cohen's painting and Marcia Goldberg's essay "Frederick E. Cohen," 56–61, for additional biography.

24. "Correspondence of the Tribune. Cincinnati, July 29, 1846," *The Liberator* 16, no. 34 (August 21, 1846): 146.

25. Ibid.

26. U.S. census, 1850, Hamilton Township, Springfield County, Ohio, 78, records Rebecca Graham's birthplace as Tennessee.

27. See John L. Stevens and Frederick Catherwood, *Incidents of Travel in the Yucatan* (New York: Dover Publishers, 1980), for the illustrations cited and a discussion of the popularity of this book.

28. Donald Chaput, *The Cliff Mine: America's First Great Copper Mine* (Kalamazoo: Sequoia Press, 1971), 57–58.

29. *The Cliff Mine* was first published by Sadayoshi Omoto in *The Michigan Experience,* and the iconography of this painting was interpreted in my article "Robert S. Duncanson (1821–1872)."

30. Thomas Cole, "Lecture on American Scenery," *Northern Light* 1 (May 1841): 25–26.

31. Chaput, *The Cliff Mine,* 39.

32. Roberta Hampton Dean, "The Western Art Union, 1847–1851," 36, appendix.

33. The 1845 Cincinnati Firemen's Fair catalog (available at the Cincinnati Historical Society) notes this contribution by Duncanson. The fair and its accompanying exhibit were created to raise funds for the local fire department.

34. Bertha L. Heilbron, ed., *With Pen and Pencil on the Frontier in 1851: The Diary and Sketches of Frank Blackwell Mayer,* 44. *Daily Cincinnati Gazette*

(January 30, 1850), 2.

35. Although Duncanson first exhibited at the Western Art Union in 1849, he showed only one "Landscape" (no. 19) and a "Fruit" piece (no. 39). In the December 1850 exhibit he showcased his new genre by submitting eleven paintings, all landscapes (nos. 480, 1225, 2207, 2941, 3081, 4170, 4191, 4306). See Dean, "Western Art Union," 52, and *Daily Cincinnati Gazette,* January 22, 1851, p. 2.

36. *Daily Cincinnati Gazette,* January 30, 1850, p. 2.

2. "A Token of Gratitude"
The Ohio River Valley Landscape Tradition

1. James G. Birney wrote in his essay "American Slavery" (September 9, 1839), reprinted in Louis Ruchames *The Abolitionists: A Collection of Their Writings* (New York: Capricorn Press, 1964), 176, that "in Ohio the laws regard all who are mulattoes, or above the grade of mulattoes, as white." On the "free colored" population of Cincinnati see also Horton, "Shades of Color," and Henry L. Taylor, "Spatial Organization and the Residential Experience: Black Cincinnati in 1850," *Social Science History* 10, no. 1 (Spring 1986): 45–69.

2. Charles Cist, *Cincinnati in 1841: Its Early Annals and Future Prospects,* 139, and *Sketches and Statistics in Cincinnati in 1851,* 121.

3. Janson, "Cincinnati Landscape Tradition," 11.

4. Heilbron, *With Pen and Pencil,* 44.

5. Janson, "Cincinnati Landscape Tradition," 13.

6. Anthony Janson, "Worthington Whittredge: Two Early Landscapes," *Bulletin of the Detroit Institute of Arts* 55, no. 4 (1977): 204. See also Janson's *Worthington Whittredge,* Cambridge Monographs on American Artists (New York: Cambridge University Press, 1989).

7. *Liberty Hall and Cincinnati Gazette,* June 24, 1847, p. 1.

8. *Daily Cincinnati Gazette,* January 30, 1850, p. 2.

9. Junius Sloan to Robert Spencer, March 4, 1851, Spencer Papers.

10. *Daily Cincinnati Gazette,* December 19, 1850, p. 2.

11. Ibid., June 18, 1851, p. 2.

12. Lubin, *Picturing a Nation.*

13. Miner K. Kellogg, "Journal Cincinnati May 18th 1833," Cincinnati Historical Society. See also Cincinnati Art Museum, *The Golden Age,* 14.

14. "Cincinnati," *Graham's Magazine* (Philadelphia) 2, no. 6 (June 1848): 352.

15. *William's Cincinnati Directory, City Guide, and Business Mirror; or Cincinnati Illustrated As It Is in 1853* (Cincinnati: Published by C. S. Williams, 1853), 107.

16. Albert Boime in *The Magisterial Gaze: Manifest Destiny and American Landscape Painting, c. 1830–1865* (Washington, D.C.: Smithsonian Institution Press, 1991), 121–23, offers a different interpretation of this painting that exposes an insensitive reading of an African-American's perspective on this subject. Boime believes, "Either they are slaves making use of Sunday free time, or what is more likely, they are freed, inhabiting the periphery of the town of Covington." It is inconceivable that Duncanson, as an antislavery activist, would have made the conscious decision to

depict blacks laboring as freemen on the slaveholding side of the Ohio River (in place of the Caucasians in the engraving); rather he was making a statement condemning the bondage of blacks to a life of oppression while freedom existed within their sight.

17. For a thorough discussion of history painting and the hierarchy of genres in the United States see William Gerdts and Mark Thistlethwaite, *Grand Illusions: History Painting in America* (Fort Worth: Amon Carter Museum, 1988). On p. 7 they cite the quotation from E. Anna Lewis, "Art and Artists of America," *Graham's Magazine* 45 (August 1854): 141.

18. Louis Legrand Noble, *The Course of Empire: The Life and Works of Thomas Cole* (Cambridge: Harvard University Press, 1964), xxiv.

19. Sloan to Spencer, March 4, 1851. In this series of letters Sloan relates to Spencer the conception and development of the *Garden of Eden* painting.

20. Robert Spencer to Junius Sloan, July 12, 1852, Spencer Papers; and *Daily Cincinnati Gazette,* June 11, 1852, p. 2.

21. *Daily Cincinnati Gazette,* June 11, 1852, p. 2.

22. Barbara Novak summarizes the ideas of Perry Miller, Henry Nash Smith, and R. W. B. Lewis on nineteenth-century Americans' edenic view of nature in *Nature and Culture,* 3–17. She elaborates to refine four approaches to this subject: nature as primordial wilderness, nature as the garden of the world, American wilderness as the original paradise, and America as the site for paradise regained in the millennium. Duncanson's work most closely relates to the latter view.

23. "A Token of Gratitude," *Frederick Douglass' Paper* (Rochester, N.Y.), August 6, 1852, p. 3.

24. *Daily Cincinnati Gazette,* October

15, 1852, p. 2. Only the second, smaller version of the painting is extant, and this is the work illustrated from the West Foundation Collection at the High Museum of Art, Atlanta.

25. *Frederick Douglass' Paper,* August 6, 1852, p. 2.

26. The facts surrounding this event were somewhat confused by the *Daily Cincinnati Gazette,* August 24, 1852, p. 2, which reported that Duncanson's *Garden of Eden* was purchased for $800. It is possible that a third party reimbursed Duncanson for the painting in advance of the presentation.

27. *Daily Cincinnati Gazette,* September 22, 1852, p. 2.

28. Ibid., October 6, 1852, p. 2.

29. For information on the importance of the Fireman's Fairs see Susan Hobbs, "Detroit and Its Development in the Arts," *Artists of Michigan from the Nineteenth Century* (Michigan: Muskegon Museum of Art, 1987), 76. Other resources on the history of painting in Michigan include Silas Farmer, *The History of Detroit and Michigan* (Detroit, 1886); Clyde H. Burroughs, "Painting and Sculpture in Michigan," *Michigan History Magazine* 20–21 (Autumn 1936): 395–409, (Winter 1937): 39–54, (Spring 1937): 141–57; Sister M. Killian Kenny, "A History of Painting in Michigan, 1850 to World War II."

30. *Daily Cincinnati Gazette,* March 17, 1853, p. 2; undated obituary, Robert M. Zug Scrapbook, Burton Historical Collection, Detroit Public Library.

31. Harriet Beecher Stowe, *Uncle Tom's Cabin; or, Life Among the Lowly* (Boston: John P. Jewett & Company, 1852), vi.

32. Harry Birdoff, *The World's Greatest Hit: Uncle Tom's Cabin* (New York: S. F. Vanni, 1947). See also the introduction to Harriet Beecher Stowe, *Uncle Tom's*

Cabin (New York: Bantam Books, 1981).

33. Stowe, *Uncle Tom's Cabin,* 1981 ed., 259–60.

34. Stowe, *Uncle Tom's Cabin,* 1852 ed., v–vi.

35. Stowe, *Uncle Tom's Cabin,* 1981 ed., 258.

36. Stowe, *Uncle Tom's Cabin,* 1852 ed., ii, 63.

37. An illustration of this work is available in my Master's thesis, "Robert S. Duncanson: The Late Literary Landscape Paintings," 7, fig. 10.

38. *Daily Cincinnati Gazette,* March 17, 1853, p. 2. The second review was cited in the *Detroit Free Press,* April 21, 1853, p. 2.

3. "The well-known decorative painter Duncanson"
Nicholas Longworth's Belmont Murals

1. Jones served as a faithful butler to Longworth in gratitude for his benevolence; supposedly Longworth's act inspired Stowe's account of Eliza's escape from Kentucky in *Uncle Tom's Cabin* (see Comtesse Clara Longworth DeChambrun, *The Making of Nicholas Longworth* [New York: Long & Smith, 1933], 34–35). For biographical information on Nicholas Longworth see DeChambrun, *The Making of Nicholas Longworth,* 86–89; Cincinnati Art Museum, *The Golden Age,* 15–16; Denny Carter Young, "The Longworths: Three Generations of Art Patronage in Cincinnati," in *Celebrate Cincinnati Art* (Cincinnati: Cincinnati Art Museum, 1982), 31; Rita Steininger Niblack, "Nicholas Longworth, Art Patron of Cincinnati"; and Abby S. Schwartz, "Nicholas Longworth: Art Patron of Cincinnati."

2. All of these resources are in the Cincinnati Historical Society. Charles Cist mentions Duncanson in his *Sketches and Statistics in Cincinnati in 1851,* 126, and cites Longworth's collection as having contained his work. Since none of the artist's easel paintings were in Longworth's estate at his death, Cist may have been referring to the murals.

3. Clara Longworth DeChambrun,

Cincinnati: The Story of the Queen City (New York: Scribner's, 1939), 113.

4. Walter Siple, "The Taft Museum"; Edward H. Dwight, "Robert S. Duncanson," 44; Porter, "Robert S. Duncanson"; Guy McElroy, *Robert S. Duncanson: A Centennial Exhibition,* 8–9.

5. Longworth to Powers, June 20, 1852.

6. Young, "The Longworths," 29.

7. Siple, "The Taft Museum," 3–5.

8. DeChambrun, *The Making of Nicholas Longworth,* 39.

9. Siple, "The Taft Museum," 4.

10. Mrs. Charles Phelps Taft recalled her father discussing the decorations during her childhood. See Siple, "The Taft Museum," 7; Ruth Neely, "Art Treasures of Old Taft Home," *Cincinnati Post,* November 29, 1932, p. 1.

11. *Cincinnati Times-Star* (March 8, 1932), 1; Siple, "The Taft Museum"; Neely, "Art Treasures."

12. Catherine Lynn, *Wallpaper in America: From the Seventeenth Century to World War I* (New York: W. W. Norton & Company, 1980), 228.

13. Catherine Lynn Frangiamore, *Wallpaper in Historic Preservation* (Washington, D.C.: National Park Service, 1977), 33.

14. Lynn, *Wallpaper in America,* 52, 54, 89.

15. Ibid., 56, 76.

16. Ibid., 183.

17. Ibid., 250–51.

18. Little, *Decorative Wall Painting,* 66.

19. *Record of the Western Art Union* 1, no. 5 (October 1849): 12, 17, no. 66, 180. *Michigan Farmer* 7, no. 19 (October 1, 1849): 299. *Bulletin of the American Art Union,* no. 313 (December 1850): 88. *Detroit Free Press,* September 27, 1849, p. 3.

20. Little, *Decorative Wall Painting,* xix, 85.

21. Sloan to Spencer, March 4, 1851. J. Carson Webster, "Junius R. Sloan: Self-Taught Artist," 104, 106, 107.

22. Radford, "Canadian Photographs," 113.

23. Little, *Decorative Wall Painting,* 124.

24. The vignettes more closely resemble the work typical of late-eighteenth-century itinerant housepainters. Patriotic images of eagles were popular in the decades following the Revolutionary War, but occurred less frequently in the mid-nineteenth century (see Little, *Decorative Wall Painting,* 49).

25. Henry Percy Horne's *An Illustrated Catalogue of Engraved Portraits and Fancy Subjects Painted by Thomas Gainsborough, R.S., Published between 1760 and 1820 and By George Romney, Published between 1770 and 1830* (London: Eyre & Spottiswoode, 1891) included four engravings after the cottage door theme. In addition, Gainsborough's works regularly appeared in reproduction portfolios and instructional drawing books such as Thomas Rowlandson's *Imitations of Modern Drawings.* See John Hayes, *Gainsborough as Printmaker* (London: Yale University Press, 1972), 9, 13–15, 27.

The cabin mural points to an interesting comparison with the foremost interior decorator in early-nineteenth-century New England, Michele Felice Corné (circa 1752–1845). In 1799 Corné arrived in Salem, Mass., from Italy, where he was trained as a decorative painter. He immediately established a thriving business as an interior mural painter (see Little, *Decorative Wall Painting,* 42–43, and Edward B. Allen, *Early American Wall Paintings, 1710–1850* [New York: Kennedy Graphics, Da Capo Press, 1971], 26–45). His overmantel decorations formerly in the Oak Hill Mansion in Peabody, Mass. (Museum of Fine Arts, Boston), are rustic genre scenes after British academician William Biggs's (1755–1828) *Saturday Evening.* The elements of Corné's charming overmantel—executed around 1800–1810, at least forty years before the Belmont murals—are remarkably similar to Duncanson's figural group in the cabin doorway wrapped by picturesquely contorted tree trunks. Corné's most important and ambitious frescoes were romantic landscape scenes painted around 1812–1815 in the upper and lower halls and parlor of the Sullivan Dorr house in Providence, R.I. A *Winter Scene* in the hall of this historic house (see Allen, *Early American Wall Paintings,* 35, 42, fig. 41, for an illustration) closely parallels Duncanson's image of a sparse gray landscape and snow-crested cabin in his *Winter* of 1849. There is little reason to suspect that Duncanson had ever been to New England or knew Corné's work. Yet the obvious relation between these and other paintings by the two artists is cause for speculation. Although he probably did not meet Corné, the Ohio artist worked in a similar picturesque landscape mural tradition and achieved

a greater degree of accomplishment than the older decorator.

4. The Light of Europe: *The "Grand Tour"*

1. *Liberty Hall and Cincinnati Gazette,* October 18, 1849, p. 1.

2. Robert S. Duncanson to Junius R. Sloan, January 22, 1854, Spencer Papers.

3. Ibid.

4. William Miller to Isaac Strohm, April 10, 1854, Strohm Papers, Cincinnati Historical Society.

5. The only other African-American artist to travel overseas was Patrick Reason (?1817–?1850), who was sponsored by the Anti-Slavery League to study engraving in England and then returned to America to become an illustrator for abolitionist causes. Reason was not known to have made a tour of the continental art centers.

6. "The Colored Mens' Convention," *Frederick Douglass' Paper,* July 22, 1853, p. 2. See Benjamin Quarles, *Black Abolitionists* (New York: Oxford University Press, 1969), 69, 96, 175–76, 189, and 213, for biographical information on John Mercer Langston. Langston was a black abolitionist active in Ohio in the 1850s, who was descended from a Virginia planter.

7. Nancy Dustin Wall Moure, *William Louis Sonntag: Artist of the Ideal, 1822–1900* (Los Angeles: Goldfield Galleries, 1980), 20.

8. Longworth to Powers, April 18, 1853.

9. Nicholas Longworth to Hiram Powers, December 18, 1853, Powers Papers, Cincinnati Historical Society.

10. Duncanson to Sloan, January 22, 1854.

11. *Daily Cincinnati Gazette,* August 24,

26. Sweeney, "Agrarian Paradise," 72–74.

1853, p. 2.

12. Paul R. Baker, *The Fortunate Pilgrims* (Cambridge: Harvard University Press, 1964), 56. Baker provides a thorough discussion of American artists and intellectuals in Italy in the nineteenth century.

13. Moure, *William Louis Sonntag,* 9; Duncanson to Sloan, January 22, 1854.

14. Duncanson to Sloan, January 22, 1854.

15. For a general discussion of Americans in Italy and their response to the country see Van Wyck Brooks, *The Dream of Arcadia* (New York: E. P. Dutton & Co., 1958), and Baker, *The Fortunate Pilgrims.* For more specific accounts of American artists in Italy and interpretations of their reactions to the country see Barbara Novak's *The Arcadian Landscape: Nineteenth Century American Painters in Italy,* the revision of her essay, "Arcady Revisited: Americans in Italy" in *Nature and Culture* (pt. 4), and John W. Coffey's *Twilight of Arcadia: American Landscape Painters in Rome, 1830–1880.*

16. Miller to Strohm, April 10, 1854.

17. Marcel Roethlisberger, *Im Licht von Claude Lorrain: Landschaftsmalerei aus drei Jahrhundert,* 31–41, 278–81.

18. See R. W. B. Lewis's *The American Adam* (Chicago: University of Chicago Press, 1955) for further discussion.

19. Thomas Cole, "Sicilian Scenery and Antiquities," *Knickerbocker* (March 1844): 244.

20. *Daily Cincinnati Commercial,* July 1, 1854, p. 2; June 10, 1854, p. 2.

21. Ibid., June 10, 1854, p. 2.

22. Robert S. Duncanson to Junius R. Sloan, August 21 and November 2, 1854, Spencer Papers.

23. An undated news clipping in letter from Duncanson to Sloan, November 2, 1854.

24. Duncanson to Sloan, November 2, August 21, and November 2, 1854.

25. *Detroit Free Press,* February 4, 1853, p. 3.

26. See Howard S. Merrit, *Thomas Cole* (Rochester, N.Y.: Memorial Art Gallery of the University of Rochester, 1969), 42, and Ellwood C. Parry III, *The Art of Thomas Cole: Ambition and Imagination*

(Newark: University of Delaware Press, 1988), 368–72.

27. *Catalogue of Pictures at the Ladies' Gallery, First Exhibition,* nos. 20–23.

28. *Daily Cincinnati Commercial,* September 19, 1856, p. 2.

29. *Cincinnati Daily Enquirer,* June 22, 1859, p. 2.

30. Asher Durand, "Letters on Landscape Painting," *The Crayon* 1 (1855): 369.

31. Moure, *William Louis Sonntag,* 23. The second version, in the Corcoran Gallery of Art, is now known as *Classic Italian Landscape with Temple of Venus.*

32. *Detroit Daily Tribune,* September 20, 1860, p. 1.

5. "The best landscape painter in the West"

1. *Daily Cincinnati Gazette,* May 30, 1861, p. 3.

2. *Daily Cincinnati Commercial,* June 10, 1854, p. 2.

3. The most thorough study of Ruskin's influence on aesthetics in the United States is Stein, *John Ruskin and Aesthetic Thought in America.* On Ruskin's influence on the American Pre-Raphaelite movement in the mid-nineteenth century see Linda S. Ferber and William H. Gerdts, *The New Path: Ruskin and the American Pre-Raphaelites* (New York: Brooklyn Museum and Schocken Books, 1985).

4. *Daily Cincinnati Commercial,* December 23, 1856, p. 2.

5. Ibid., December 23, 1856, January 31 and March 9, 1857; *Cincinnati Enquirer,* January 11 and February 11, 1857.

6. *Daily Cincinnati Commercial,* March 9, 1857, p. 2; March 26, 1857, p. 2.

7. *Cincinnati Daily Enquirer,* April 28, 1858, p. 3.

8. See Joseph Leach, *Bright Particular Star: The Life and Times of Charlotte Cushman* (New Haven: Yale University Press, 1970), 335–36, for a discussion of Cushman's patronage of Edmonia Lewis.

9. Duncanson to Sloan, August 21, 1854.

10. Charles Cist, *Cincinnati in 1859* (Cincinnati, 1861), 204.

11. *Daily Cincinnati Commercial,* March 26, 1857, p. 2.

12. Ibid., February 11, 1857, p. 1.

13. James Jackson Jarves, *The Art Idea* (1864) cited in Novak, *Nature and Culture,* 8.

14. *Cincinnati Daily Enquirer,* December 13, 1859, p. 2.

15. Ibid.

16. Durand, "Letters on Landscape Painting," 369.

17. *Cincinnati Daily Enquirer,* July 8, 1860, 2.

18. Kevin J. Avery, "*The Heart of the Andes* Exhibited: Frederic E. Church's Window on the Equatorial World," *American Art Journal* 18, no. 1 (1986):

54–55.

19. Alfred, Lord Tennyson, "Land of the Lotus Eaters," in *The Harvard Classics*, ed. Charles W. Eliot (New York, 1910), 42:1026–27.

20. *Cincinnati Daily Enquirer*, May 26, 1861, p. 2; May 28, 1861, p. 2.

21. *Daily Cincinnati Gazette*, May 30, 1861, p. 2.

22. *Cincinnati Daily Enquirer*, June 4,

1861, p. 2; June 7, 1861, p. 2; June 9, 1861, p. 3; June 23, 1861, p. 3; *Daily Cincinnati Gazette*, June 3, 1861, p. 2.

23. *Daily Cincinnati Gazette*, May 30, 1861, p. 2; *Cincinnati Daily Enquirer*, June 4, 1861, p. 2.

24. *Daily Cincinnati Gazette*, June 3, 1861, p. 2.

25. *Cincinnati Daily Enquirer*, June 28, 1861, p. 2.

6. "My Heart has always been with the down-trodden race" *The African-American Artist and Abolitionist Patronage*

1. Robert Duncanson to Reuben Duncanson, June 28, 1871, private collection, Cincinnati, Ohio.

2. See Cincinnati Art Museum, *The Golden Age*, 14–15; Cist, *Cincinnati in 1851*, 121; and *Liberty Hall and Cincinnati Gazette*, October 18, 1849, p. 1.

3. *Cincinnati Daily Enquirer*, December 13, 1859, p. 2.

4. See Hartigan, *Sharing Traditions*, 51, for a complete entry on his 1853 passport description. Horton, "Shades of Color," 41, relates that U.S. census takers were instructed to visually assess the racial makeup of citizens. Each census recorded the Duncanson family as "free colored persons" and, after 1860, classified them as mulattoes. Williamson, *New People*, xii, outlines a general definition of a mulatto.

5. Berlin, *Slaves without Masters*, 6; Toplin, "Between Black and White," 185; Horton, "Shades of Color," 38.

6. Hartigan, *Sharing Traditions*, 39–41.

7. Elsa Honig Fine, *The Afro-American Artist: Search for Identity*, 33–34.

8. Hartigan, *Sharing Traditions*, 69–75.

9. Ibid., 85–89.

10. Biographical information on Tanner

was derived from Joseph D. Ketner, "An African-American in Paris," *Journal of Art* (Rizzoli) 4, no. 2 (February 1991): 18, and Dewey F. Mosby et al., *Henry Ossawa Tanner* (Philadelphia: Philadelphia Museum of Art, 1991). Two major resources on the Harlem Renaissance are Alain Locke's *The New Negro* (rpt. New York: Atheneum, 1980) and the Studio Museum in Harlem, *Harlem Renaissance Art of Black America* (New York: Harry N. Abrams, 1987).

11. The Friend Palmer Scrapbook of the Burton Historical Collection, Detroit Public Library, provided biographical details on Henry N. Walker. In his bequest of paintings to the Detroit Institute of Arts the son of Henry Walker offered notes on the relationship between Duncanson and Walker (Duncanson file, Detroit Institute of Arts). "List of Premiums Awarded by the Michigan State Agricultural Society," *Michigan Farmer* 3, no. 19 (October 1, 1849): 295, 299, records Duncanson's award.

12. "Daguerrean Gallery of the West," *Frederick Douglass' Paper*, May 5, 1854, p. 1; *Daily Cincinnati Commercial*, June 3, 1857, p. 2.

13. *Frederick Douglass' Paper*, May 5,

1854, p. 1. This article also appeared in the *Provincial Freeman* (Toronto), June 3, 1854, p. 2.

14. *William's Cincinnati Directory, 1853,* 107.

15. *Cincinnati Daily Enquirer,* August 29, 1857, p. 3; September 27, 1857, p. 3.

16. "Daguerrean Gallery of the West," *Frederick Douglass' Paper,* May 5, 1854, p. 1.

17. *Cincinnati Daily Enquirer,* September 6, 1857, p. 3; February 21, 1858, p. 3.

18. Ann Thomas, *Fact and Fiction: Canadian Painting and Photography, 1860–1900* (Montreal: McCord Museum, 1979), 45–48.

19. U.S. census, 1860, Cincinnati, Hamilton County, Ohio, 255, provides data on Duncanson family members and indicates that the artist owned $3,000 of real estate and possessed $800 worth of personal property. *William's Cincinnati Directory for 1861* (Cincinnati: C. S. Williams, 1861) lists Reuben Duncanson's business.

20. Horton, "Shades of Color," 47, 49, 51–52; Taylor, "Spatial Organization"; *Frederick Douglass' Paper,* May 5, 1854, p. 1; U.S. census, 1860, Cincinnati, Hamilton County, Ohio, 255; and, *William's Directory for 1861,* 130, provided information on the demographic, professional, and social structures of the African-American community in Cincinnati.

21. See John Francis McDermott's *The Lost Panoramas of the Mississippi* (Chicago: University of Chicago Press, 1958) and "Banvard's Mississippi Panorama Pamphlets," *Bibliographical Society of America* 43 (1st quarter 1949).

22. *Ball's Splendid Mammoth Pictorial Tour of the United States Comprising Views of the African Slave Trade; of Northern and Southern Cities, of Cotton and Sugar Plantations; of the Mississippi,*

Ohio and Susquehanna Rivers, Niagara Falls, &C., 44.

23. *Daily Cincinnati Commercial,* October 20, 1855, p. 2, mentions the artist's donation of this painting but does not record the title or subject.

24. The painting of James Birney is not extant and was not preserved in any reproduction. The portrait of Robert Bishop, also lost, is illustrated in A. B. Huston, *Historical Sketch of Farmer's College* (Cincinnati: Students' Association of Farmer's College, 1906), 33, and Porter, "Robert S. Duncanson," 123, fig. 15. The portrait of Freeman Cary is in the National Museum of American Art, but the painting of William Cary did not survive the Ohio Military Institute. It is illustrated in Porter, "Robert S. Duncanson," 124, fig. 17.

25. Birney, "American Slavery," in Ruchames, *The Abolitionists,* 172; Charles Goss, *Cincinnati: The Queen City* (Chicago, 1912), 2:448.

26. James H. Rodabaugh, *Robert Hamilton Bishop* (Columbus: Ohio State Archaeological and Historical Society, 1935), 108–9, 111, 168 and n. 55.

27. Huston, *Historical Sketch,* 133.

28. "Preacher, Mobbed for Antislavery Lectures, Became Educator and a Union Central Founder," *UCL Carillon* (Union Central Life Insurance Co., Cincinnati) 4, no. 1 (January 1976): 1–2. Some biographical information passed down orally through the Rust family was related to the author by Richard Rust III.

29. For an explanation of the "grand manner" style in portraiture see Michael Quick *American Portraiture in the Grand Manner, 1720–1920* (Los Angeles: Los Angeles County Museum of Art, 1981).

30. Cedric Dover, *American Negro Art,* 25, deriving his thesis from E. Franklin

Frazier's *Black Bourgeoisie* (New York: Free Press, 1957).

31. Robert Duncanson to Reuben Duncanson, June 28, 1871.

7. "I have made up my mind to paint a great picture"
Exile and International Acclaim

1. Duncanson to Sloan, August 21, 1854. Gerald Carr, *Frederic Edwin Church: The Iceberg* (Dallas: Dallas Museum of Arts, 1980), 23–30, discusses the contemporary conception of the "great picture." Miss Ludlow's *A General View of the Fine Arts, Critical and Historical* (New York: Putnam, 1851) reinforced the academic hierarchy when the author proclaimed, "Historical painting is the noblest and most comprehensive branch of art" (quoted in Gerdts and Thistlethwaite, *Grand Illusions,* 41).

2. *Cincinnati Daily Enquirer,* June 7, 1861, p. 2.

3. For further discussion of the exhibition picture see James Thomas Flexner's *The Light of Distant Skies* (New York: Dover Publications, 1969), 162–69.

4. *Daily Cincinnati Gazette,* May 30, 1861, p. 2.

5. *The Globe* (Toronto), November 5, 1861. Dennis Reid, curator of the Art Gallery of Ontario in Toronto, graciously supplied this citation. See his *Our Own Country Canada,* 4, for a discussion of Toronto and Canadian cultural history.

6. Edward Radford, "Canadian Photographs." *Cincinnati Daily Enquirer,* January 19, 1862, p. 3; and March 5, 1862, p. 2. The earlier article reported that Duncanson was at home and the March article mentions "'The Tornado' and 'the Lotus Eaters,' both of which are now on their journey to Europe."

7. *Cincinnati Daily Enquirer,* March 5, 1862, p. 2. The painting was subsequently exhibited at the Art Association of

Montreal's Second Conversazione of February 11, 1864, no. 35.

8. Porter, "Robert S. Duncanson," 134, fig. 23. This painting, formerly in the collection of Wendall Dabney, a black Cincinnati journalist and civic leader, was attributed to Duncanson by James Porter but was dispersed with Dabney's estate and remains unlocated. This version attributed to Duncanson is not to be confused with a copy of the *Buffalo Hunt* painted by Wimar for the English Lord Lyons that is now in the Gilcrease Museum of Art, Tulsa, Oklahoma. For more information on Carl Wimar see Rick Stewart, Joseph D. Ketner, and Angela Miller, *Carl Wimar: Chronicler of the Missouri River Frontier* (Ft. Worth: Amon Carter Museum, 1991).

9. *Cincinnati Weekly Gazette,* October 22, 1862, p. 2.

10. *The Globe* (Toronto), September 24, 1862. Dennis Reid graciously supplied this citation.

11. Rena Neumann Coen, *Painting and Sculpture in Minnesota, 1820–1914,* 38–46.

12. *Cincinnati Weekly Gazette,* October 22, 1862, p. 2.

13. Henry Wadsworth Longfellow, "The Song of Hiawatha," from *The Complete Poetical Works of Henry Wadsworth Longfellow,* ed. Horace E. Scudder (Boston and New York: Houghton, Mifflin and Co., 1893), 124.

14. *Cincinnati Daily Enquirer,* July 8, 1860, p. 2, and January 19, 1862, p. 3.

15. The minutes from the first meeting

of the Association are quoted in Metropol-
itan Museum of Art, *American Paradise:
The World of the Hudson River School,*
55; *Cincinnati Weekly Gazette,* October
22, 1862, p. 2.

16. *Cincinnati Weekly Gazette,* October
22, 1862, p. 2.

17. *Cincinnati Daily Enquirer,* March
15, 1862, p. 2.

18. *History of the Great Western
Sanitary Fair,* 410.

19. Radford, "Canadian Photographs."

20. Hartigan, *Sharing Traditions,*
66, n. 4.

21. *Daily Cincinnati Gazette,* November
24, 1865, p. 2; *Montreal Herald,* September
22, 1863, pp. 2, 3.

22. Reid, *Our Own Country Canada,* 5.
Reid provides a thorough discussion of
the development of nationalism in
Canadian art.

23. Stanley G. Triggs, *William Notman:
The Stamp of a Studio* (Toronto: Coach
House Press for the Art Gallery of Ontario,
1985); *Photographic Selections by William
Notman,* introduction by Thomas D. King.

24. *Photographic Selections; Montreal
Herald,* February 8, 1864, p. 3.

25. "Canadian Photographs."

26. *Photographic Selections.*

27. *Montreal Herald,* December 24,
1863, p. 1.

28. "Conversazione of the Association of
Fine Arts," *Montreal Herald,* February
12, 1864, p. 1.

29. Art Association of Montreal, *Second
Conversazione,* nos. 109 and 35.

30. *Montreal Herald,* February 12,
1864, p. 2.

31. Both artists were German-trained
immigrants. For more biographical
information see Reid, *Our Own Country
Canada,* and J. Russell Harper, *Painting in
Canada* (Toronto: University of Toronto,
1977).

32. *Montreal Herald,* February 12,
1864, p. 2.

33. *Art Association Exhibition 1865*
(Montreal, February 27, 1865), nos. 62,
64–65, 89, 97–99, 103.

34. *Montreal Herald,* February 28,
1865, p. 2.

35. Ibid. Unfortunately, Jacobi's
monumental painting remains unlocated,
but one of Notman's *Photographic
Selections* (Montreal: William Notman,
1865) reproduced the picture as fig. 99.

36. *Montreal Herald,* December
12, 1863, p. 2, describes a mass of people
from the United States moving to Canada
fleeing the Civil War: "American
Immigration. Almost every tram from the
frontier, says the *Globe,* brings families
from the United States, who are anxious to
take land and invest their means in
making for themselves homes in Canada.
We learn that a large number of persons
are locating in the western counties."
See also Reid, *Our Own Country Canada.*

37. For more information on Jacobi's
copies of Notman's photographs see
Reid, *Our Own Country Canada,* 68–74,
and S. Allan Pringle, "Robert S. Duncanson
in Montreal, 1863–1865," 35.

38. Reid, *Our Own Country Canada,*
94–96; Julia H. S. Bugelia and Theodora
Cornell Moore, *In Old Missiquoi: With
History and Reminiscences of Stanbridge
Academy;* Elizabeth Collard, "Eastern
Townships Artist: Allan Edson," *Canadian
Antiques Collector 5,* no. 1 (January
1970): 13; Gordon Day, "The Life and
Times of Aaron Allan Edson" (Master's
thesis, Concordia University, 1977); *Aaron
Allan Edson (1846–1888)* (St. Lambert,
Quebec: Musée Marsil Museum de
St. Lambert, 1985).

39. Pringle, "Duncanson in Montreal,"
35. This article offers a thorough
discussion of Duncanson's career and

stylistic development in Canada.

40. See Reid, *Our Own Country Canada;* Thomas, *Fact and Fiction;* and Pringle, "Duncanson in Montreal," for more detailed discussions.

41. See Pringle, "Duncanson in Montreal," 48, and R. H. Hubbard, "Artists in Common: Canadian-American Contacts," *Racar* 3, no. 2 (1976): 45, for more detailed discussion of Bierstadt in Canada.

42. Harper, *Painting in Canada,* 71.

43. Reid, *Our Own Country Canada,* 98.

44. Radford, "Canadian Photographs."

45. Reid, *Our Own Country Canada,* 43.

46. "*The Land of the Lotus-Eaters.* Painted by R. S. Duncanson."

47. *Art-Journal* (London) n.s. 4 (1865): 237, 257; *Art-Journal* n.s. 7 (1868): 99, 159.

48. *Montreal Herald,* February 8, 1864, p. 3; and *Photographic Selections.*

49. Moncure D. Conway, *Autobiography, Memories and Experiences of Moncure Daniel Conway* (Boston and New York: Houghton, Mifflin and Co., 1904), 293; *Cincinnati Weekly Gazette,* November 24, 1865, p. 2. Cincinnati held Conway in high regard as an author and journalist who was reported to harbor abolitionist sympathies.

50. *Cincinnati Weekly Gazette,* November 24, 1865, p. 2; "*The Land of the Lotus-Eaters.* Painted by Robert S. Duncanson."

51. "Death of Duncanson the Artist," *Detroit Tribune,* December 26, 1872, p. 4.

52. This painting was rediscovered by Romare Bearden and Harry Henderson in 1972 and subsequently published for the first time in Kynaston McShine's *The Natural Paradise* (New York: Museum of Modern Art, 1976), 170.

53. Radford, "Canadian Photographs."

8. The Lure of Scotland

1. *Catalogue of the First Annual Exhibition of the Associated Artists of Cincinnati, 1866–1867.*

2. Ibid., no. 41.

3. Perry Miller, *Nature's Nation* (Cambridge: Harvard University Press, 1967), 241–78; Park Godwin, ed., *Prose Writings of William Cullen Bryant* (New York: D. Appleton and Co., 1884), 2:310–11; Thomas Carlyle, "Sir Walter Scott," in *The Harvard Classics,* ed. Charles W. Eliot (New York: P. F. Collier & Son, 1909), 25:430.

4. Sir Walter Scott, *Waverly Novels,* vol. 15, *A Legend of Montrose* (Edinburgh: 1848), 13.

5. See Howard Jones, *The Harp That Once* (New York: Henry Holt & Co., 1937), for a biography of Moore and a discussion of his position as a romantic author.

6. *Cincinnati Daily Enquirer,* March 24, 1863, p. 3.

7. Thomas Moore, *Lalla Rookh, An Oriental Romance* (London: 1817), 295.

8. Ibid., 343.

9. Ibid., 327–28.

10. Cincinnati Academy of Fine Arts, *Catalogue of the First Exhibition at Wiswell's Gallery, 1868,* no. 30; *Catalogue of the Second Exhibition at Wiswell's Gallery, 1868–9,* no. 20; Chicago Academy of Design, *Catalogue of the Third Annual Exhibition,* nos. 14–16.

11. The artist file on Robert Duncanson at the library of the Montreal Museum of Fine Arts contains a list of all his entries in the Art Association exhibitions.

among the Landscapists," *Cincinnati Daily Enquirer*, September 24, 1871, p. 4.

20. This change in the aesthetic climate, expressed by Earl Marble in his "Charles Sumner's Fine-Art Legacy," had a direct effect on the financial fortunes of Duncanson's family. A decade after his death, Duncanson's wife and daughter suffered severe financial and health problems. In 1881 Mrs. Duncanson began borrowing money against the painting of *Ellen's Isle,* which was still at the Museum of Fine Arts in Boston. As stipulated in Sumner's will, the painting was returned to Mrs. Duncanson in 1884. In the intervening time Berta, the daughter, had married and had a baby who died shortly after birth. This seriously affected Berta's health and, when her husband abandoned her, required Phoebe Duncanson to support her daughter again. This was too great a burden for Phoebe, whose health had also become fragile. By 1885 she was forced to mortgage most of her personal property. She borrowed money from her attorney regularly and was soon unable to pay off her debts. In 1888 she offered the attorney the painting of *Ellen's Isle* in exchange for $100 and a release from her debts. The attorney, Ralzemond D. Parker, a longtime friend of the family, realized the desperate situation in which the family found itself and accepted the offer. The painting remained in the Parker family until it was donated to the Detroit Institute of Arts. Nearly destitute, Phoebe moved on to Chicago and later to Seattle, where she died in obscurity. This information is found in receipts, mortgages, and letters between Phoebe Duncanson and Ralzemond Parker in the Parker Papers, Burton Historical Collection, Detroit Public Library.

21. Porter, "Robert S. Duncanson," 145.

22. *Daily Cincinnati Gazette,* May 31, 1861, p. 2.

BIBLIOGRAPHY

Art Association of Montreal. *Second Conversazione*. Exhibition, February 11, 1864. Montreal: Herald Steam Press, 1864.

———. *Third Conversazione*. Exhibition, February 1865. Montreal: Herald Steam Press, 1865.

Ball's Splendid Mammoth Pictorial Tour of the United States Comprising Views of the African Slave Trade; of Northern and Southern Cities, of Cotton and Sugar Plantations; of the Mississippi, Ohio and Susquehanna Rivers, Niagara Falls, &C. Cincinnati, Ohio: Achilles Pugh, Printer, 1855.

Beach Institute, King-Tisdell Museum, Savannah, Georgia. *Walter O. Evans Collection of African American Art*. Essays by Leslie King-Hammond et al. Detroit: Walter O. Evans, King-Tisdell Foundation, 1991.

Broken Fetter (Detroit), February 28, 1865, pp. 3, 5, 29.

Brownell, William C. "The Younger Painters of America." *Scribner's Monthly* 20 (July 1880).

Buffalo Fine Arts Academy. *Catalogue of Works of Art on Exhibition at the Buffalo Fine Arts Academy*. Buffalo: Warren, Johnson, & Co., Printers, 1869.

Bugelia, Julia H. S., and Theodora Cornell Moore. *In Old Missiquoi: With History and Reminiscences of Stanbridge Academy*. Montreal: John Lovel & Son, 1910.

"Canadian Photographs." *Art Journal* (London) n.s. 3 (1864): 58–59.

Catalog of Articles in Exhibition at the Gallery of Fine Arts. Exhibition, Fireman's Hall, Detroit, Michigan, February 1852. Detroit: Duncklee, Wales and Co., Printers, 1852.

Catalog of Articles in Exhibition at the Gallery of Fine Arts. Exhibition, Fireman's Hall, Detroit, Michigan, February 1853. Detroit: Duncklee, Wales and Co., Printers, 1853.

Catalog of Painting and Sculpture Exhibited at the Fireman's Fair. Exhibition, Cincinnati, Ohio, June 16, 1845.

Catalog of the Second Annual Exhibition of Painting and Statuary by the Section of Fine Arts of the Society for the Promotion of Useful Knowledge. Exhibition, Cincinnati, Ohio, June 9, 1842. Cincinnati: Daily Republican Office, 1842.

Catalogue of the First Annual Exhibition of the Associated Artists of Cincinnati, 1866–1867. Cincinnati: Times Steam Book and Job Printing Establishment, 1867.

Catalogue of Pictures at the Ladies' Gallery, First Exhibition, 1854. Independence Hall. Cincinnati: Cincinnati Job Rooms, 1854.

Cavallo, A. S. "*Uncle Tom and Little Eva*, a Painting by Robert S. Duncanson." *Bulletin of the Detroit Institute of Arts* 30, no. 1 (1950–1951): 21–25.

Cedarholm, Theresa D. *Afro-American Artists: A Bio-Bibliographical Directory*. Boston: Trustees of the Boston Public Library, 1973.

Chicago Academy of Design. *Catalogue of the Third Annual Exhibition*. Chicago, 1868.

Cincinnati Academy of Fine Arts. *Catalogue of the First Exhibition at Wiswell's Gallery, 1868*. Cincinnati,

Robert Clarke & Co., Printers, 1868.

———. *Catalogue of the Second Exhibition at Wiswell's Gallery, 1868–9.* Cincinnati: Robert Clarke & Co., Printers, 1869.

Cincinnati Art Museum. *Rediscoveries in American Painting.* Exhibition, October 3–November 6, 1955. Cincinnati: Cincinnati Art Musuem, 1955.

———. *The Golden Age: Nineteenth Century Cincinnati Artists Represented in the Cincinnati Art Museum.* Exhibition, October 6–January 13, 1979. Cincinnati: Cincinnati Art Museum, 1979.

Cincinnati Institute of Fine Arts. *Catalogue of the Taft Museum*, 109–12. Cincinnati: Cincinnati Institute of Fine Arts, 1939.

Cist, Charles. *Cincinnati in 1841: Its Early Annals and Future Prospects.* Cincinnati, 1841.

———. *Sketches and Statistics in Cincinnati in 1851.* Cincinnati: William H. Moore & Co., 1851.

Coen, Rena Neumann. *Painting and Sculpture in Minnesota, 1820–1914.* Minneapolis: University of Minnesota Press, 1976.

Coffey, John W. *Twilight of Arcadia: American Landscape Painters in Rome, 1830–1880.* Brunswick, Maine: Bowdoin College Museum of Art, 1987.

"A Colored Artist." *Pacific Appeal* (San Francisco) 9, no. 13 (November 14, 1874): 1.

Conway, Rev. Moncure D. "A Cincinnati Colored Artist in England." *Cincinnati Gazette*, November 24, 1865.

Cosmopolitan Art Association (Sandusky, Ohio). *The Cosmopolitan Art Association Illustrated Catalogue 1855–1856.* Exhibition, December 1855–January 31, 1856.

Cowdrey, Mary Bartlett. *American Academy of Fine Arts and American Art Union.* New York: New-York Historical Society, 1953.

Dabney, Wendell P. *Cincinnati's Colored Citizens.* Cincinnati: Dabney Publishing Co., 1926.

Dean, Roberta Hampton. "The Western Art Union, 1847–1851." Master's thesis, George Washington University, 1978.

Detroit Art Association. *Catalogue of the First Exhibition.* 1876.

Detroit Art Loan. *Catalogue of Art Works Exhibited.* 1883.

Detroit Institute of Arts. *Exhibition of Works of Painters in Detroit before 1900.* Detroit: Detroit Institute of Arts, 1949.

———. *Michigan Painters before 1900.* Detroit: Detroit Institute of Arts, 1952.

DeVries, James E. *Race and Kinship in a Midwestern Town: The Black Experience in Monroe, Michigan, 1900–1915.* Urbana and Chicago: University of Illinois Press, 1984.

Dover, Cedric. *American Negro Art.* Greenwich, Conn.: New York Graphic Society, 1960.

Driskell, David. C. *Amistad II: Afro-American Art.* Nashville: Fisk University, 1975.

———. *Two Centuries of Black American Art.* Exhibition, Los Angeles County Museum of Art, September 3–November 11, 1976. New York: Alfred A. Knopf, 1976.

———. *Hidden Heritage: Afro-American Art, 1800–1950.* Exhibition, Bellevue Art Museum, Washington, D.C. September 14–November 10, 1985. San Francisco: Art Museum Association of America, 1985.

Dwight, Edward H. "Art in Early Cincinnati." *Cincinnati Art Museum Bulletin* n.s. 3, no. 4 (August 1953): 3–11.

———. "Robert S. Duncanson." *Museum*

Echoes 27, no. 6 (June 1954): 43–45.

———. "Robert S. Duncanson." *Bulletin of the Historical and Philosophical Society of Ohio* 13, no. 3 (July 1955): 203–11.

Fine, Elsa Honig. *The Afro-American Artist: Search for Identity*. New York: Holt, Rinehart and Winston, 1973.

Foote, John P. *Schools of Cincinnati*. Cincinnati: C. F. Bradley & Co., 1855.

Gerdts, William H. *Painters of the Humble Truth: Masterpieces of American Still Life*. Columbia: University of Missouri Press, 1981.

Gibson, Arthur Hopkin. *Artists of Early Michigan*. Detroit: Wayne State University Press, 1975.

Harper, J. Russell. *Early Painters and Engravers in Canada*. Toronto: University of Toronto Press, 1970.

Hartigan, Lynda Roscoe. *Sharing Traditions: Five Black Artists in Nineteenth-Century America*. Exhibition, National Museum of American Art, January 15–April 7, 1985. Washington, D.C.: Smithsonian Institution Press, 1985.

Heilbron, Bertha, ed. *With Pen and Pencil on the Frontier in 1851: The Diary and Sketches of Frank Blackwell Mayer*. St. Paul: Minnesota Historical Society, 1932.

History of the Great Western Sanitary Fair. Cincinnati: C. F. Vent & Co., 1863.

Janson, Anthony F. "The Cincinnati Landscape Tradition." In *Celebrate Cincinnati Art*, 11–27. Cincinnati: Cincinnati Art Museum, 1982.

Kenny, Sister M. Killian. "A History of Painting in Michigan, 1850 to World War II." Master's thesis, Wayne State University, Detroit, 1965.

Ketner, Joseph D., II. "Robert S. Duncanson (1821–1872): The Late

Literary Landscape Paintings." Master's thesis, Indiana University, 1979.

———. "Robert S. Duncanson (1821–1872): The Late Literary Landscape Paintings." *American Art Journal* 15, no. 1 (Winter 1983): 35–47.

———. "Robert S. Duncanson (1821–1872)." In *Artists of Michigan from the Nineteenth Century*, edited by J. Gray Sweeney, 62–67. Muskegon, Michigan: Muskegon Museum of Art, 1987.

———. "The Belmont Murals in the Taft Museum." *Queen City Heritage* 46, no. 1 (Spring 1988): 51–63.

"*The Land of the Lotus-Eaters*. Painted by Robert S. Duncanson." *Art-Journal* (London) n.s. 5 (1866): 93.

"List of Premiums Awarded by the Michigan State Agricultural Society, at its First Annual Fair, held at Detroit, Sept. 25th, 26th, and 27th, 1849." *Michigan Farmer* (Detroit) 7, no. 19 (October 1, 1849): 295, 299.

McElroy, Guy. "Robert S. Duncanson: A Problem in Romantic Realism in American Art." Master's thesis, University of Cincinnati, 1972.

———. *Robert S. Duncanson: A Centennial Exhibition*. Exhibition, March 16–April 30, 1972. Cincinnati: Cincinnati Art Museum, 1972.

McNairn, Alan. "American Paintings in the National Gallery of Canada, Ottawa." *Antiques* 118 (November 1980): 1010–17.

Marble, Earl. "Charles Sumner's Fine-Art Legacy." *The Aldine* (Virginia) (February 1875): 277.

Mechanic's Institute Fair. Exhibition, Melodeon Building, Cincinnati, Ohio, 1844.

Metropolitan Museum of Art, New York. *American Paradise: The World of the Hudson River School*. New York:

Harry N. Abrams, 1987.

Museum of Art, North Carolina Central University. *Duncanson: A British-American Connection.* Exhibition, June 3–July 1, 1984. Durham: North Carolina Central University, 1984.

Museum of Fine Arts, Boston. *Catalogue. Pictures Exhibited by the Atheneum: Pictures and Engravings Bequested to the Museum of Fine Arts by the Hon. Charles Sumner.* Boston: Press of Rockwell & Churchill, 1874.

Museum of Fine Arts, Boston, and the National Center of Afro-American Artists. *19th Century Afro-American Artists: Duncanson and Bannister.* Boston: Museum of Fine Arts, 1972.

Niblack, Rita S. "Nicholas Longworth, Art Patron of Cincinnati." Master's thesis, University of Cincinnati, 1985.

Novak, Barbara. *The Arcadian Landscape: Nineteenth Century American Painters in Italy.* Exhibition, November 4–December 3, 1972. Lawrence: University of Kansas Museum of Art, 1972.

Omoto, Sadayoshi, and Eldon van Liere. *The Michigan Experience.* Exhibition, Kresge Art Museum, Michigan State University, June 1986–June 1987. East Lansing: Michigan State University, 1986.

Parks, James Dallas. *Robert S. Duncanson: 19th Century Black Romantic Painter.* Washington, D.C.: Associated Publishers, 1980.

Perry, Regina A. *Selections of Nineteenth-Century Afro-American Art.* Exhibition, Metropolitan Museum of Art, New York, June 19–August 1, 1976. New York: Metropolitan Museum of Art, 1976.

Photographic Selections by William Notman. Montreal: William Notman, 1863.

Pittsburgh Art Gallery. *Catalogue of the Spring Exhibition of the Pittsburgh Art Gallery.* Pittsburgh: Jas. R. Hill, Steam Job Printer, 1870.

Porter, James A. "Versatile Interests of the Early Negro Artist." *Art in America and Elsewhere* 24 (January 1936): 16–27.

———. *Modern Negro Art.* New York: 1943.

———. "Robert S. Duncanson: Midwestern Romantic-Realist." *Art in America* 39, no. 3 (1951): 99–154.

———. "Robert S. Duncanson." *Art in America* 42, no. 3 (October 1954): 220–21, 235.

———. *Ten Afro-American Artists of the Nineteenth Century.* Exhibition, February 3–March 30, 1967. Washington, D.C.: Howard University Gallery of Art, 1967.

Pringle, Allan. "Robert S. Duncanson in Montreal, 1863–1865." *American Art Journal* 17, no. 4 (Autumn 1985): 28–50.

Radford, Edward. "Canadian Photographs." *Art Journal* (London) n.s. 3 (1864): 113.

Reid, Dennis. *Our Own Country Canada.* Ottawa: National Gallery of Canada, 1979.

Roethlisberger, Marcel. *Im Licht von Claude Lorrain: Landschaftsmalerei aus drei Jahrhundert.* Exhibition, Haus der Kunst, Munich, March 12–May 29, 1983. Munich: Hirmer Verlag, 1983.

Saint Louis Art Museum. *Currents of Expansion: Painting in the Midwest, 1820–1940.* Exhibition, February 18–April 10, 1977. St. Louis: The Saint Louis Art Musuem, 1977.

Schwartz, Abby. "Nicholas Longworth: Art Patron of Cincinnati." *Queen City Heritage* 46, no. 1 (Spring 1988): 17, 22–24.

Siple, Walter. "The Taft Museum." *Bulletin of the Cincinnati Art Museum* 4, no.

1 (January 1933): 1–21.

Spassky, Natalie. *American Paintings in the Metropolitan Museum of Art.* Vol. 2. Princeton: Princeton University Press, 1985.

Taft Museum, Cincinnati, Ohio. *Nicholas Longworth: Art Patron of Cincinnati.* Cincinnati: Taft Museum, 1988.

Vitz, Robert C. "Seventy Years of Cincinnati Art: 1790–1860." *Cincinnati Historical Society Bulletin* 25, no. 1 (January 1967): 50–69.

Webster, J. Carson. "Junius R. Sloan: Self-Taught Artist." *Art in America* 40, no. 3 (Summer 1952): 101–52.

Western Art Association. Exhibition, Detroit, September 1871.

INDEX

INDEX OF ILLUSTRATIONS

ABOUT THE AUTHOR

Photograph by Joseph Angeles

Joseph D. Ketner is Director of the Washington University Gallery of Art in St. Louis, Missouri. He is co-author of *Carl F. Wimar: Chronicler of the Missouri River* and *The Beautiful, the Sublime, and the Picturesque.*